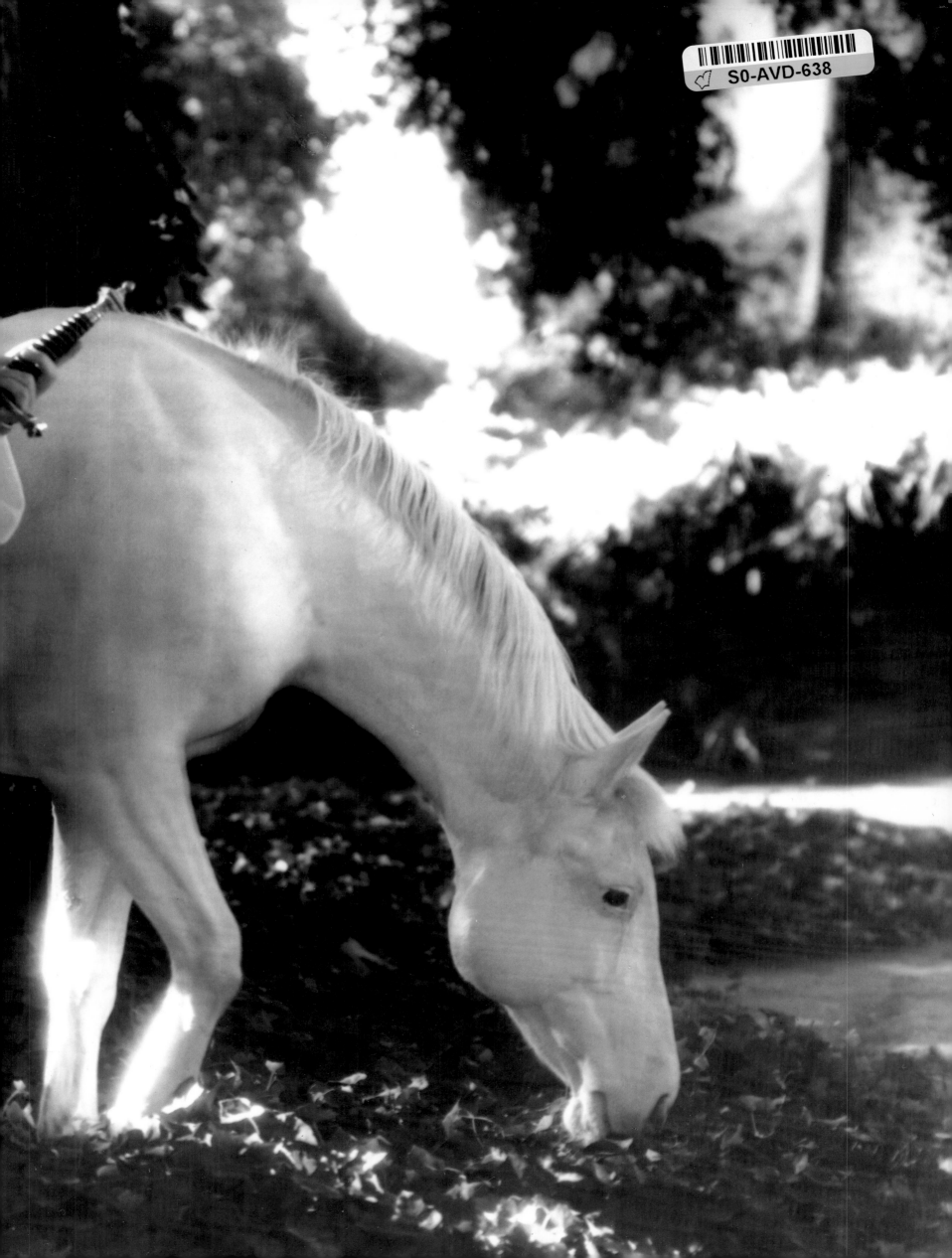

Merry
Christmas
Joseph! '94
Love,
Patty

HURRELL HOLLYWOOD

George Hurrell

HURRELL HOLLYWOOD

George Hurrell

PHOTOGRAPHS 1928–1990

ST. MARTIN'S PRESS

NEW YORK

THE CHARACTERS
IN THE ORDER OF THEIR APPEARANCE

They just didn't walk in the door...

They arrived...

It was as if they had internal trumpets

that blew for them

just as the door opens.

George Hurrell

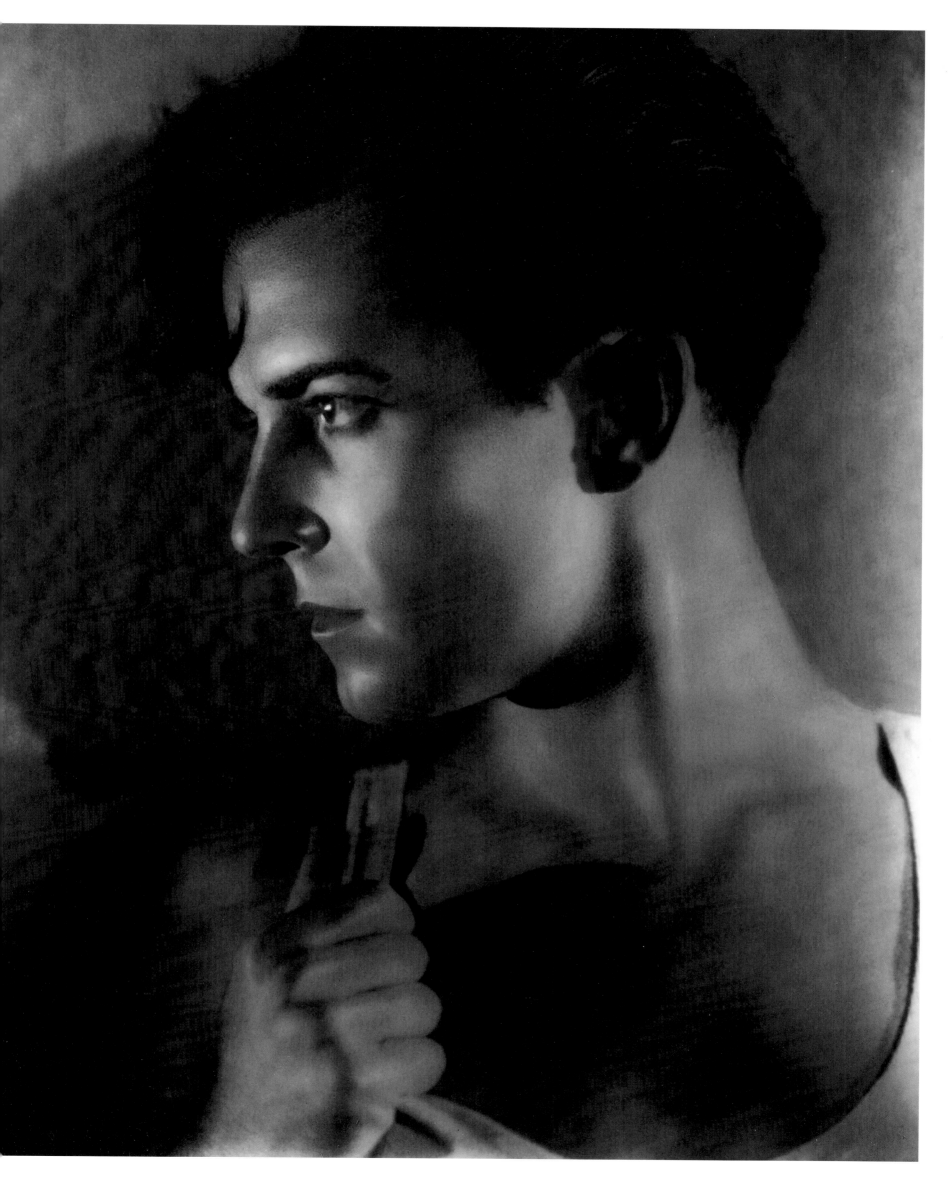

1 RAMON NOVARRO, 1928

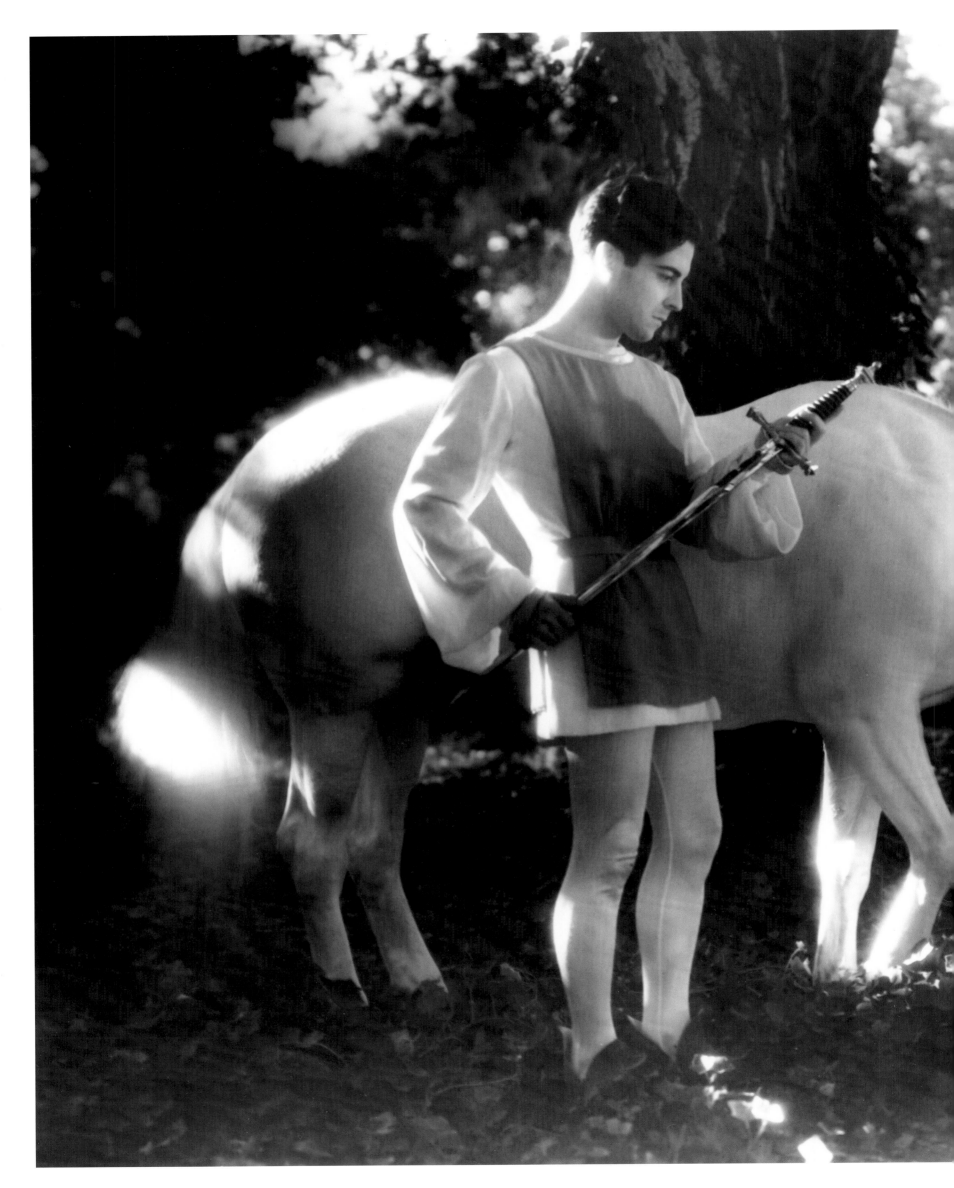

2 RAMON NOVARRO, 1928

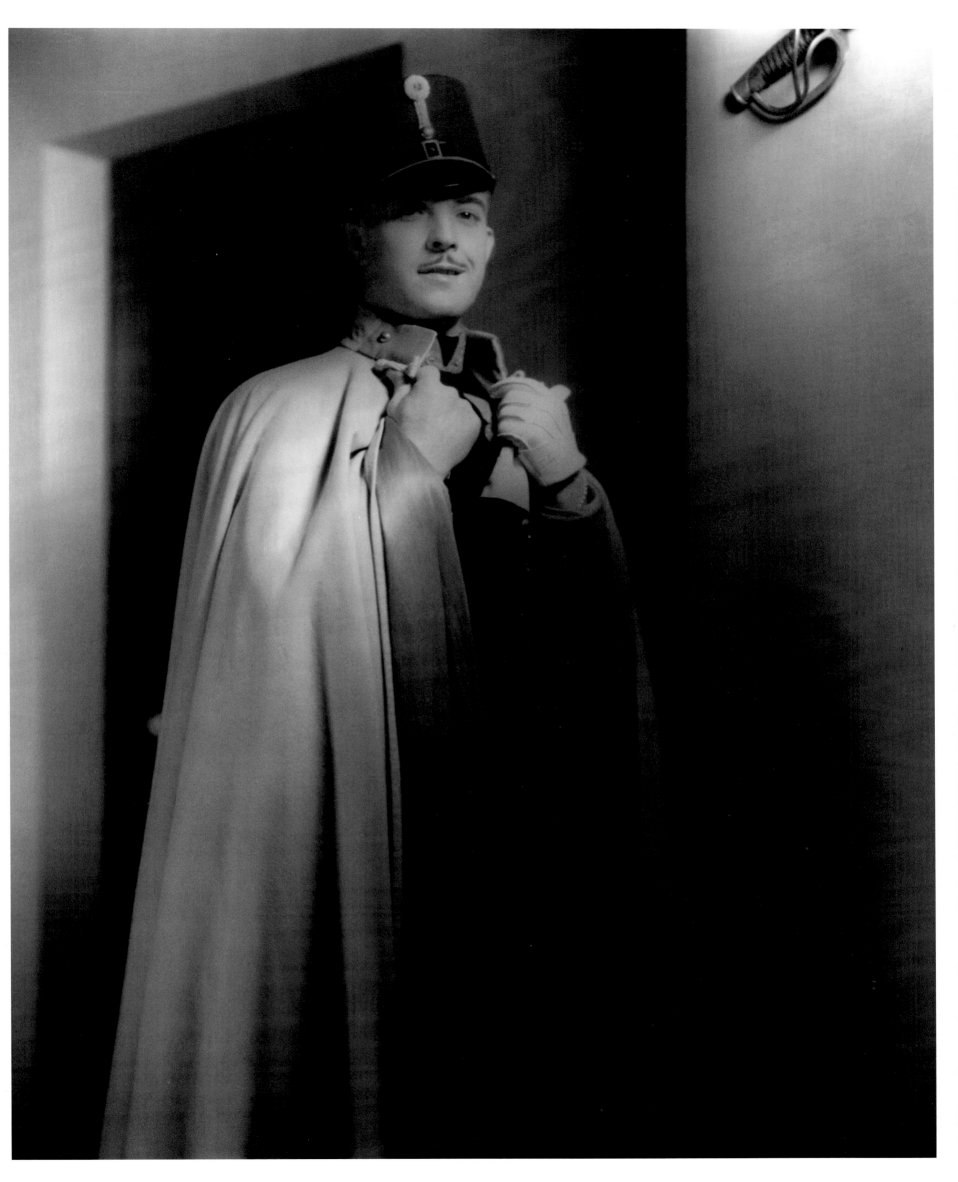

3 RAMON NOVARRO, *Mata Hari*, 1931

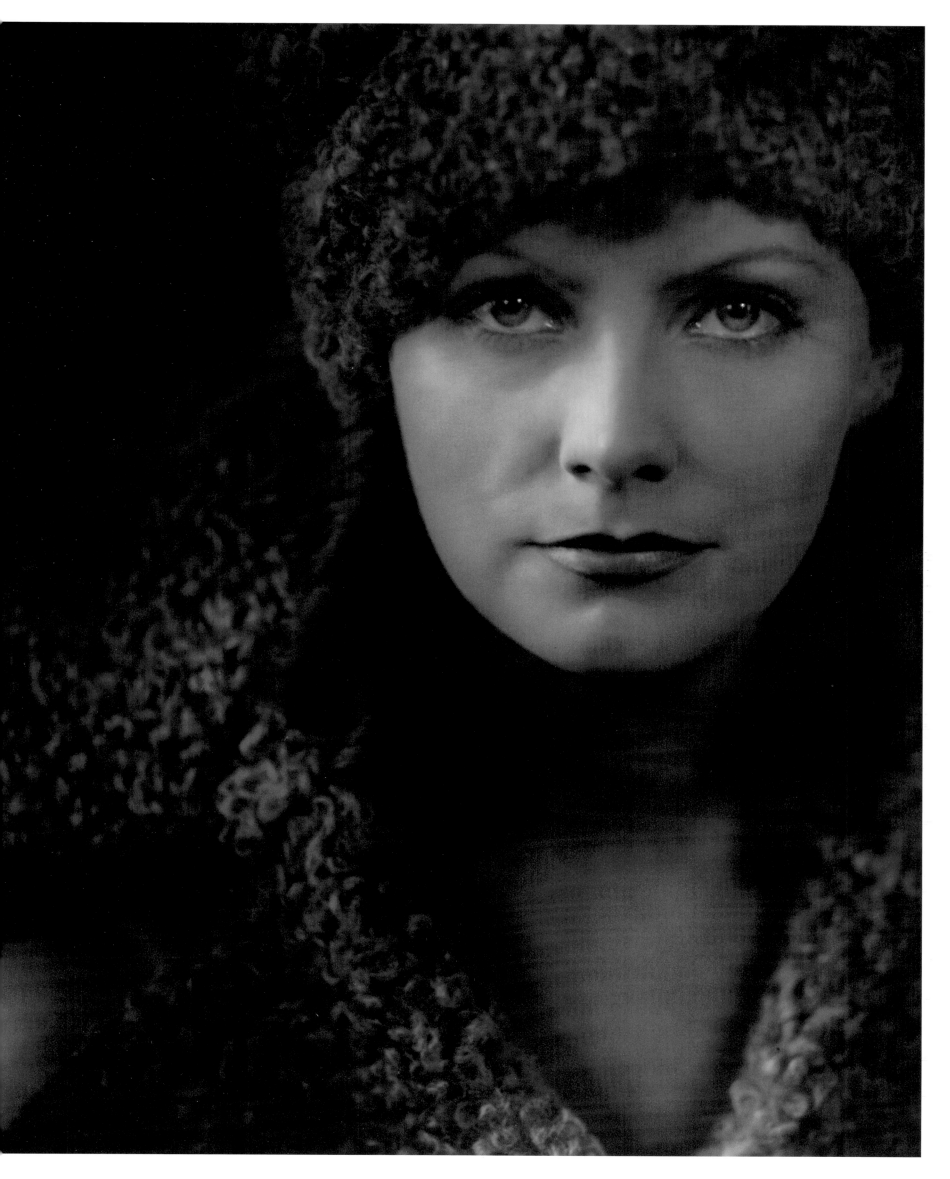

4 GRETA GARBO, *Romance*, 1930

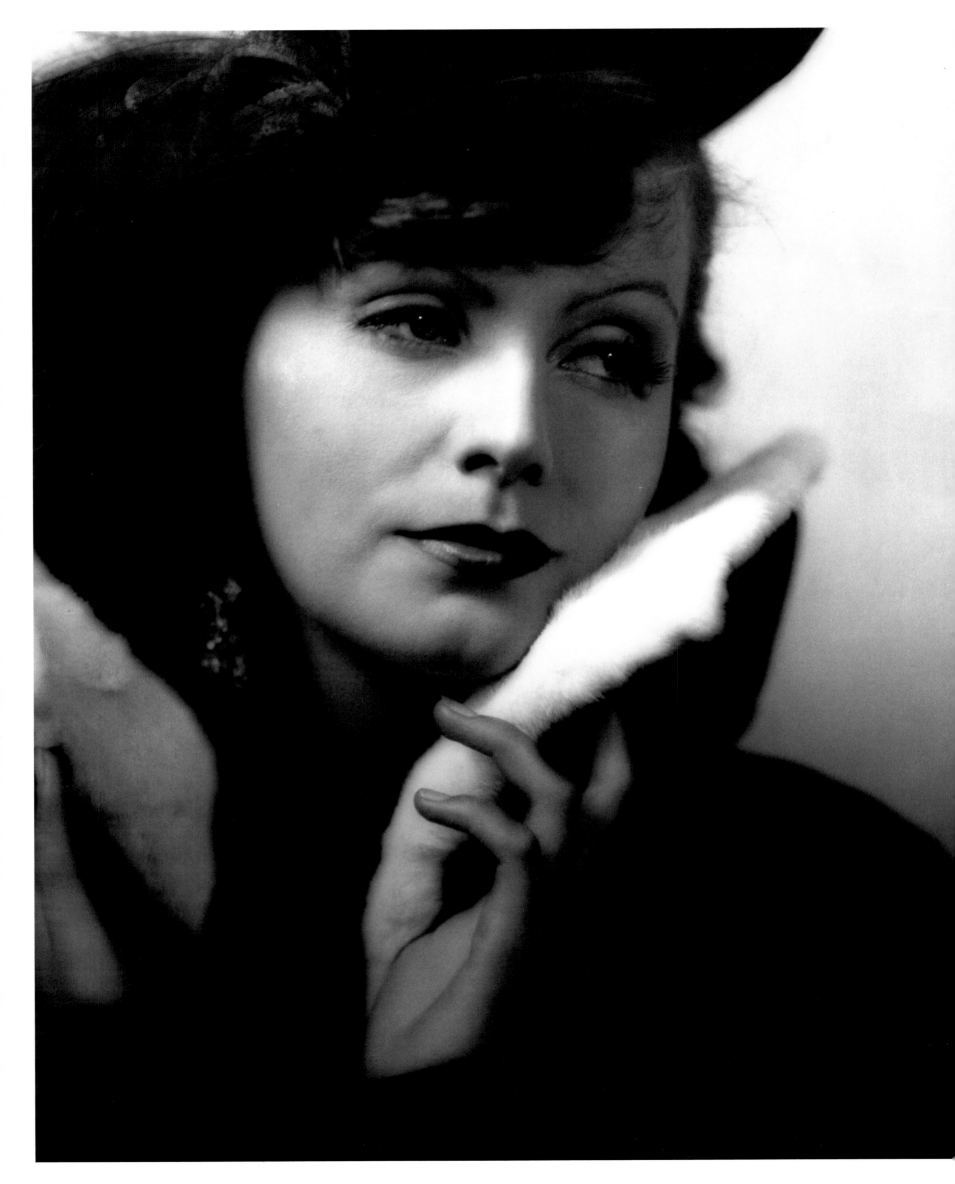

5 GRETA GARBO, *Romance*, 1930

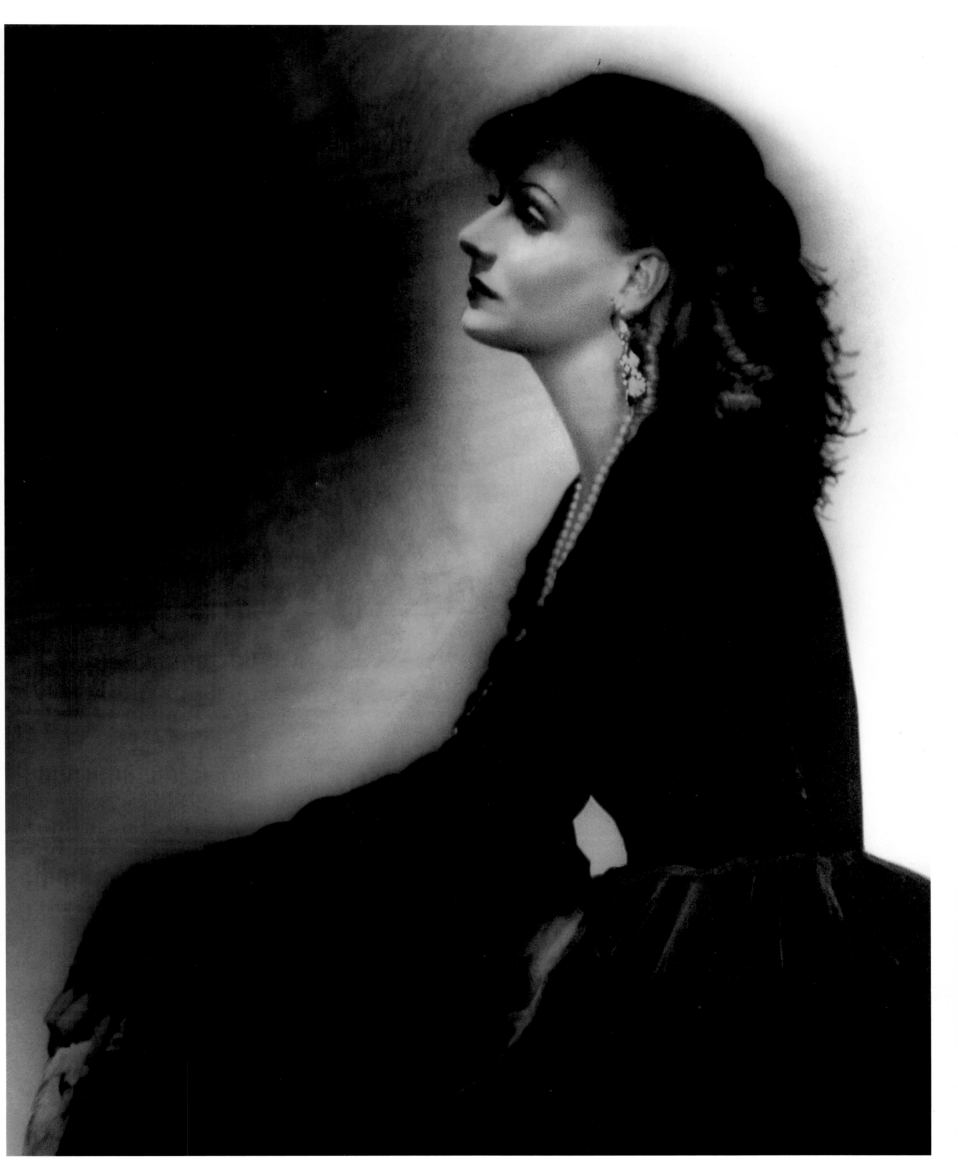

6 GRETA GARBO, *Romance*, 1930

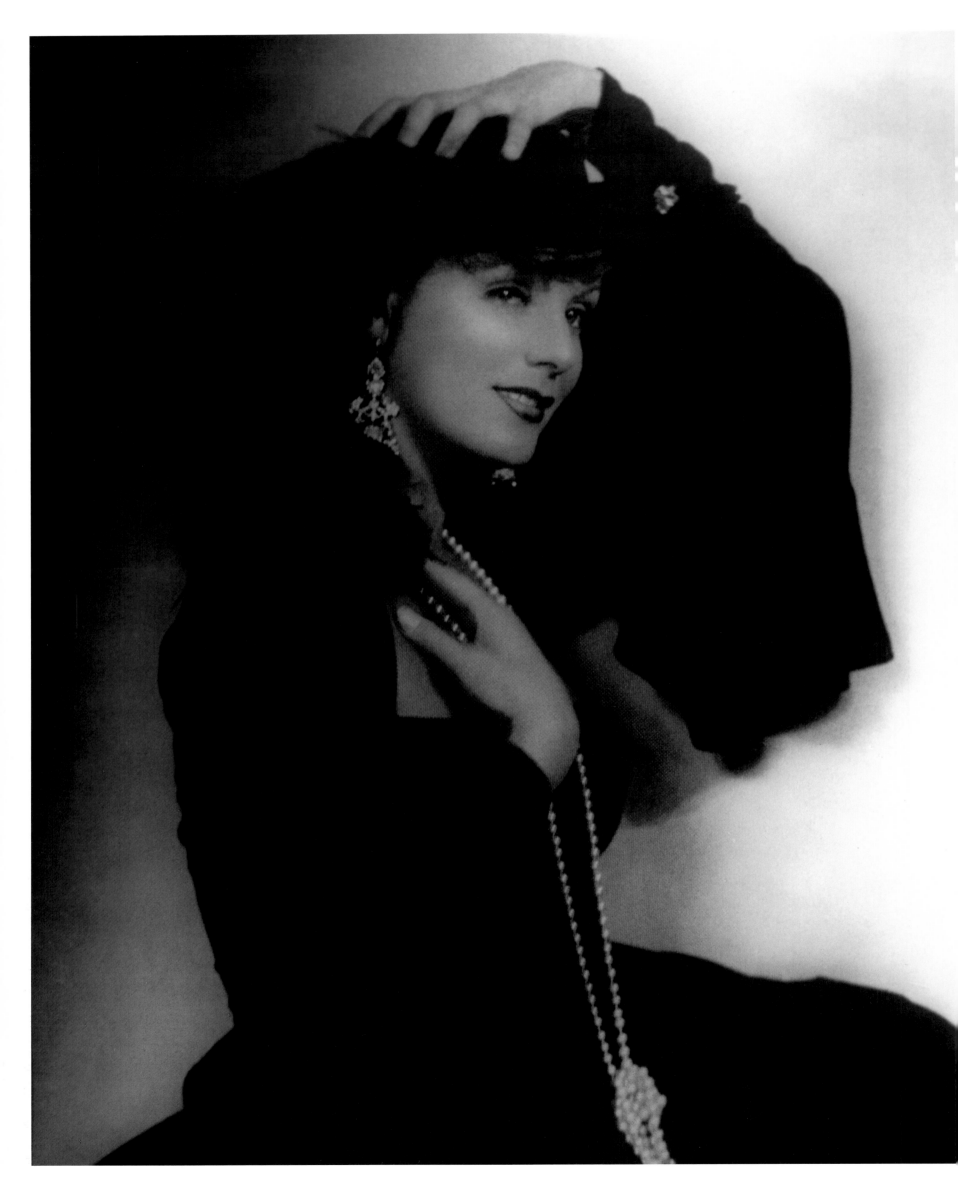

7 GRETA GARBO, *Romance*, 1930

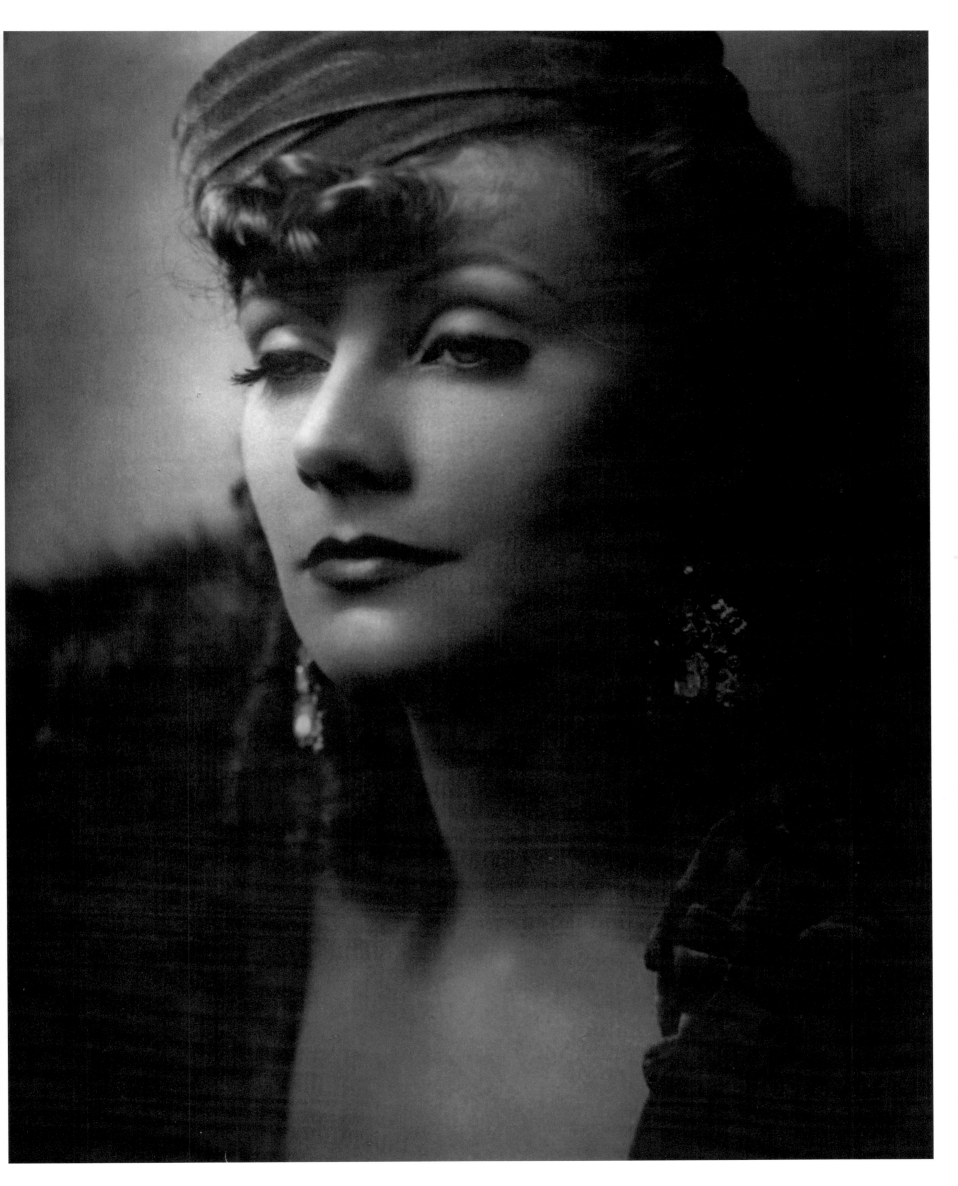

8 GRETA GARBO, *Romance*, 1930

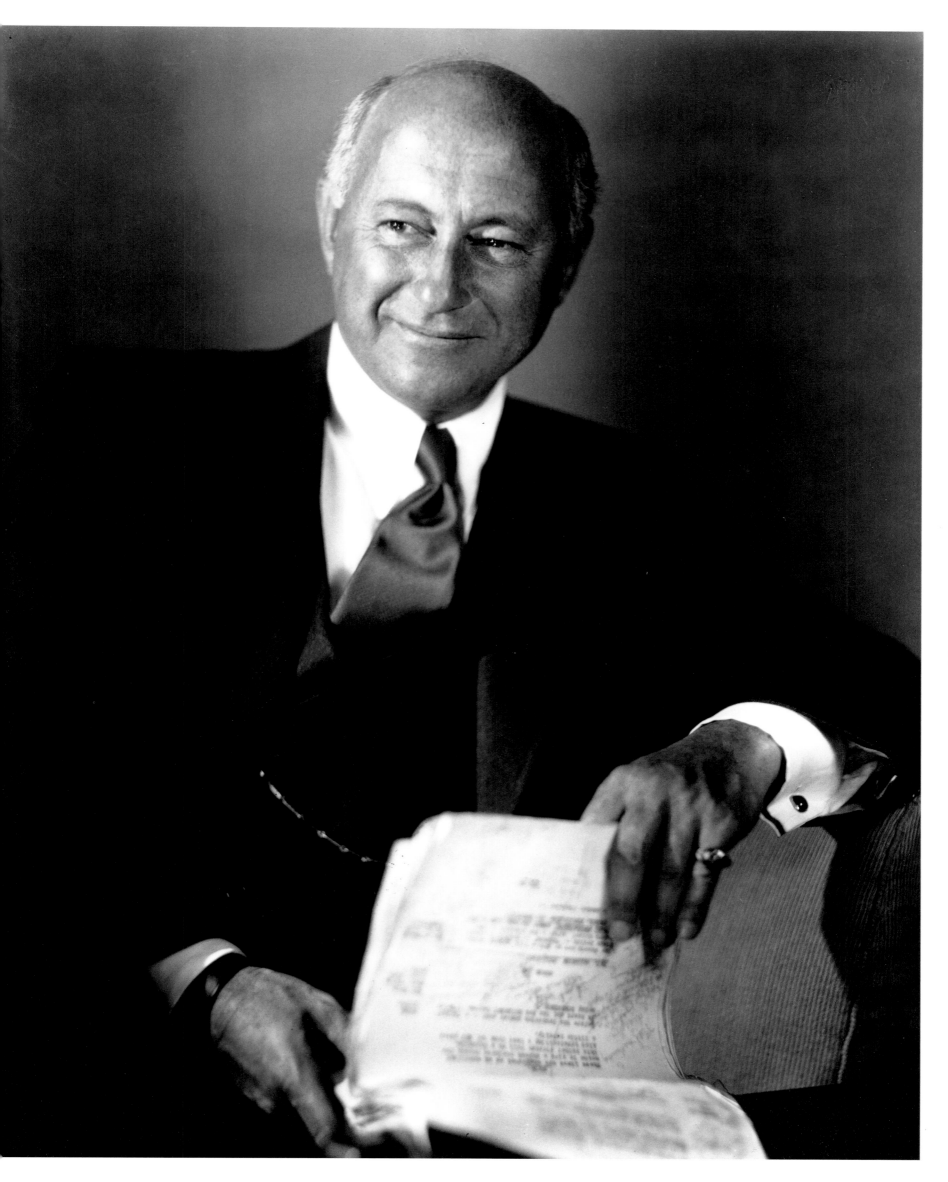

9 CECIL B. DE MILLE, 1930

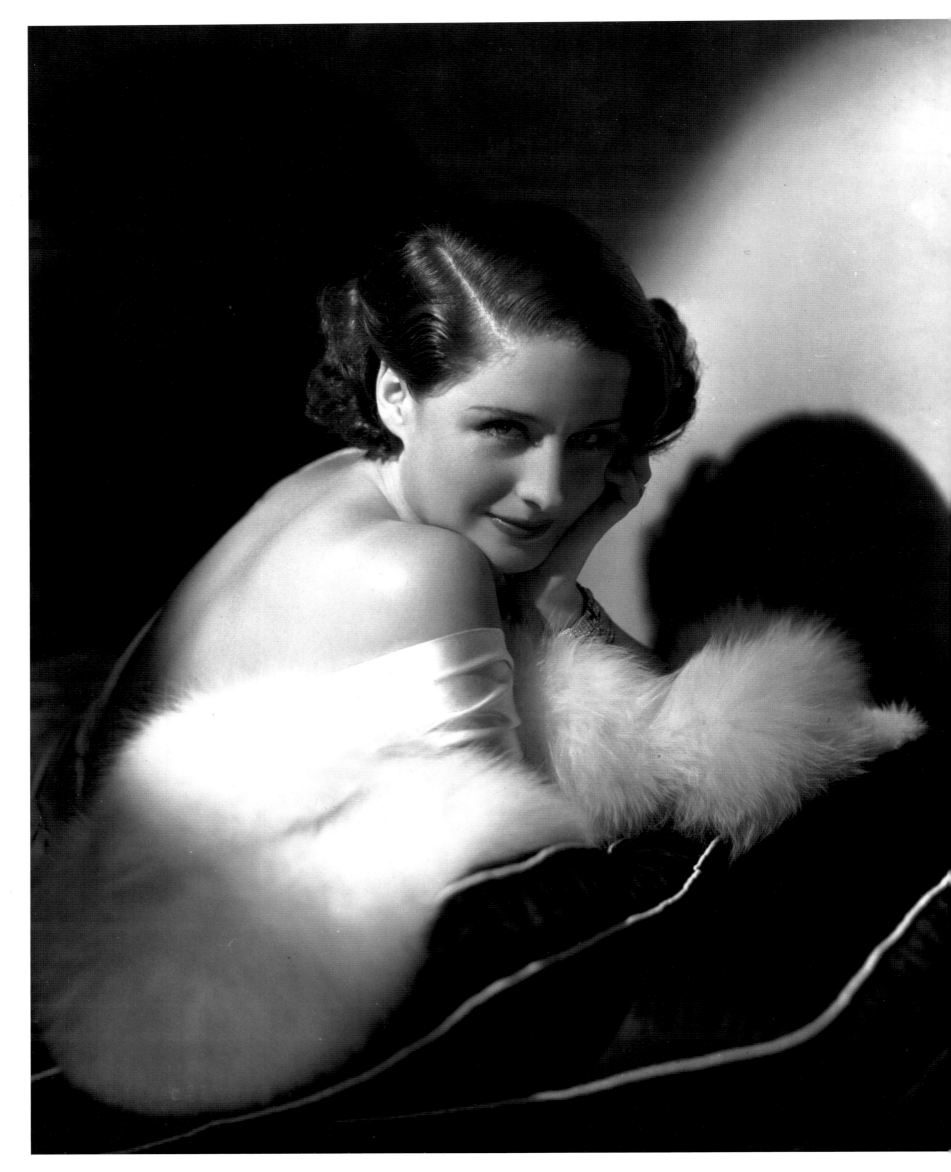

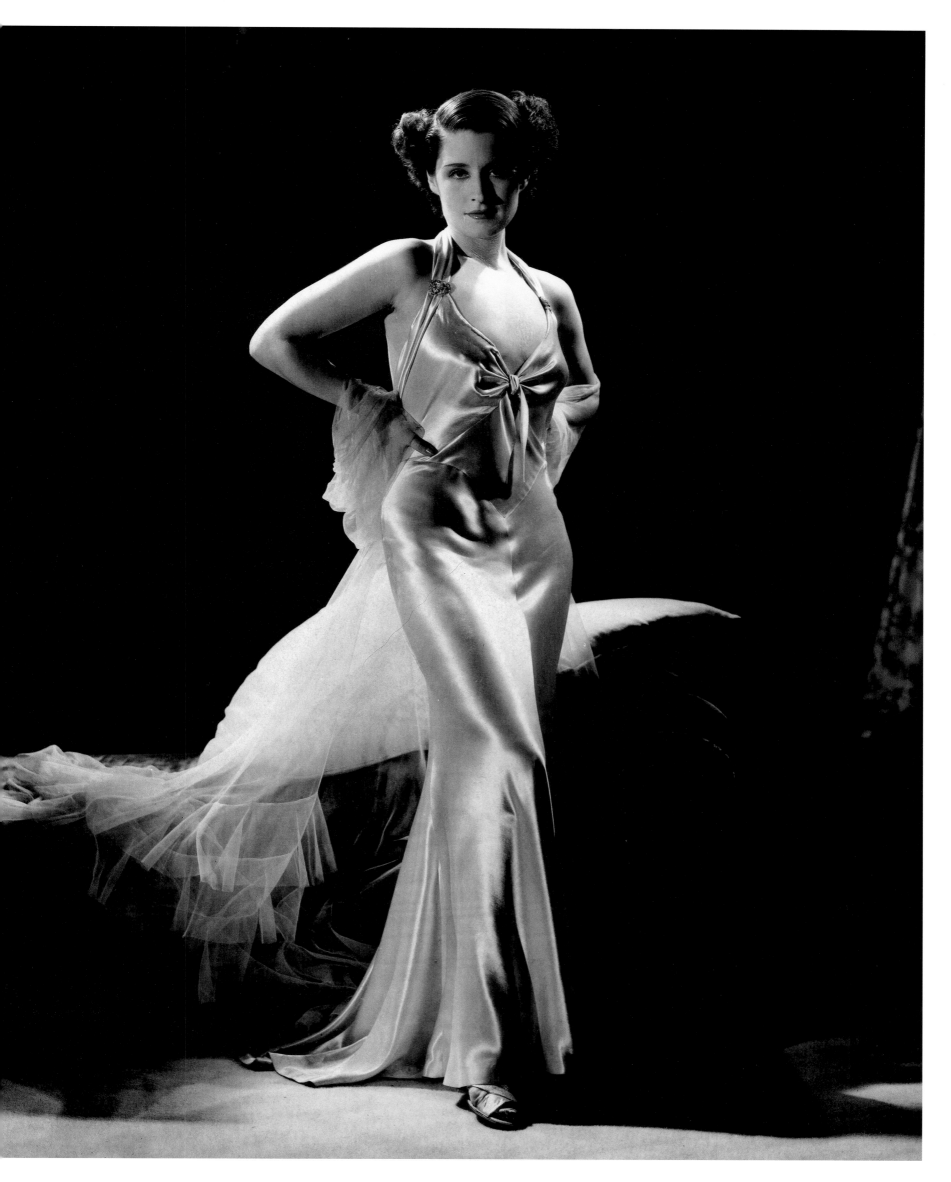

11 NORMA SHEARER, 1934

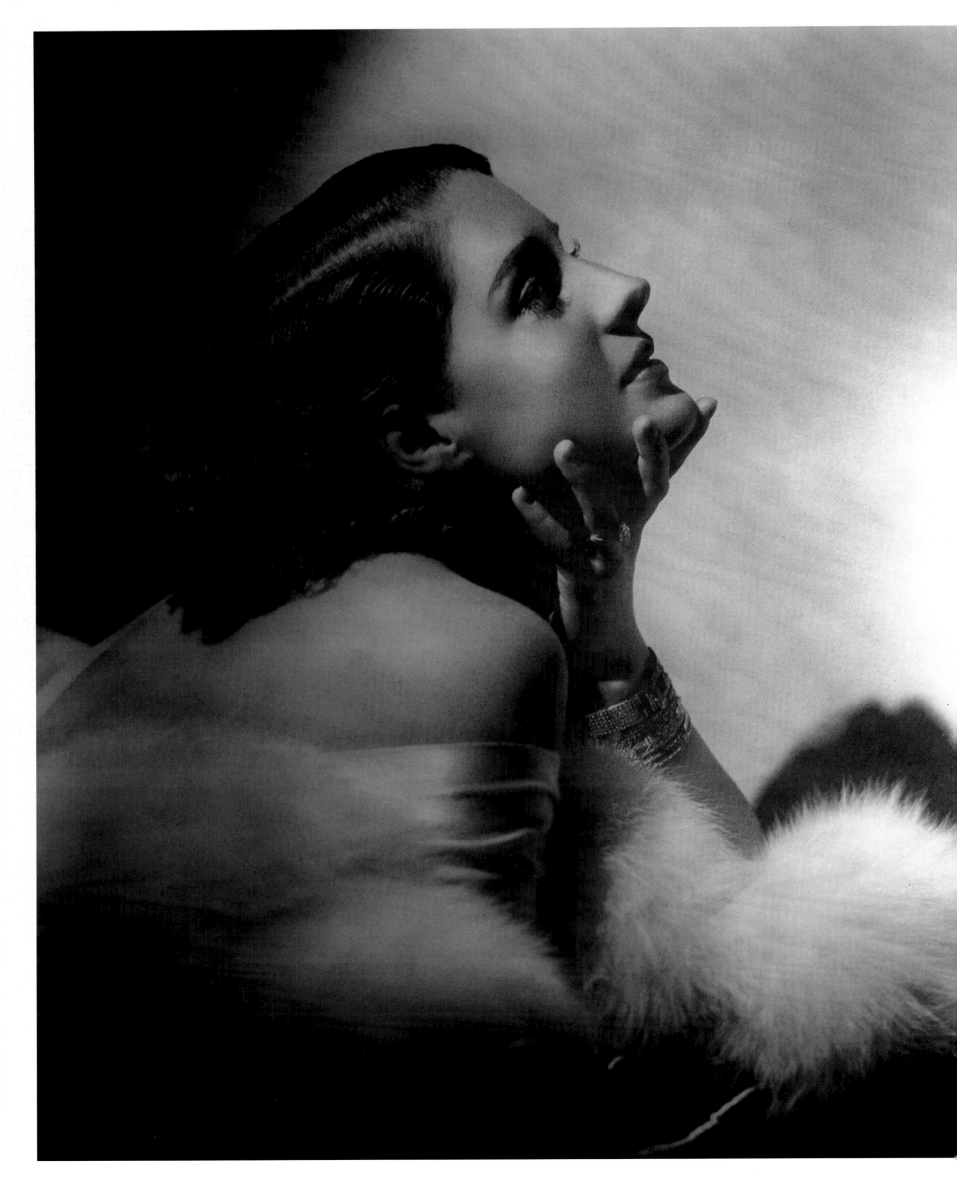

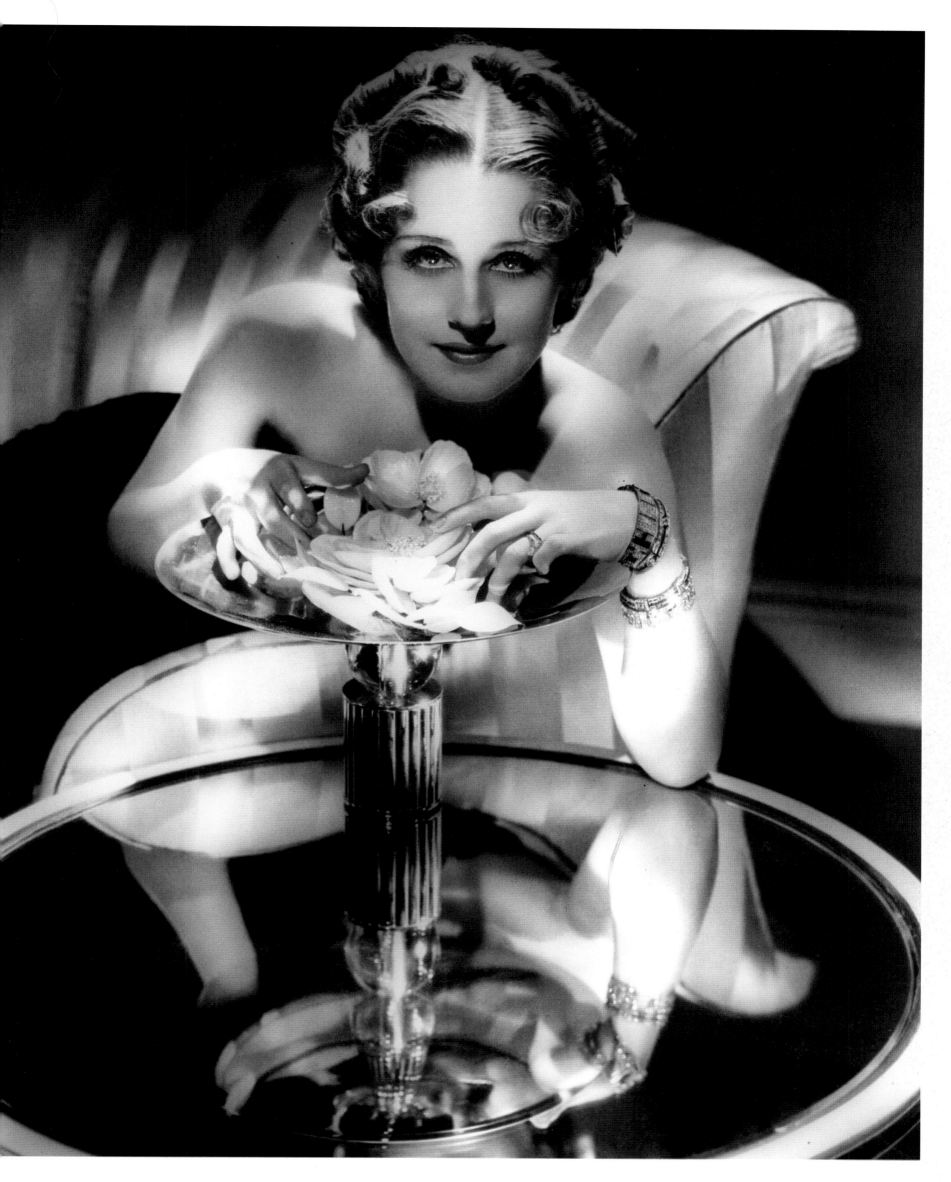

13 NORMA SHEARER

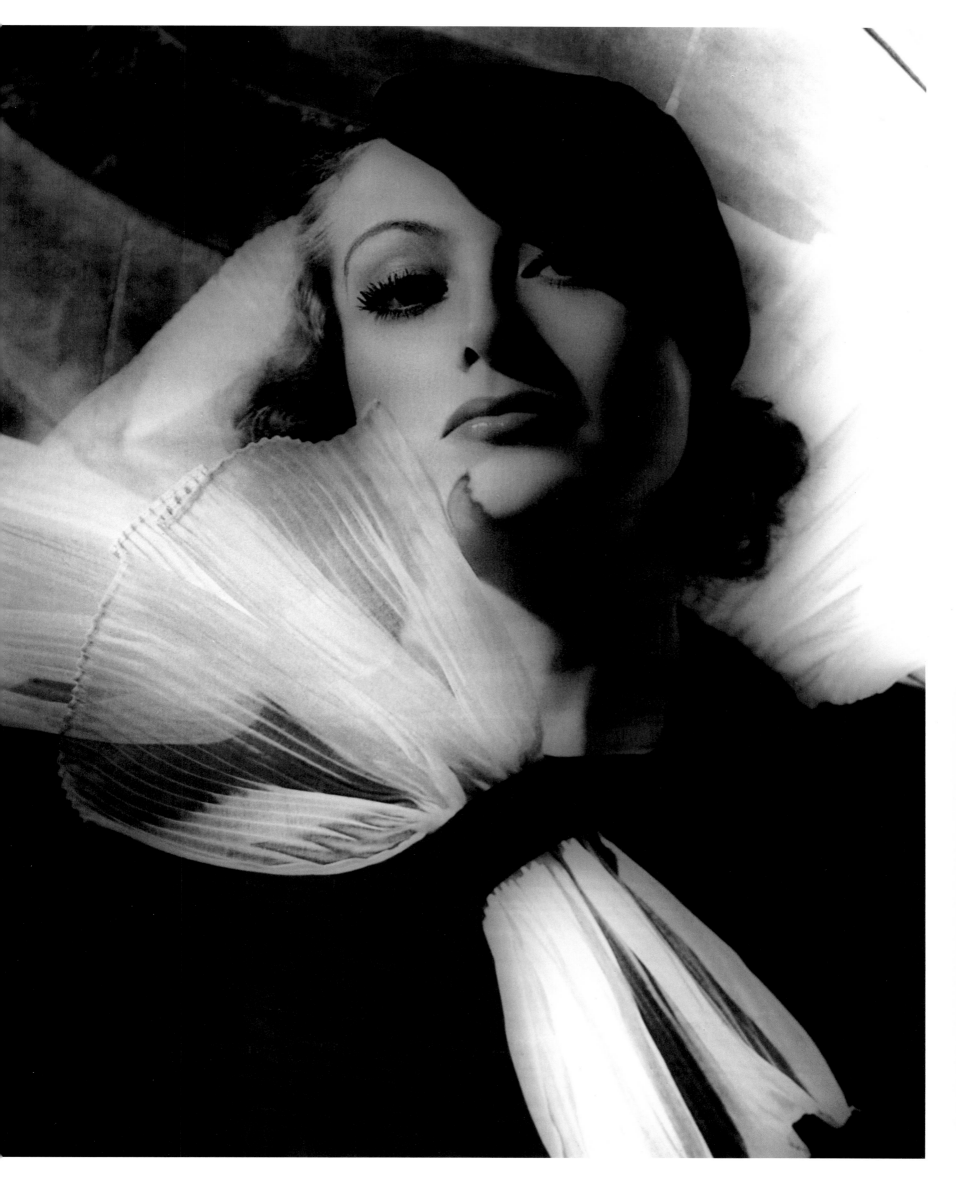

14 JOAN CRAWFORD, 1932

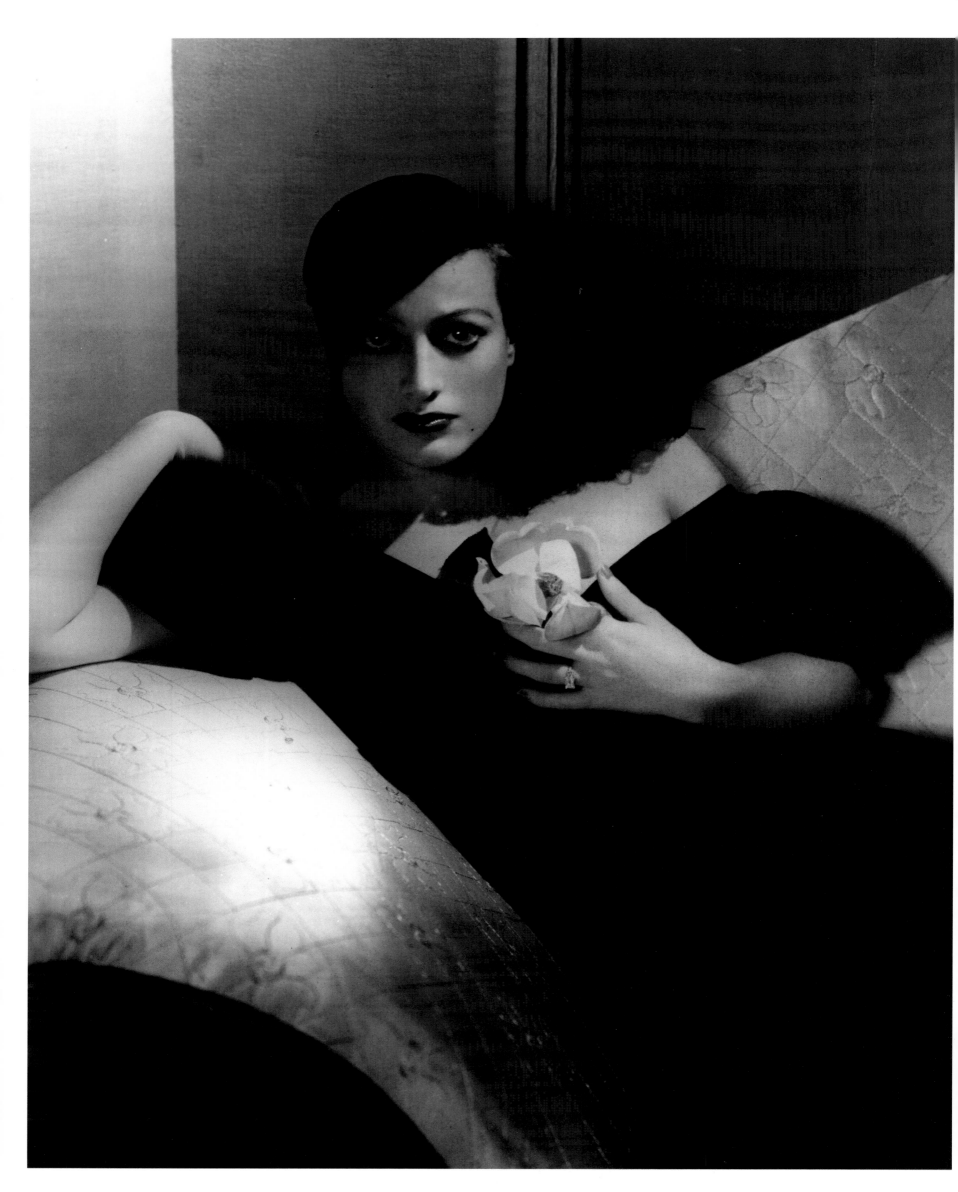

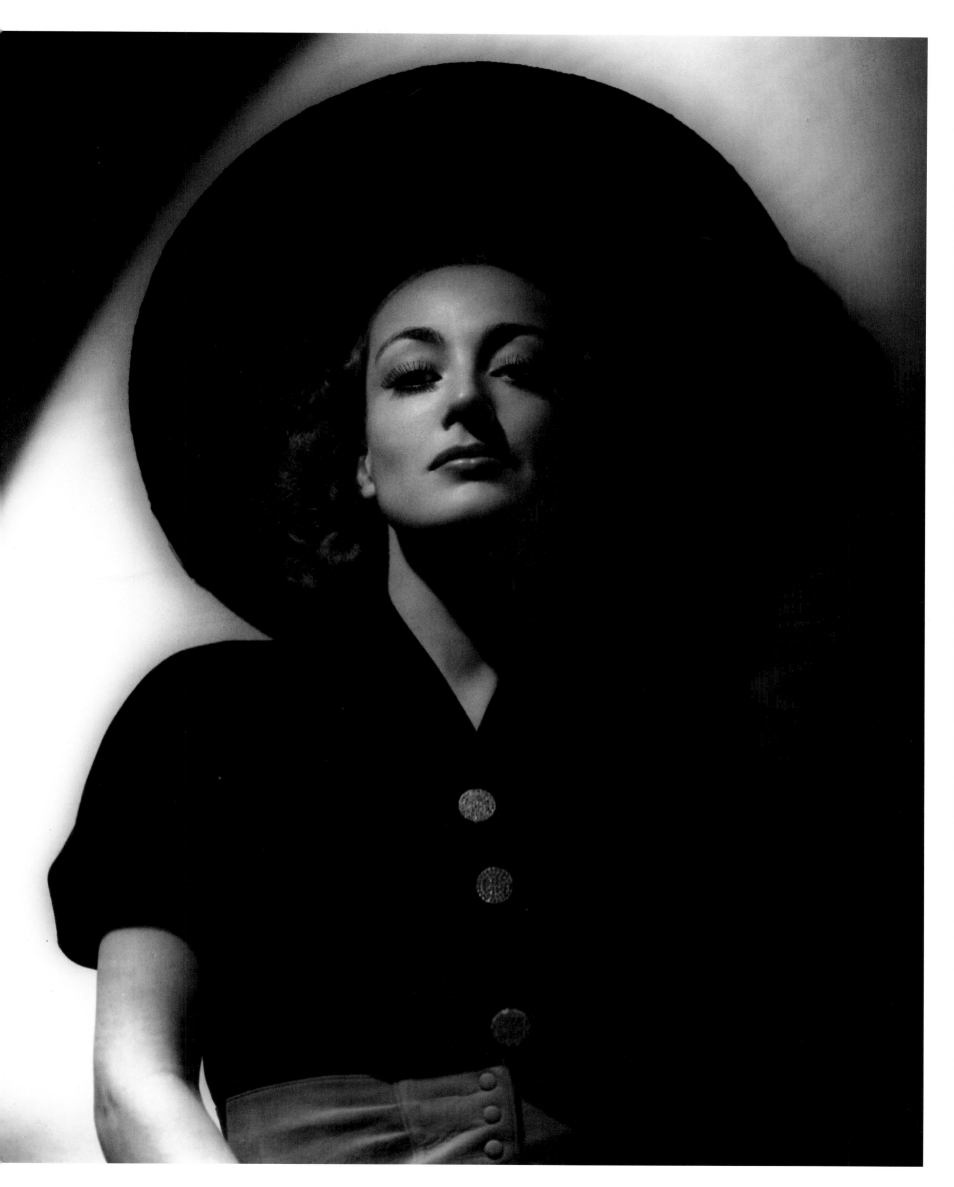

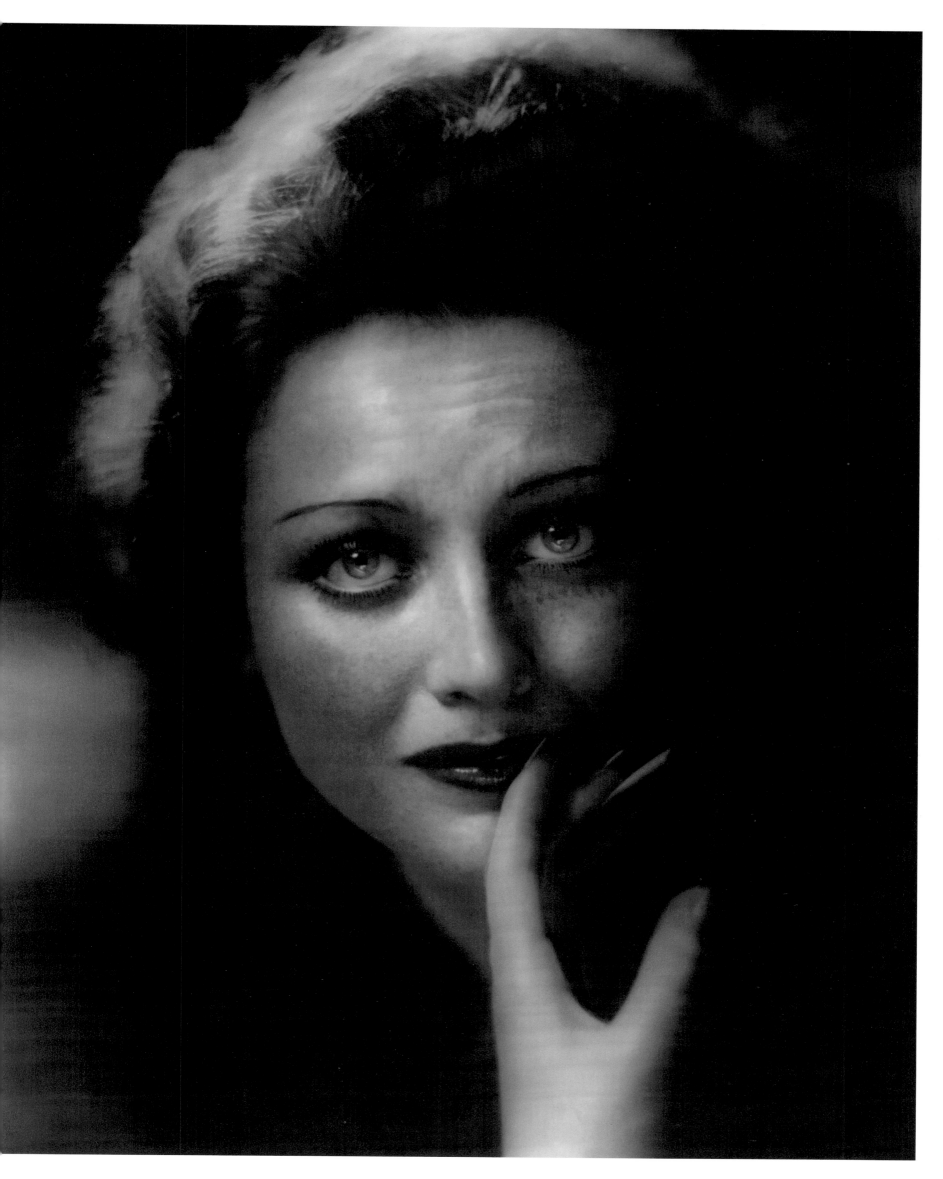

17 JOAN CRAWFORD, 1933

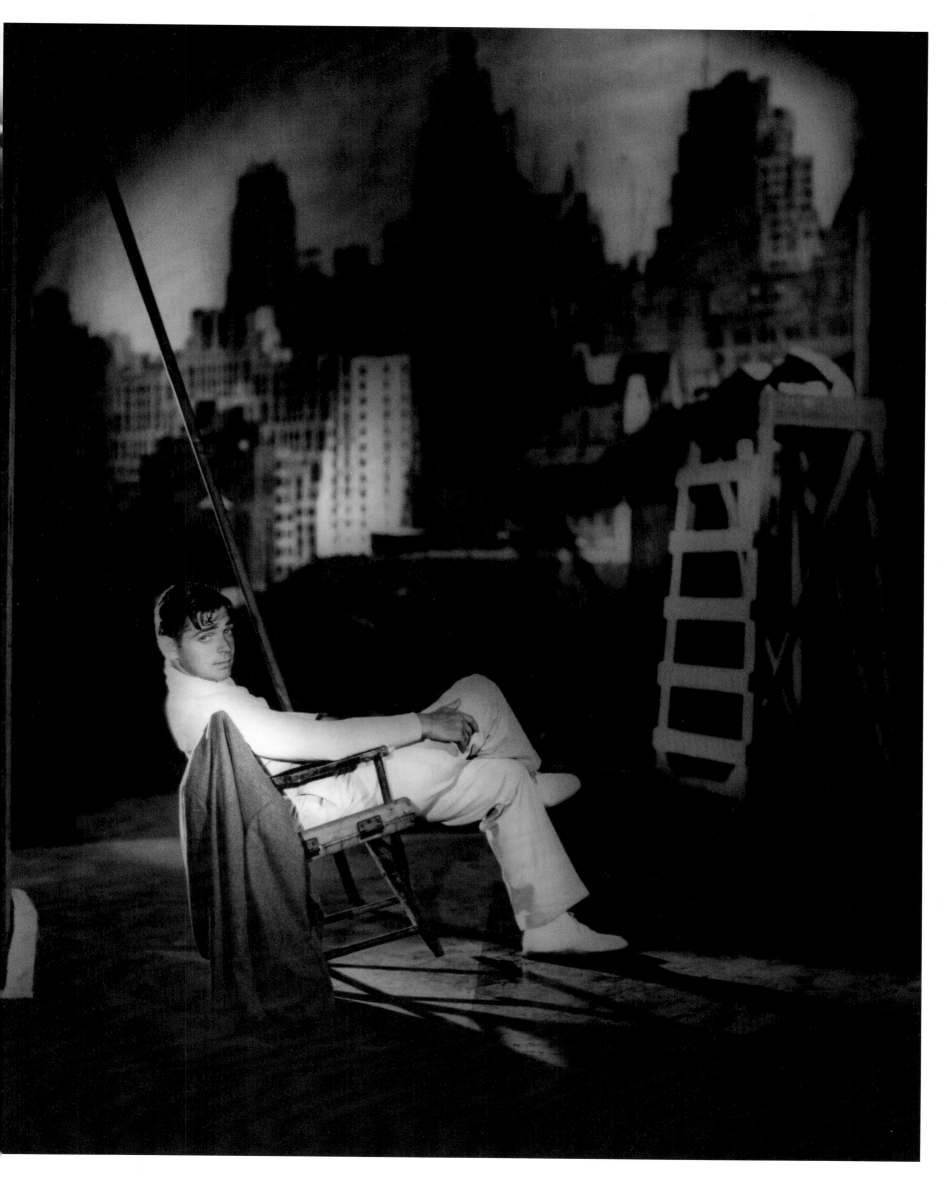

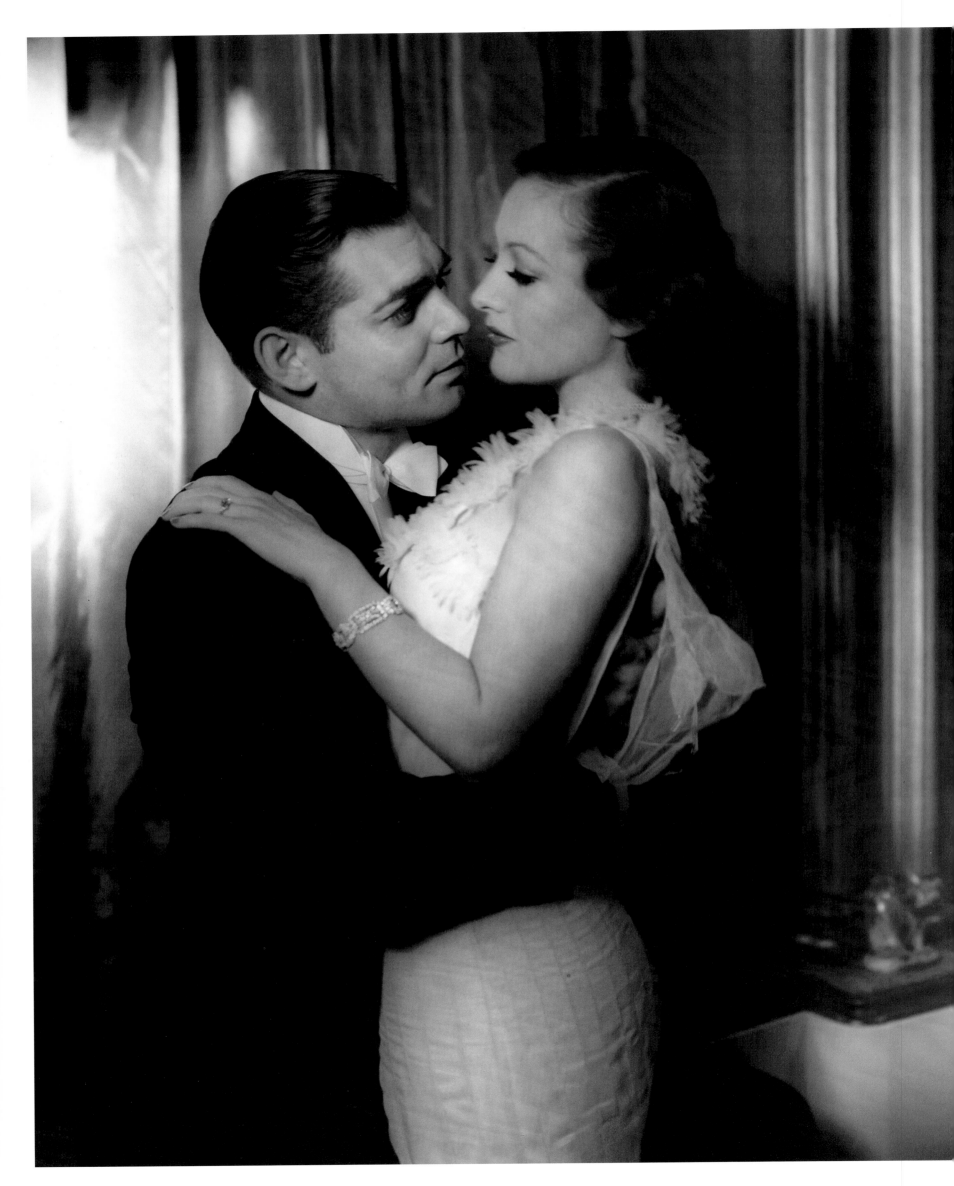

19 CLARK GABLE, JOAN CRAWFORD, *Possessed*, 1931

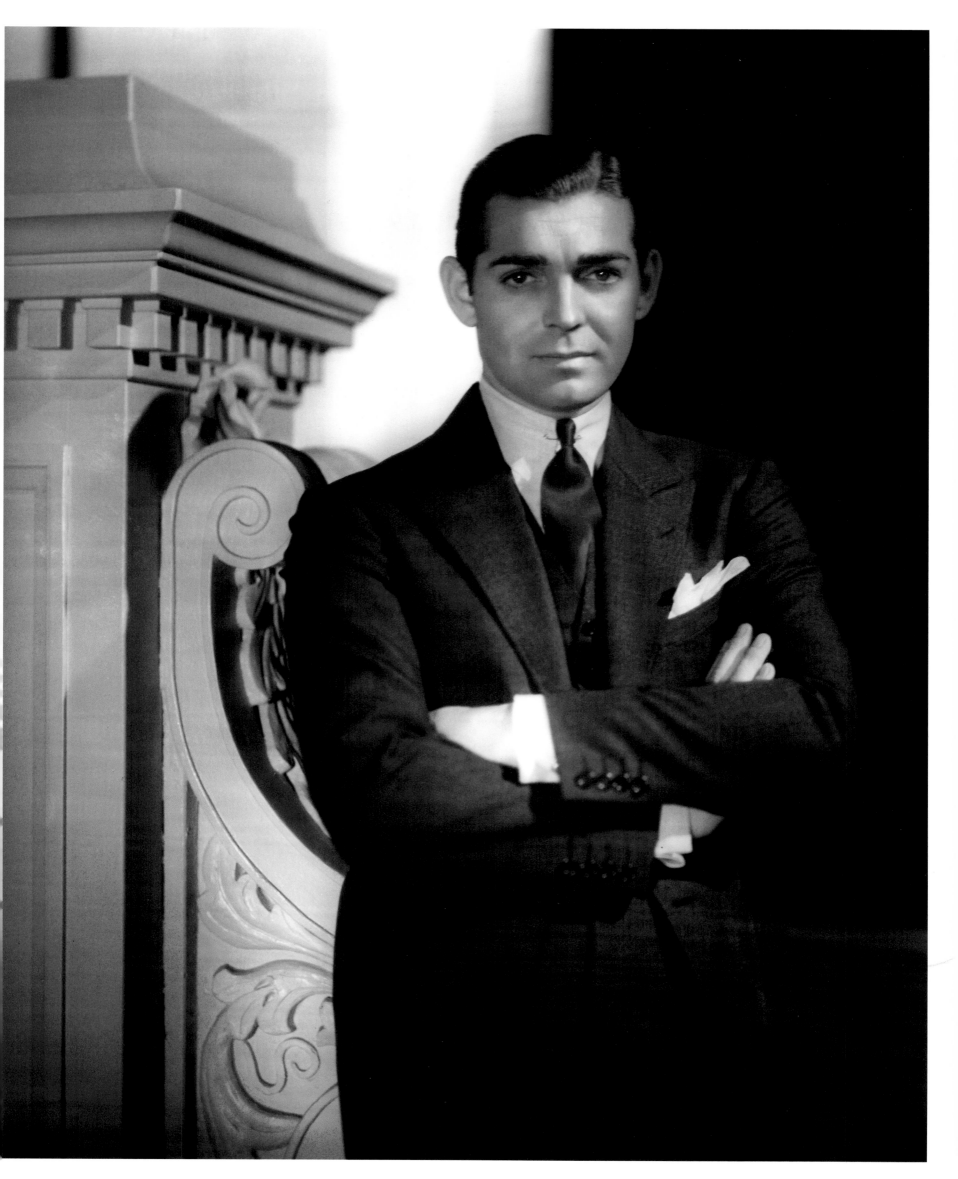

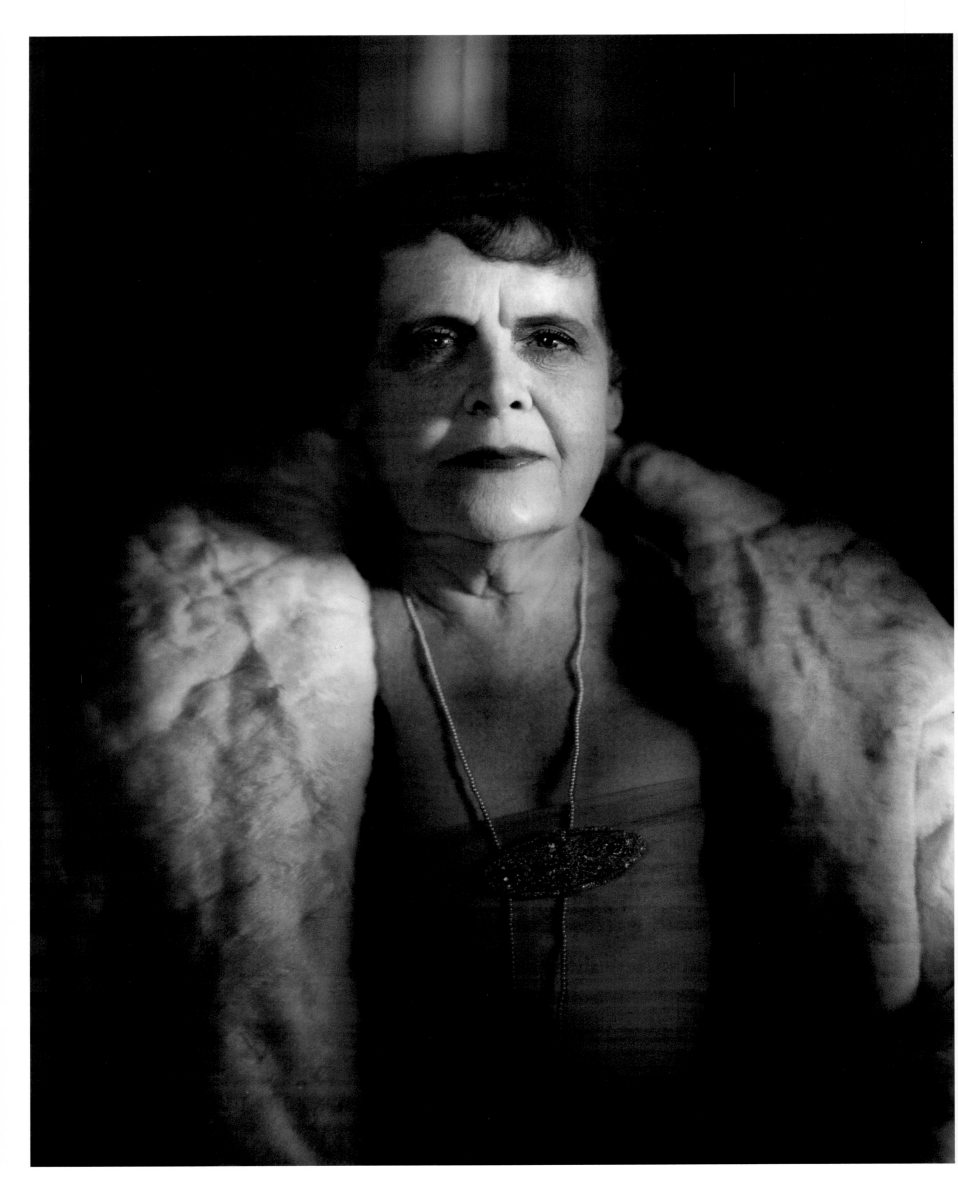

21 MARIE DRESSLER, 1934

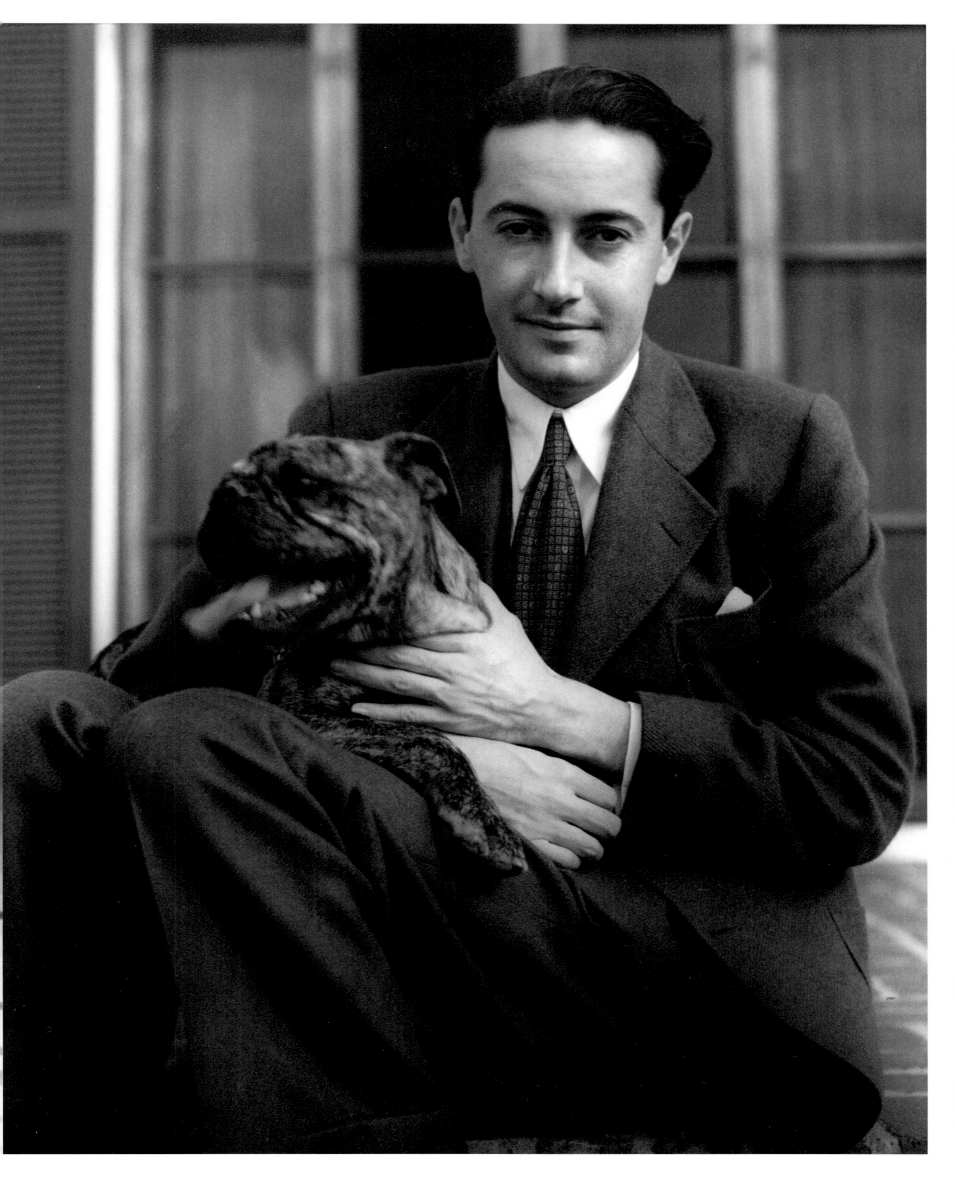

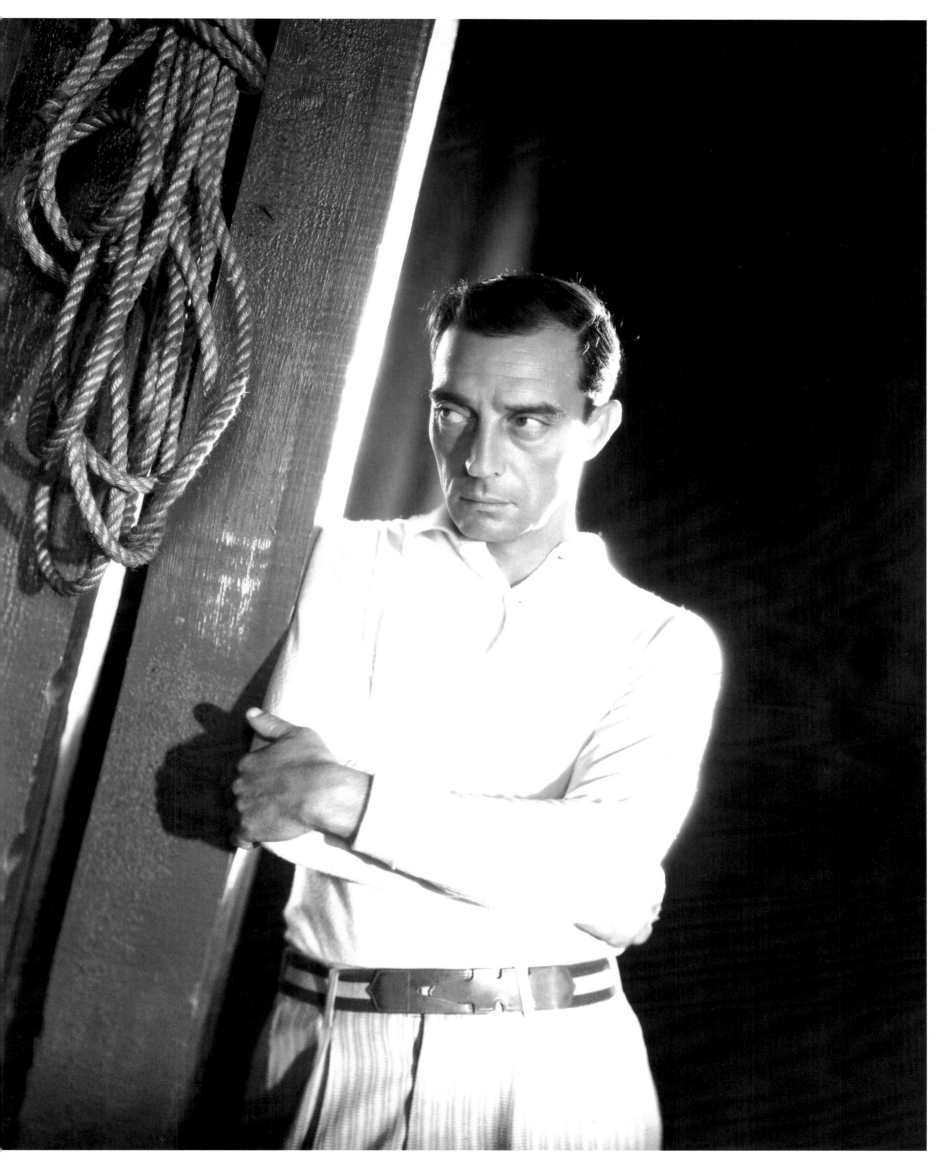

23 BUSTER KEATON

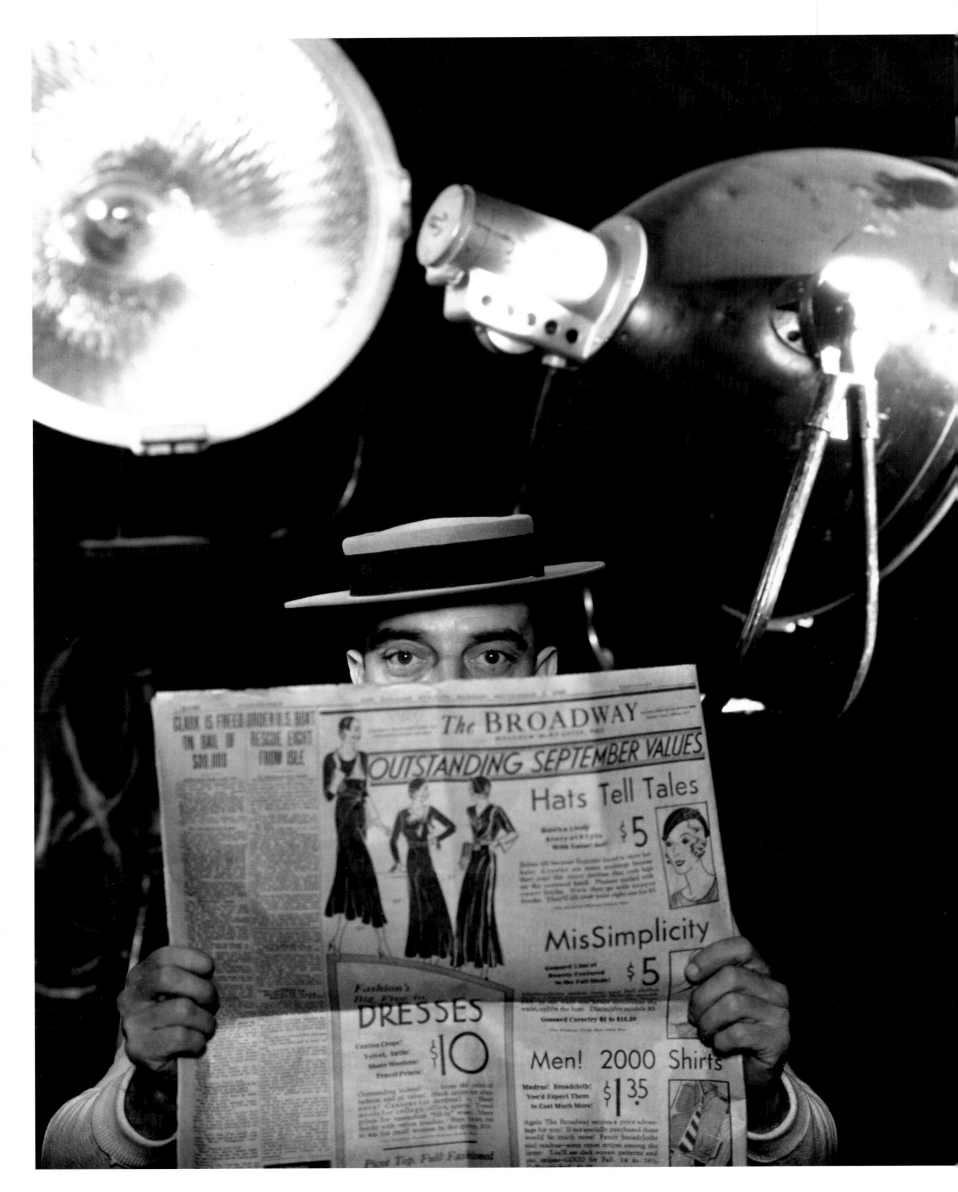

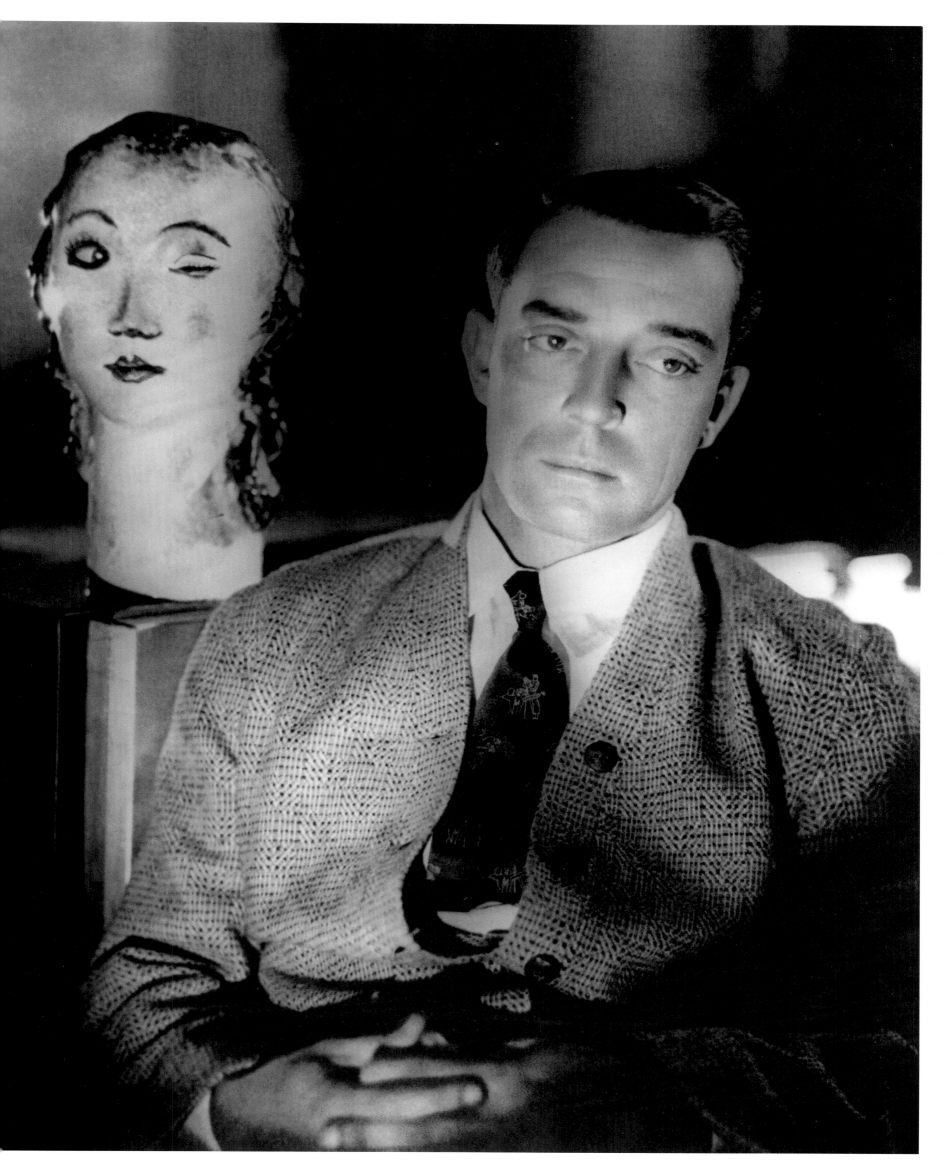

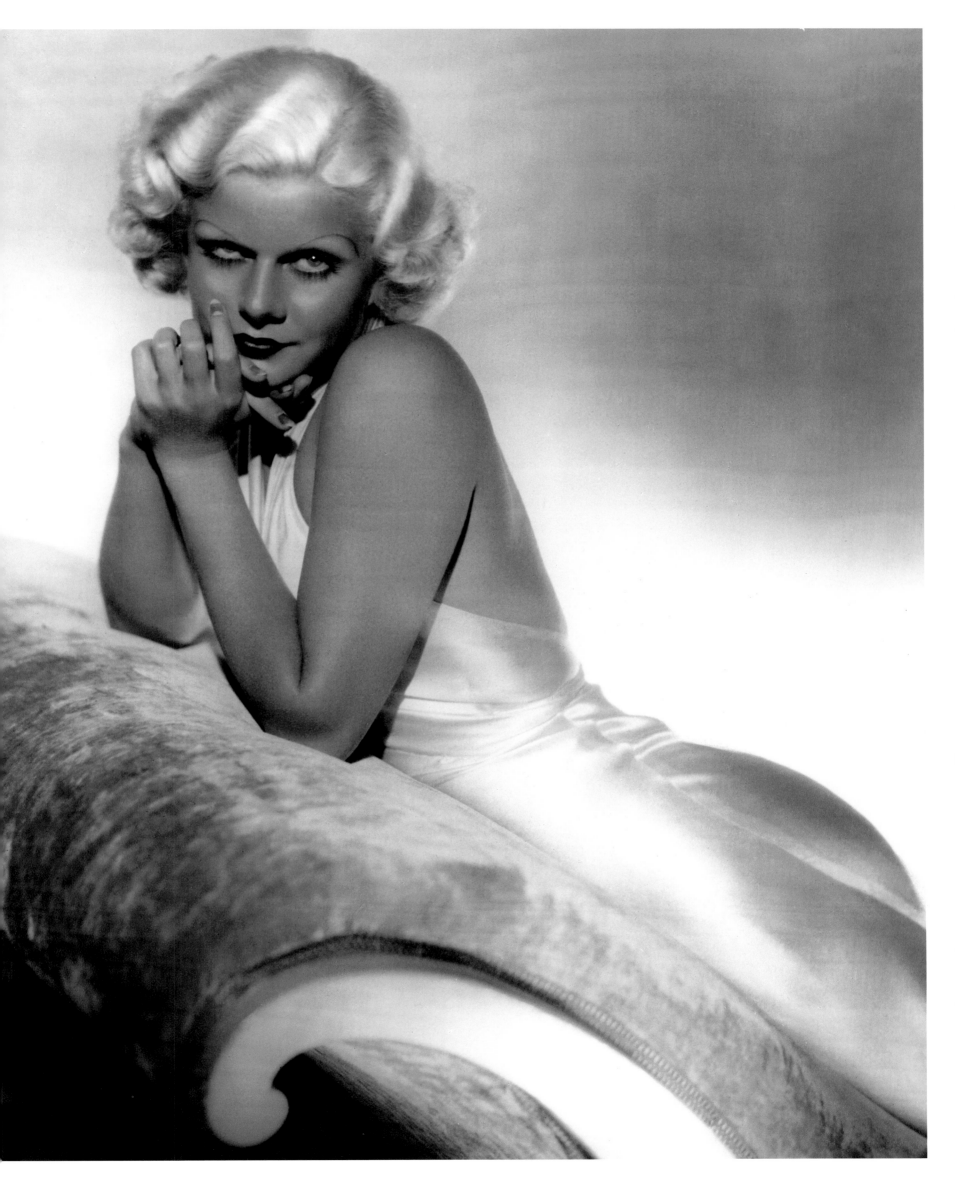

26 JEAN HARLOW, 1933

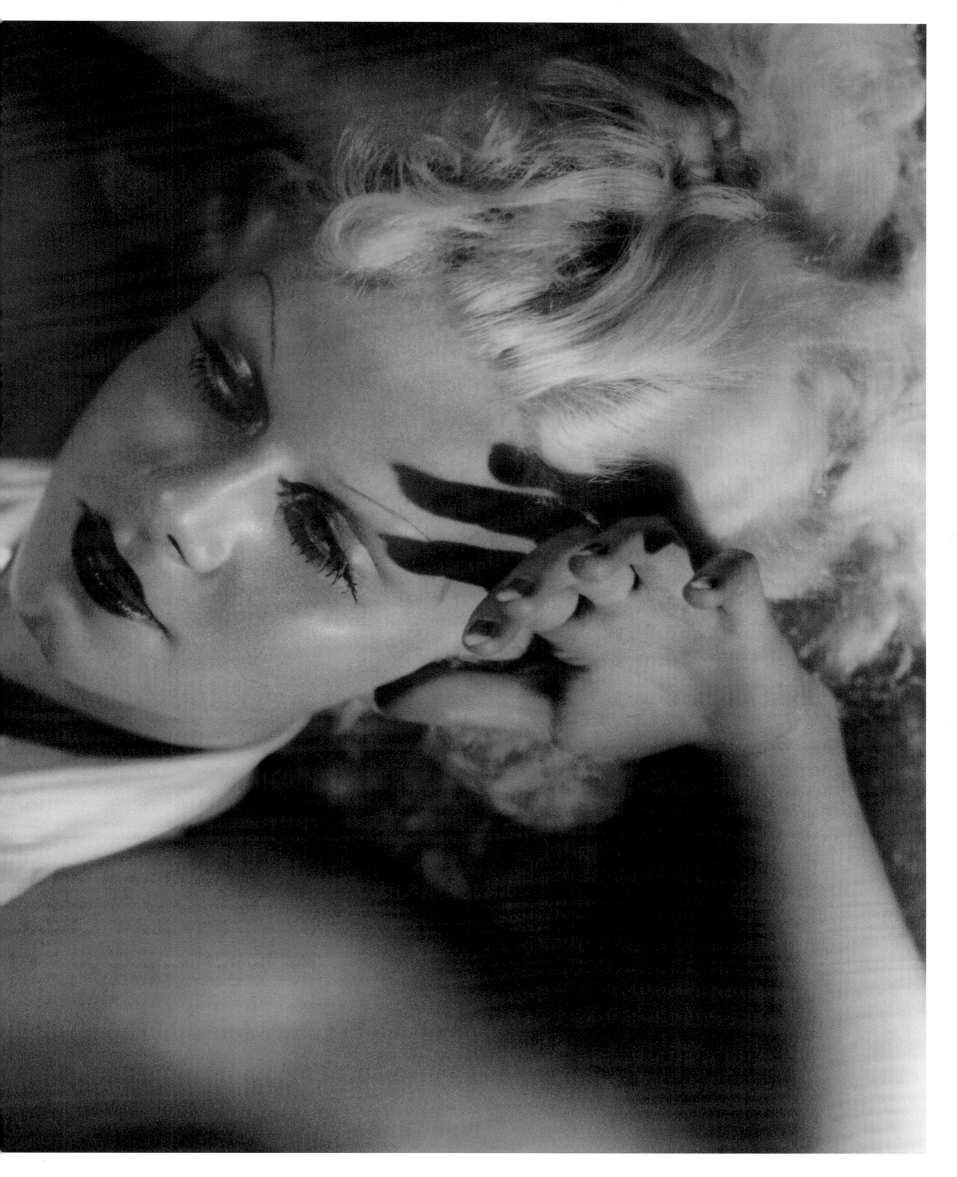

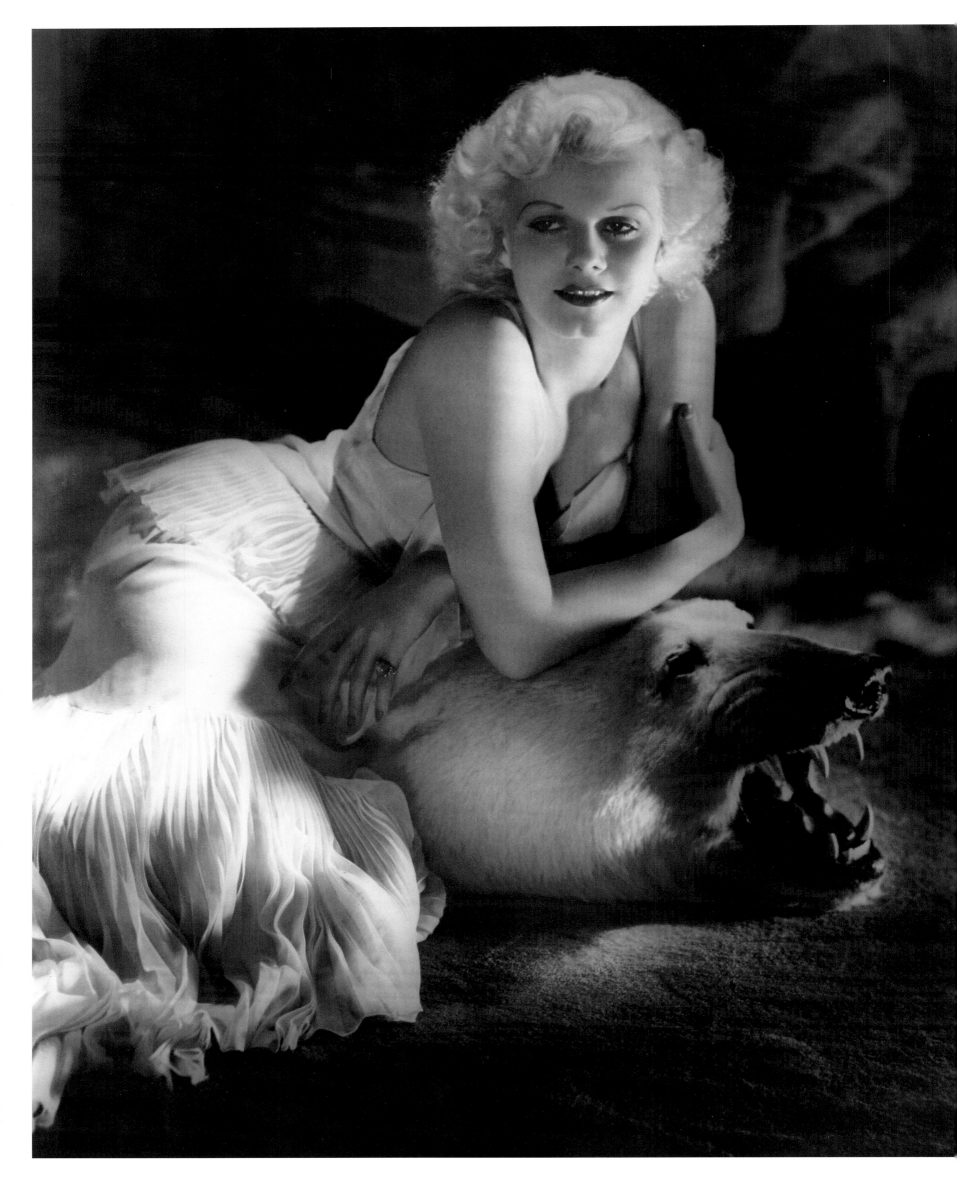

28 JEAN HARLOW, 1934

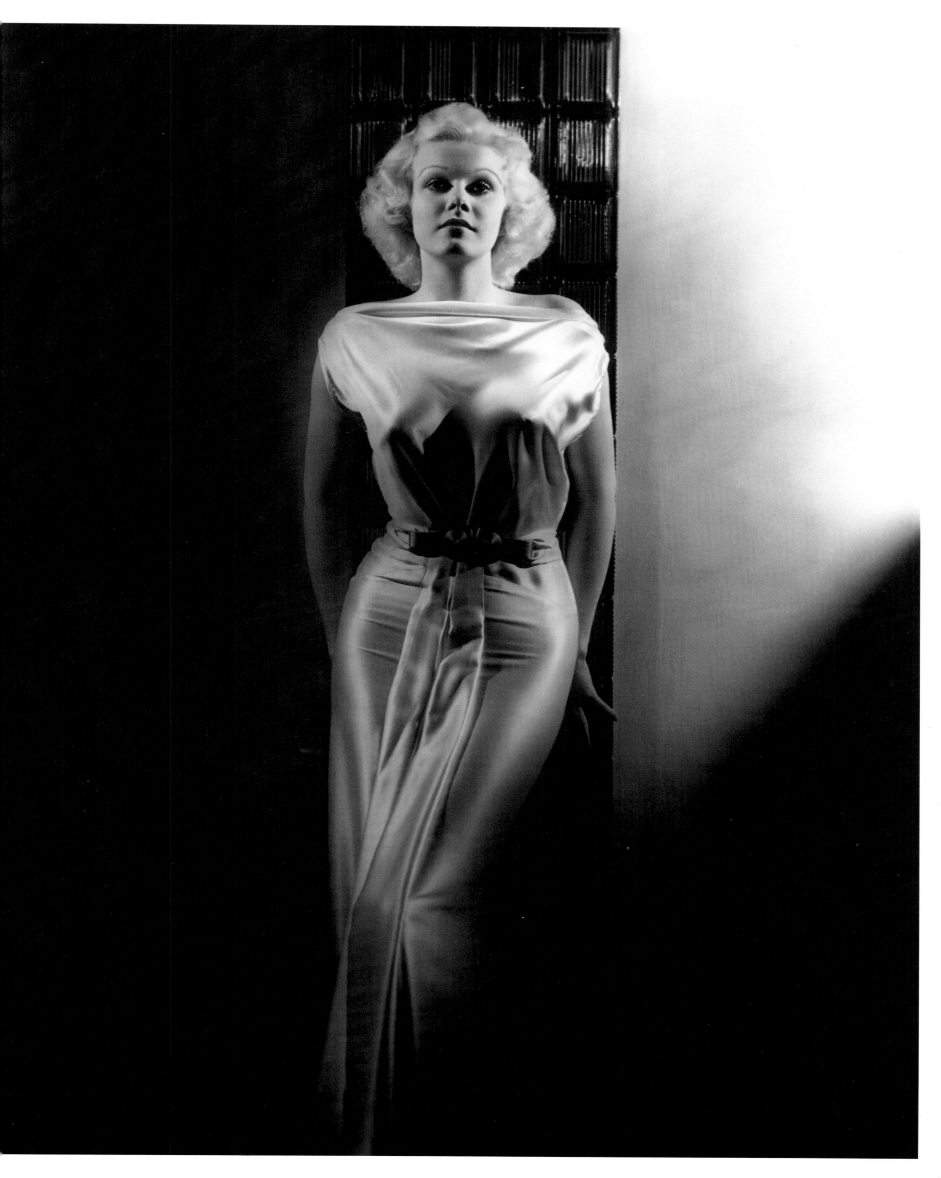

29 JEAN HARLOW, 1935

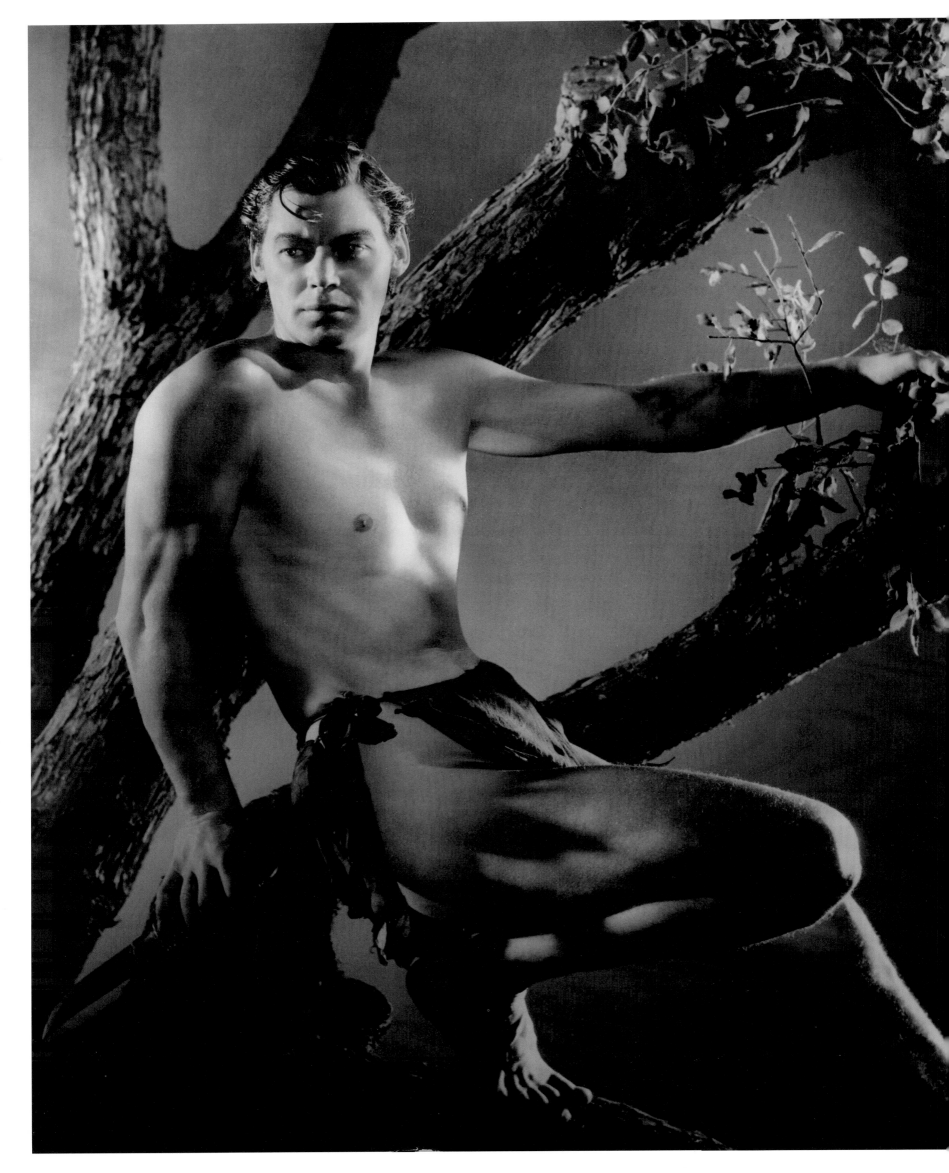

30 JOHNNY WEISSMULLER, *Tarzan the Ape Man*, 1932

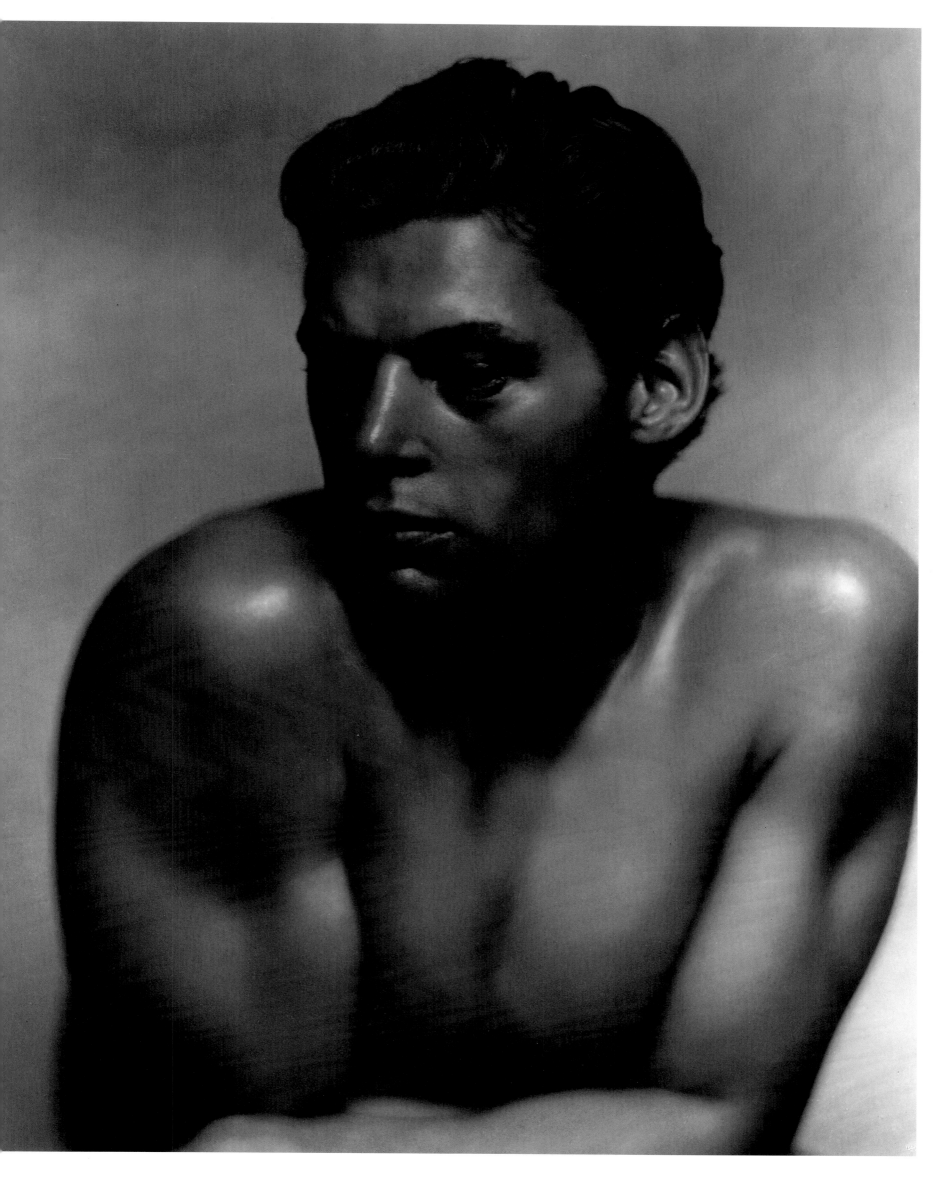

31 JOHNNY WEISSMULLER, *Tarzan the Ape Man*, 1932

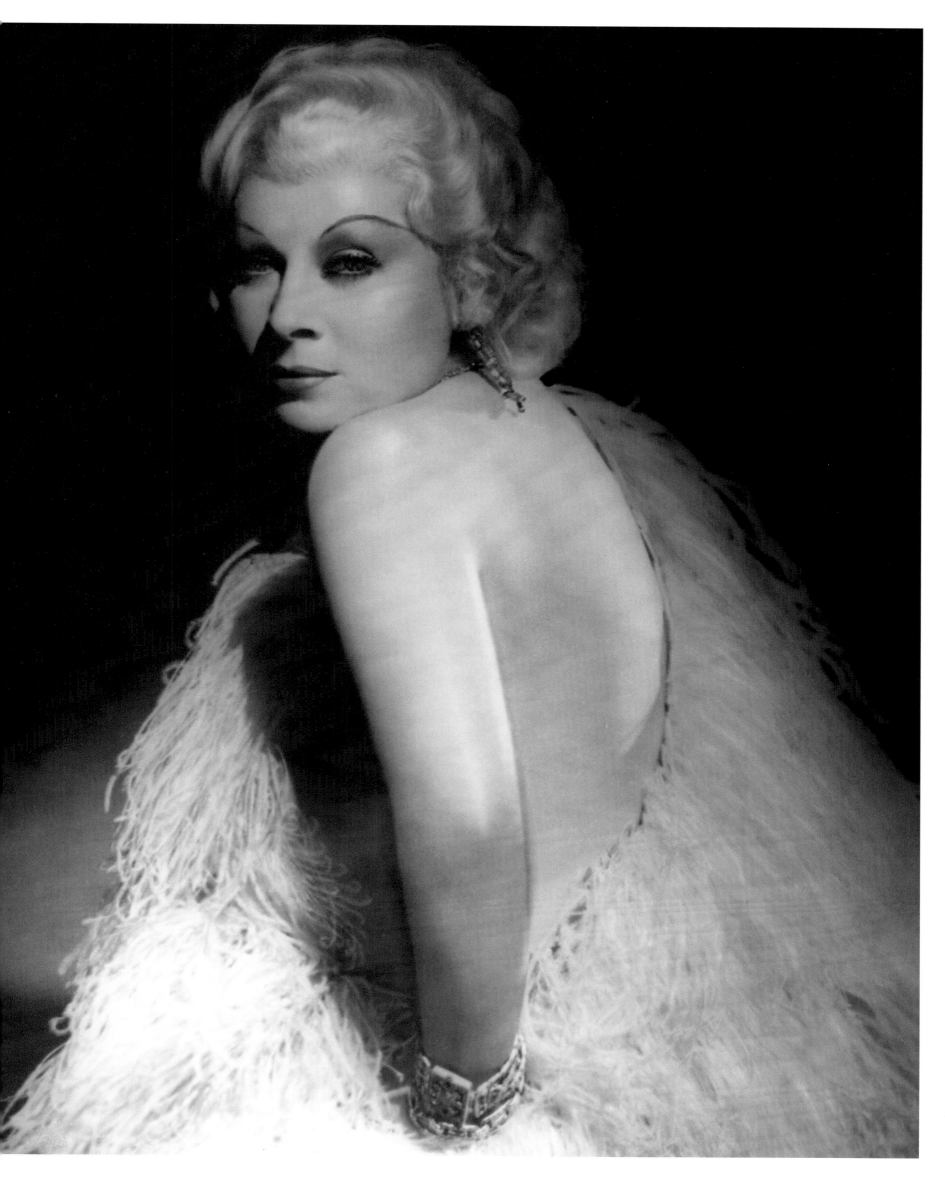

32 MAE WEST, *Goin' to Town*, 1934

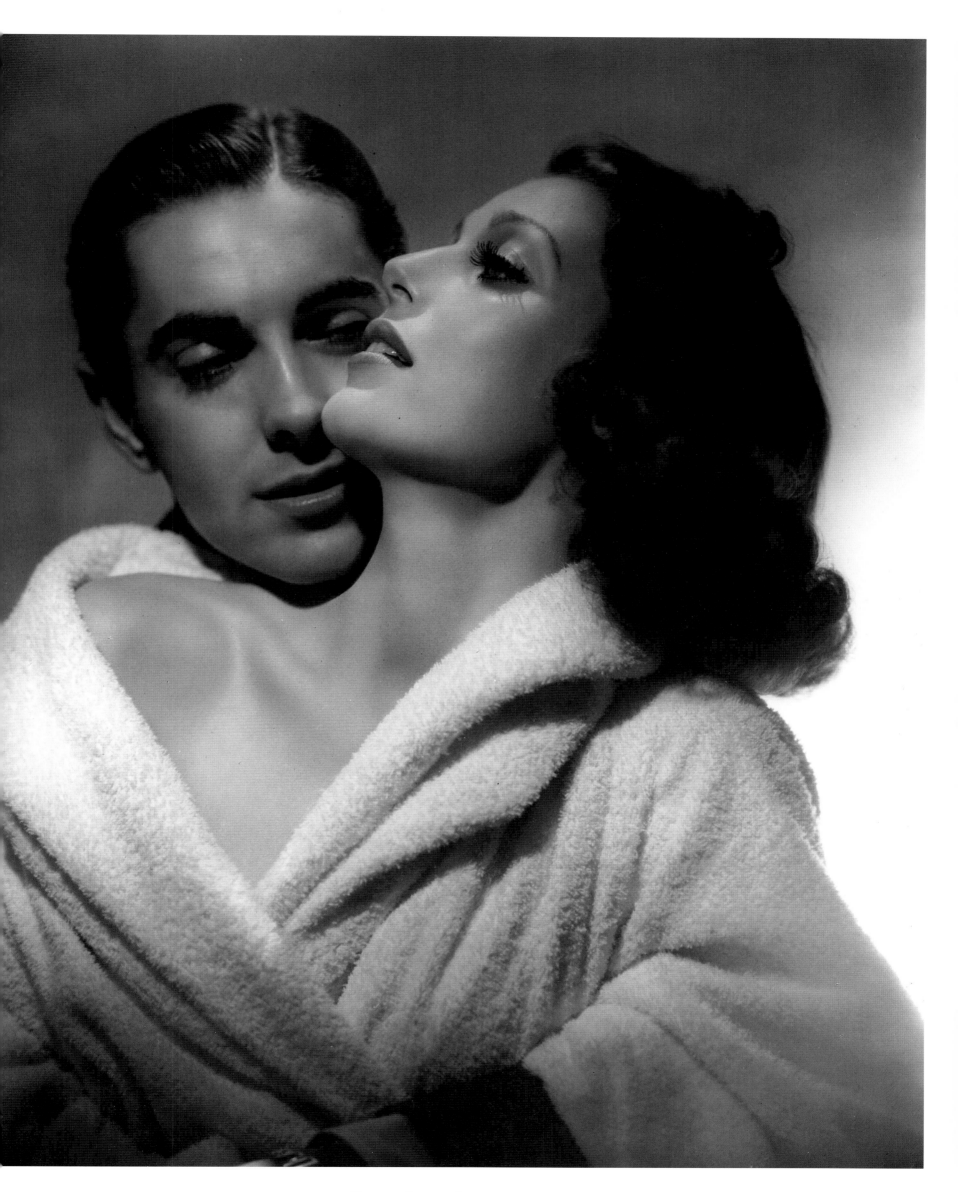

33 TYRONE POWER, LORETTA YOUNG, 1937

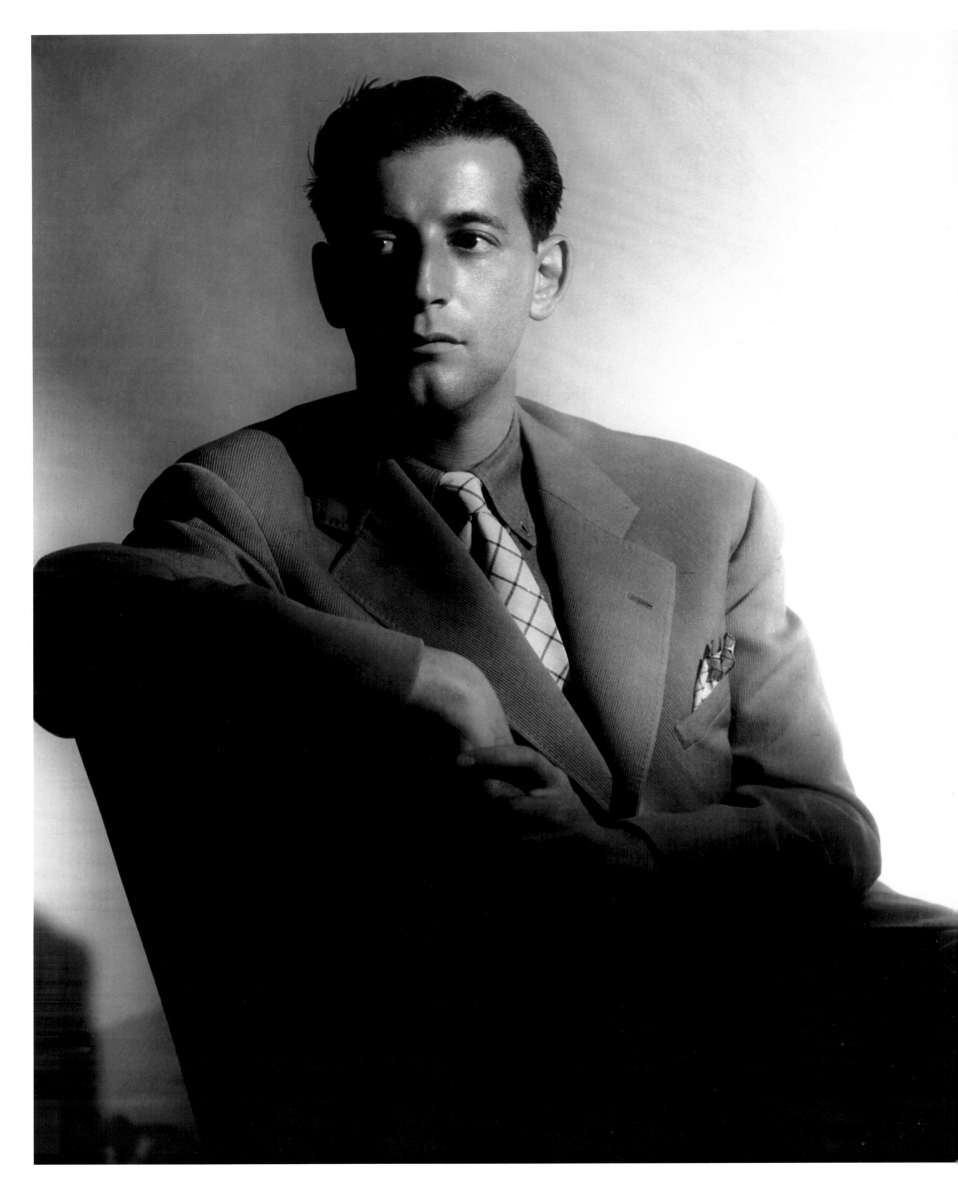

34 GILBERT ADRIAN, 1936

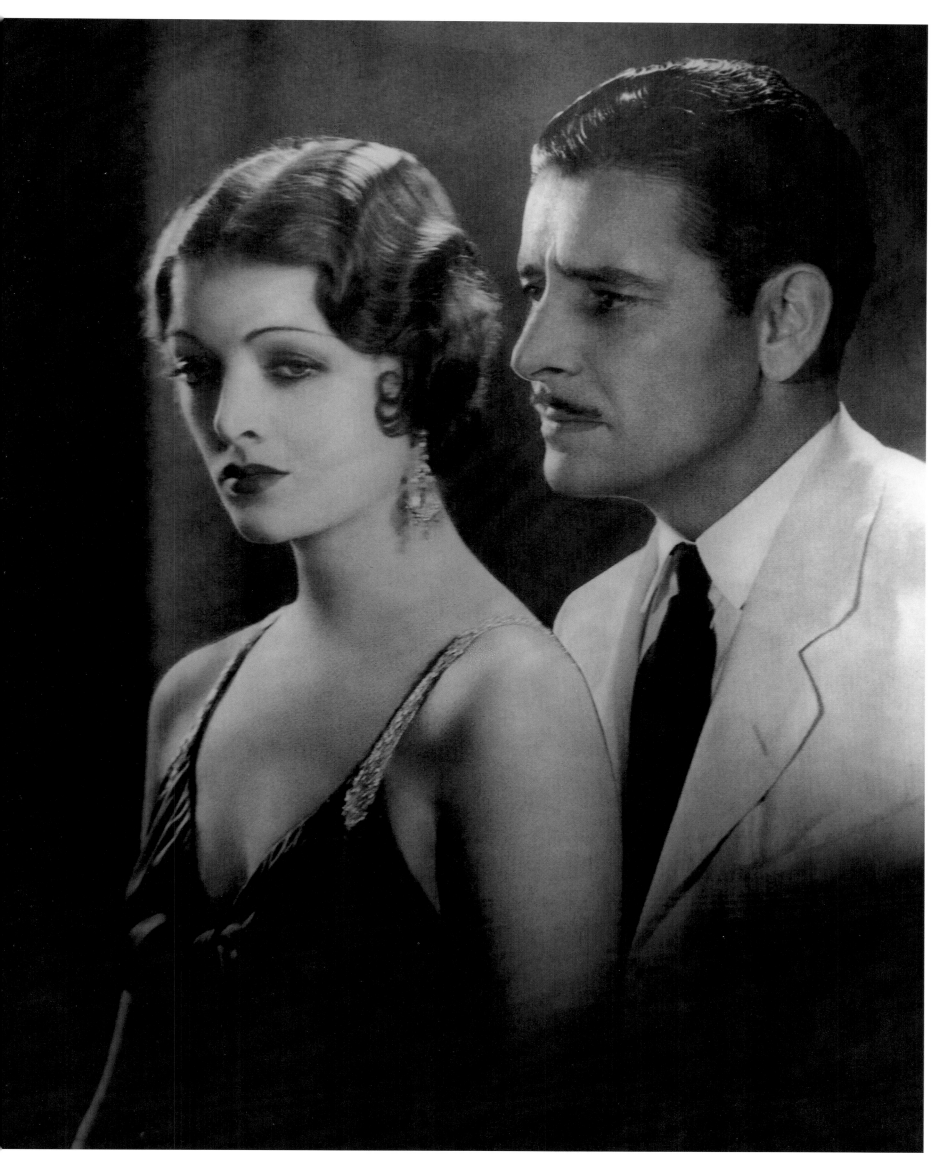

35 MYRNA LOY, RONALD COLMAN, 1930

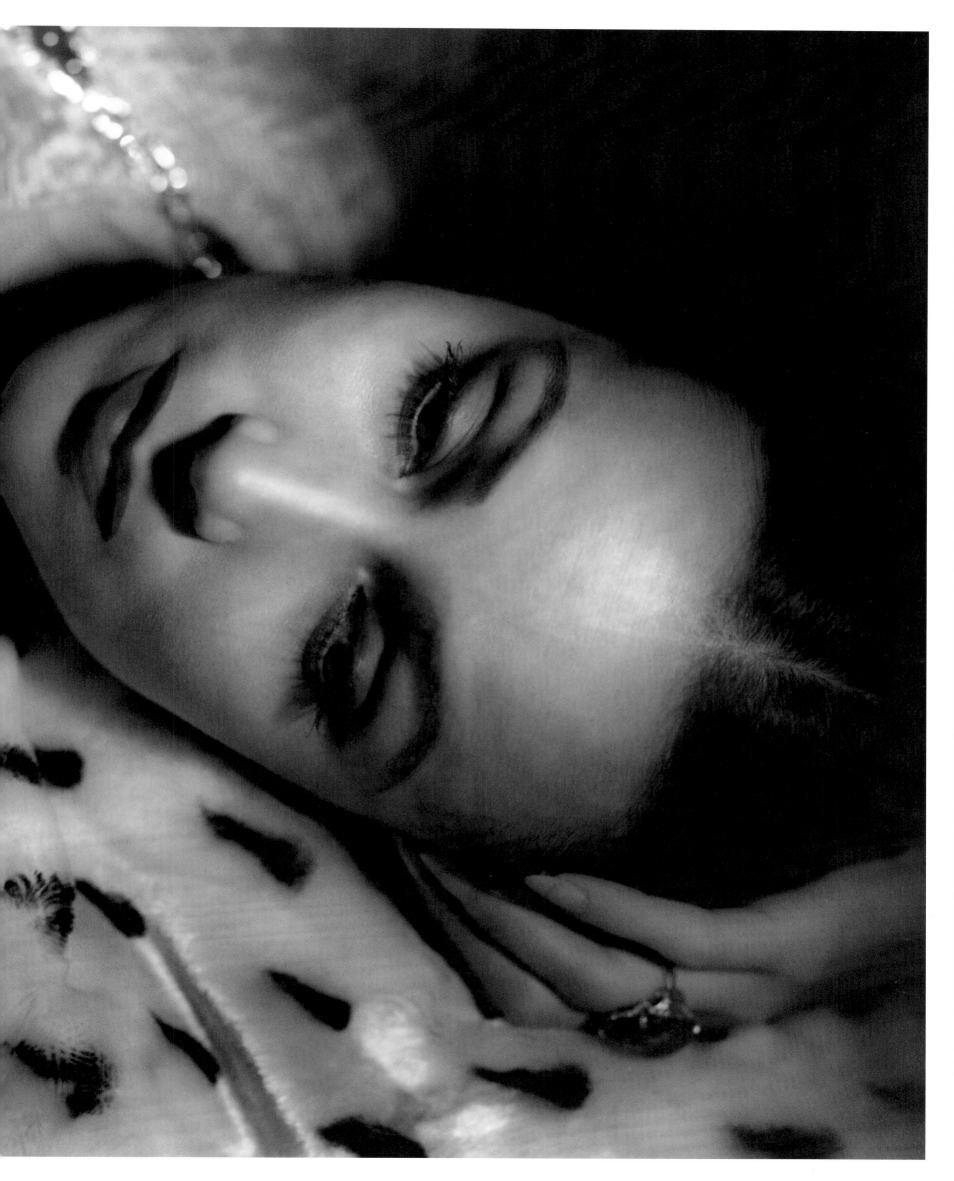

36 DOLORES DEL RIO, 1936

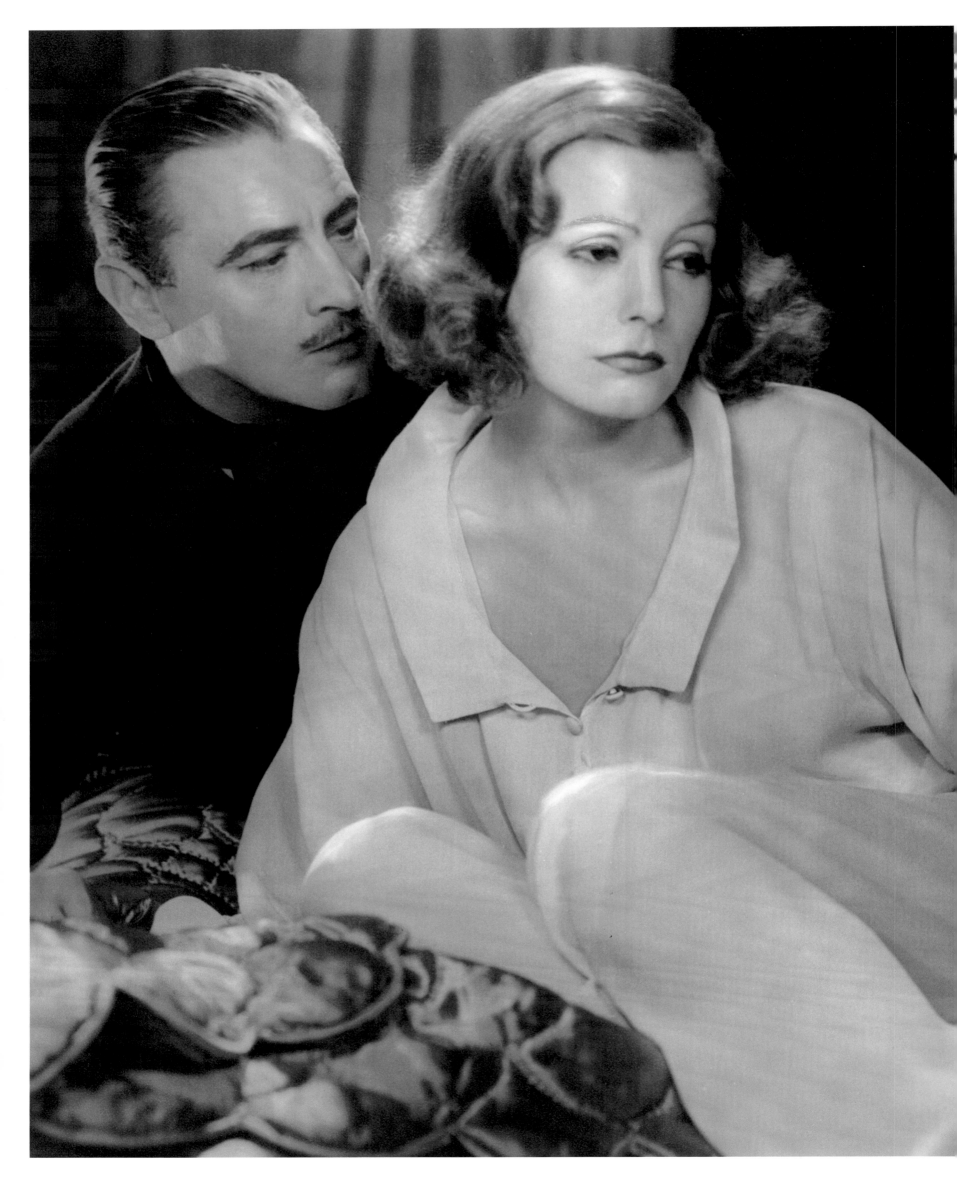

37 GRETA GARBO, JOHN BARRYMORE, *Grand Hotel*, 1933

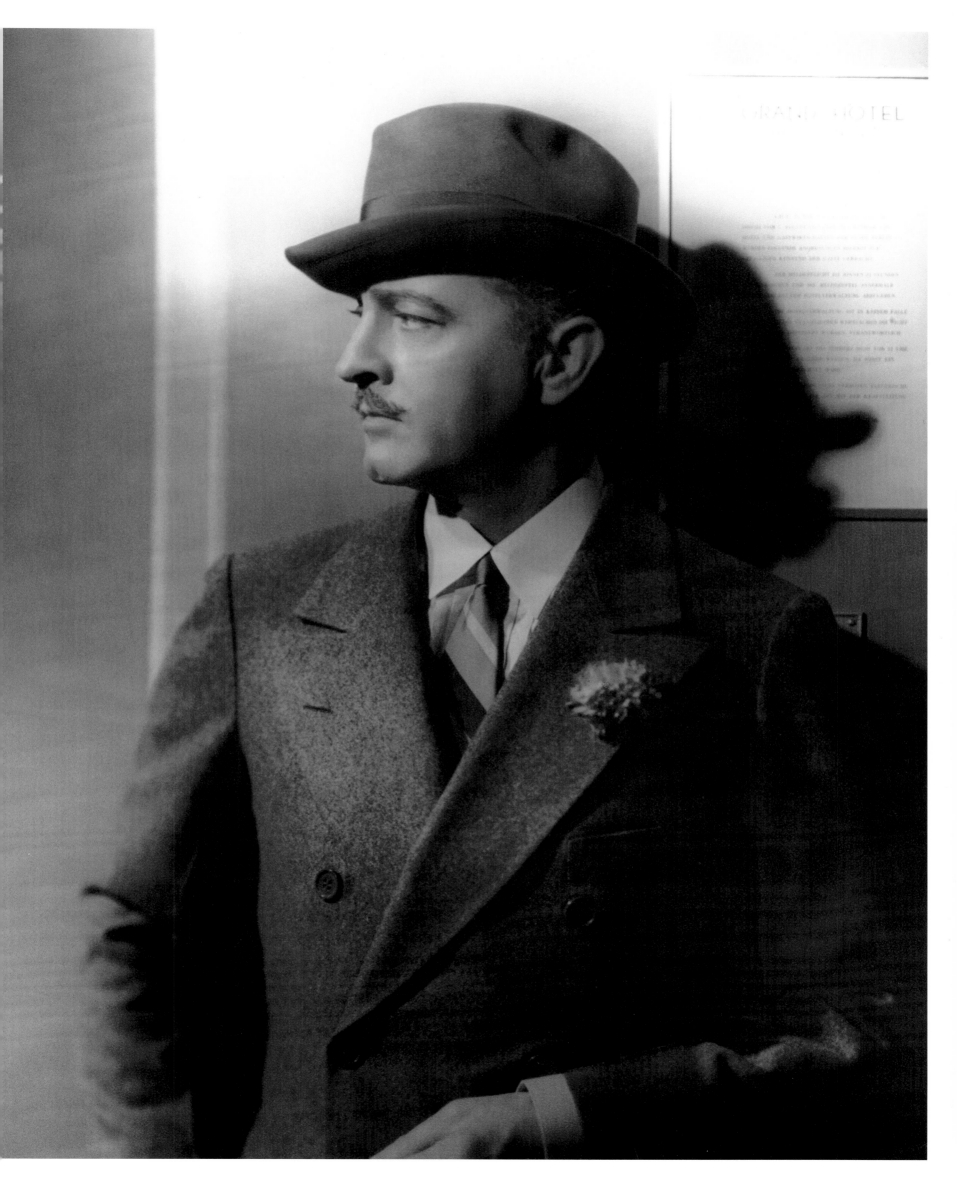

38 JOHN BARRYMORE, 1933

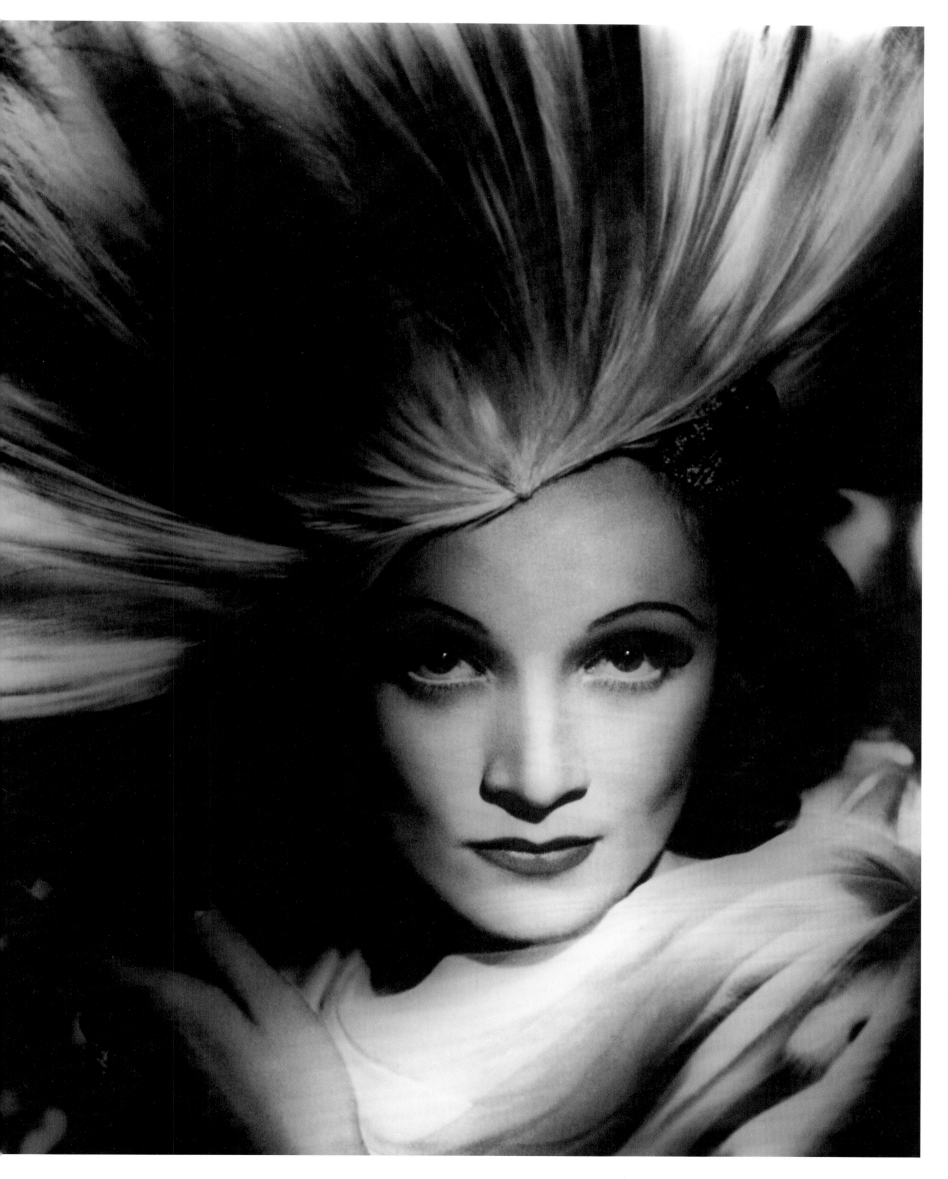

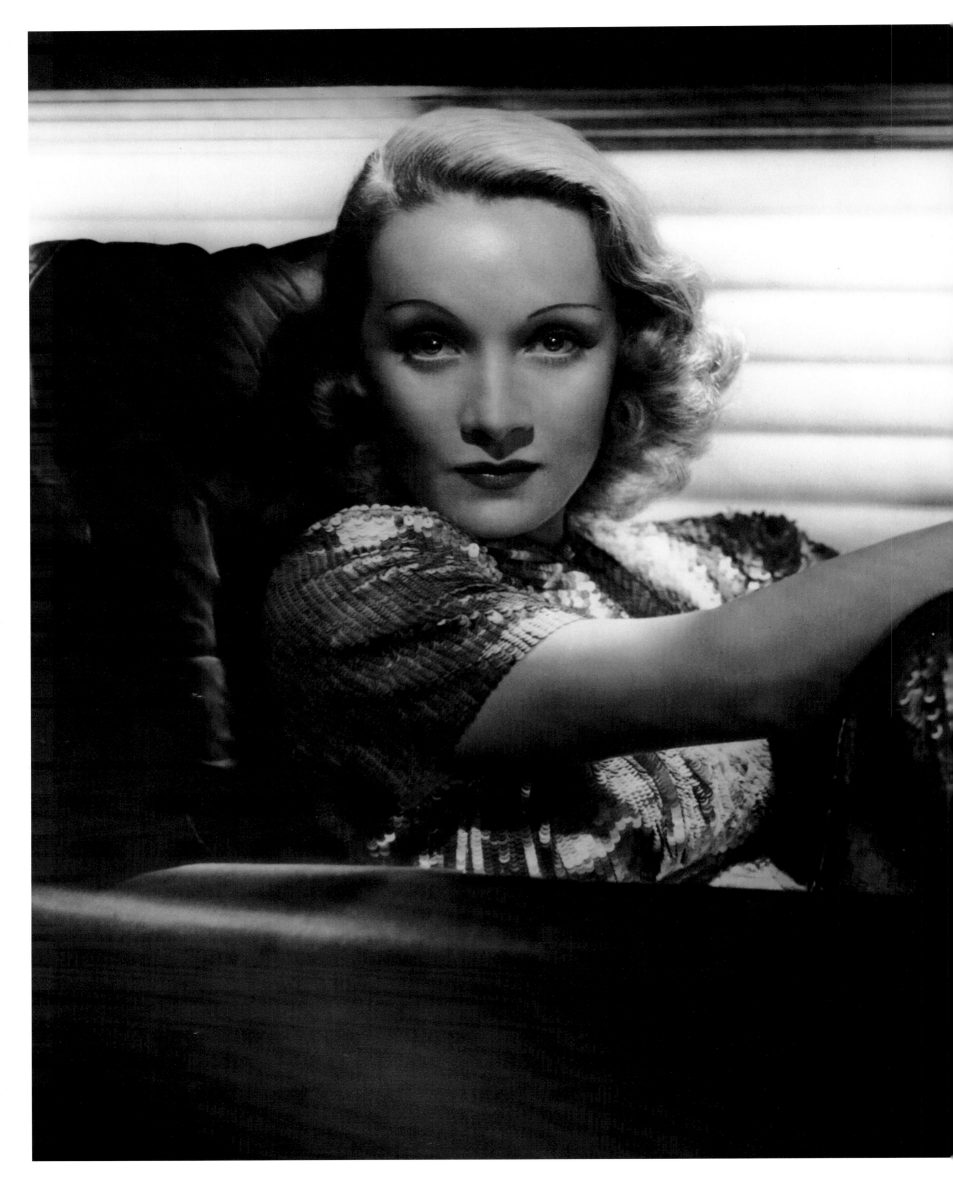

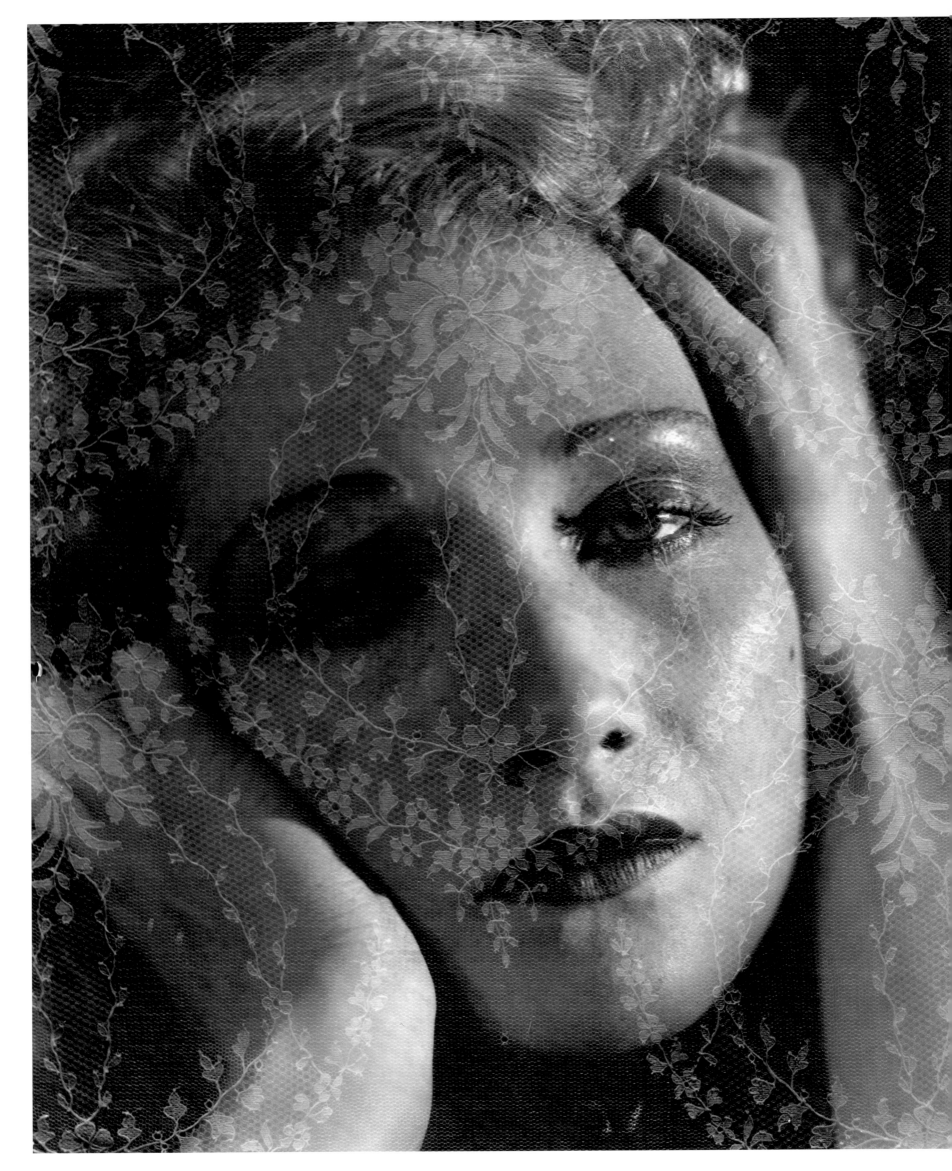

41 EDWINA BOOTH, 1930

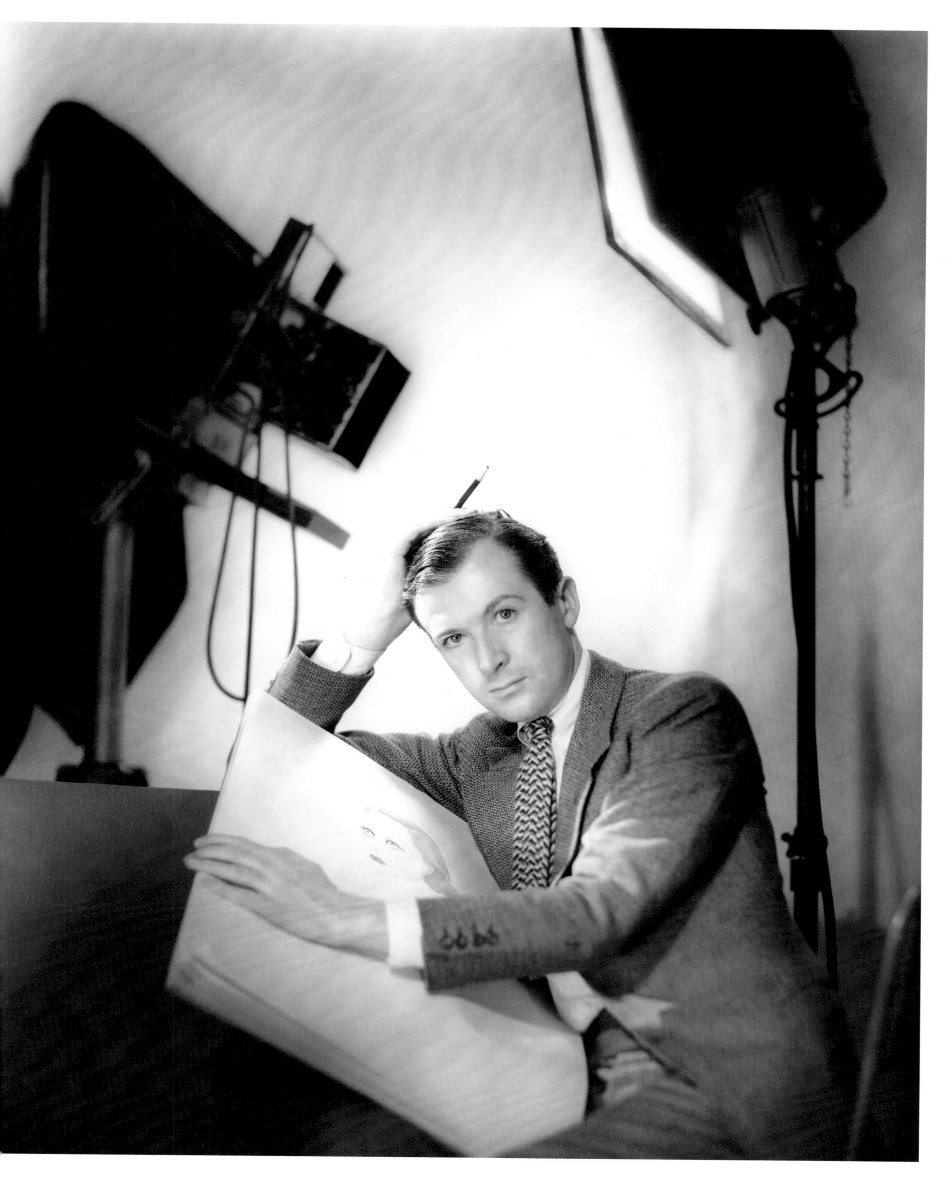

42 CECIL BEATON, 1937

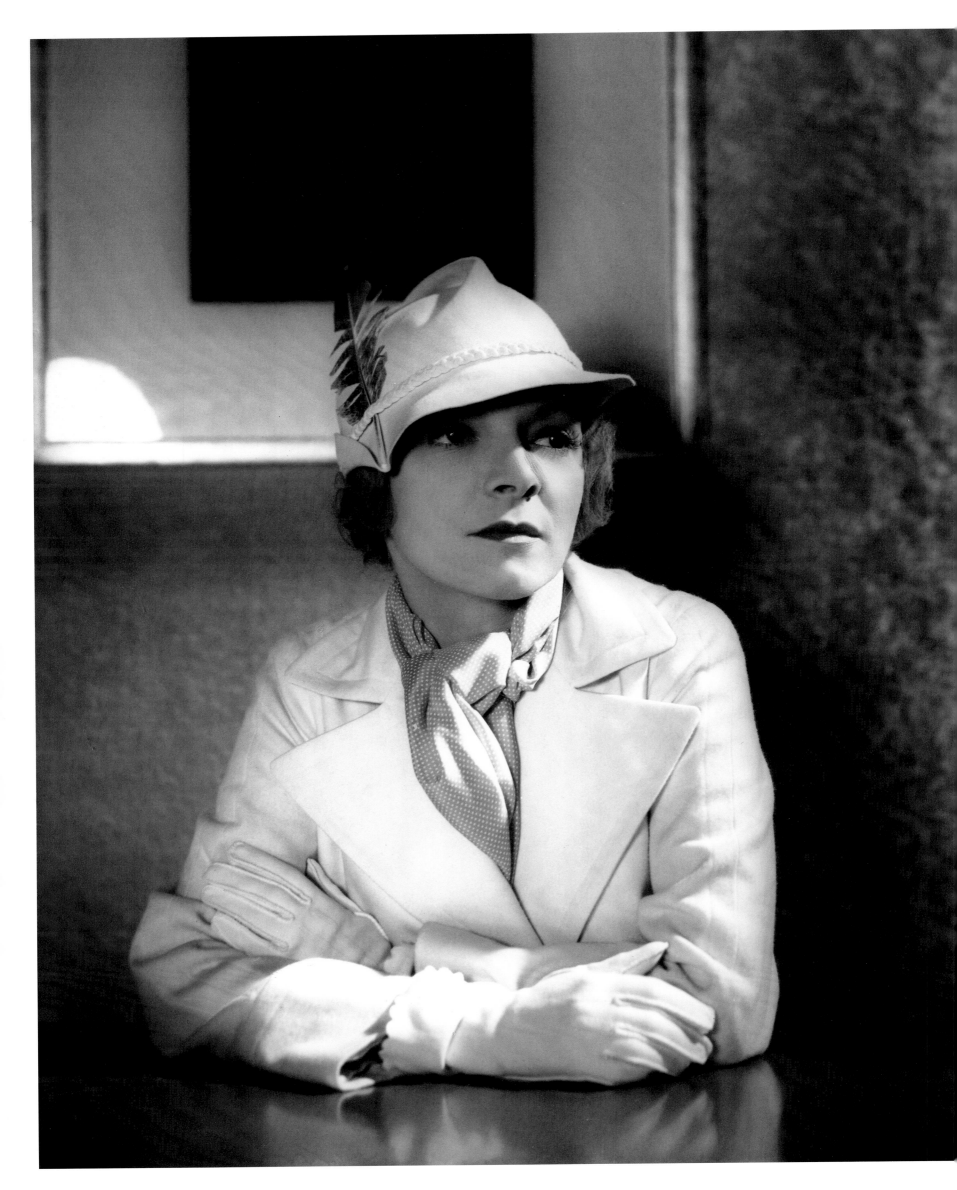

43 HELEN HAYES, 1931

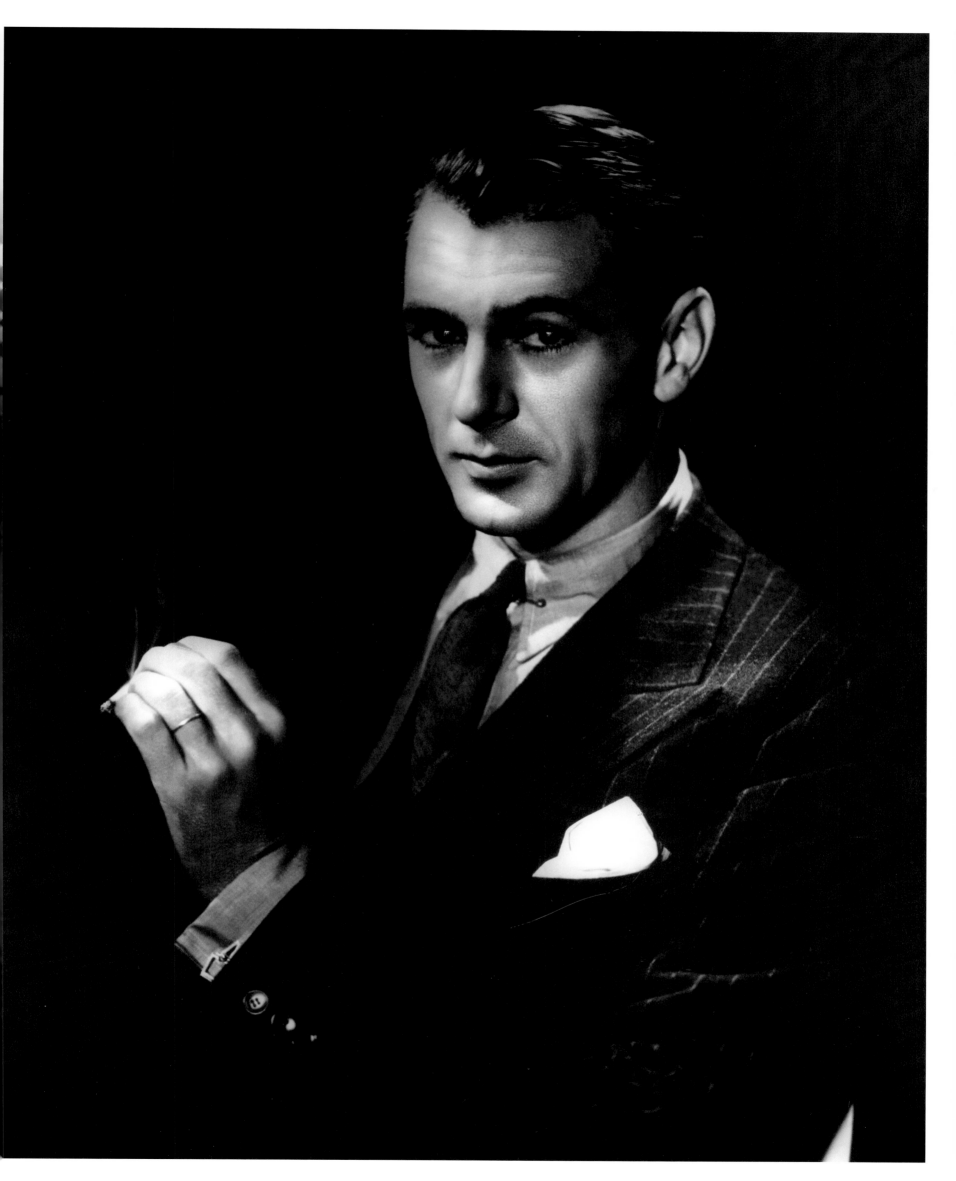

44 GARY COOPER, 1937

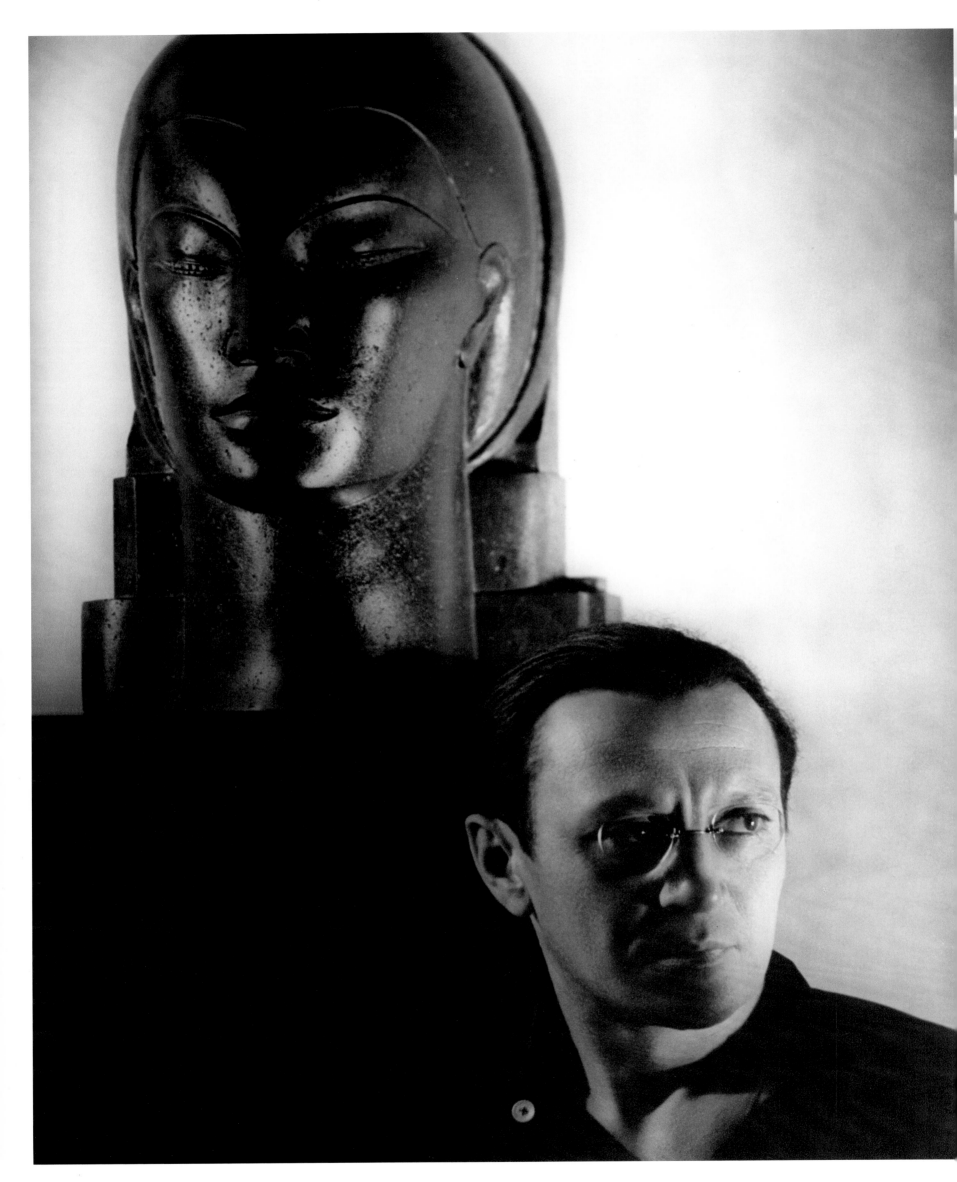

45 BORIS LOVET-LORSKI

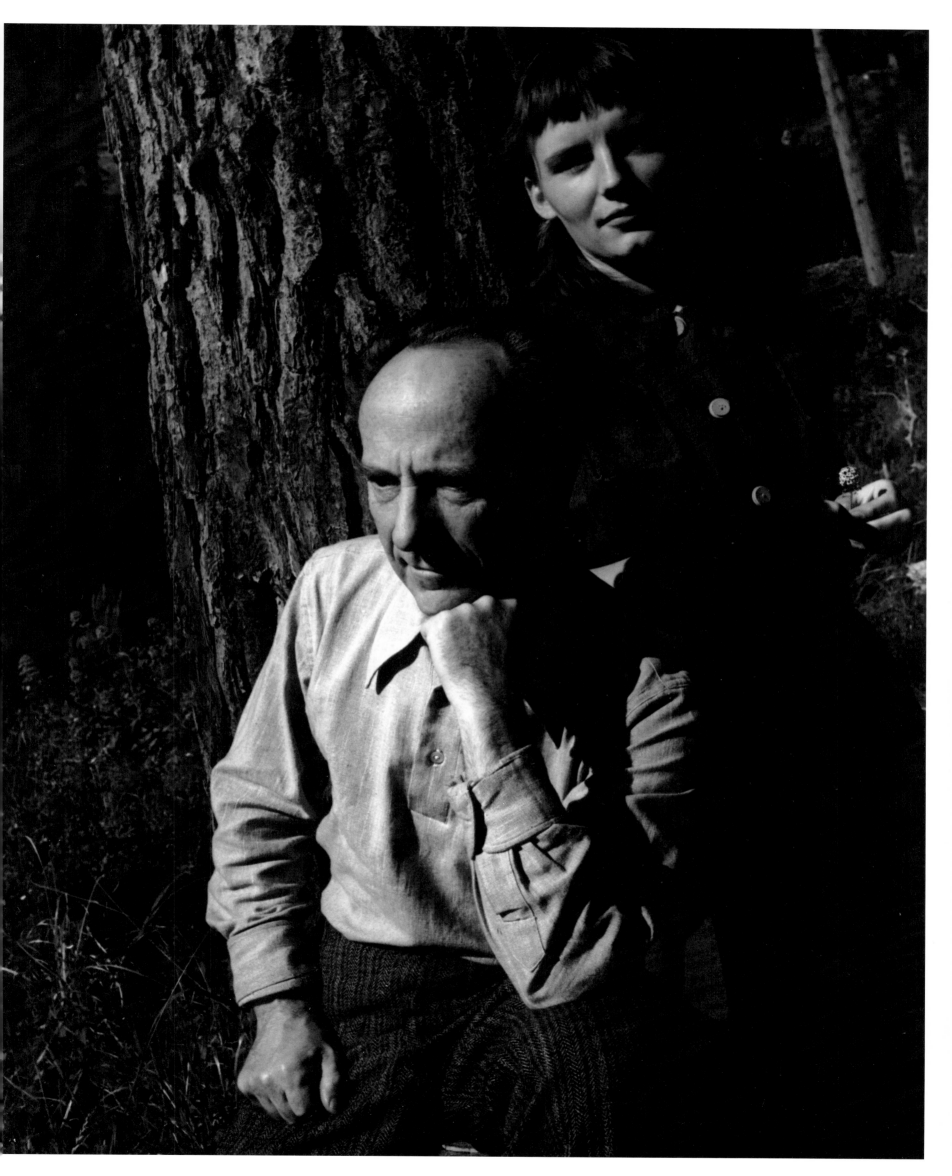

46 EDWARD, CHARIS WESTON, 1935

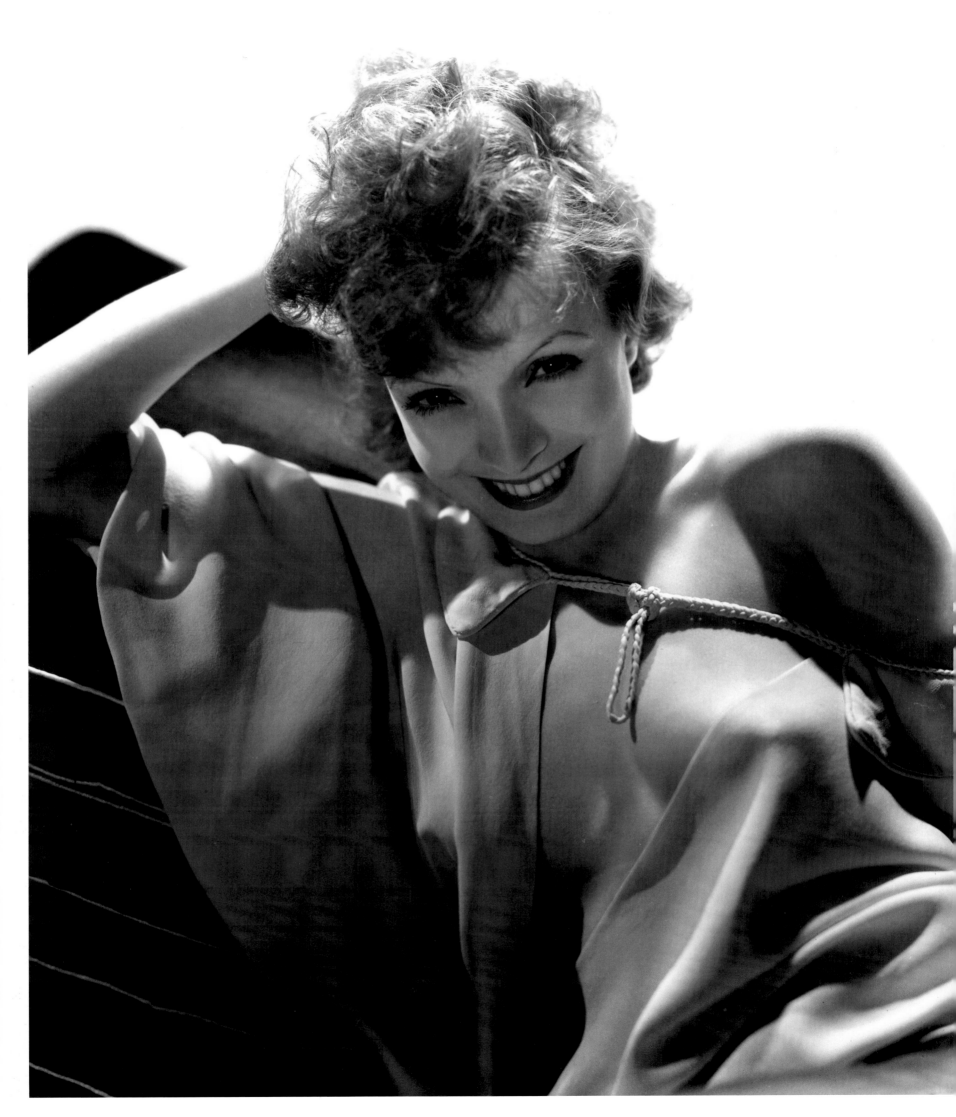

47　CONCHITA MONTENEGRO, 1931

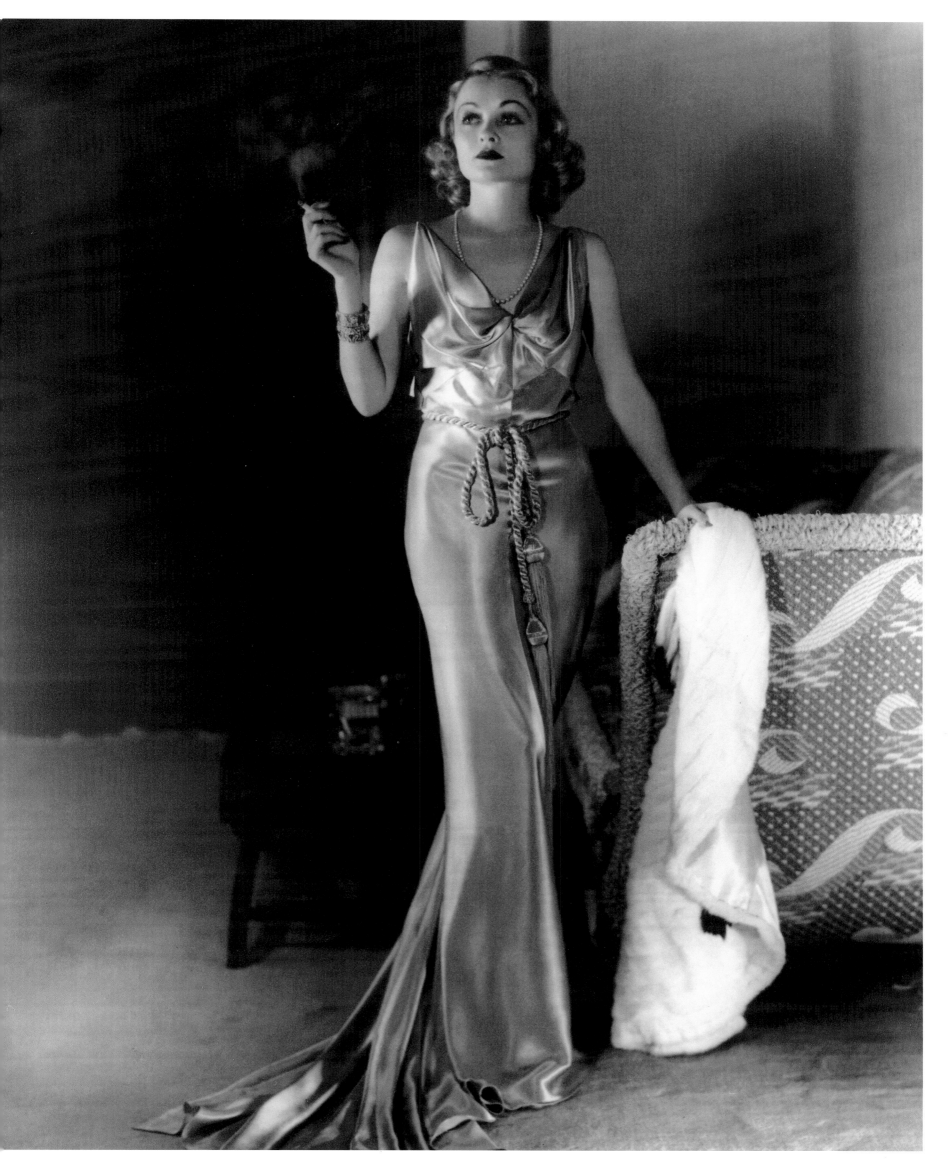

48 CONSTANCE BENNETT, 1933

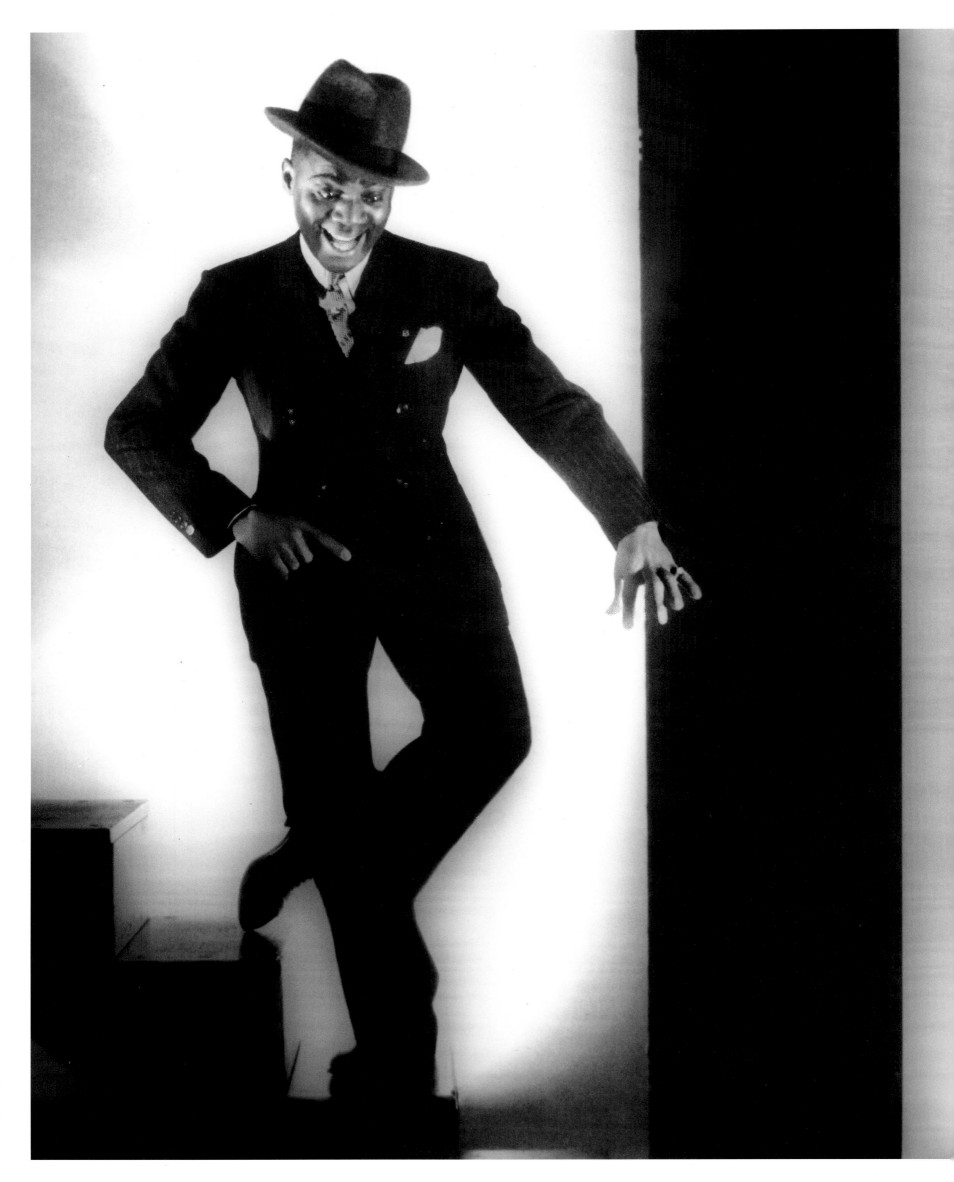

49 BILL »BOJANGLES« ROBINSON, *The Little Colonel*, 1935

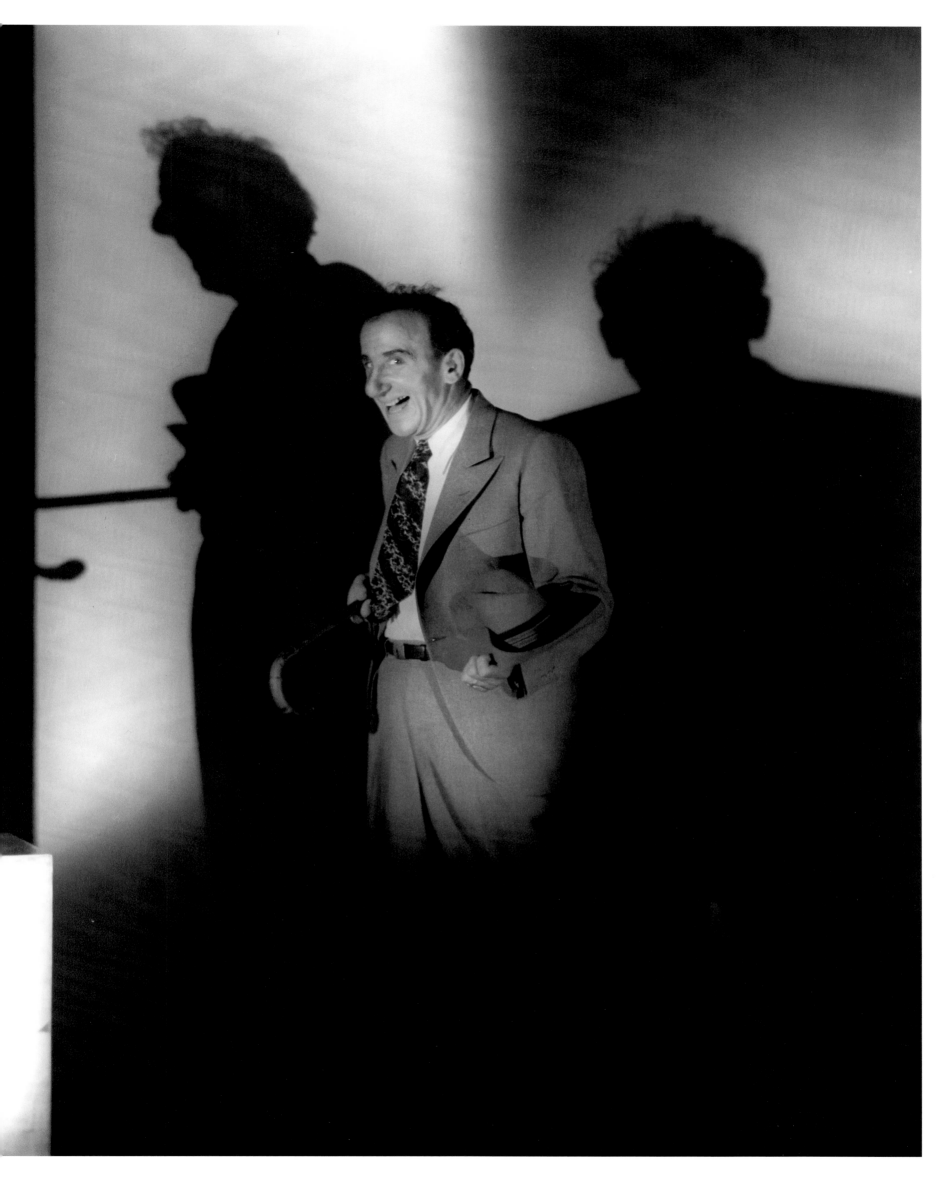

50 JIMMY DURANTE, 1931

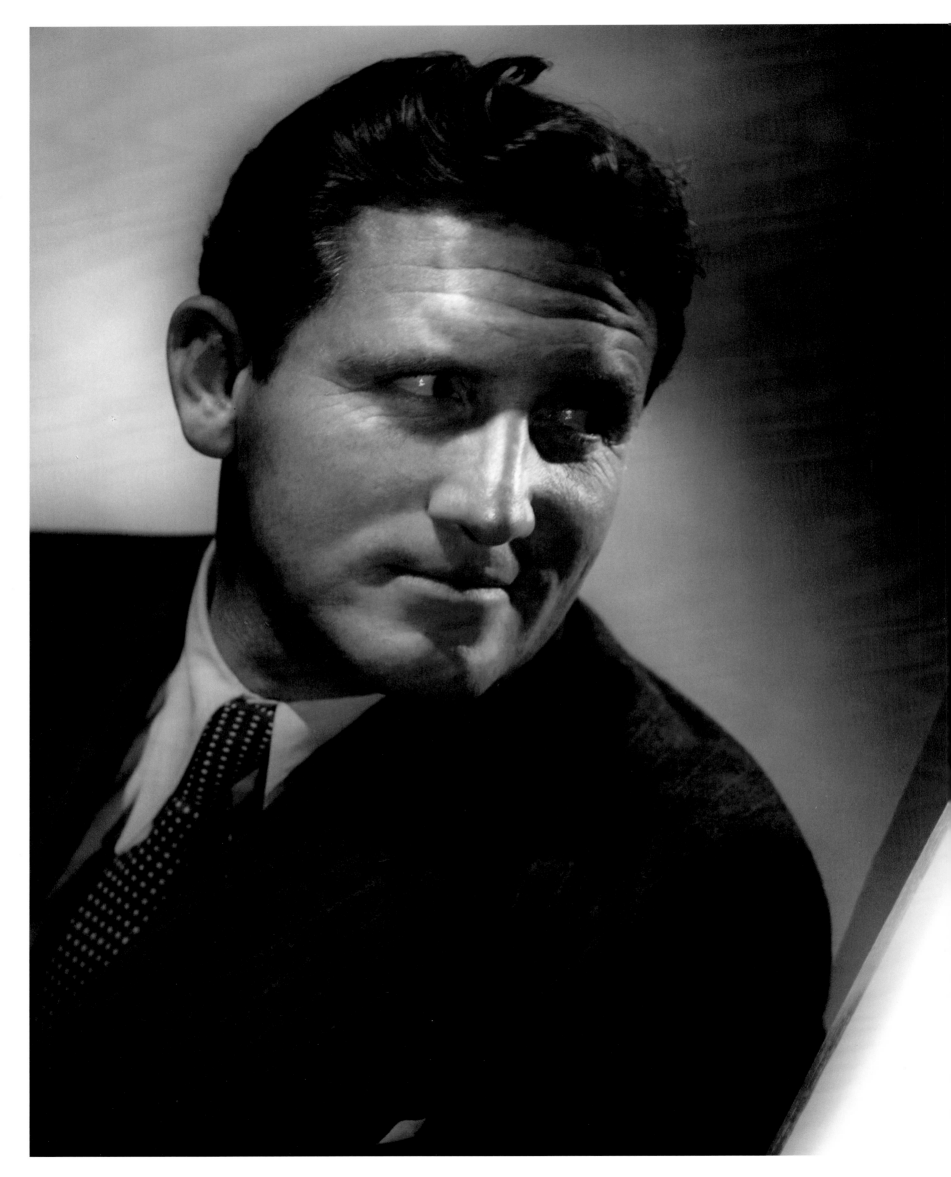

51 SPENCER TRACY, 1936

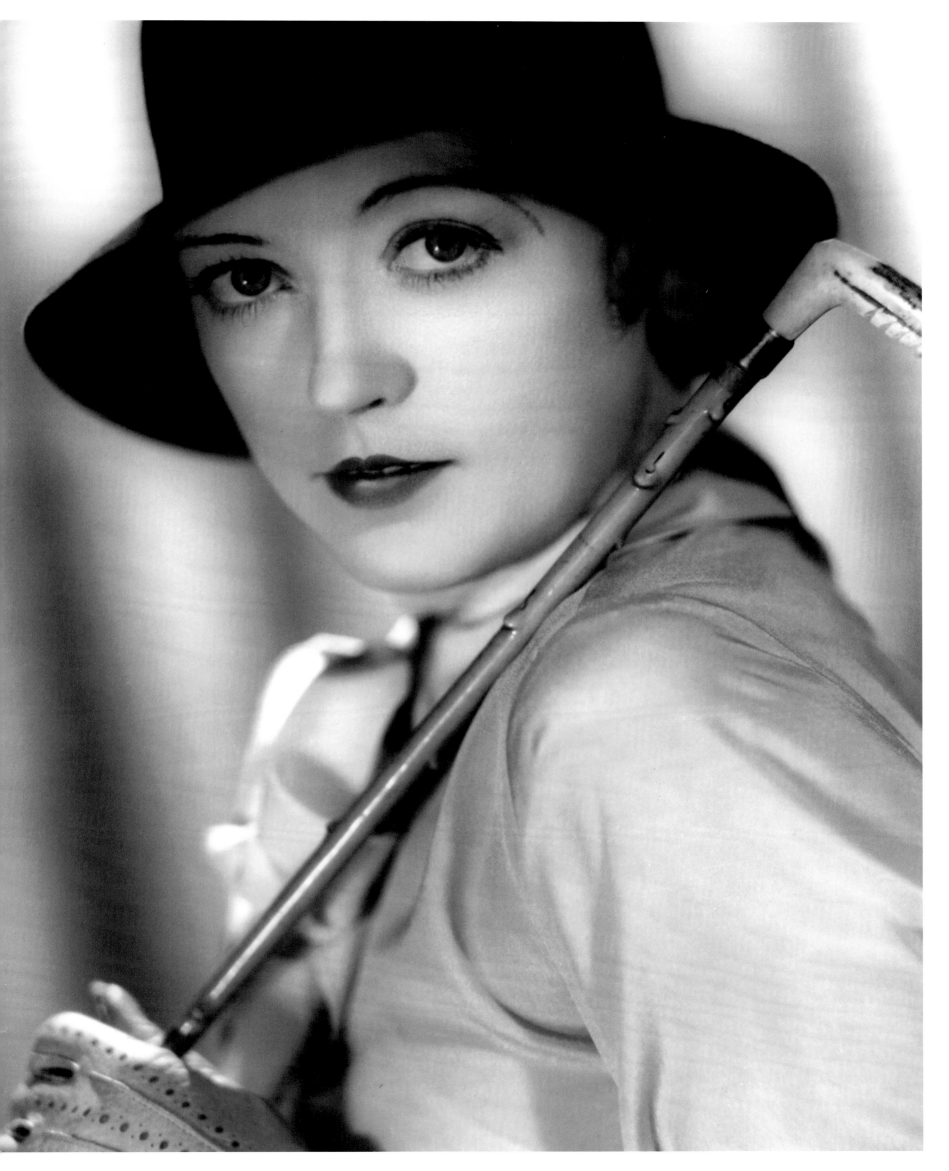

52 MARION DAVIES, 1933

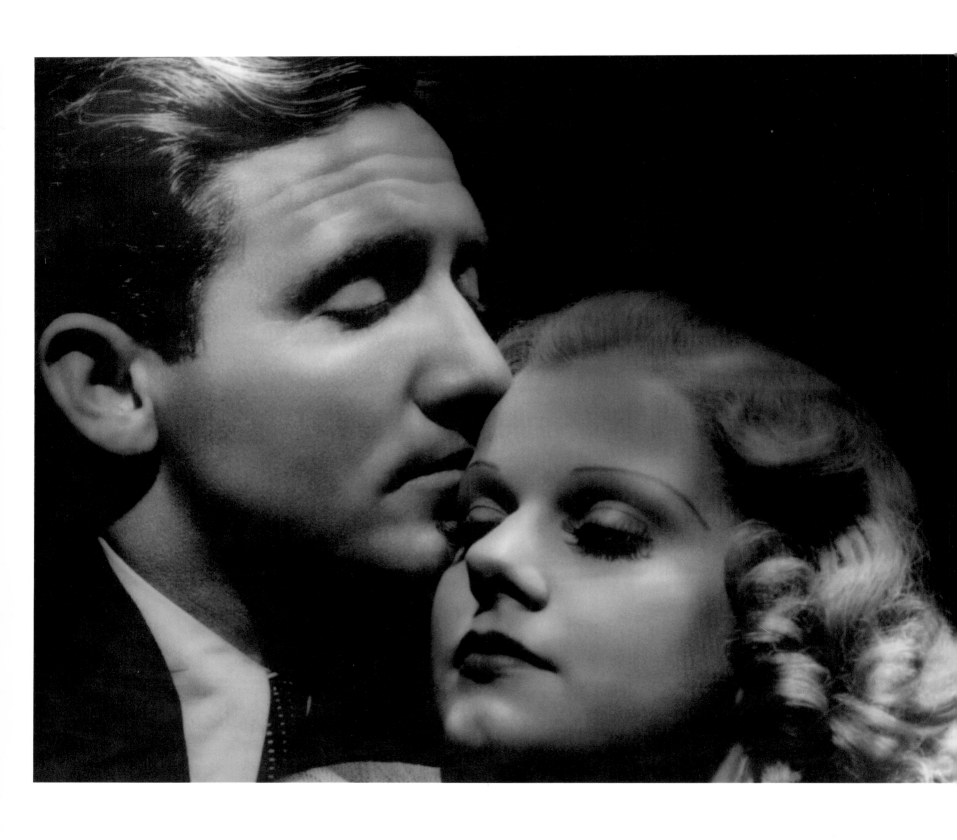

53 SPENCER TRACY, JEAN HARLOW, *Libeled Lady*, 1936

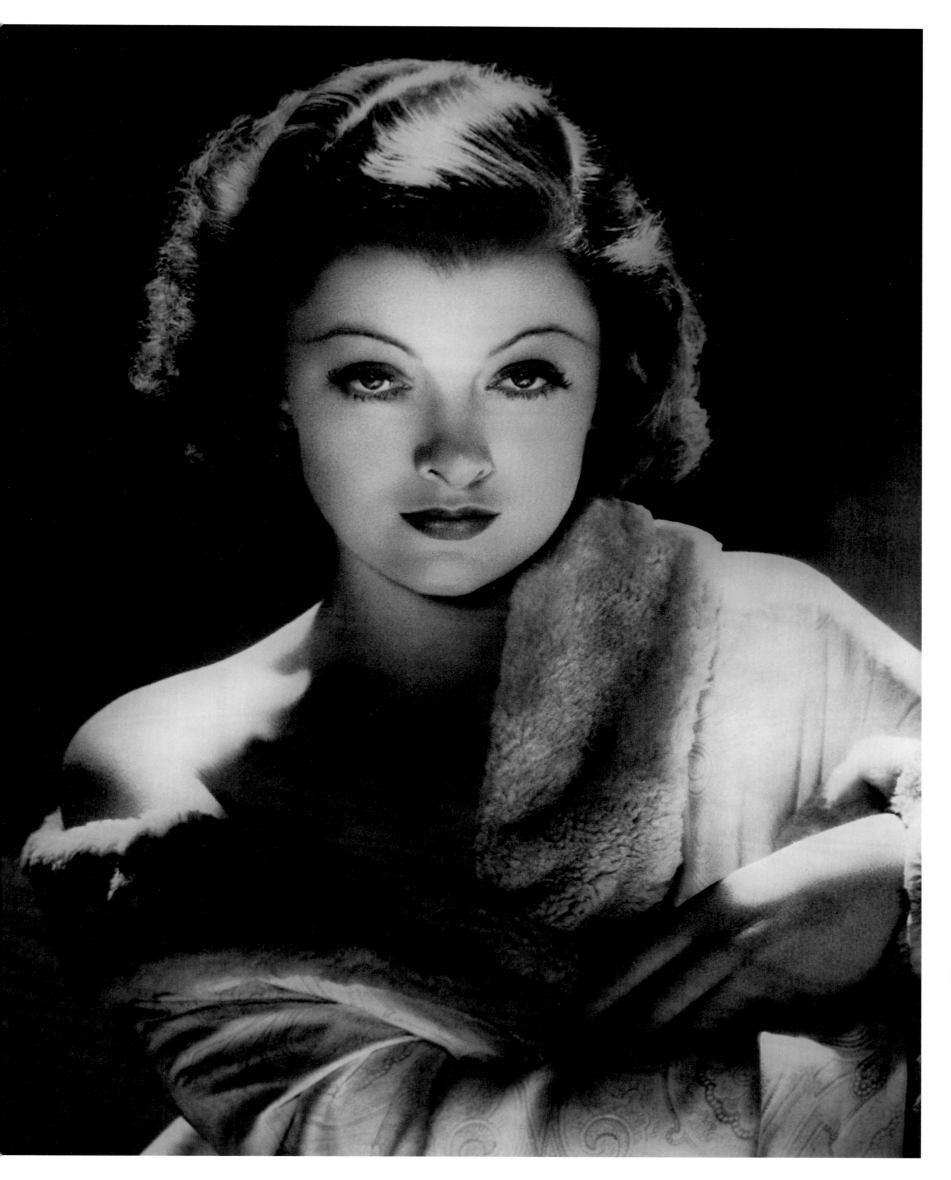

54 MYRNA LOY, 1933

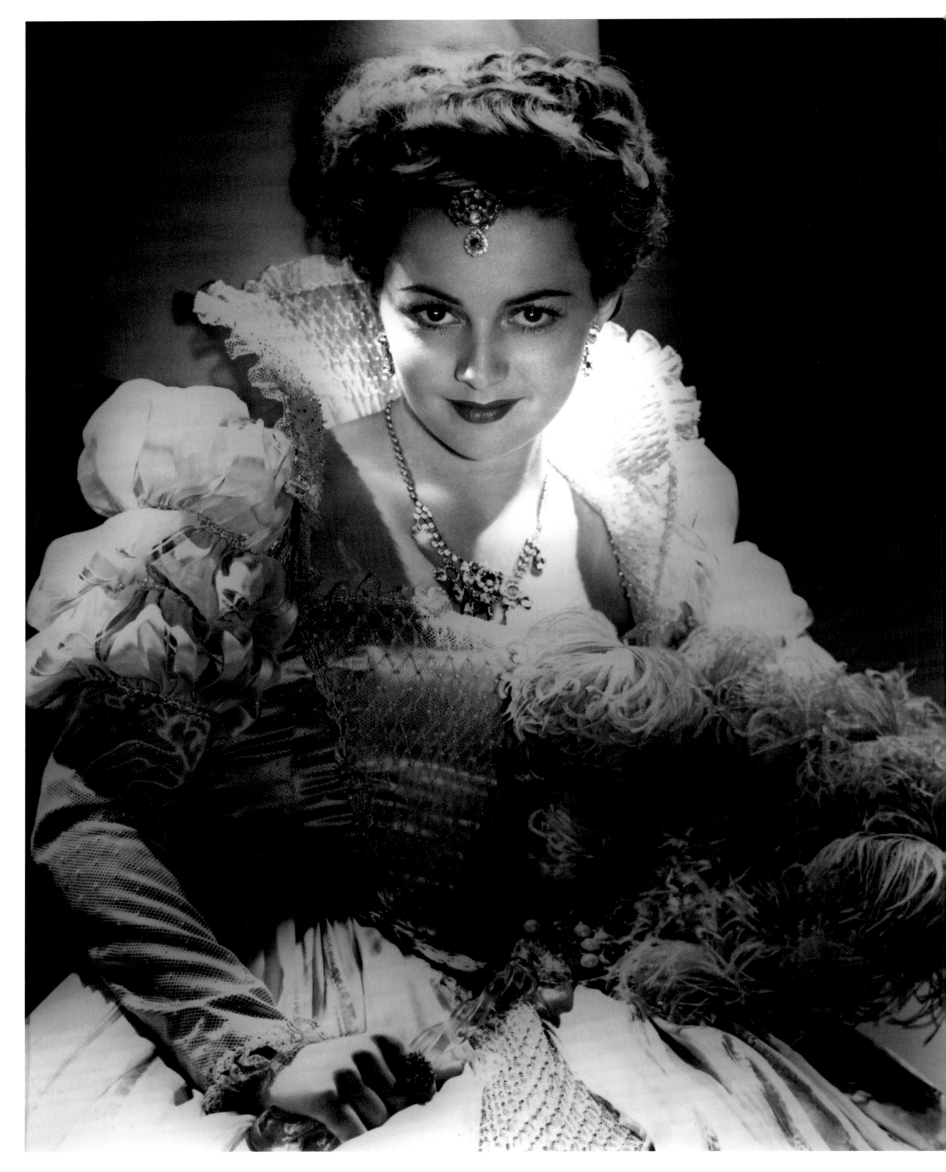

55 Olivia de Havilland, *The Private Lives of Elizabeth and Essex*, 1939

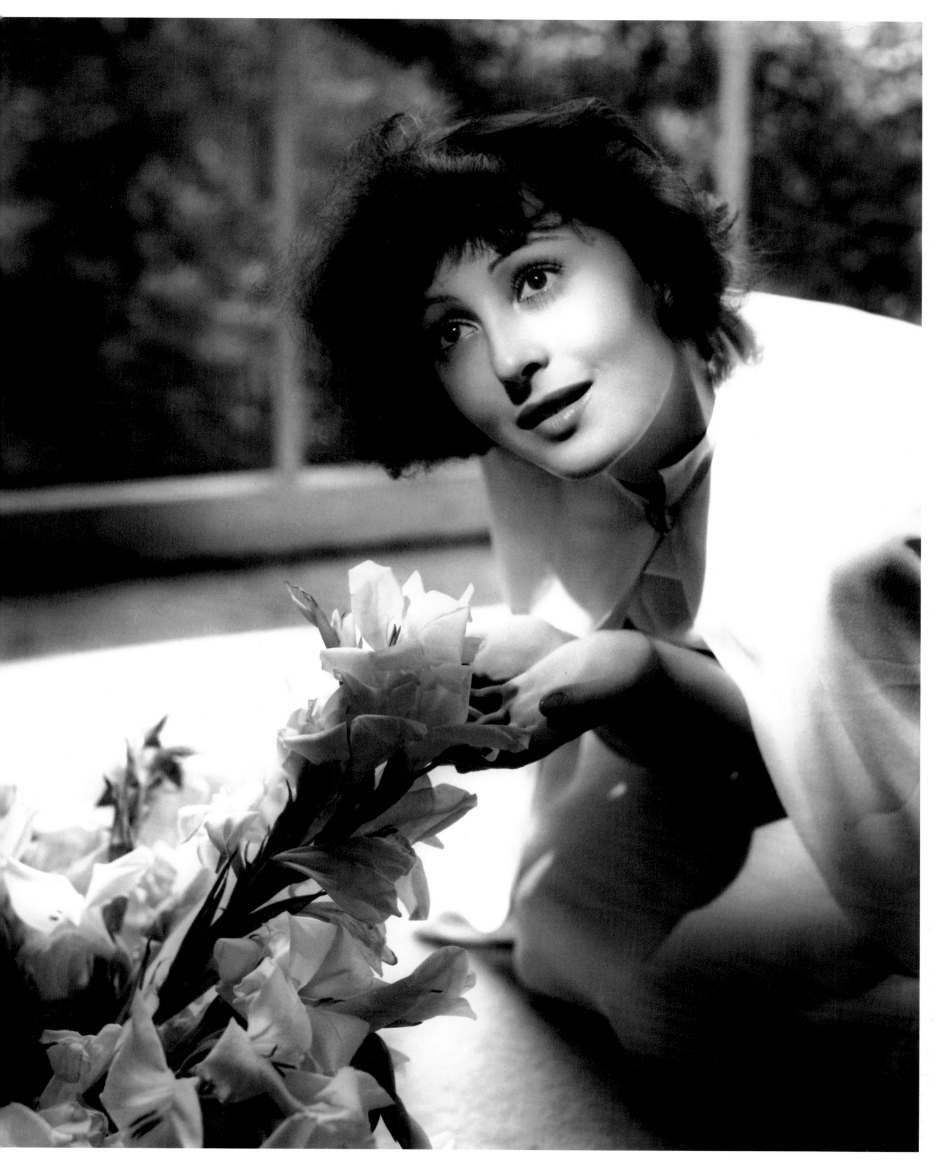

56 LUISE RAINER, 1935

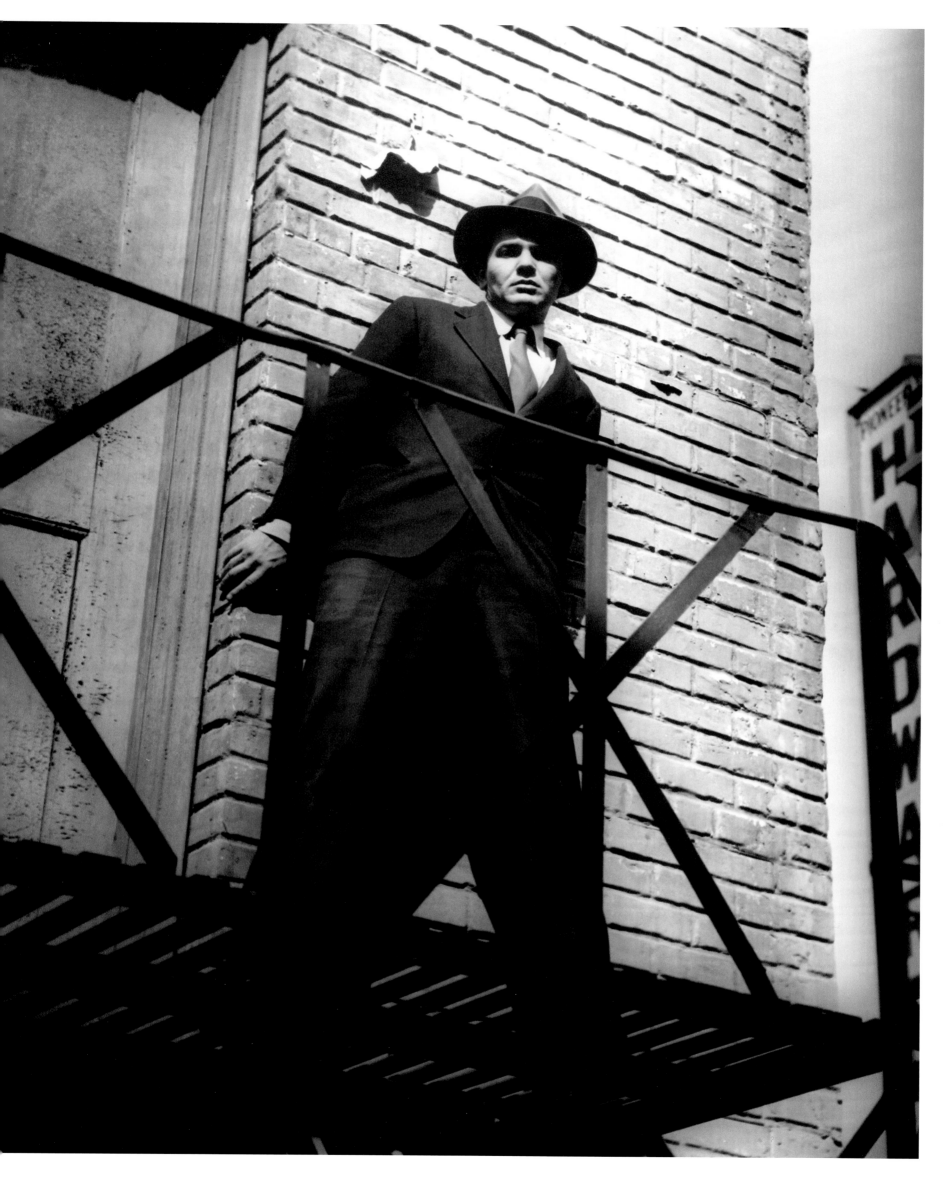

57 JOHN GARFIELD, 1939

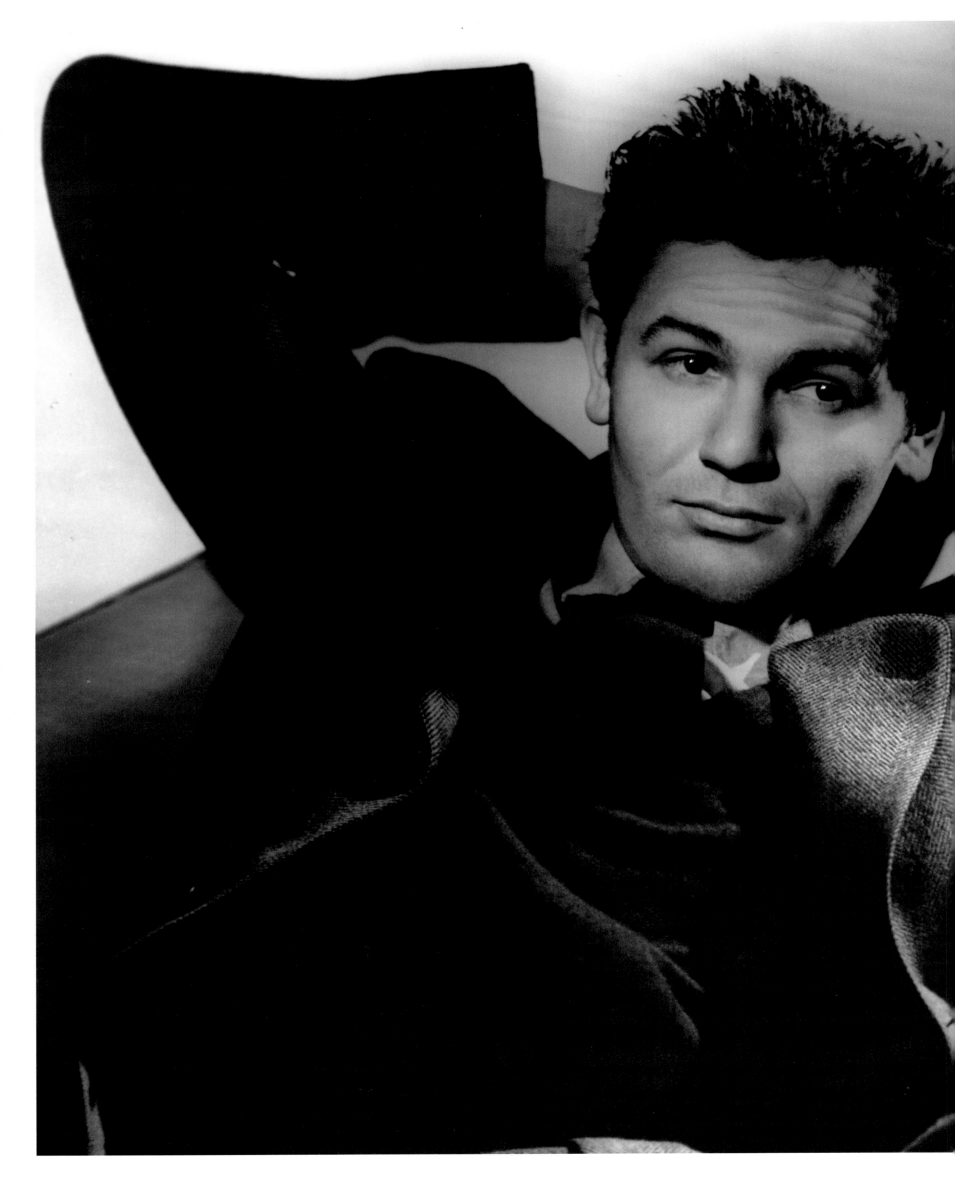

58 JOHN GARFIELD, 1939

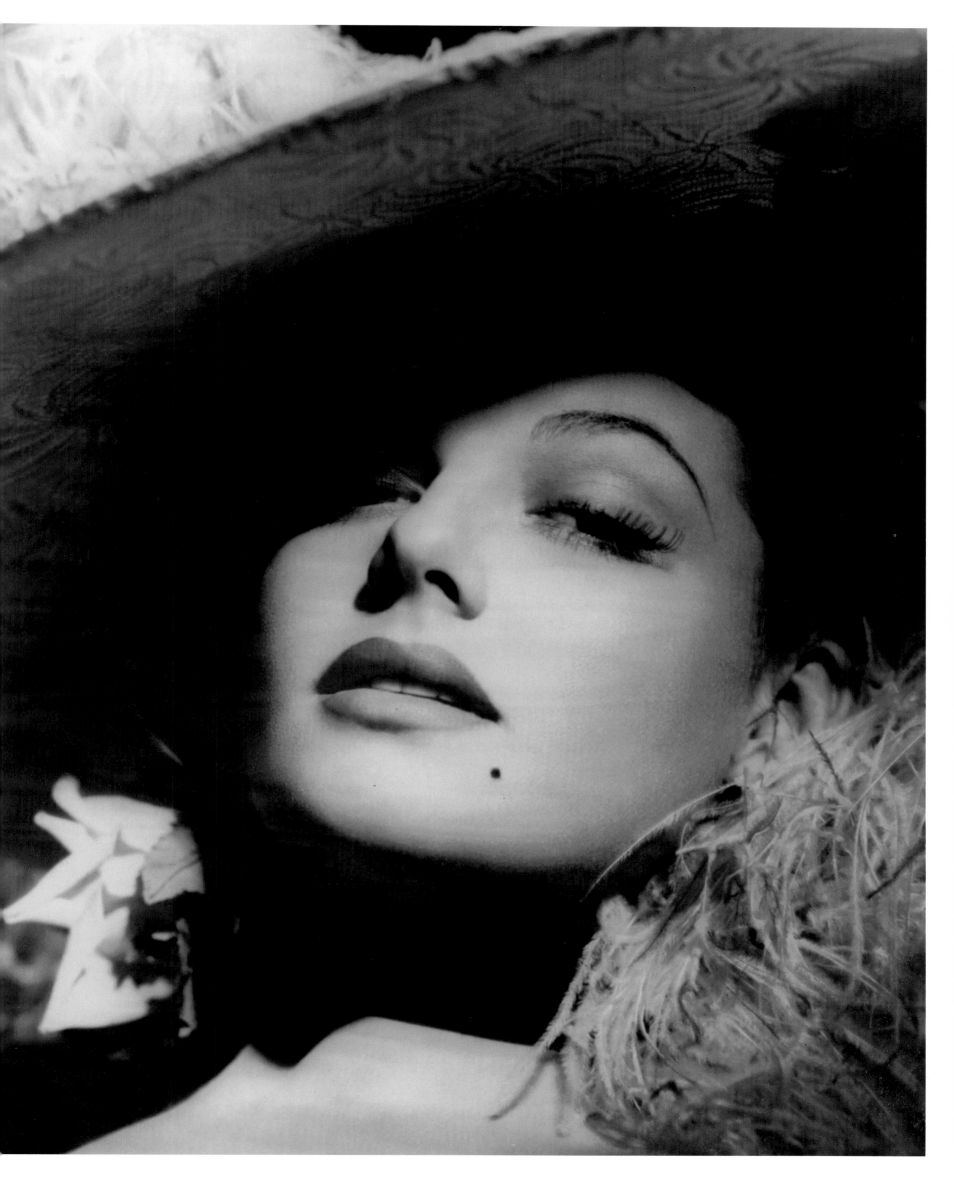

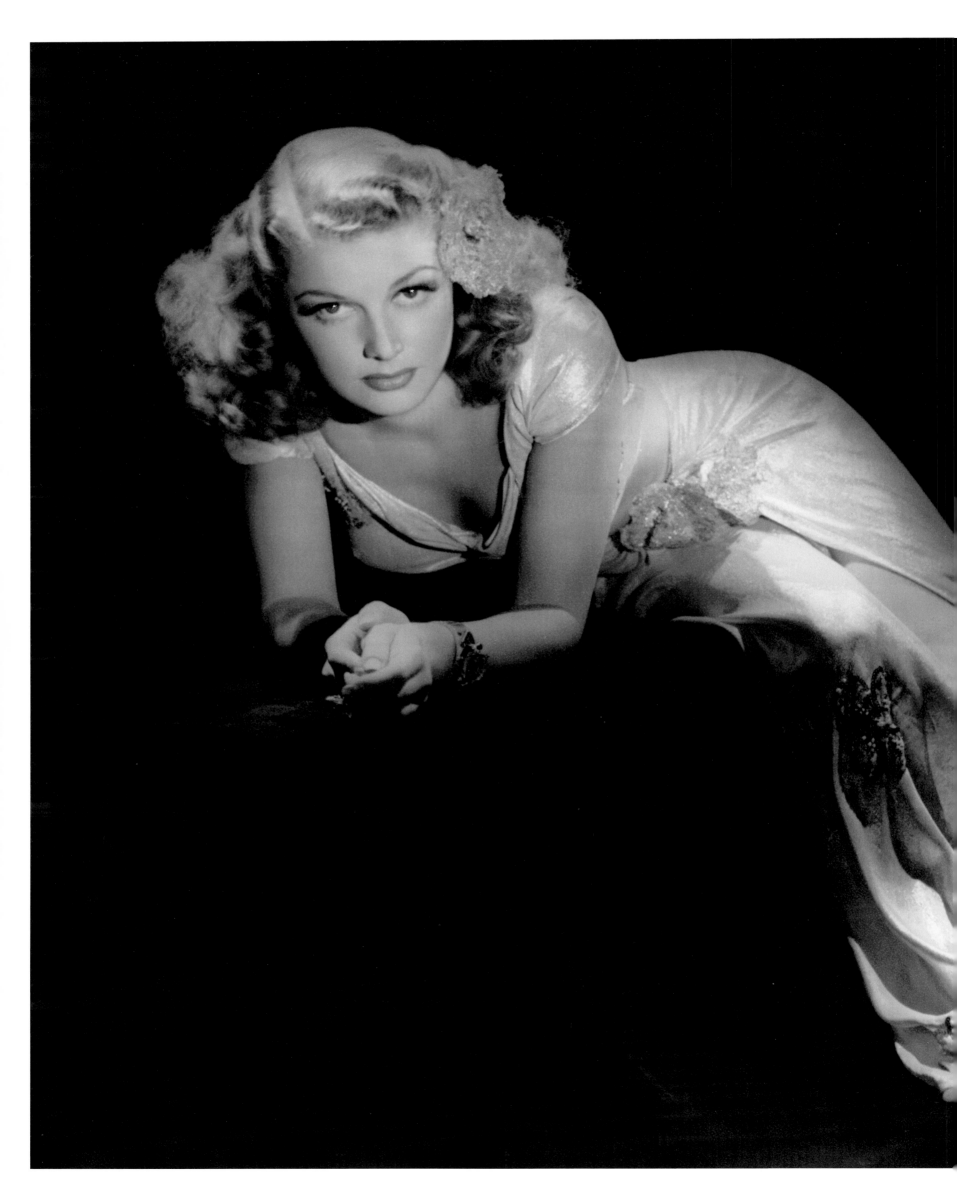

60 ANN SHERIDAN, 1939

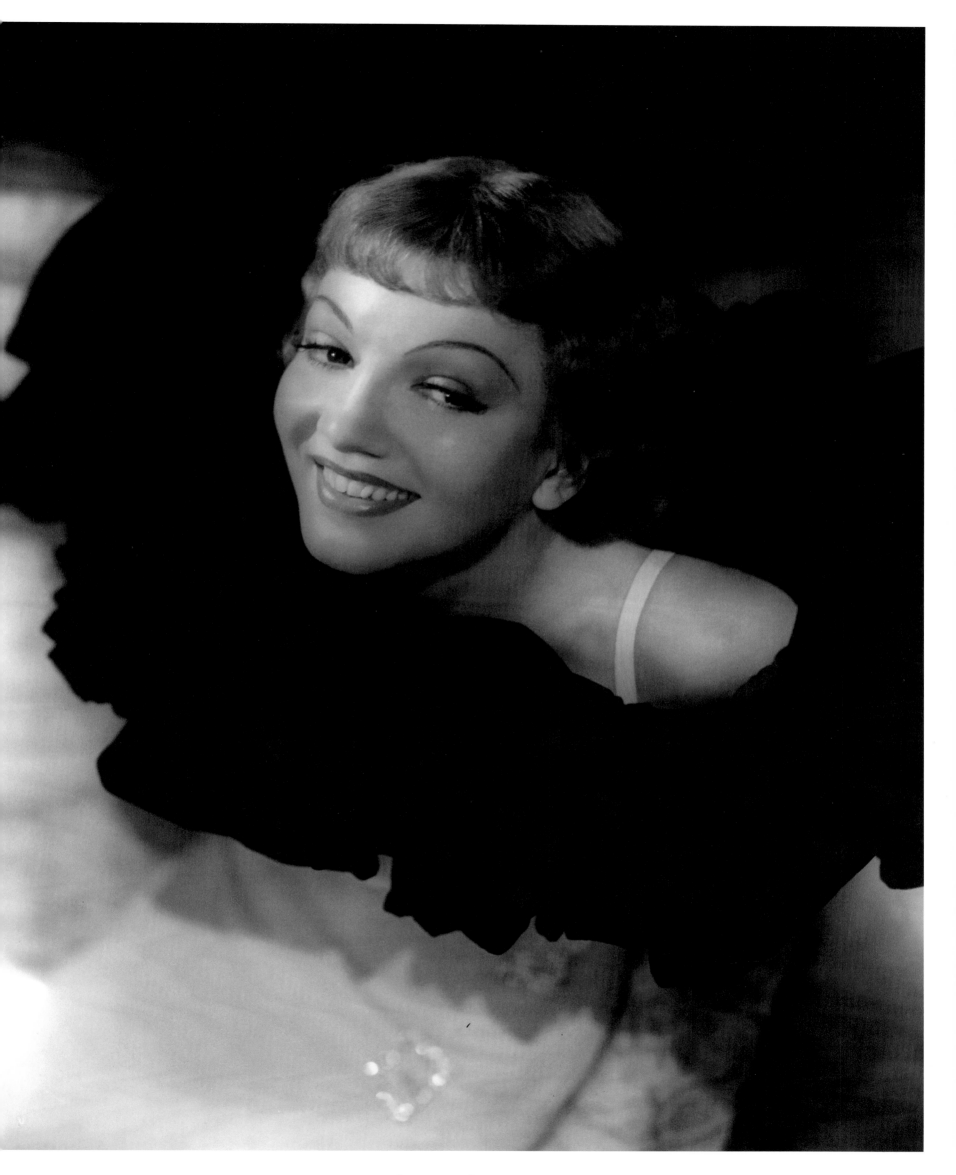

61 CLAUDETTE COLBERT, 1938

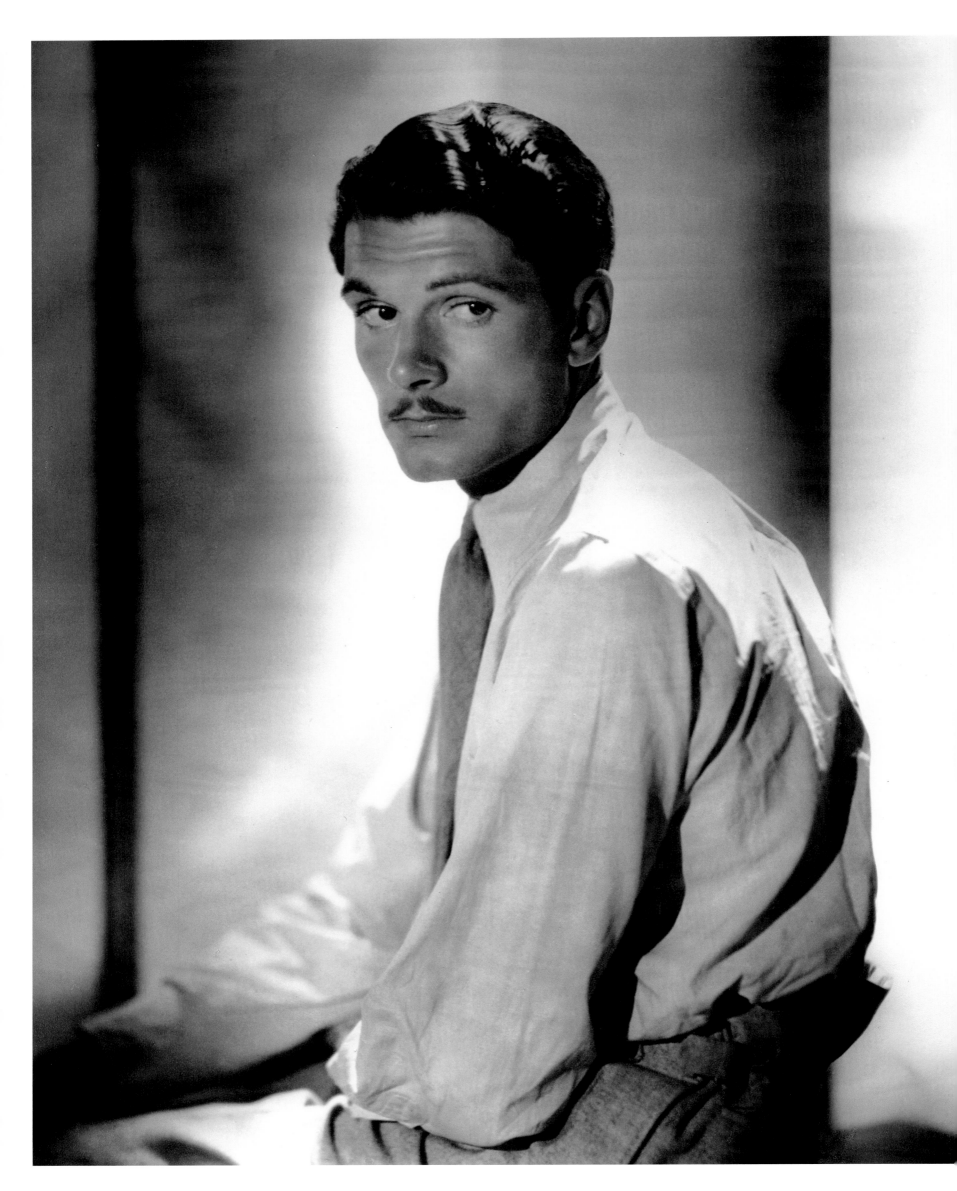

62 LAURENCE OLIVIER, 1933

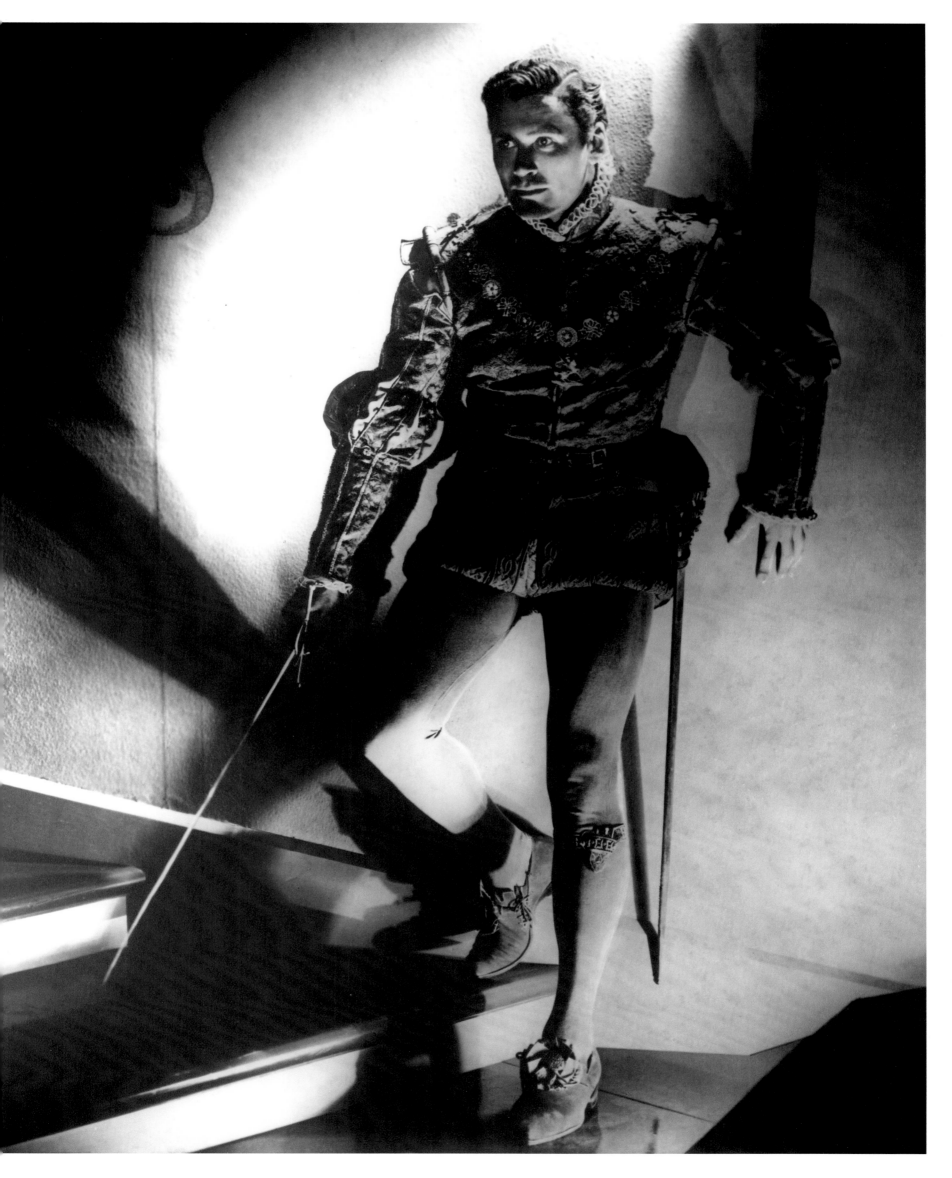

63 ERROL FLYNN, *The Private Lives of Elizabeth and Essex, 1939*

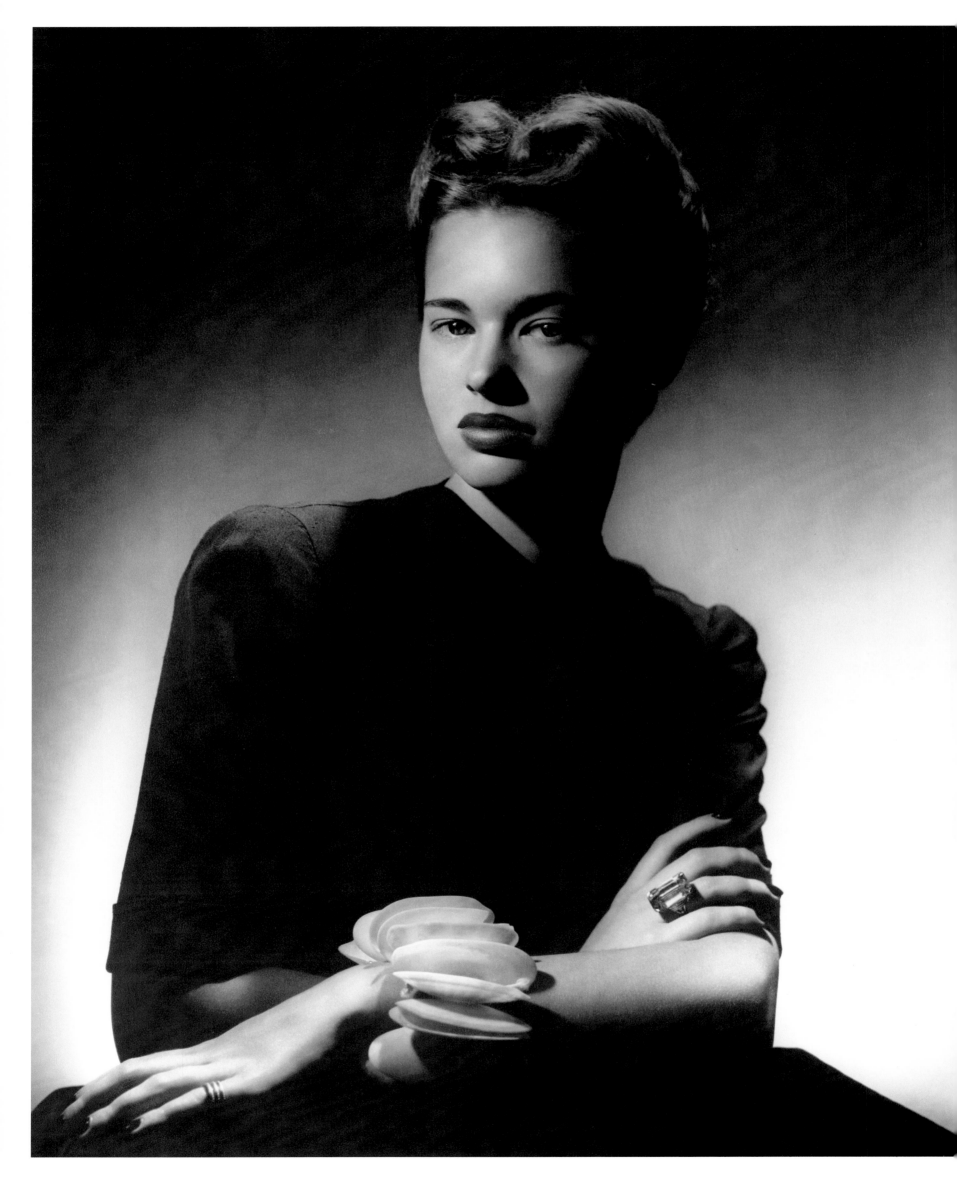

64 GLORIA VANDERBILT, 1937

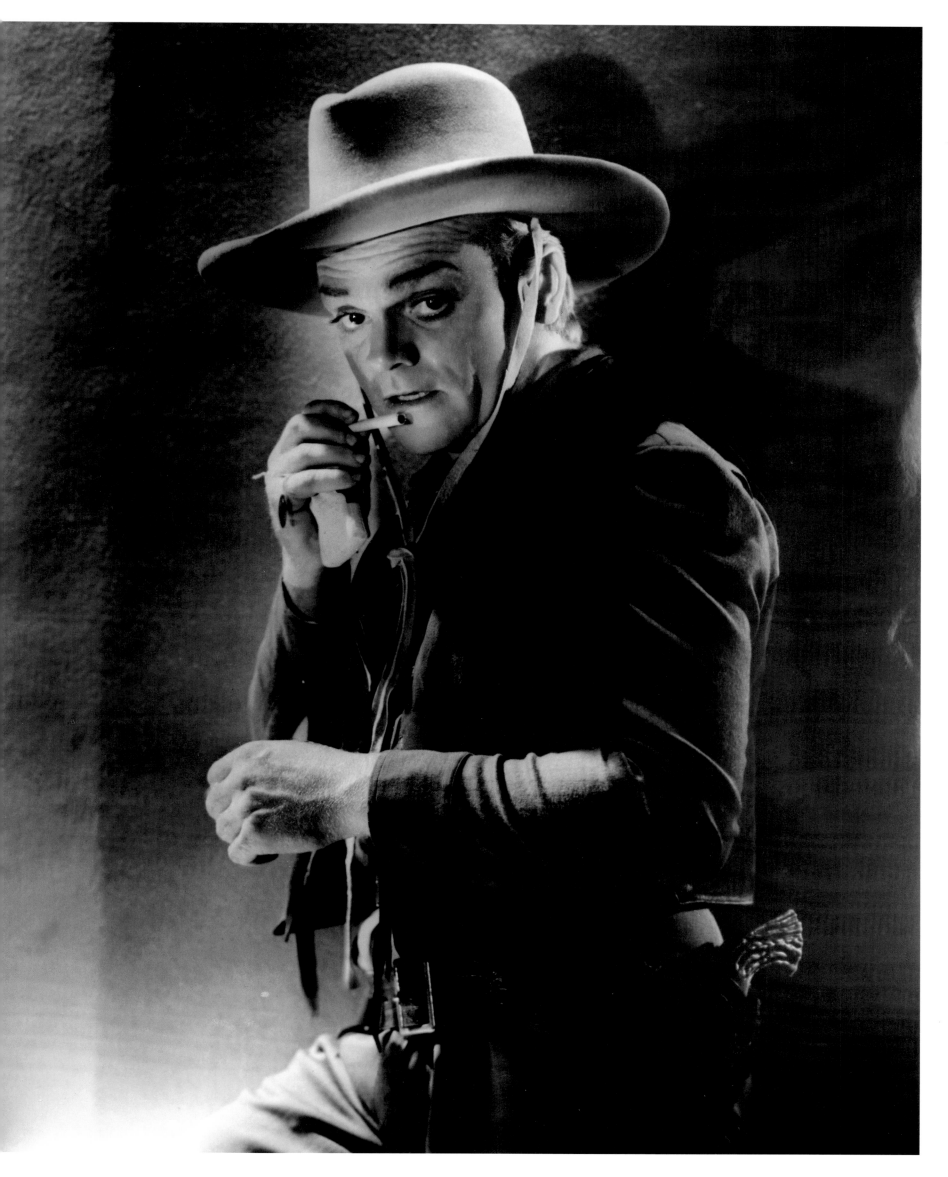

65 JAMES CAGNEY, 1938

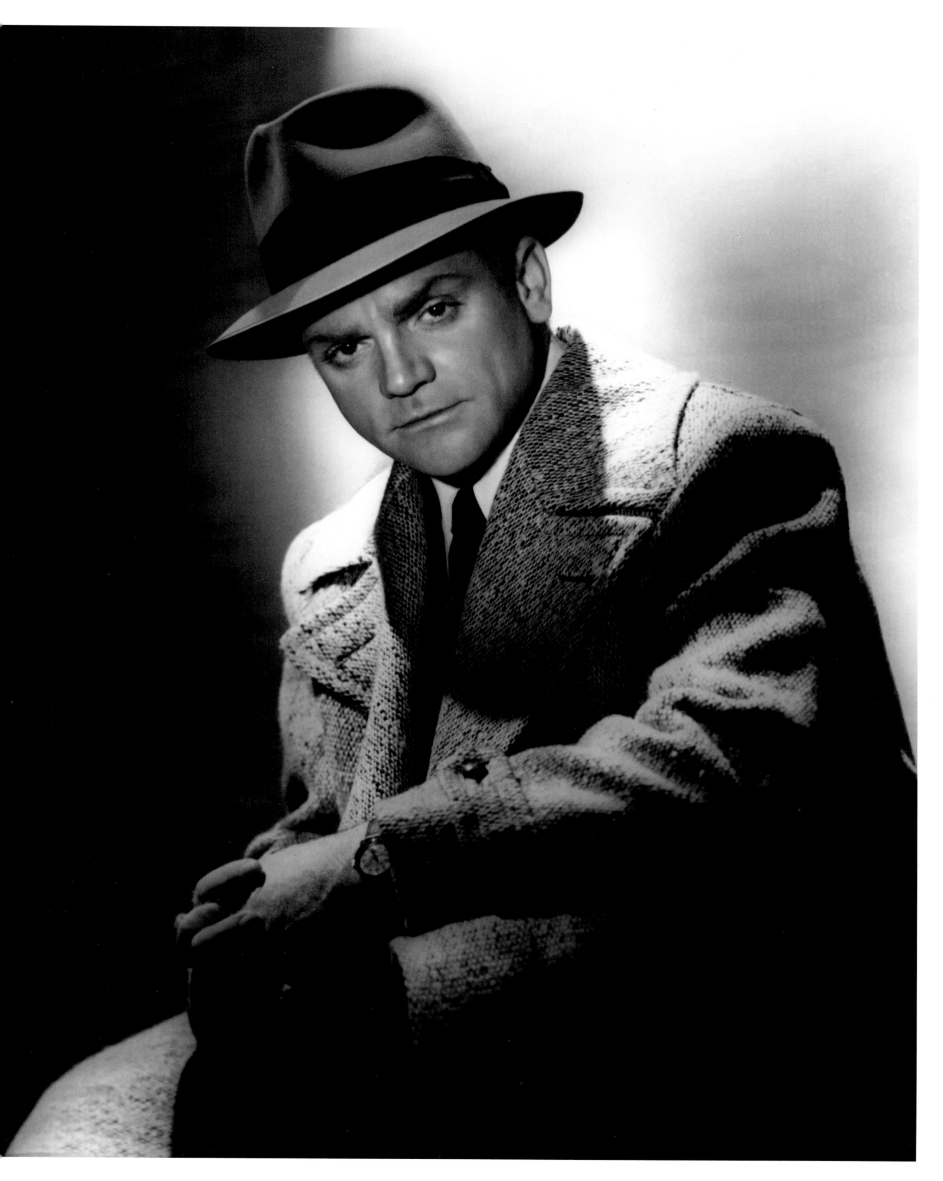

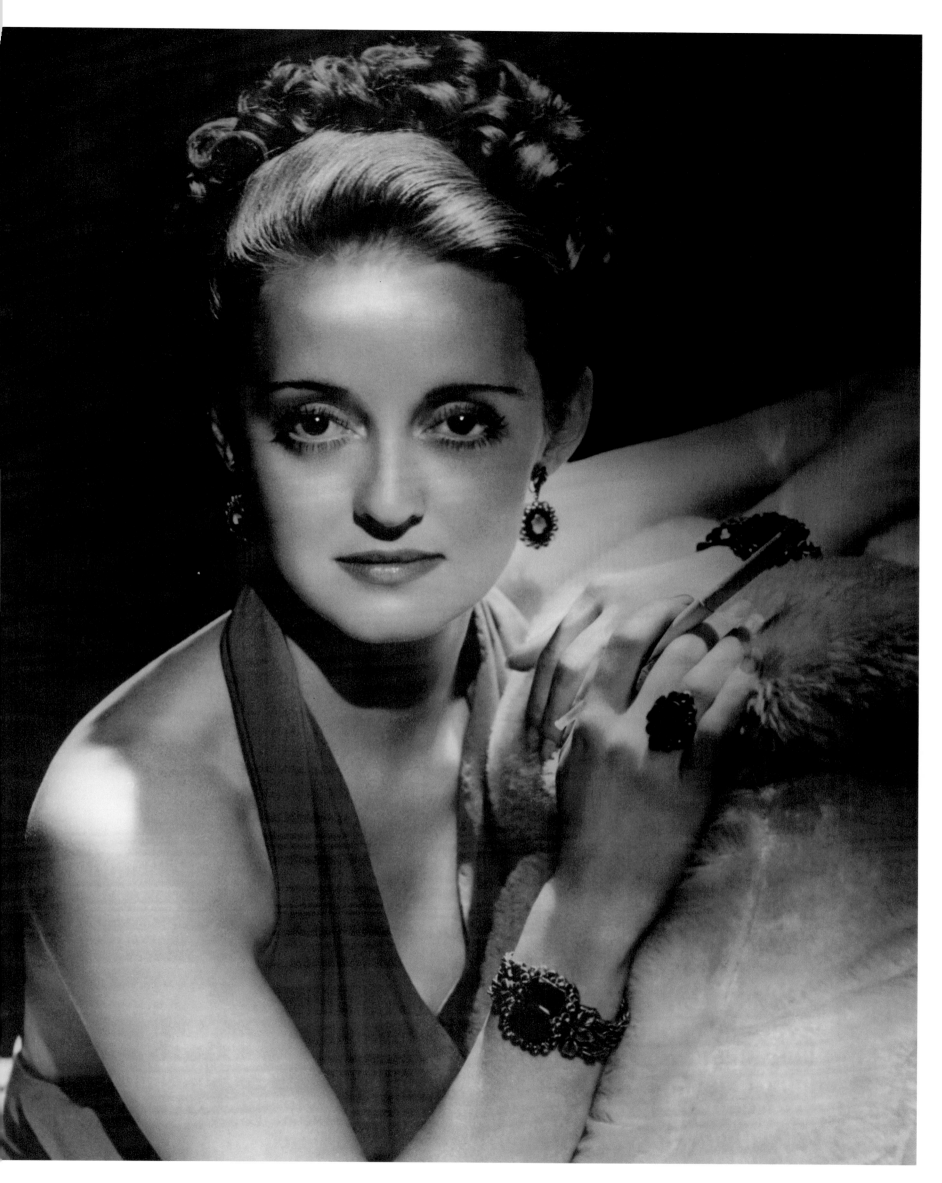

67 Bette Davis, 1938

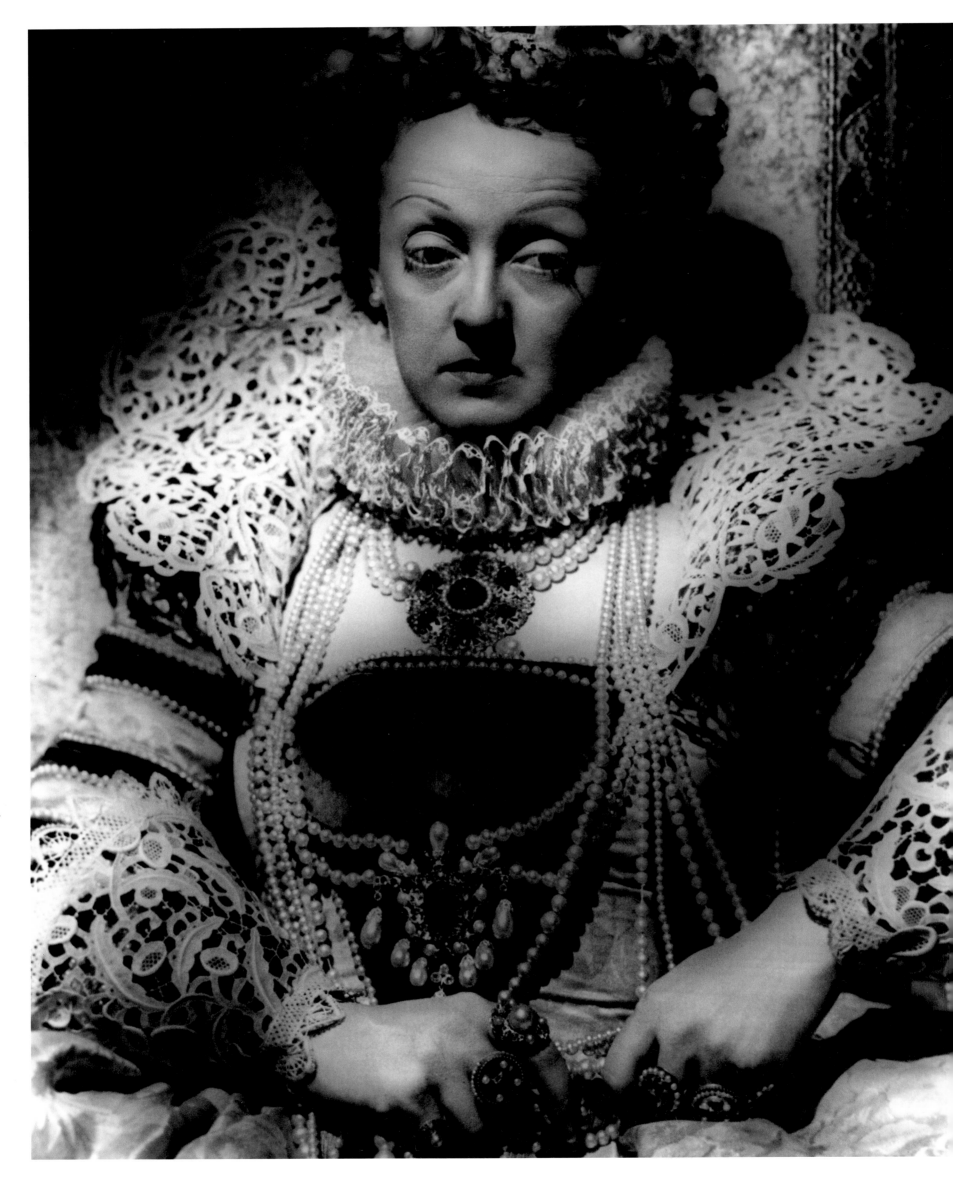

68 BETTE DAVIS, *The Private Lives of Elizabeth and Essex*, 1939

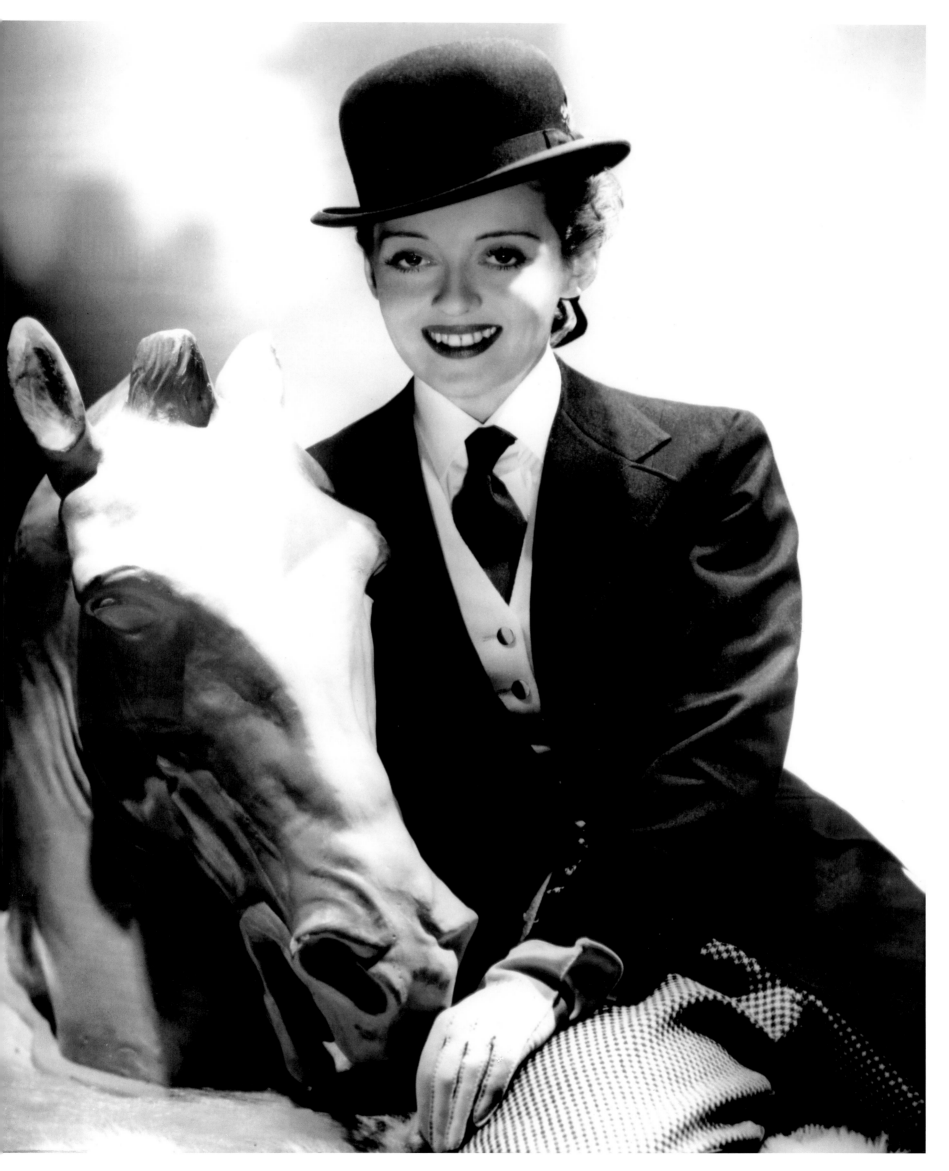

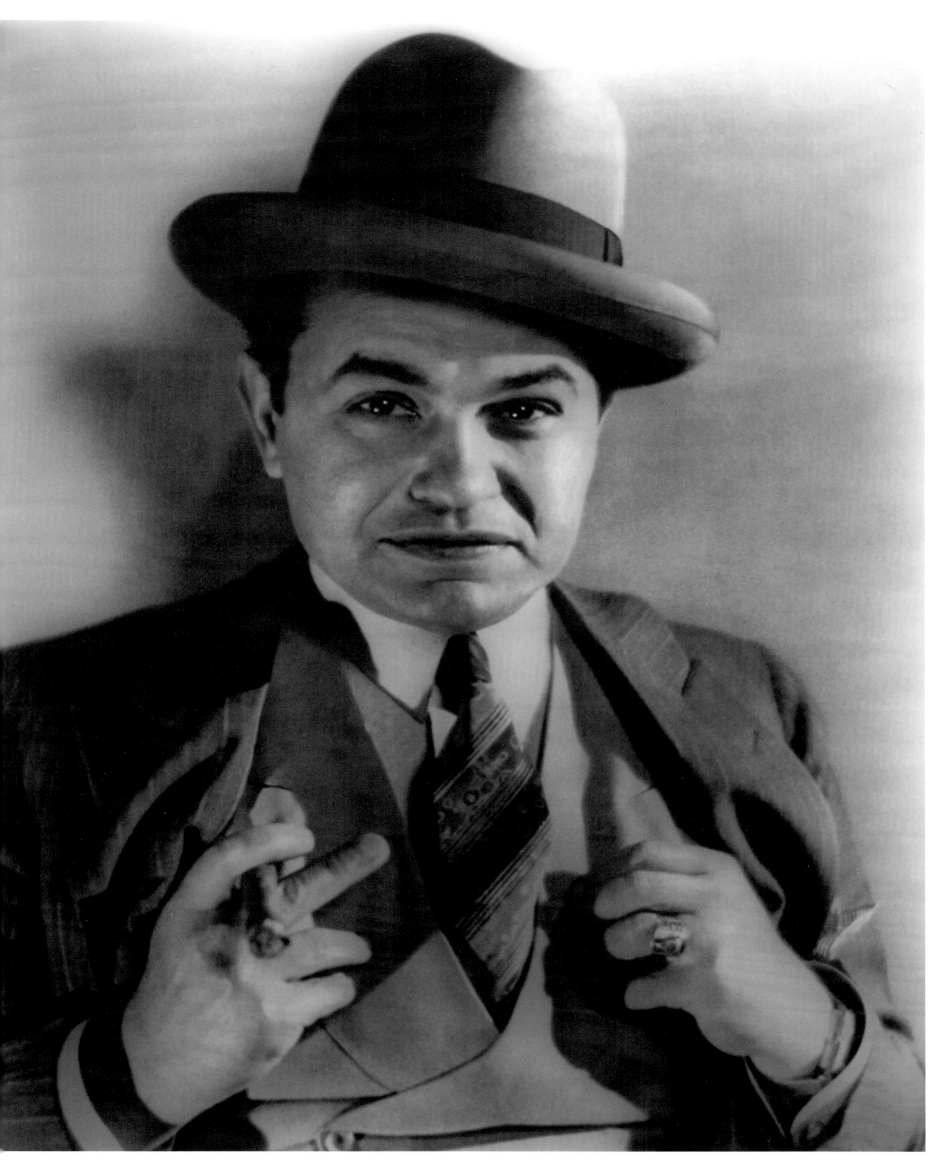

70 EDWARD G. ROBINSON, 1938

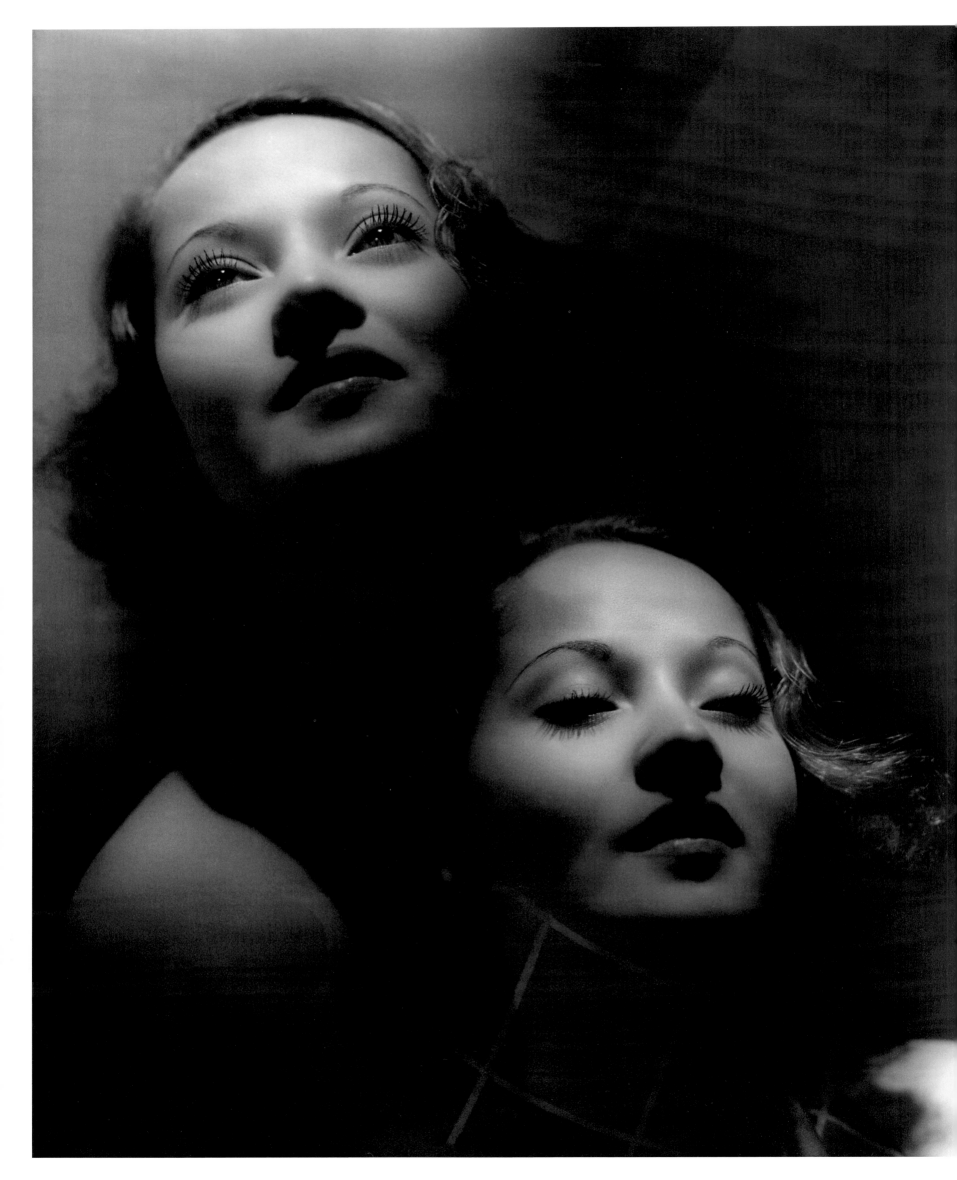

71 MERLE OBERON, 1936

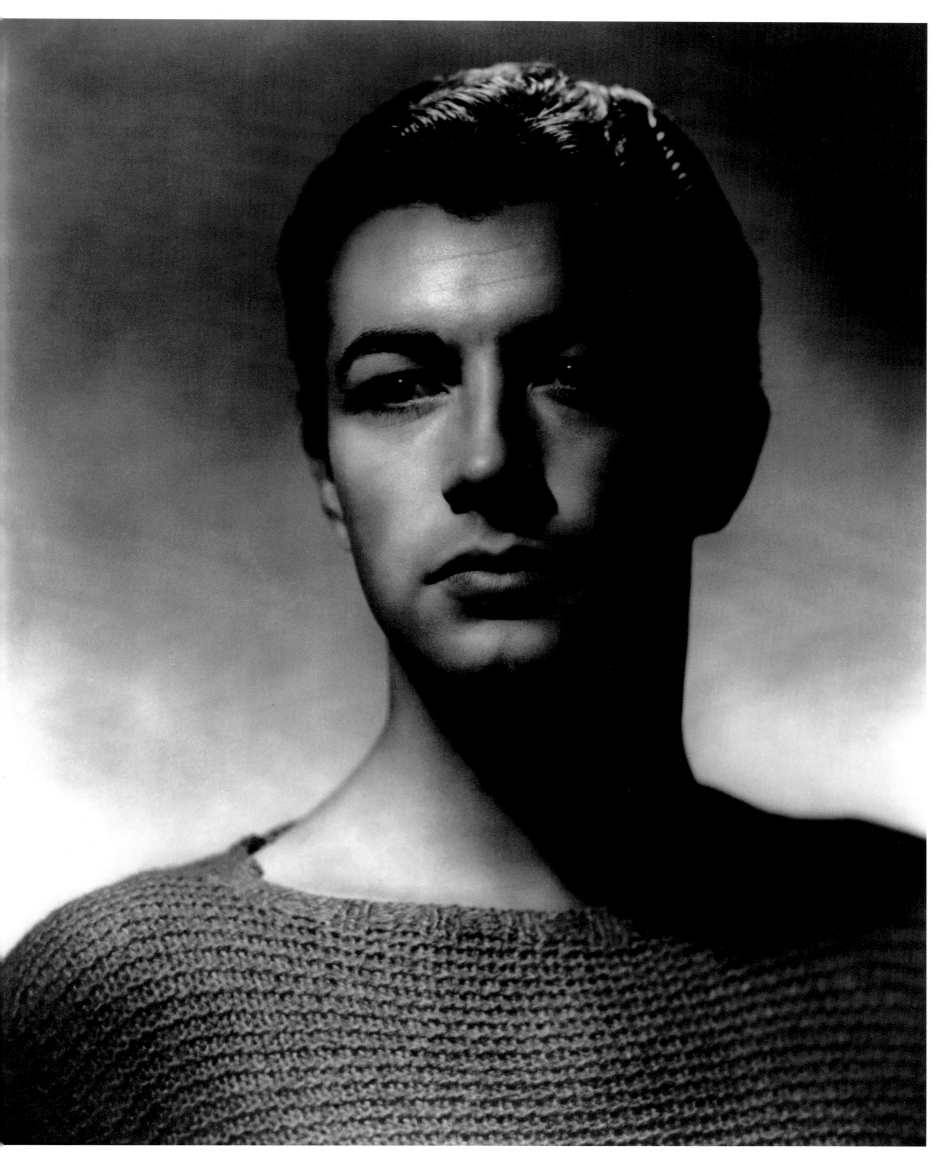

72 ROBERT TAYLOR, 1936

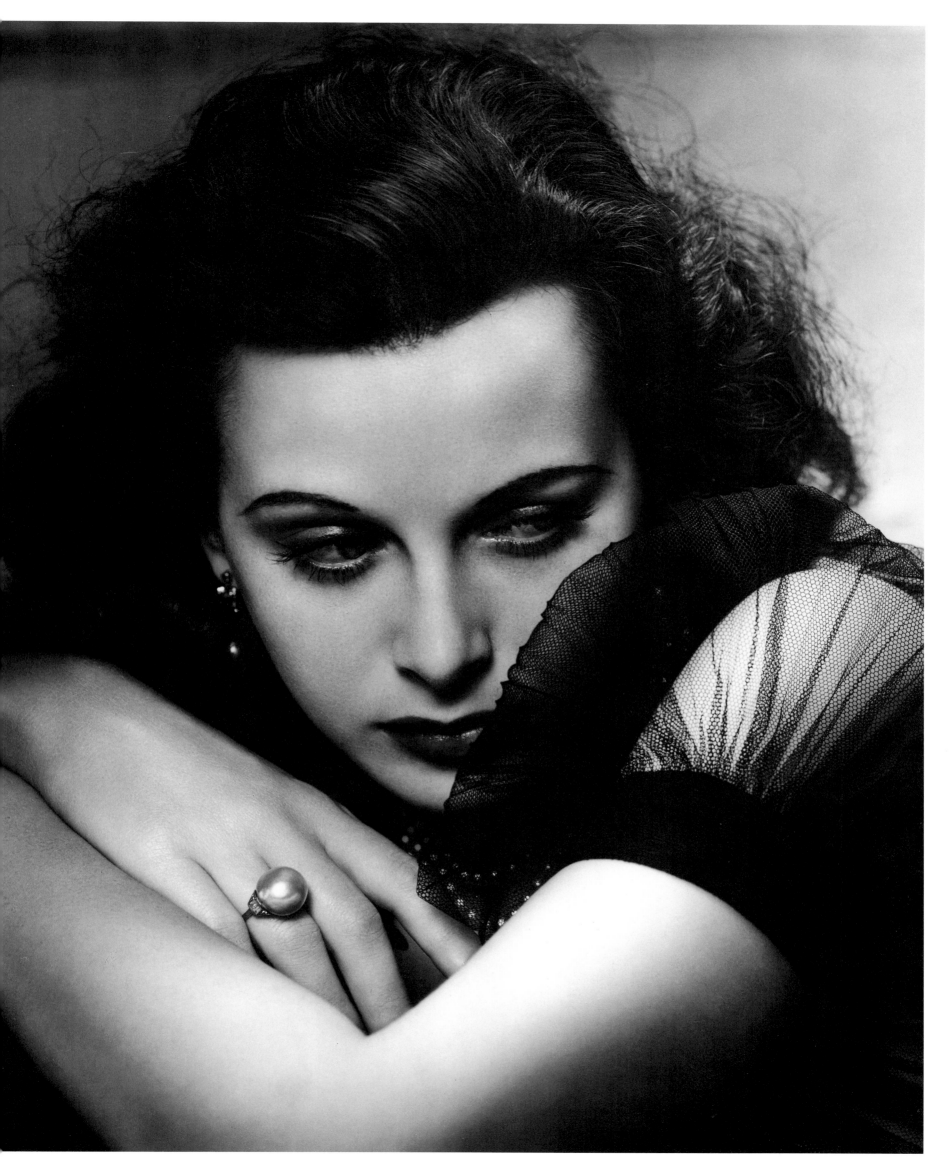

73 HEDY LAMARR, 1938

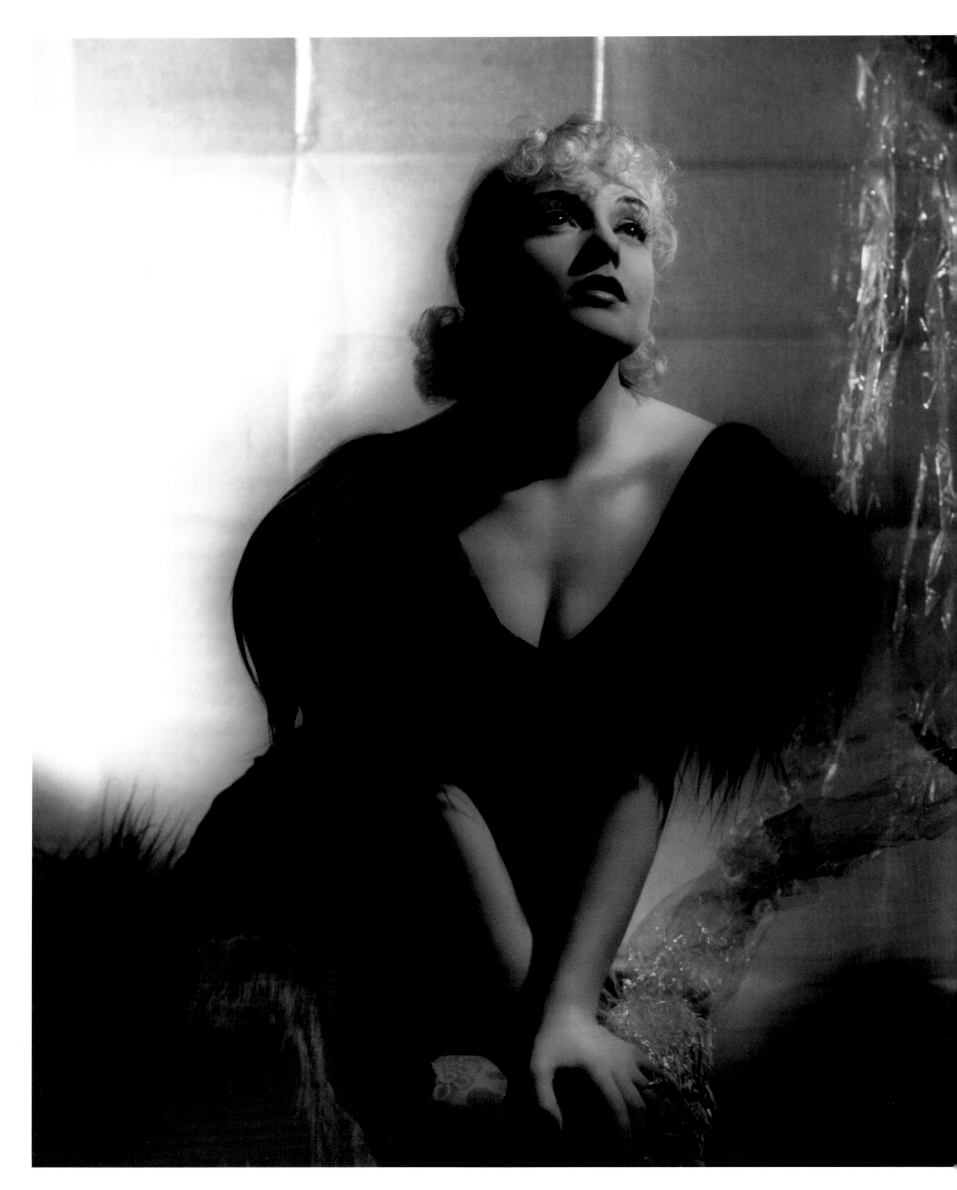

74 CAROLE LOMBARD, 1938

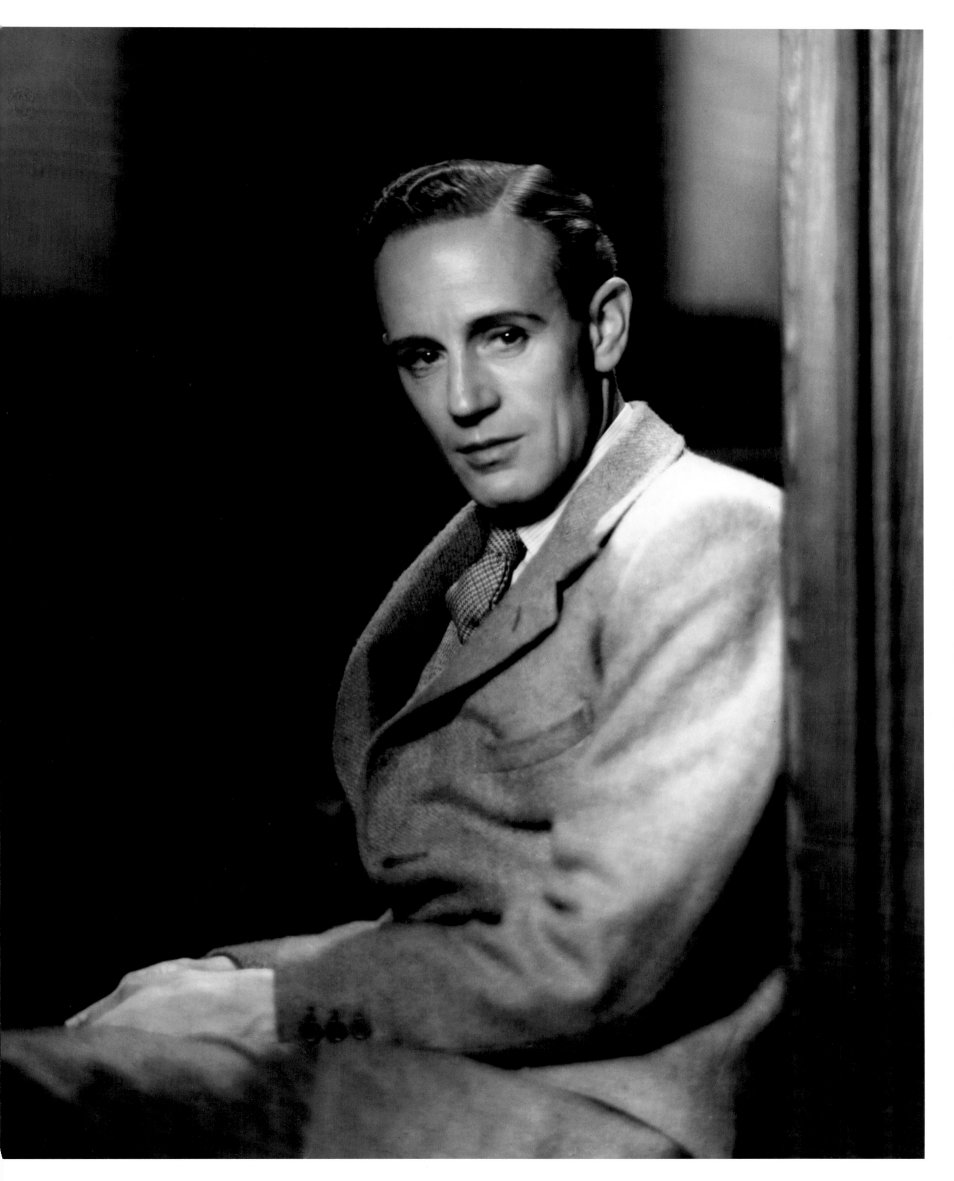

75 LESLIE HOWARD, 1931

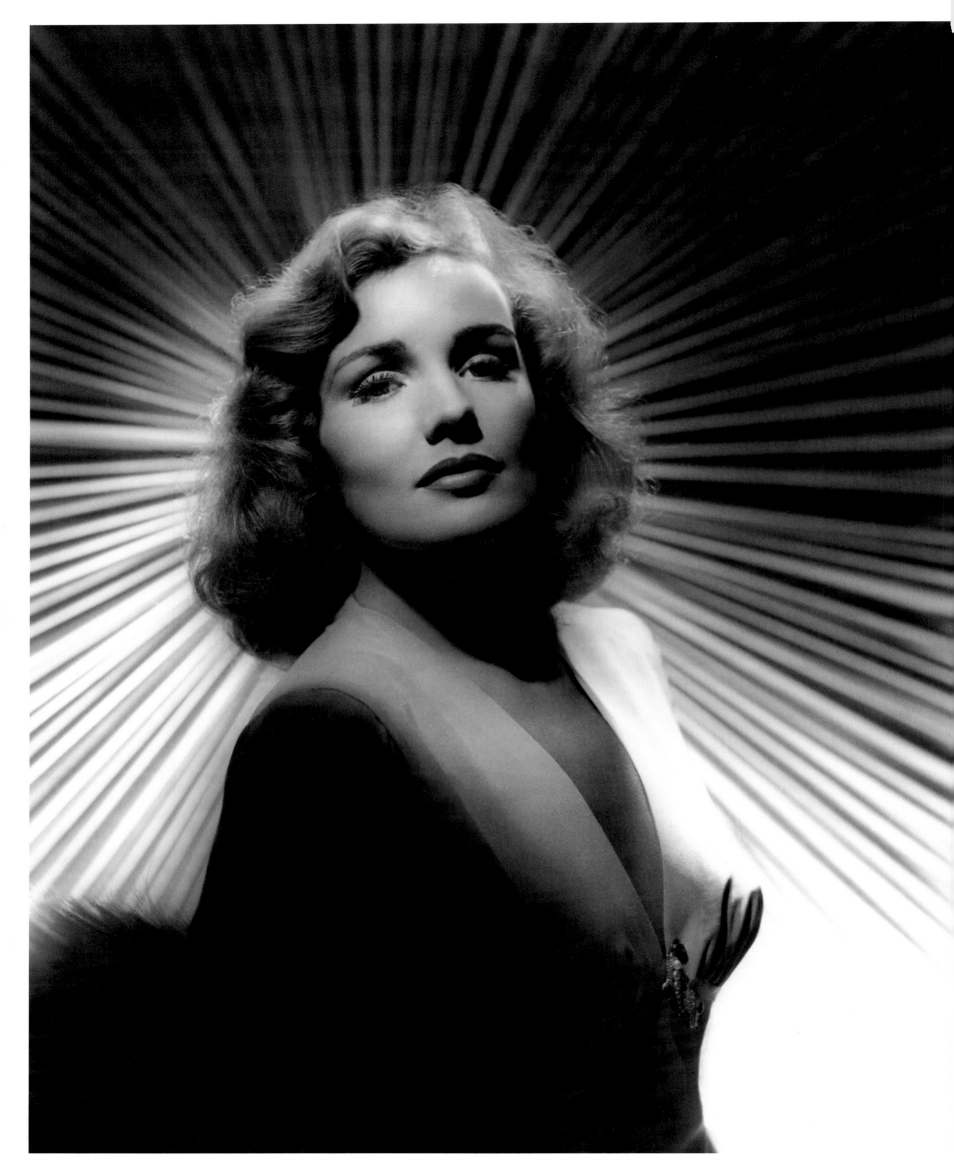

76 FRANCES FARMER, 1937

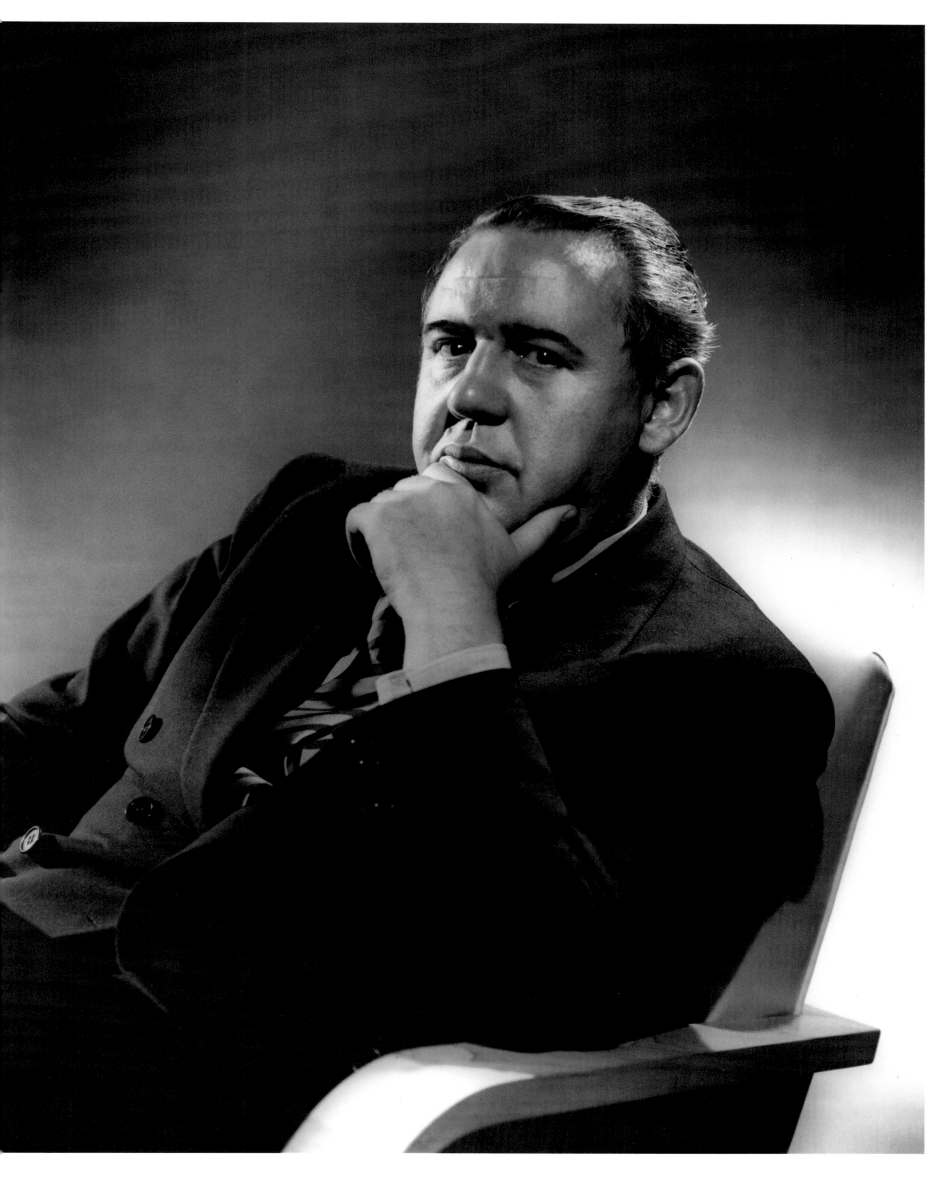

77 CHARLES LAUGHTON, 1937

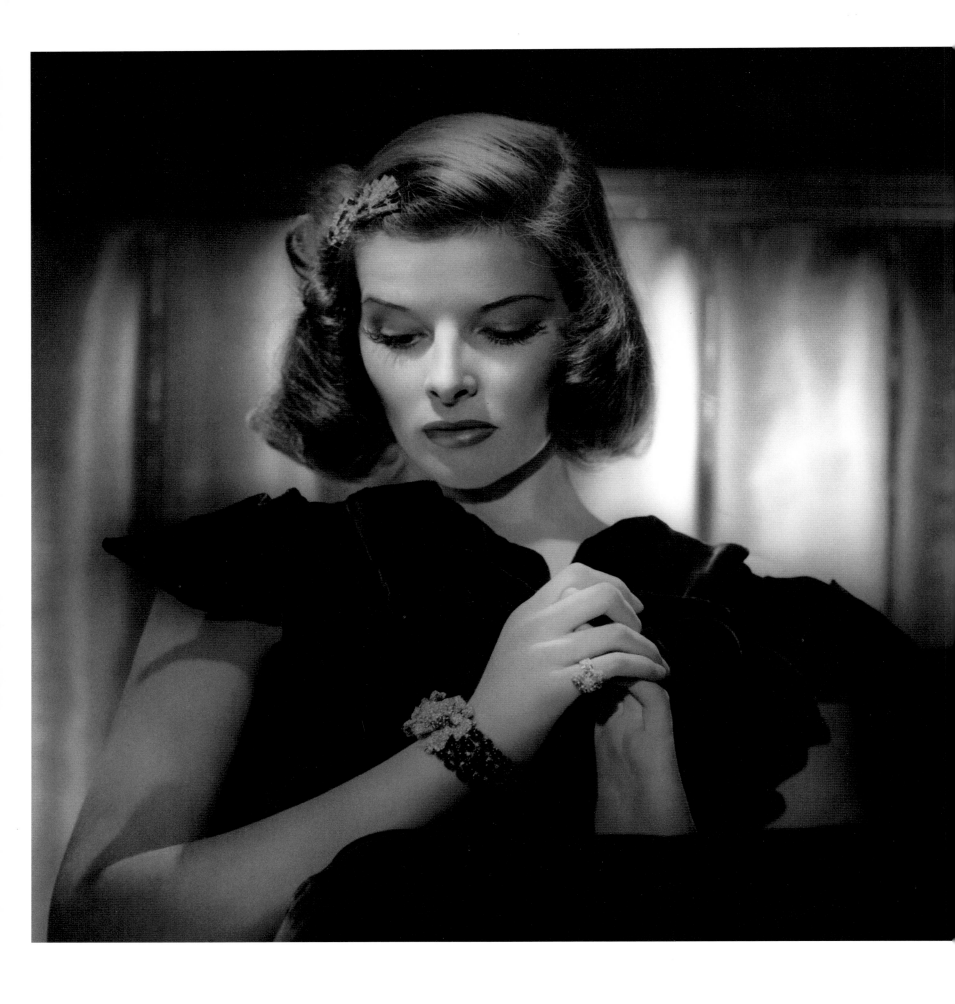

78 KATHARINE HEPBURN, 1937

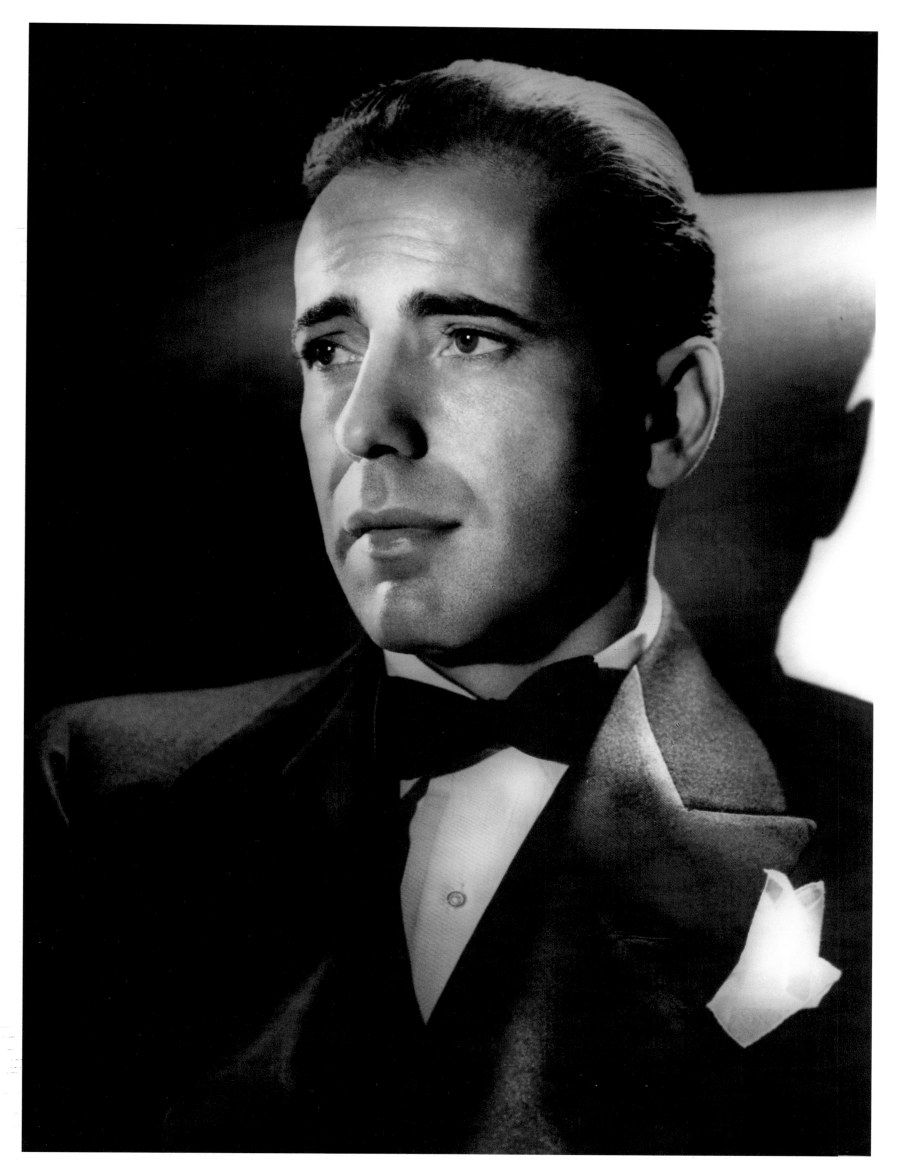

79 HUMPHREY BOGART

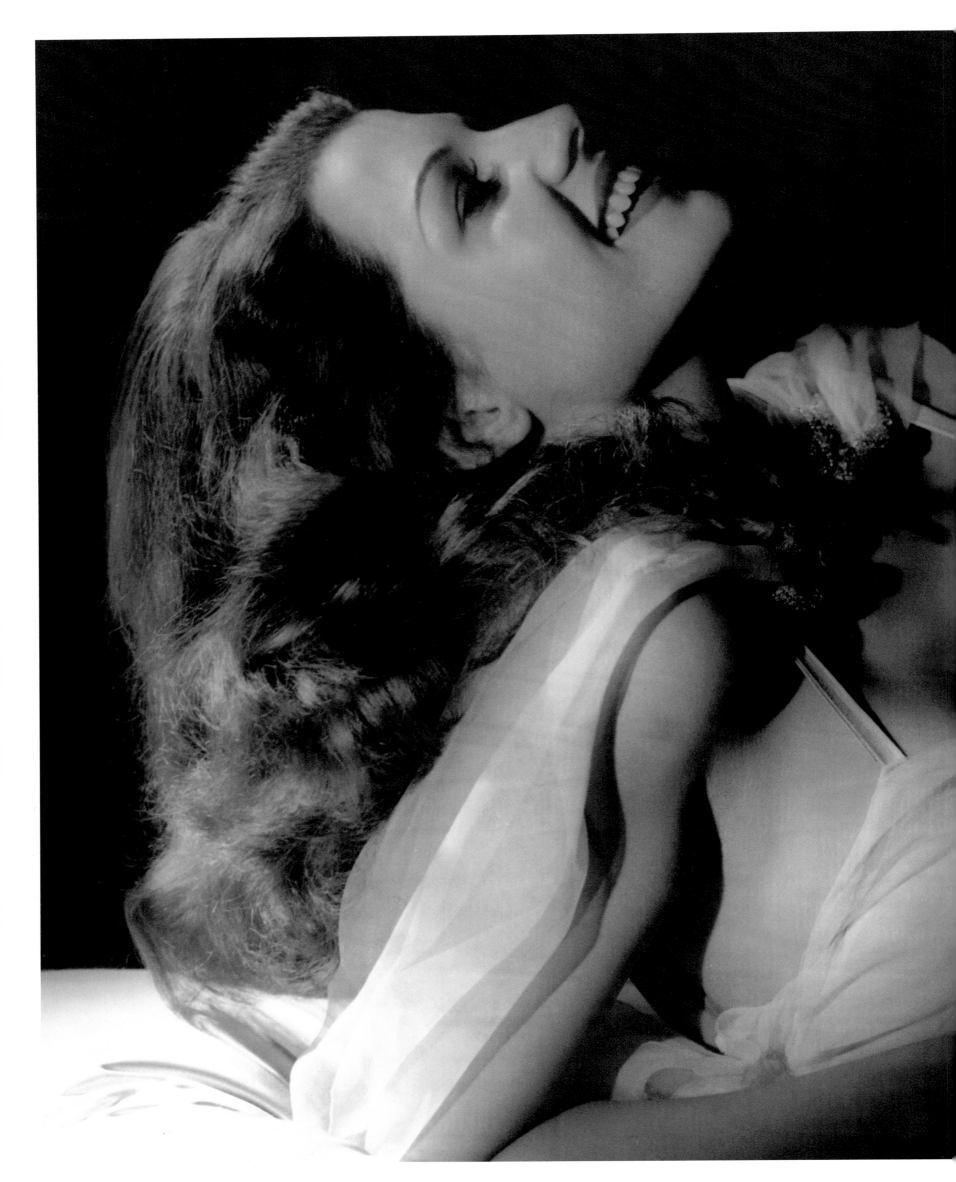

80 RITA HAYWORTH, 1941

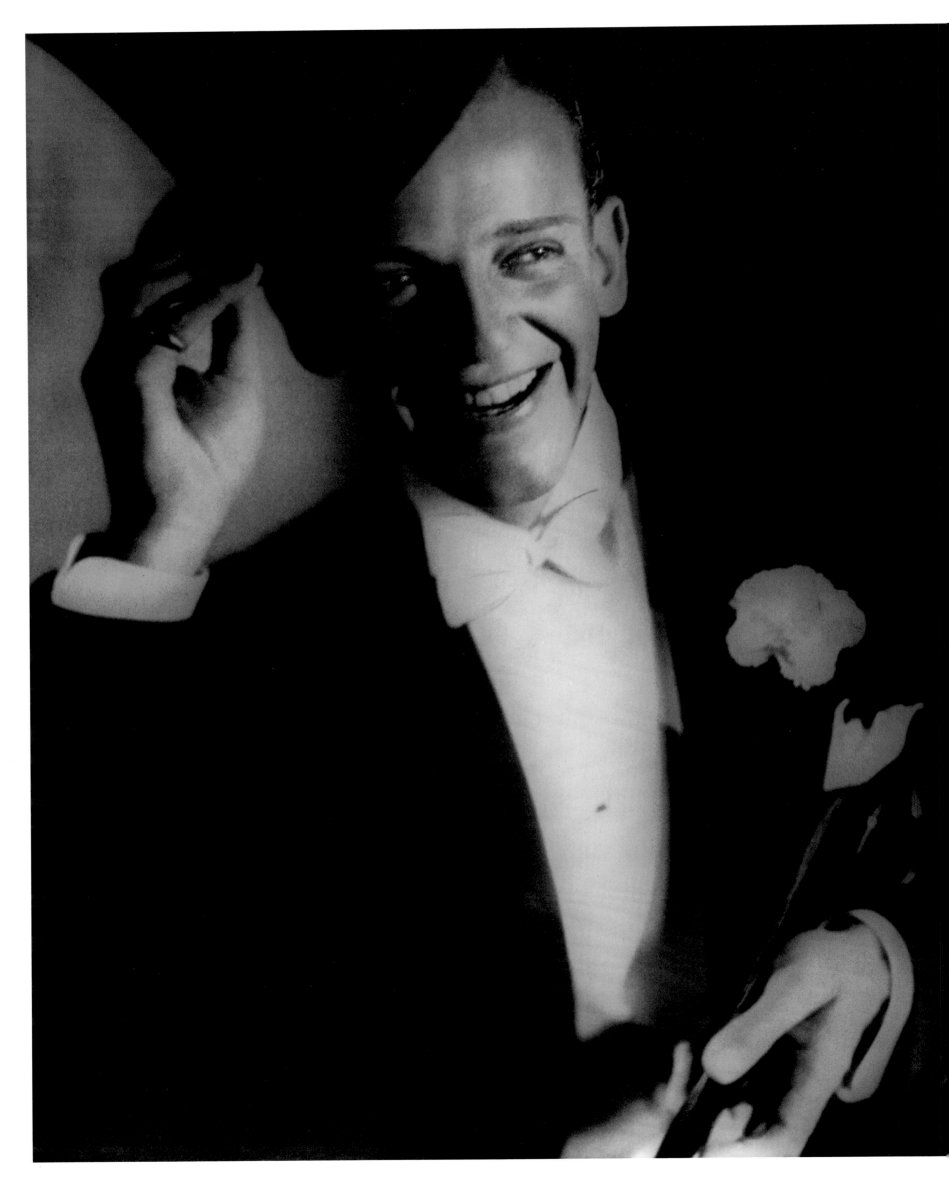

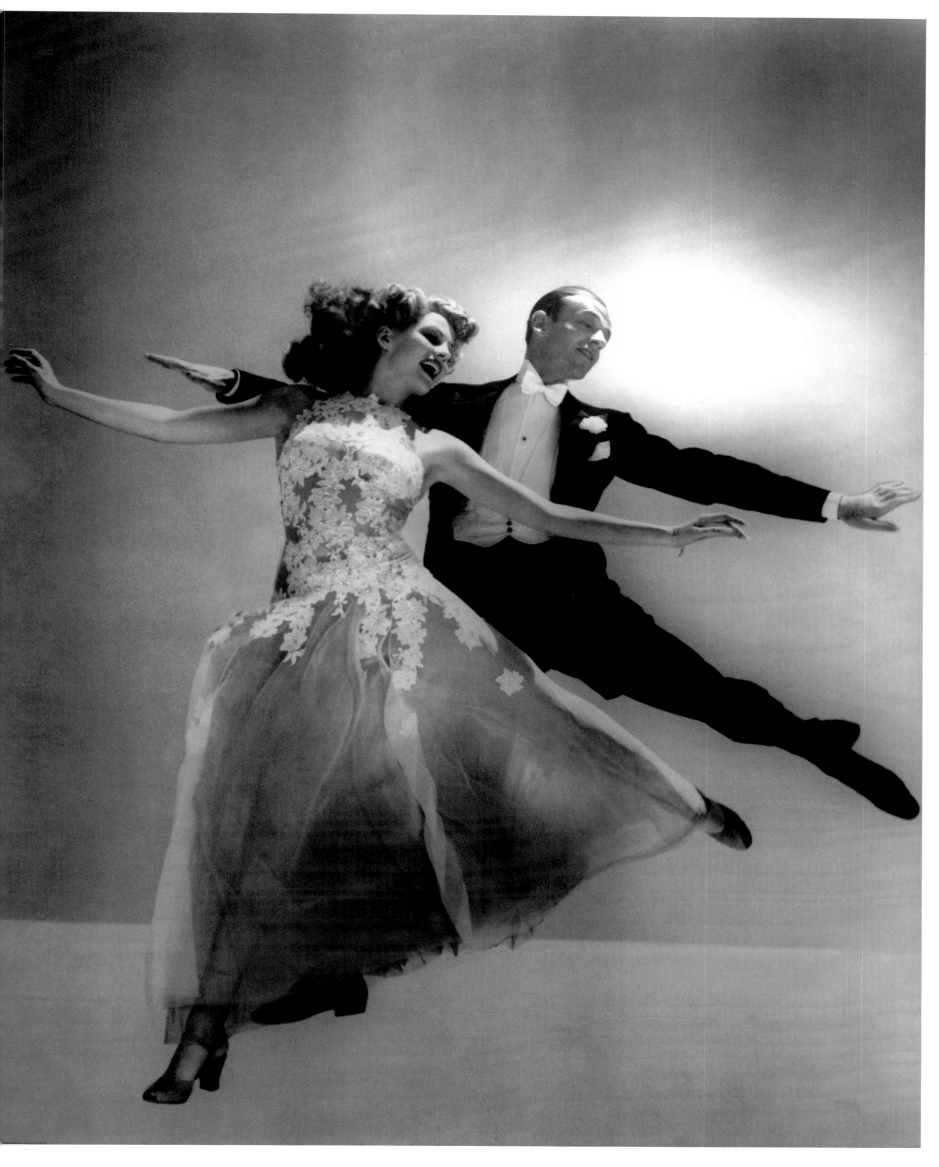

82 FRED ASTAIRE, RITA HAYWORTH, *You Were Never Lovelier*, 1943

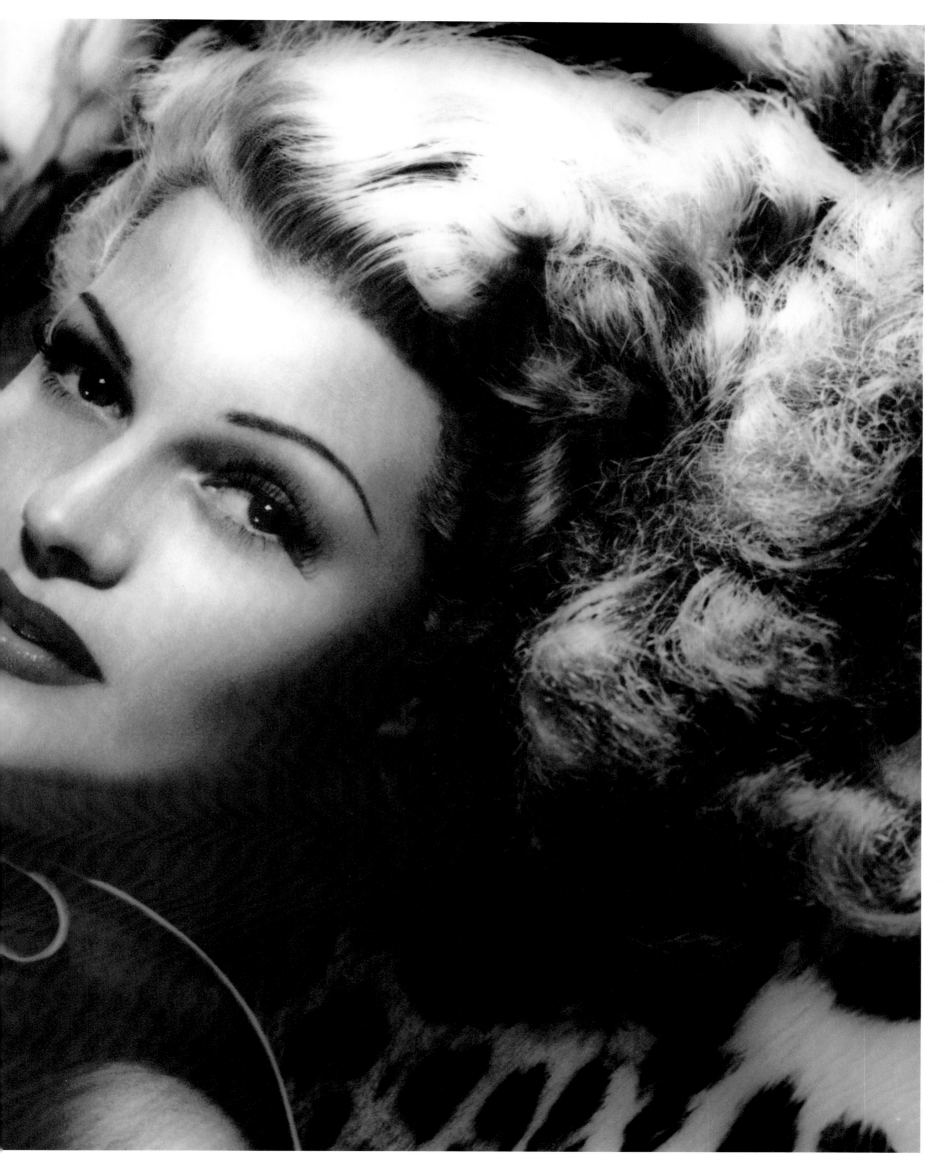

83 RITA HAYWORTH, 1943

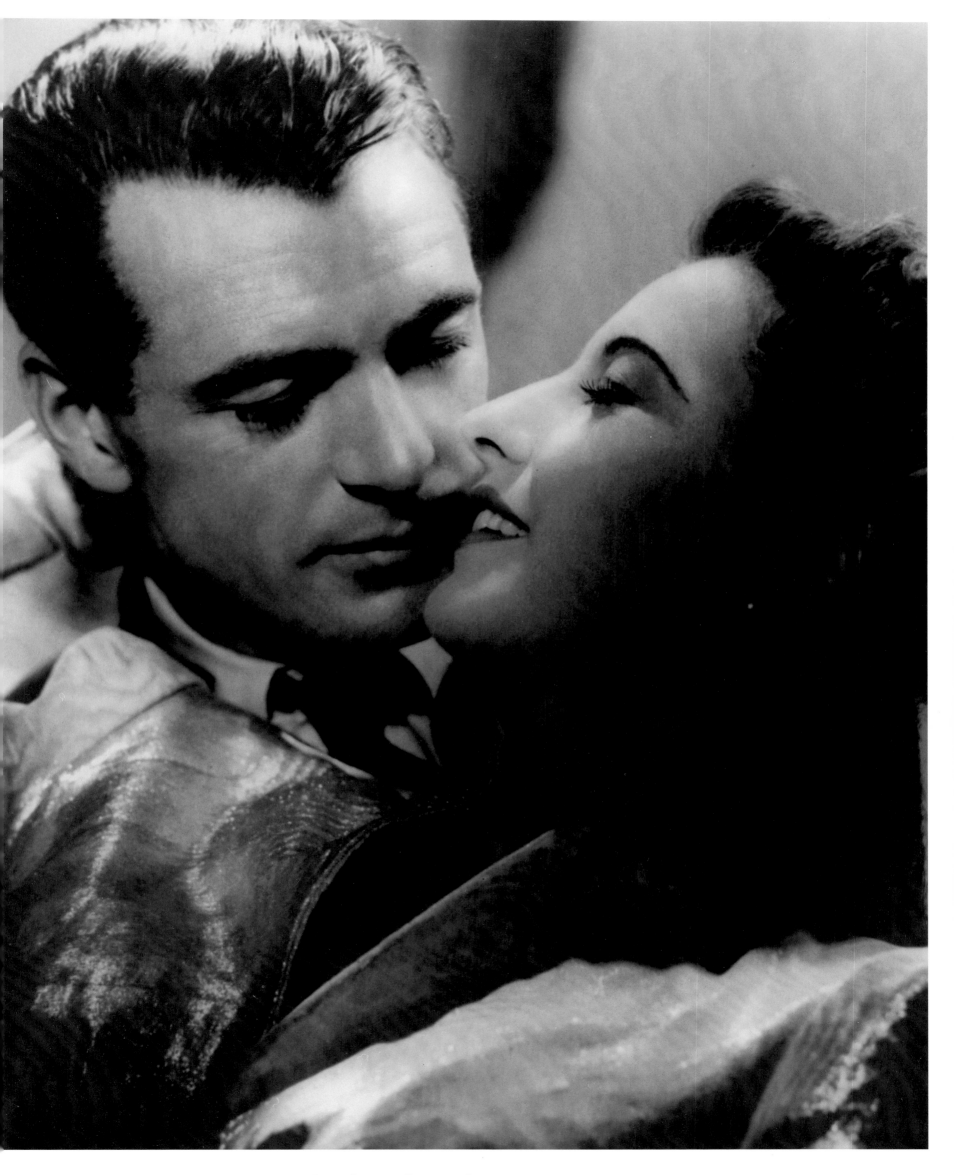

84 GARY COOPER, BARBARA STANWYCK, *Ball of Fire*, 1942

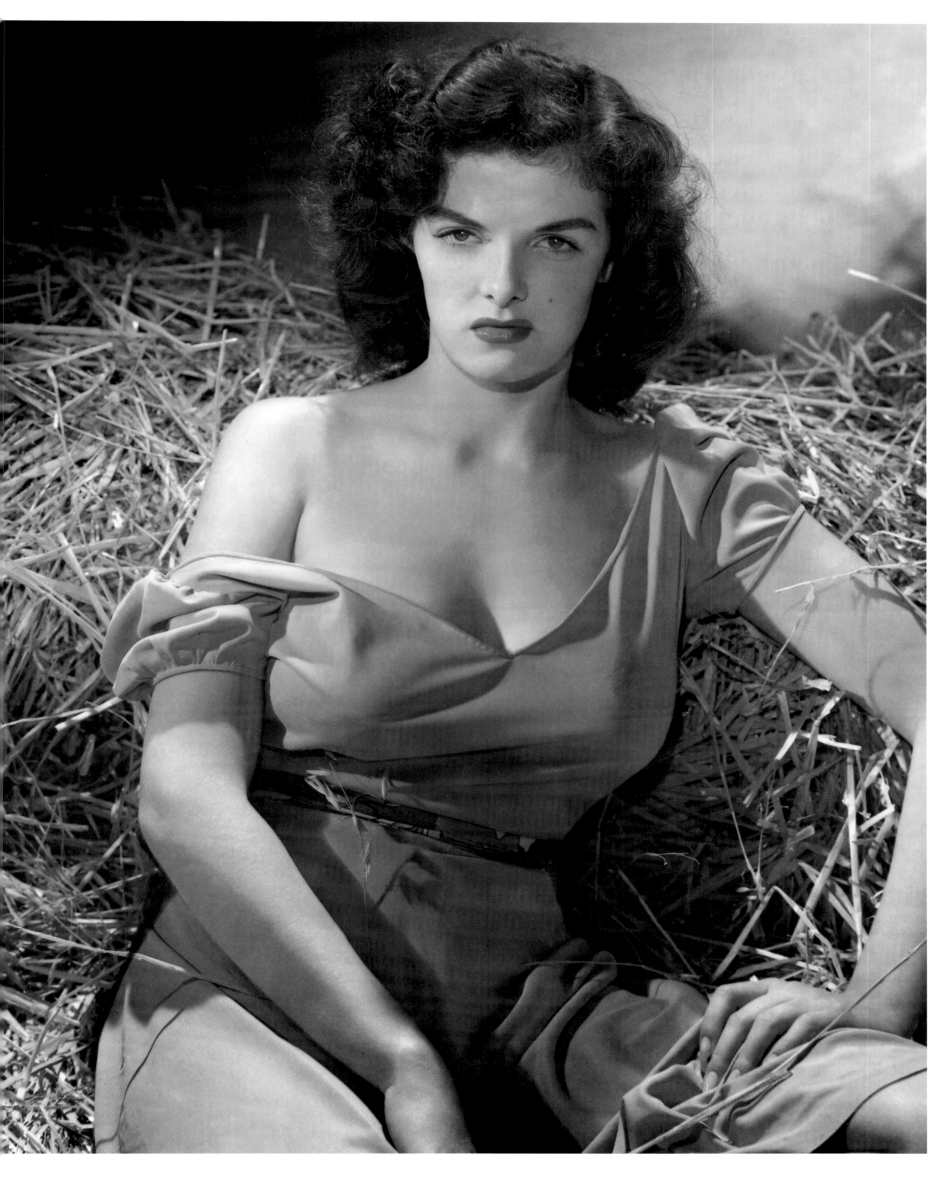

85 JANE RUSSELL. *The Outlaw*, 1942

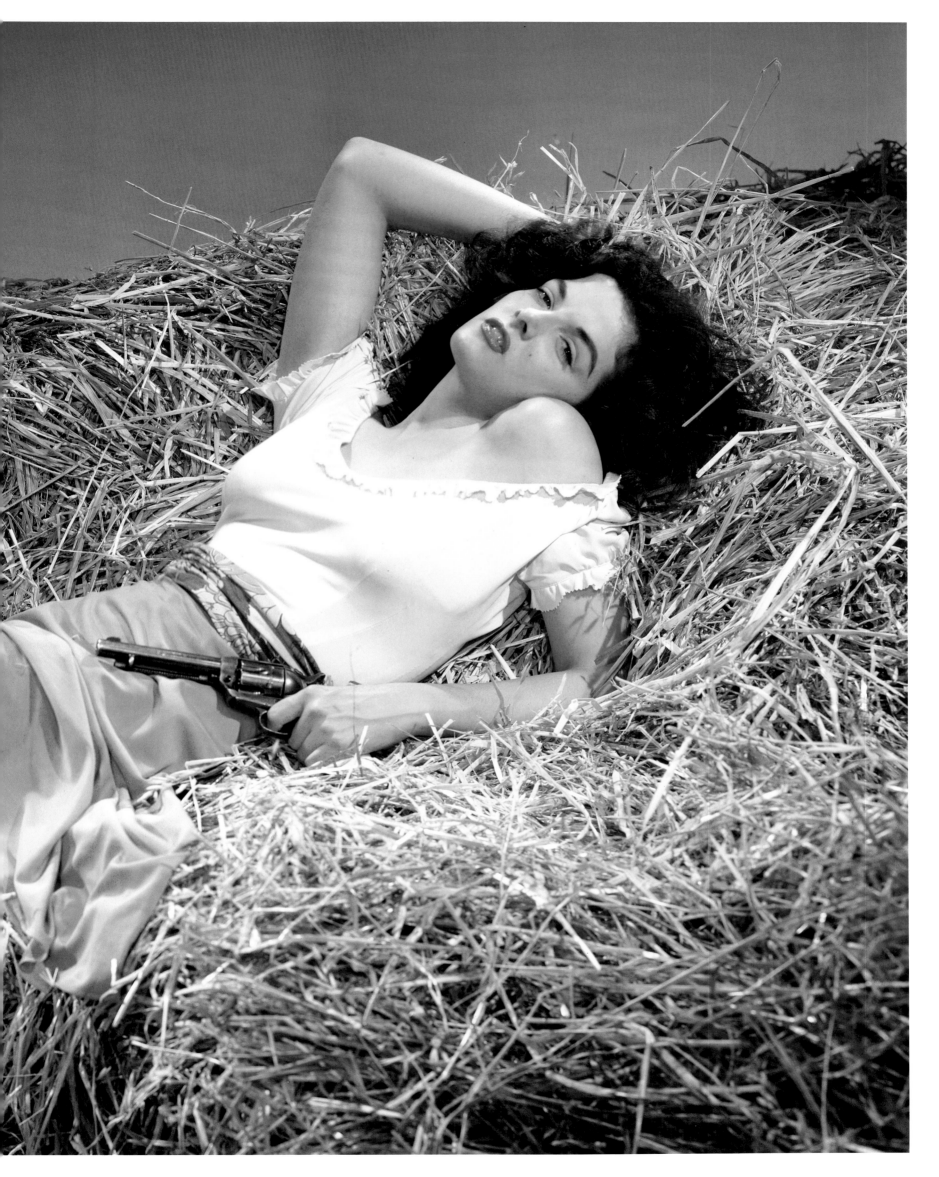

86 JANE RUSSELL. *The Outlaw*, 1942

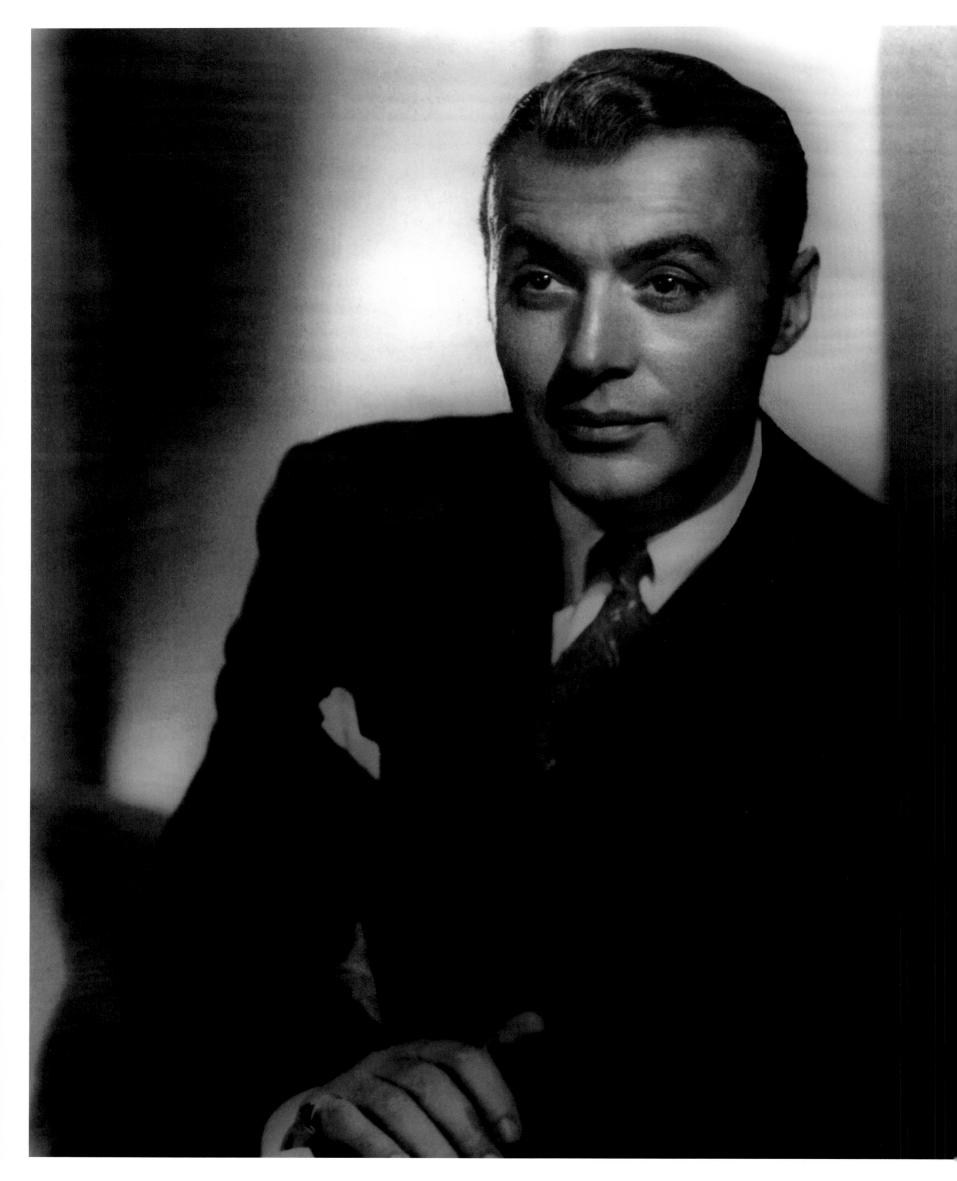

87 CHARLES BOYER, 1940

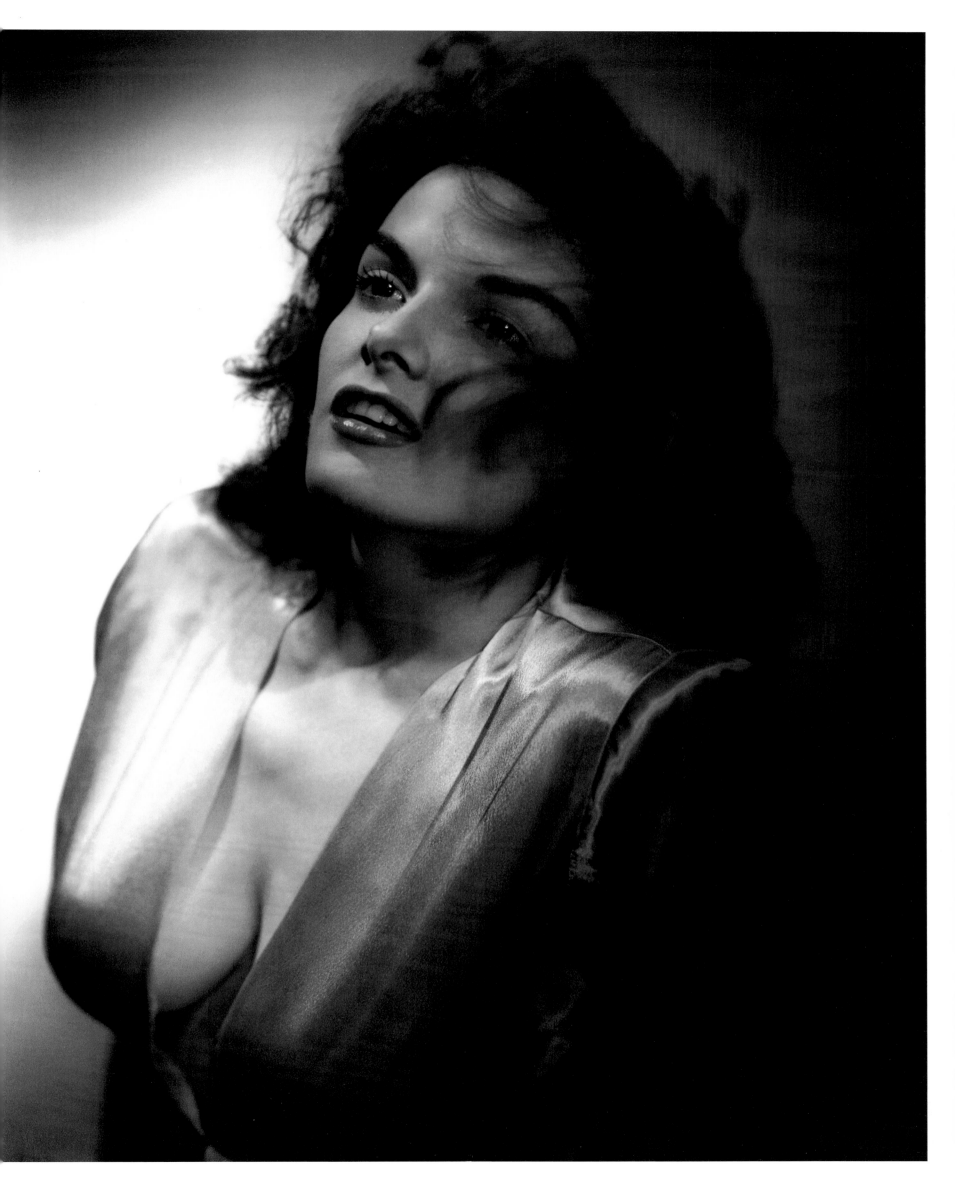

88 JANE RUSSELL, 1946

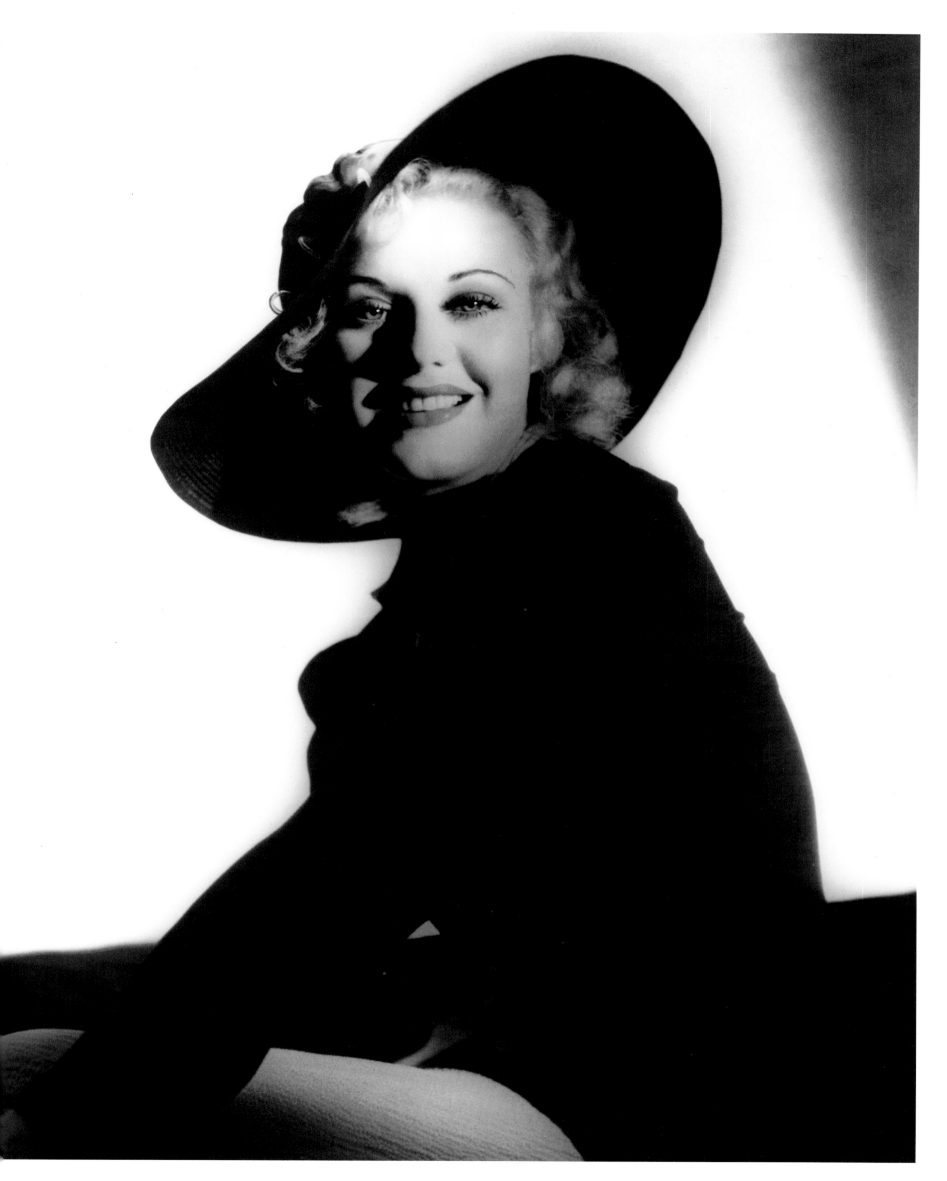

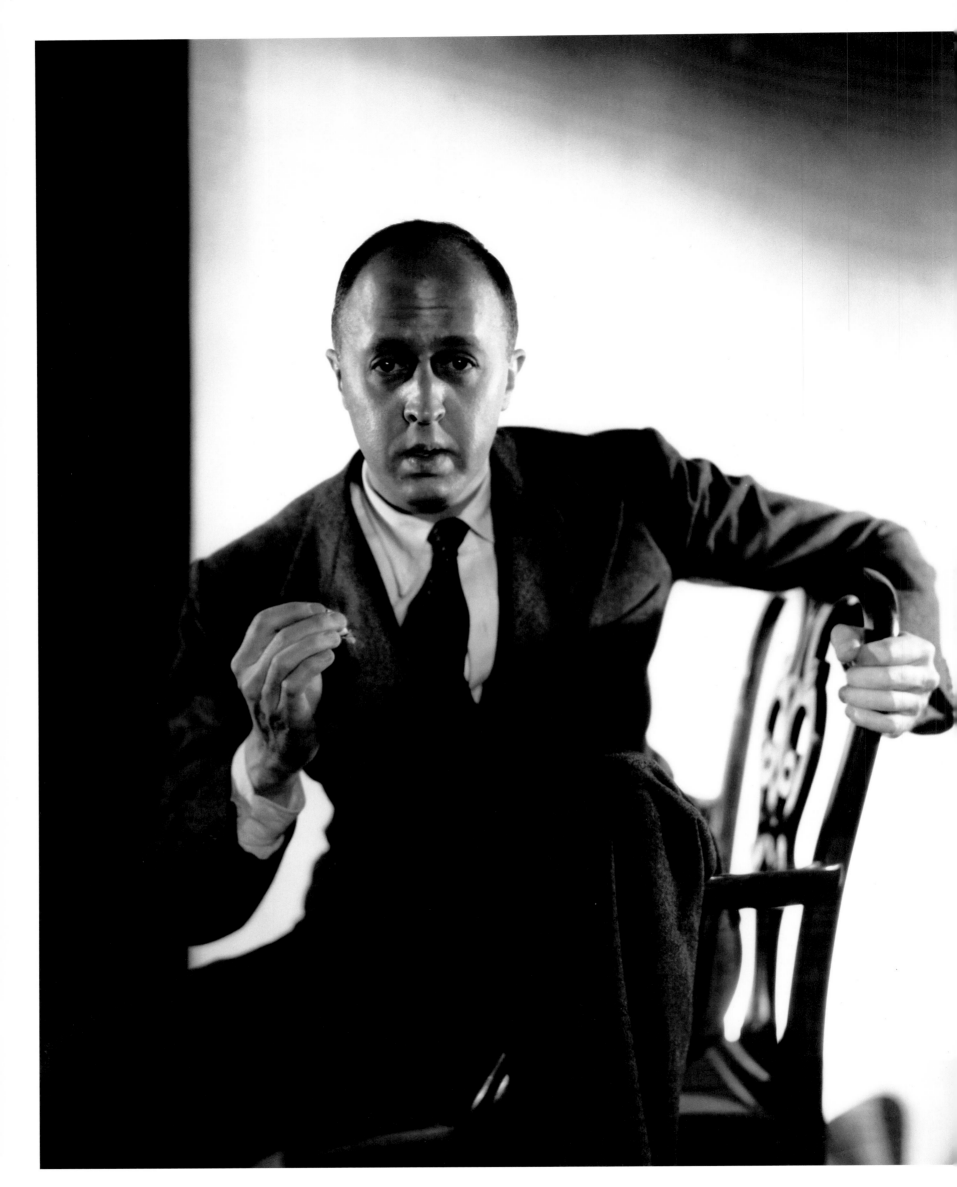

90 BARON GEORGE HOYNINGEN-HUENE

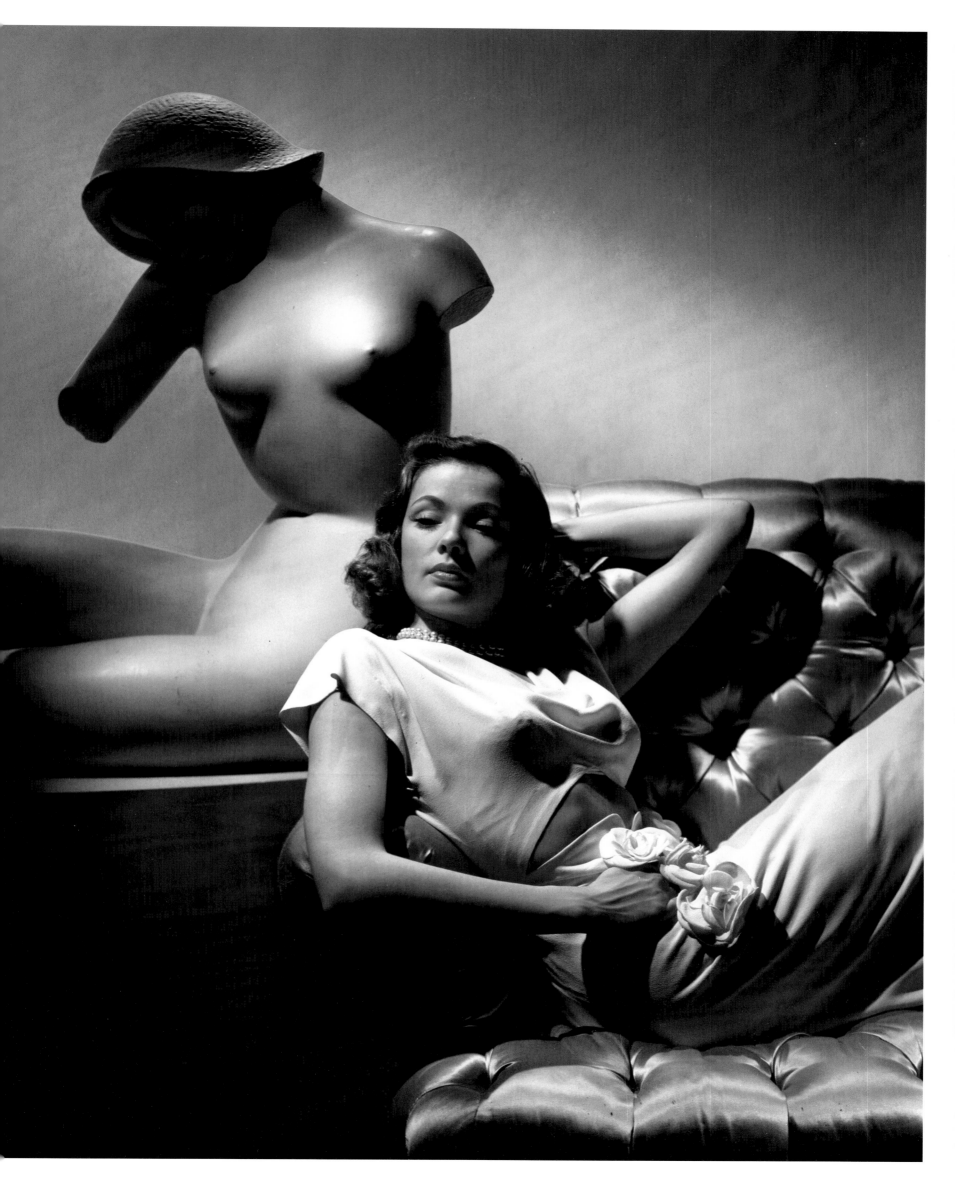

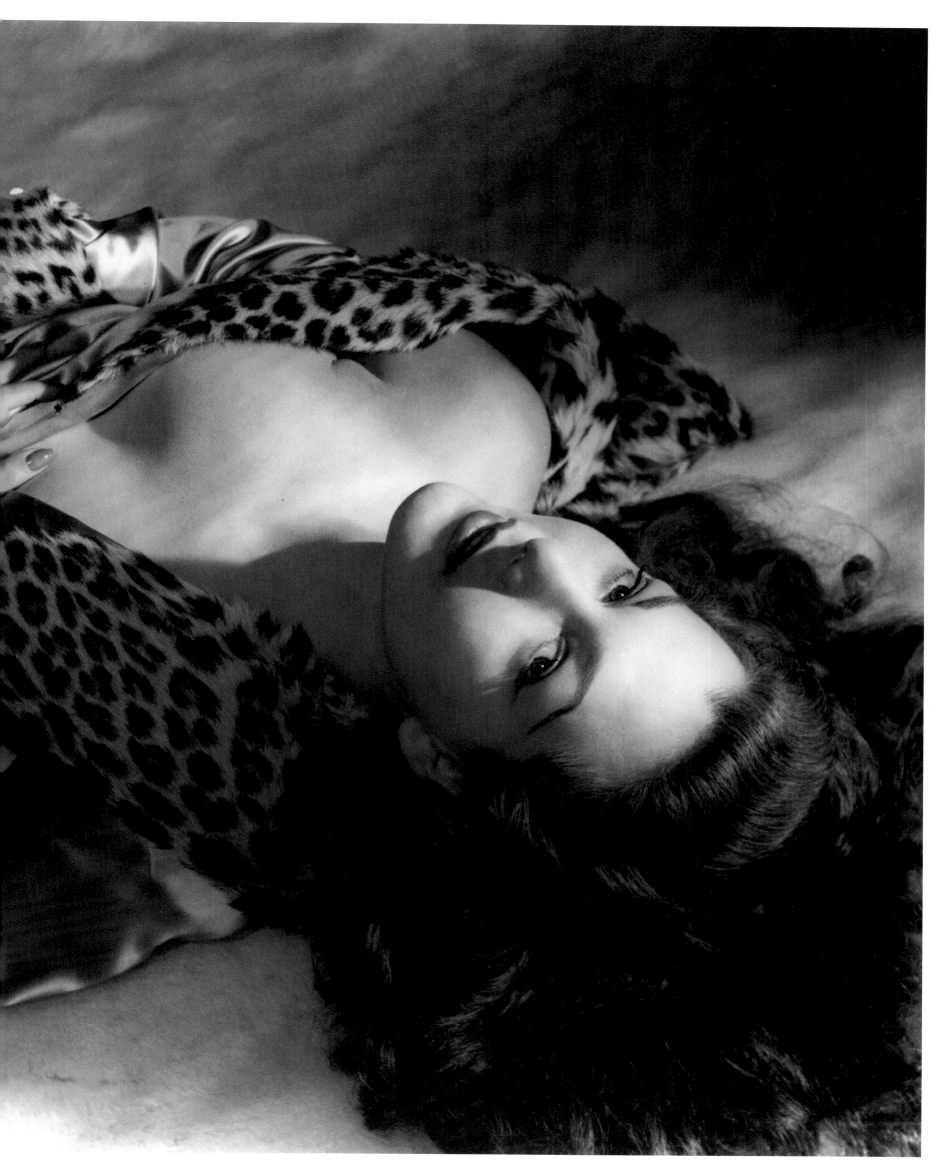

92 MARIA MONTEZ, 1941

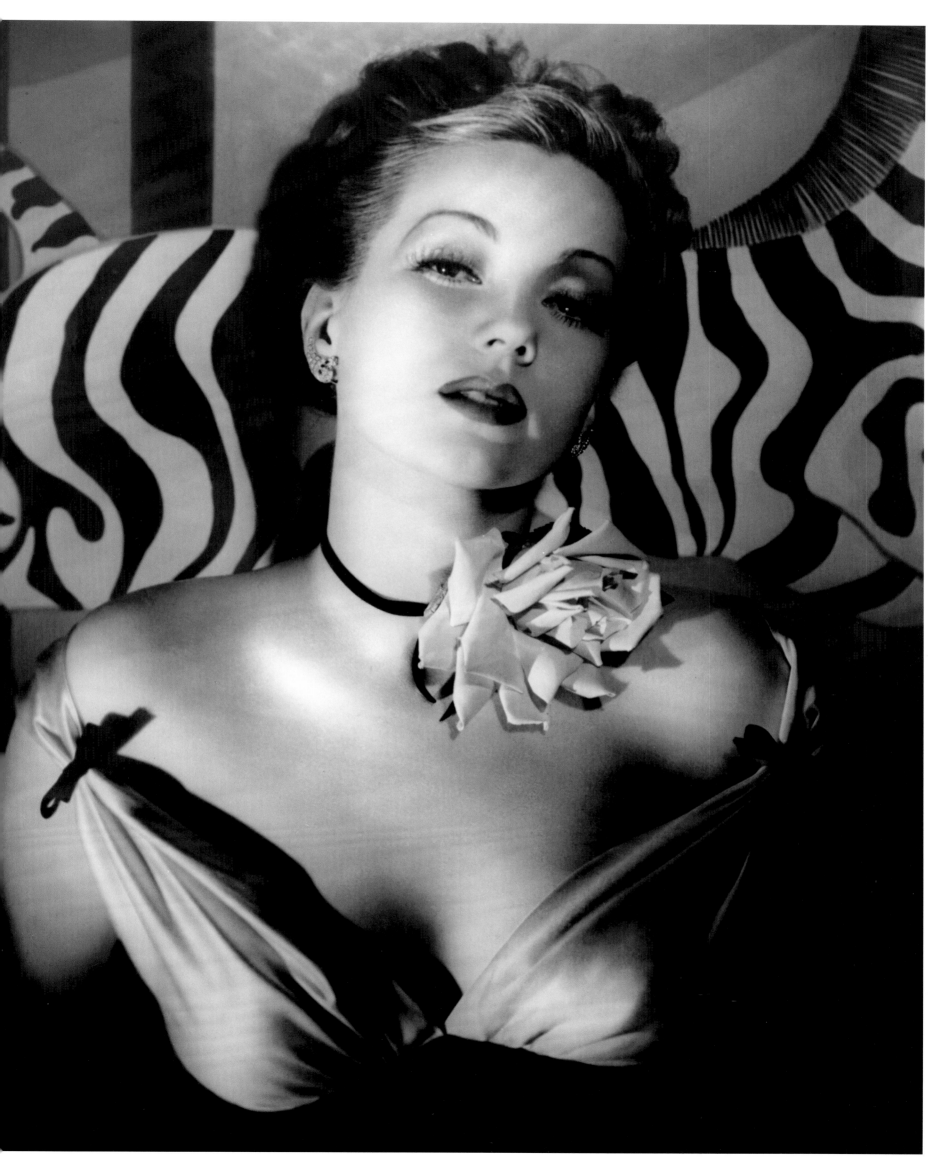

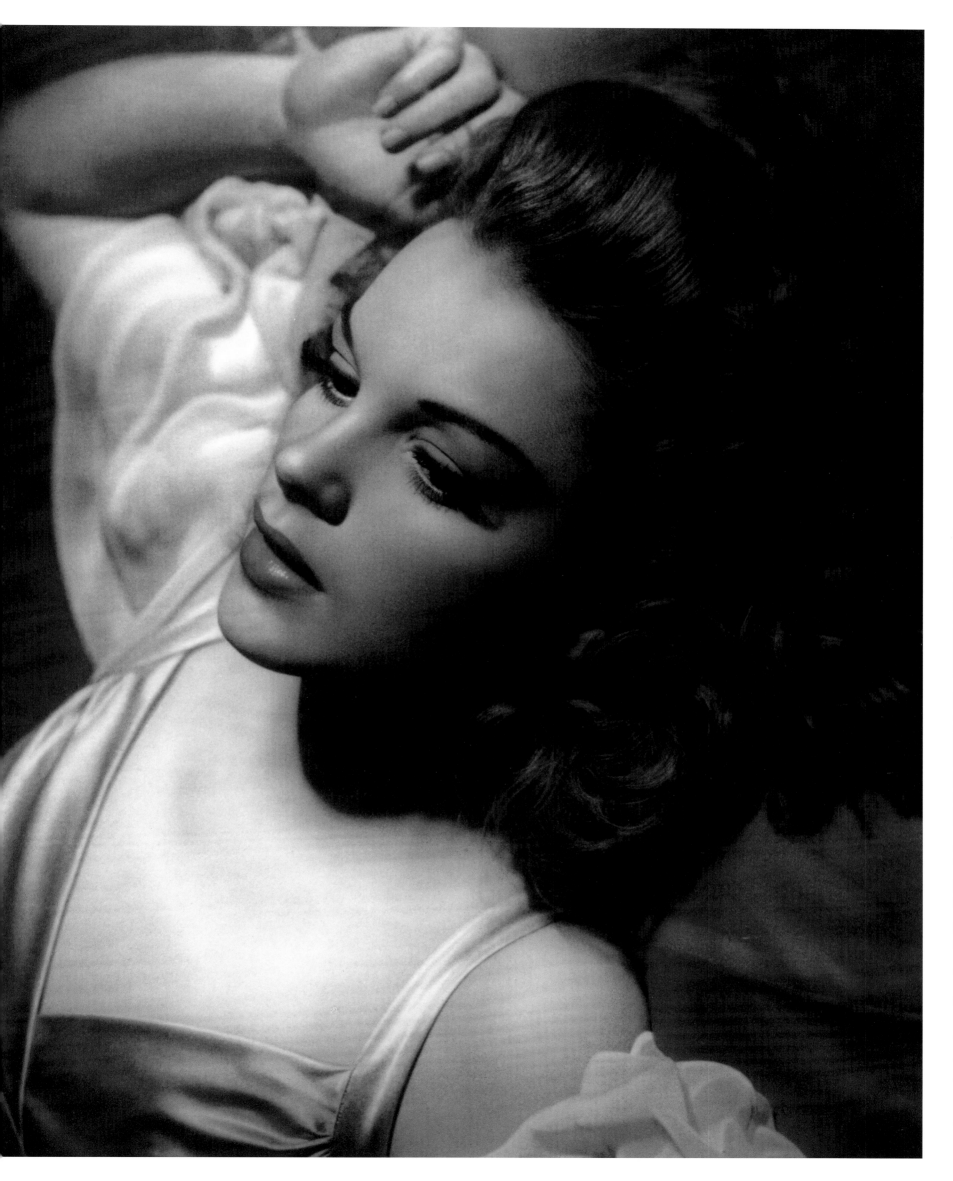

94 JUDY GARLAND, 1944

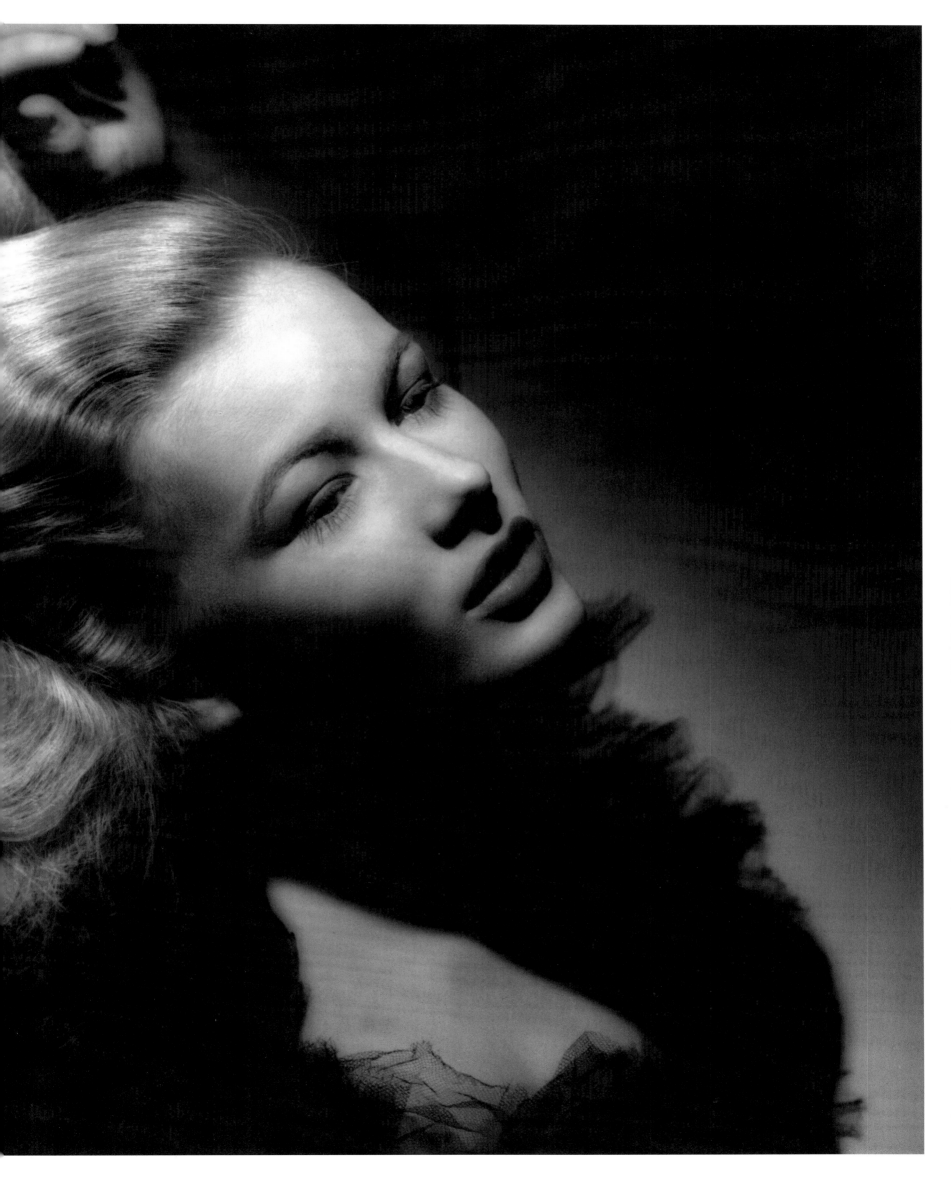

95 VERONICA LAKE, 1941

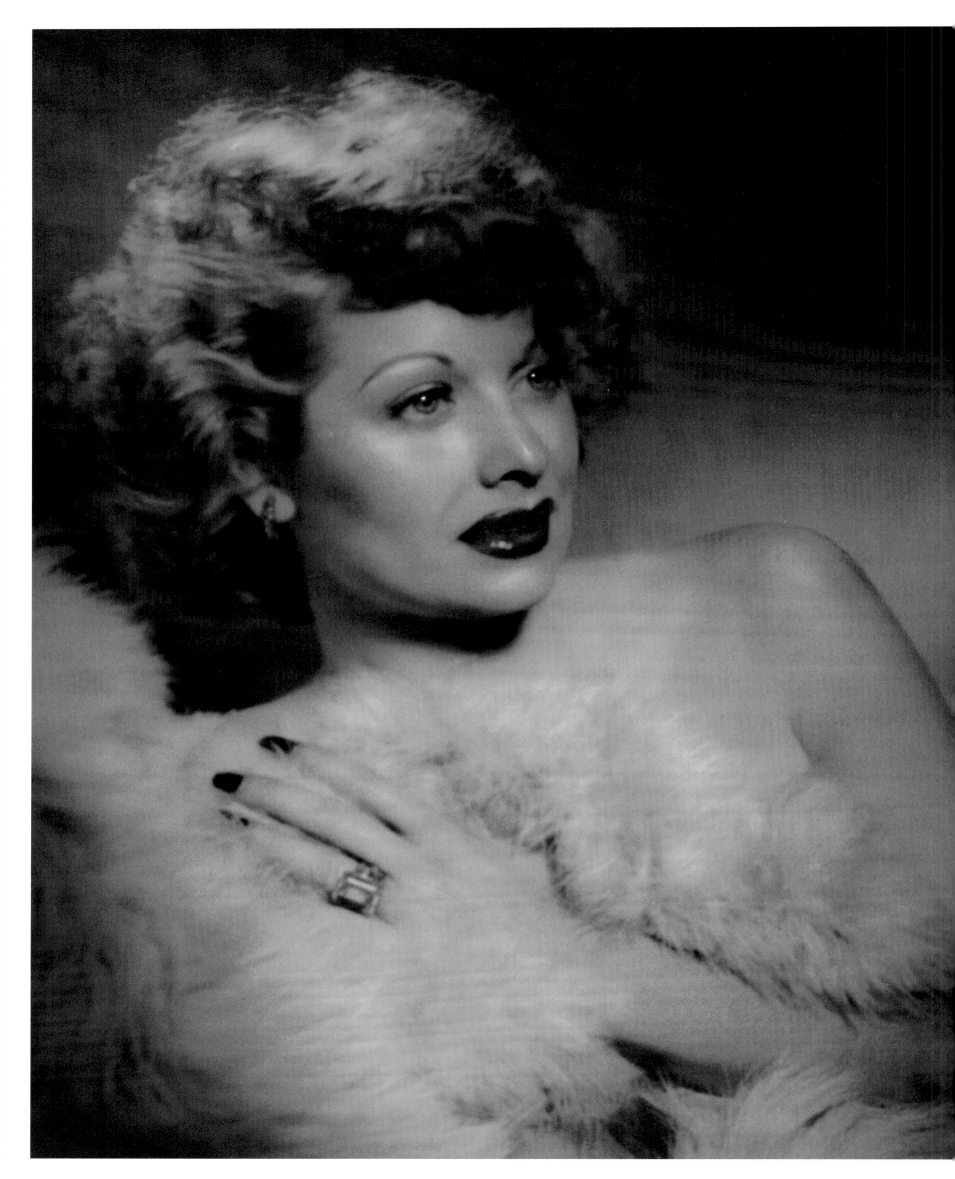

96 LUCILLE BALL, 1946

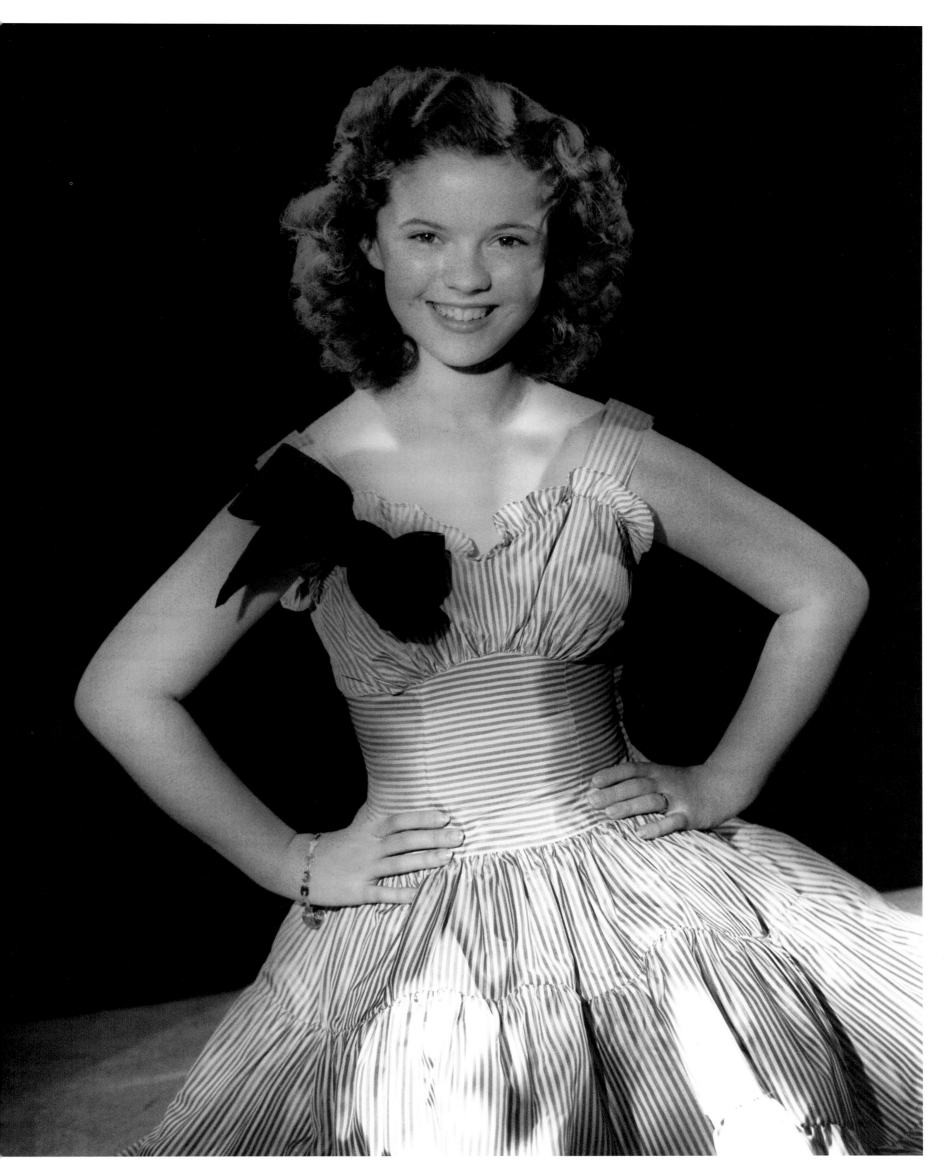

97 SHIRLEY TEMPLE, 1941

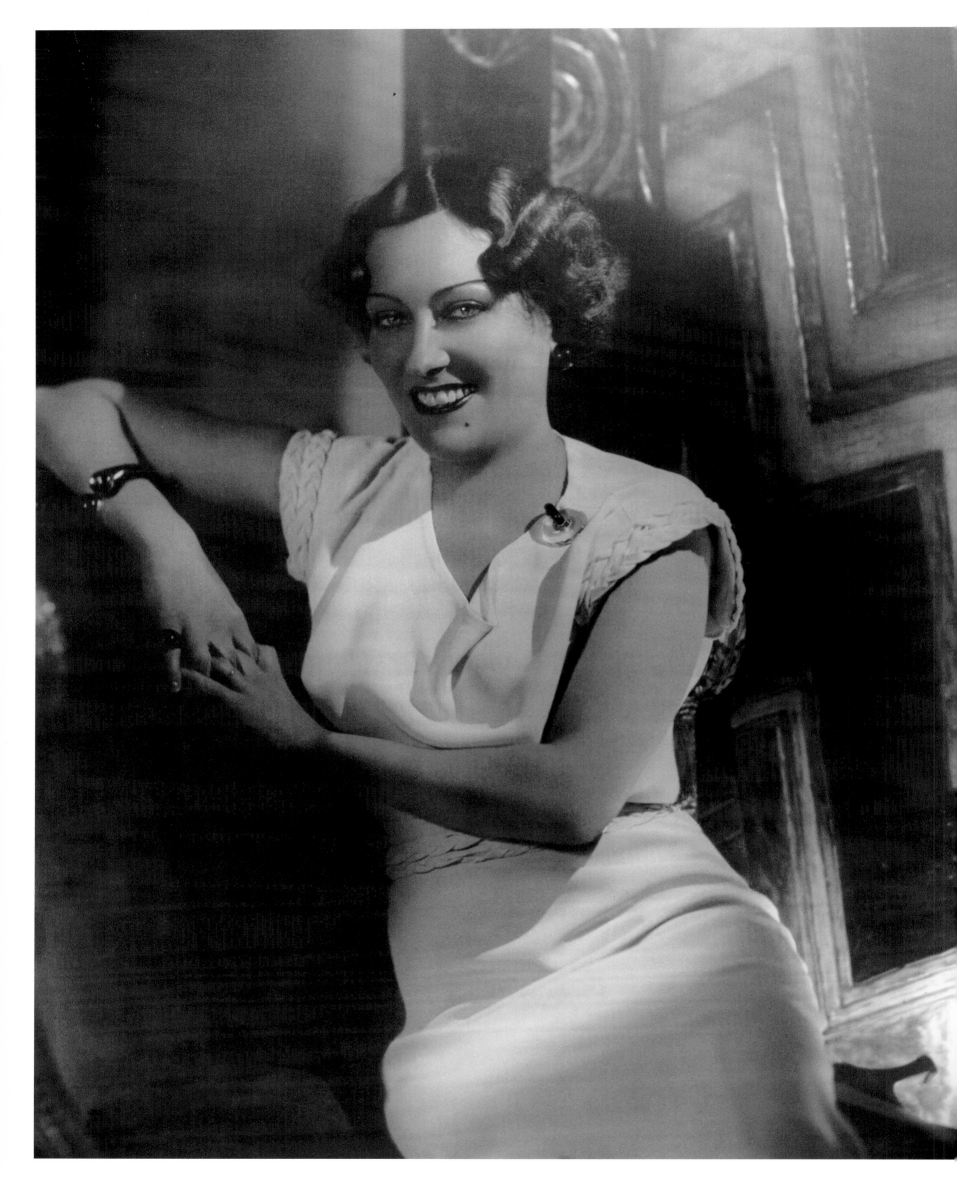

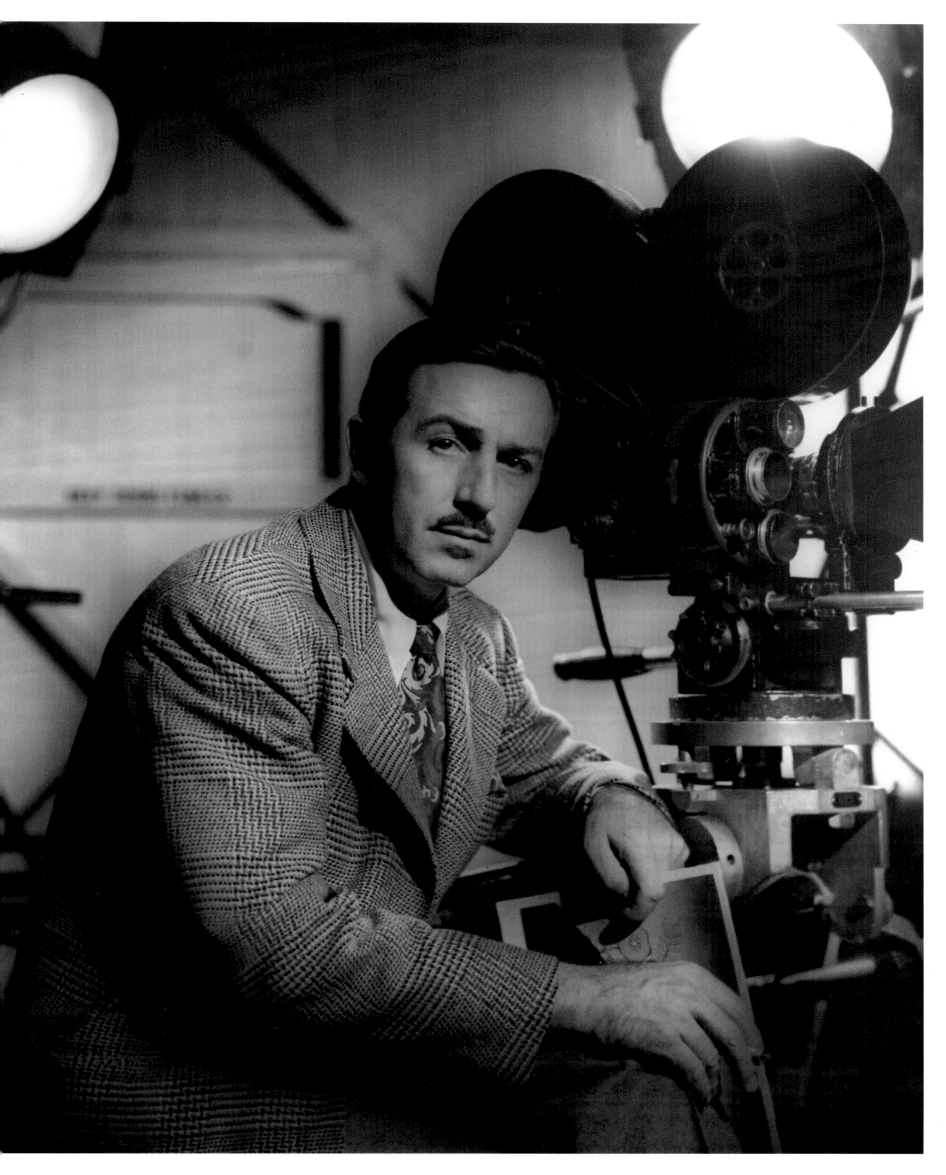

99 WALT DISNEY, 1958

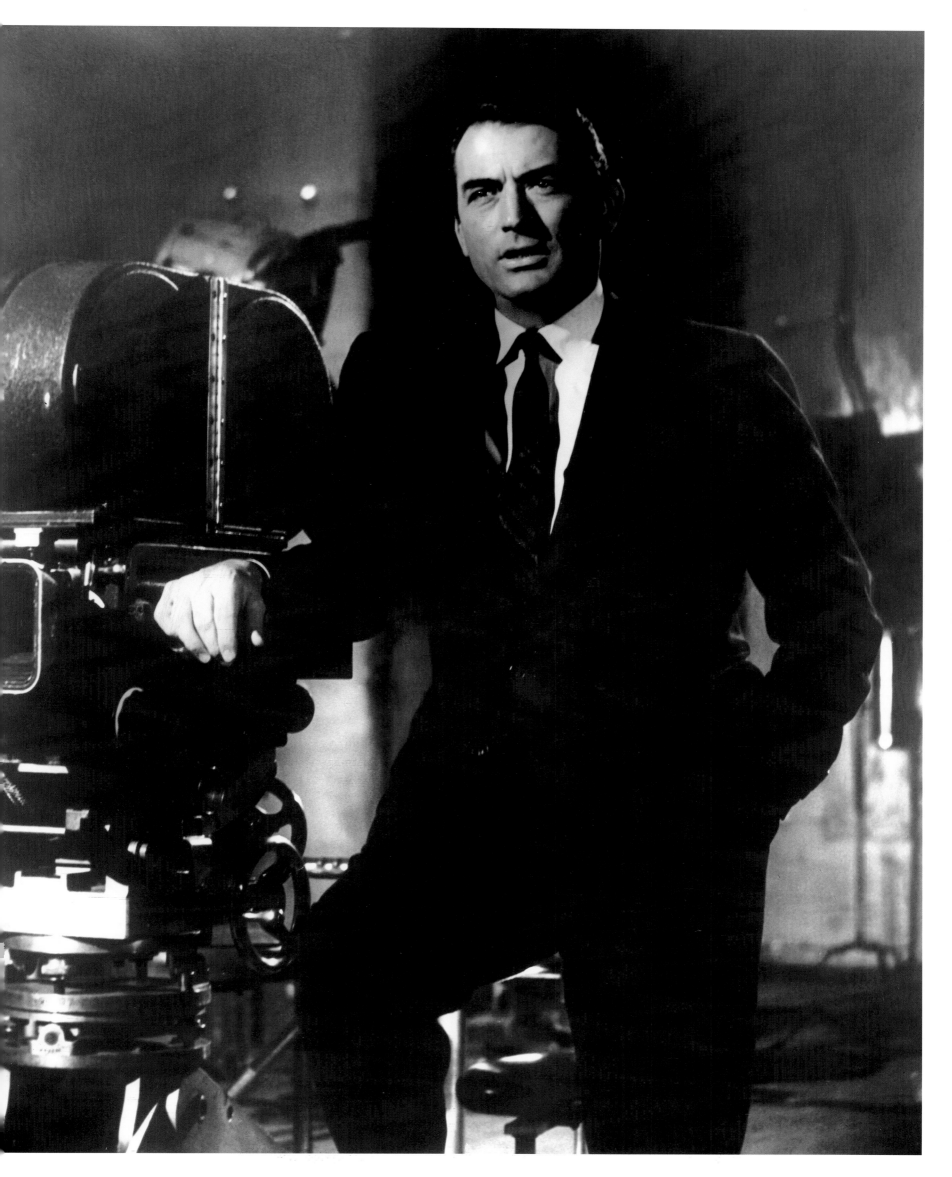

100 GREGORY PECK, 1963

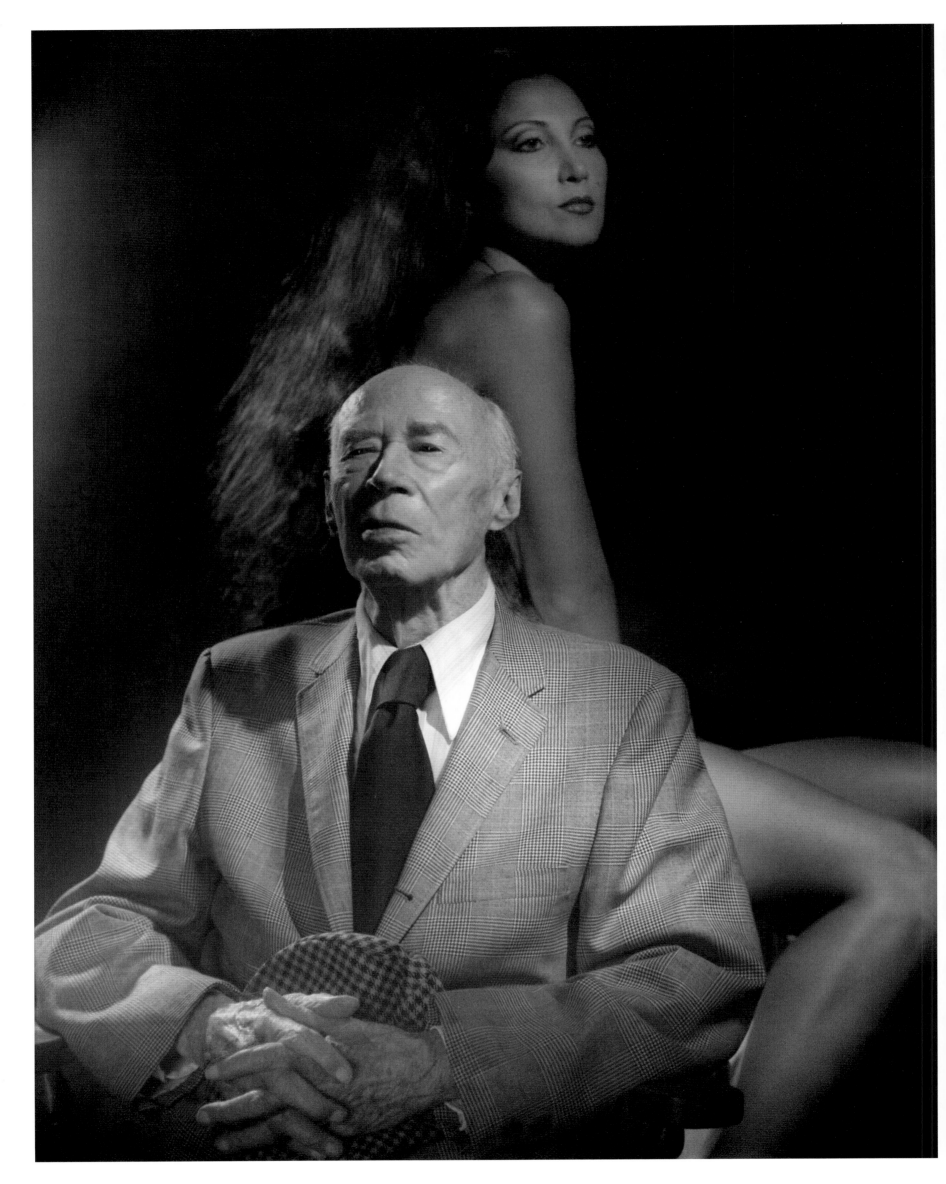

102 HENRY MILLER, BRENDA VENUS, 1980

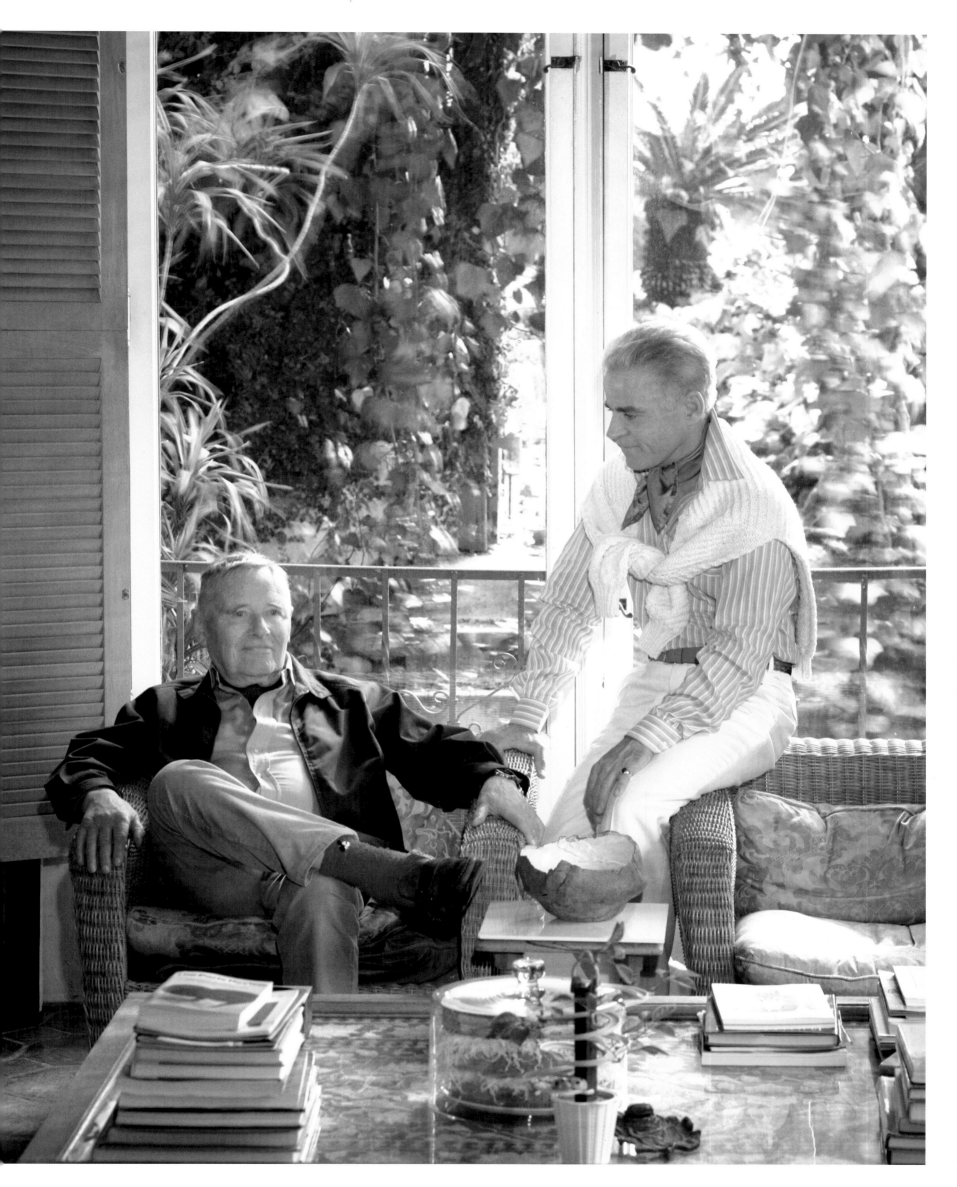

103 CHRISTOPHER ISHERWOOD, DON BACHARDY

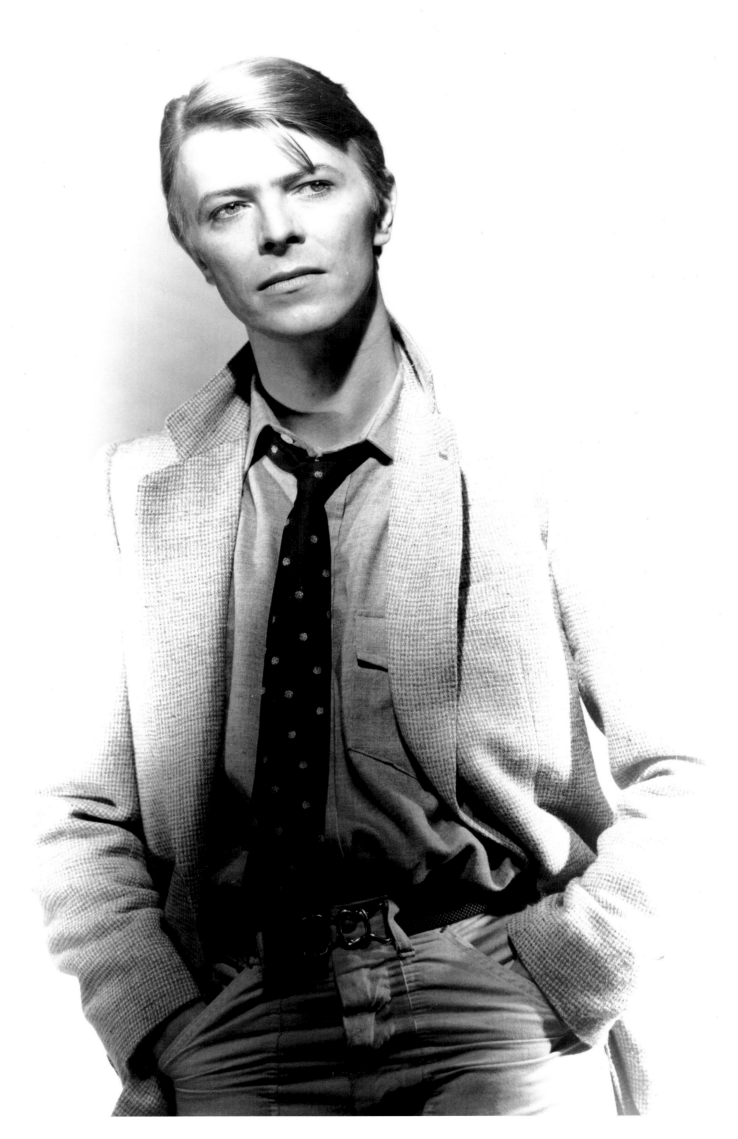

104 DAVID BOWIE

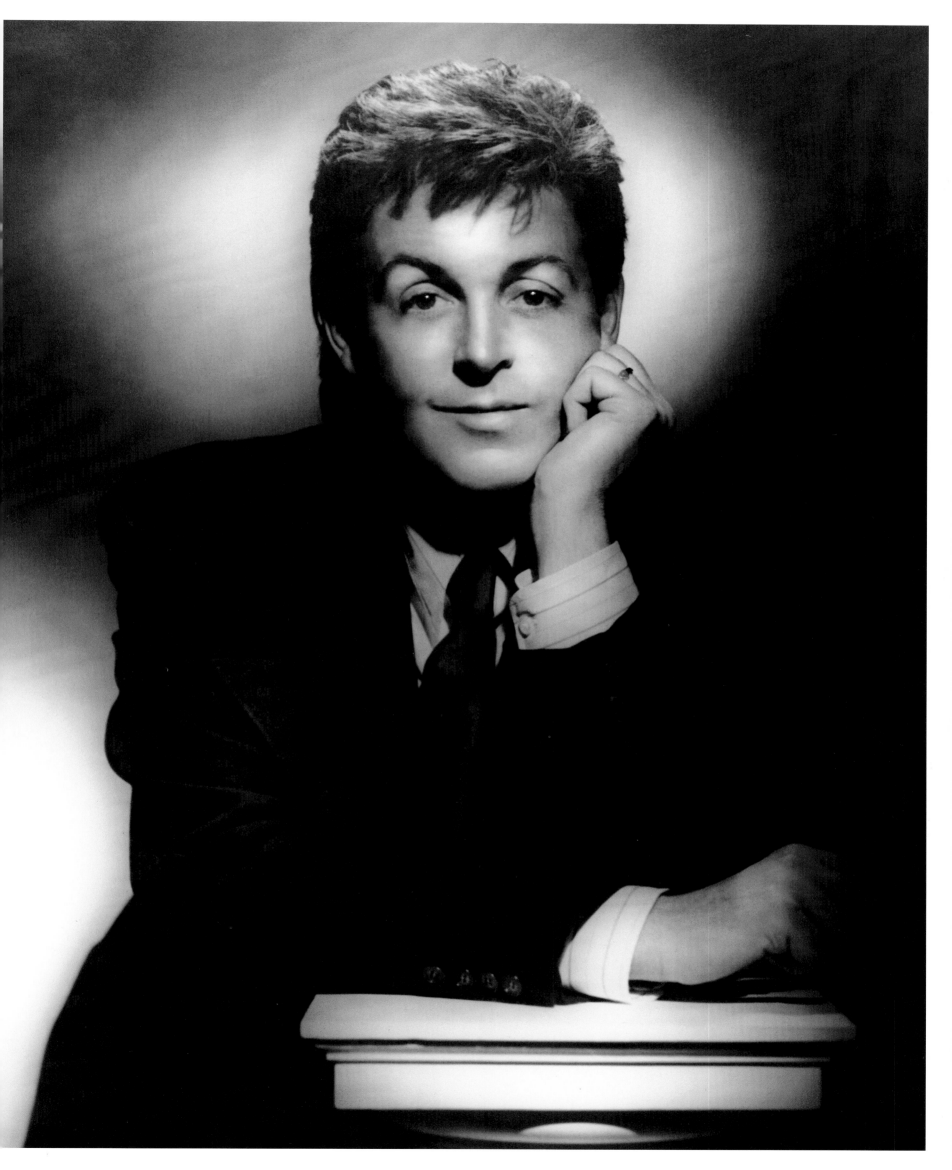

105 PAUL McCARTNEY

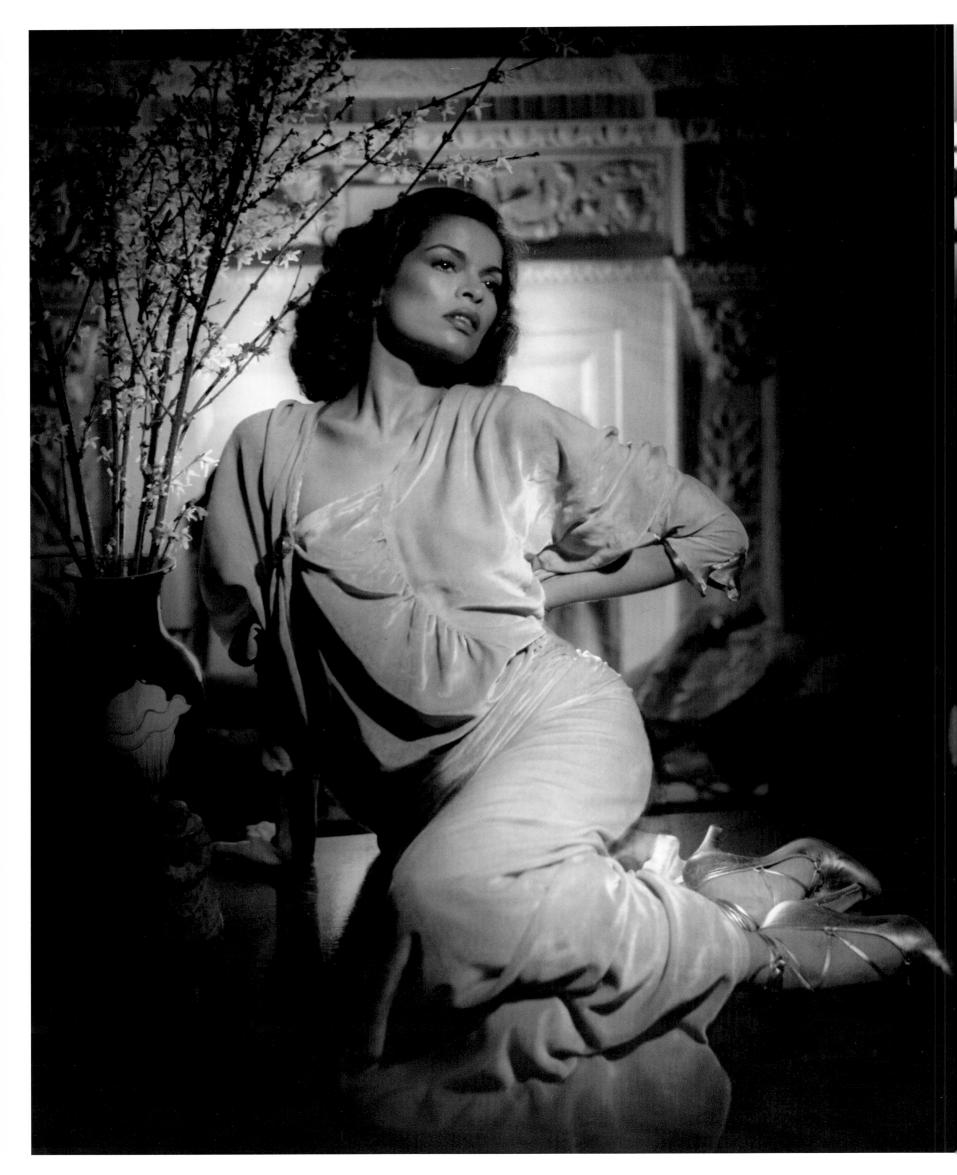

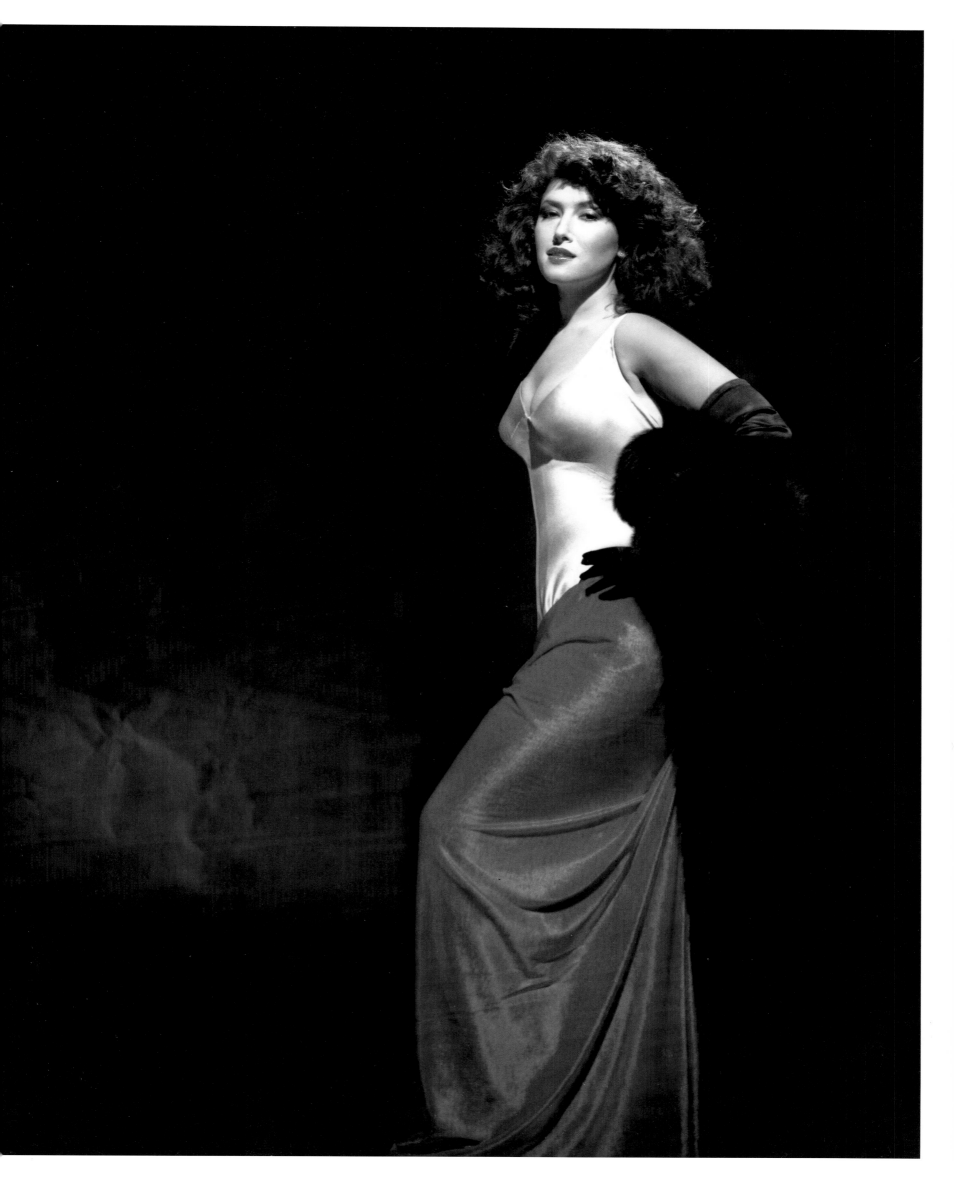

107 MELISSA MANCHESTER

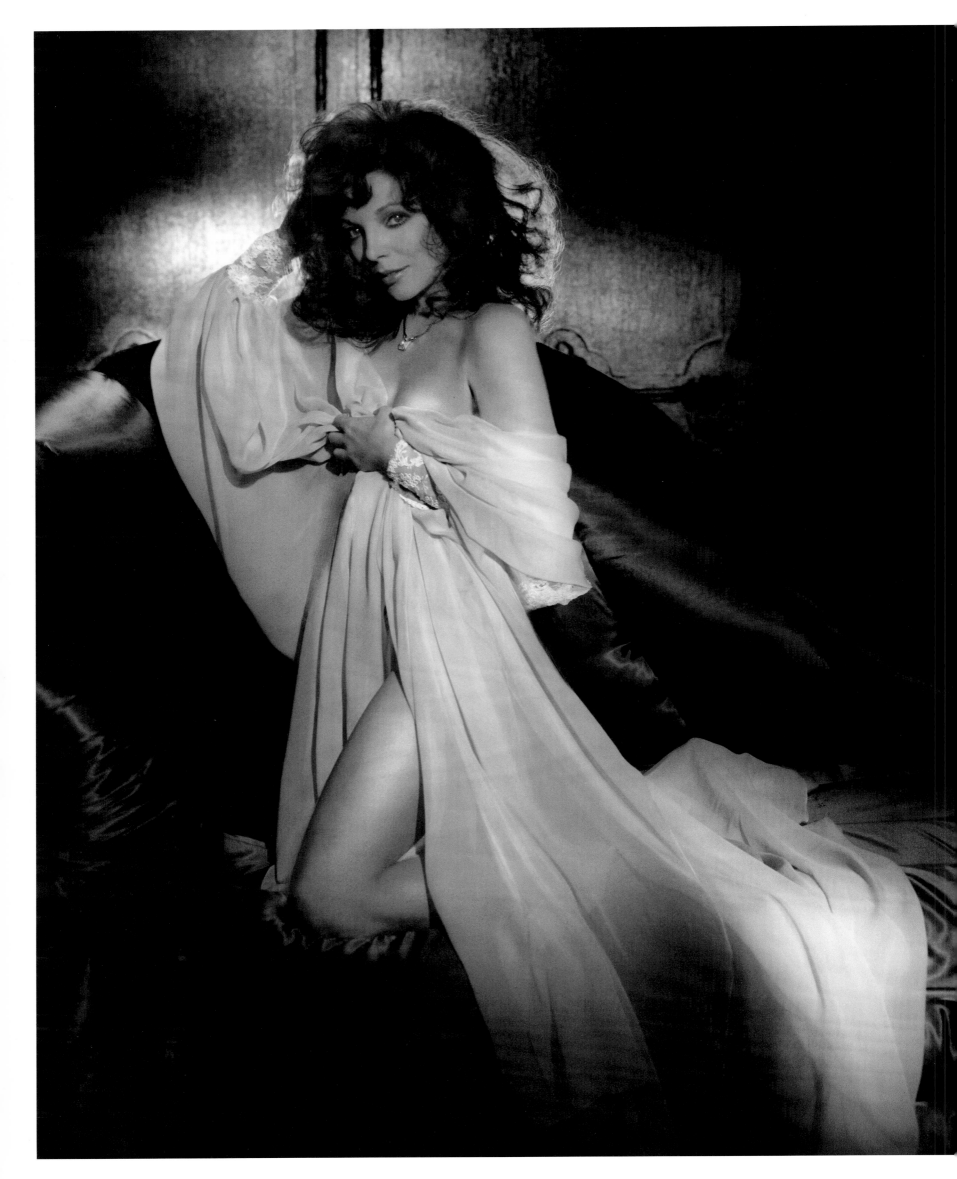

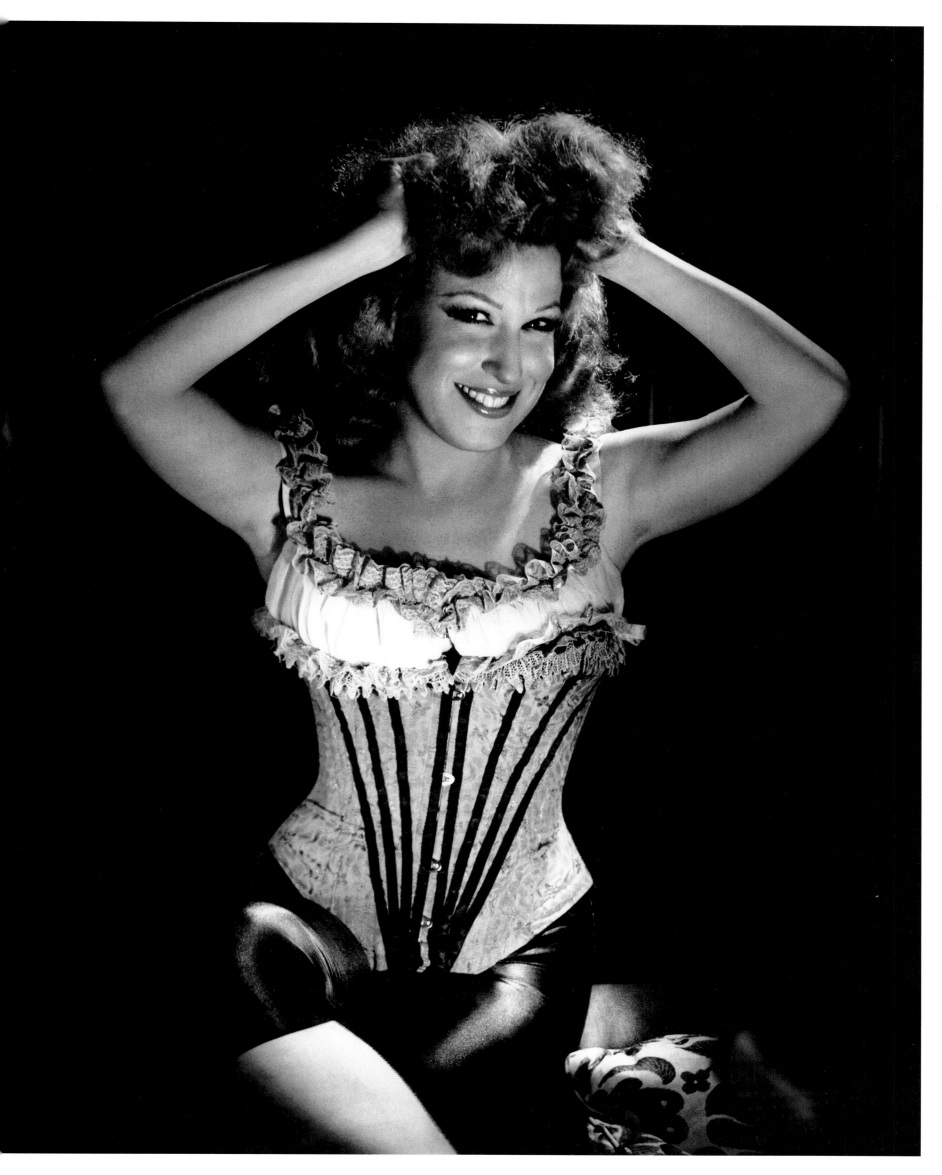

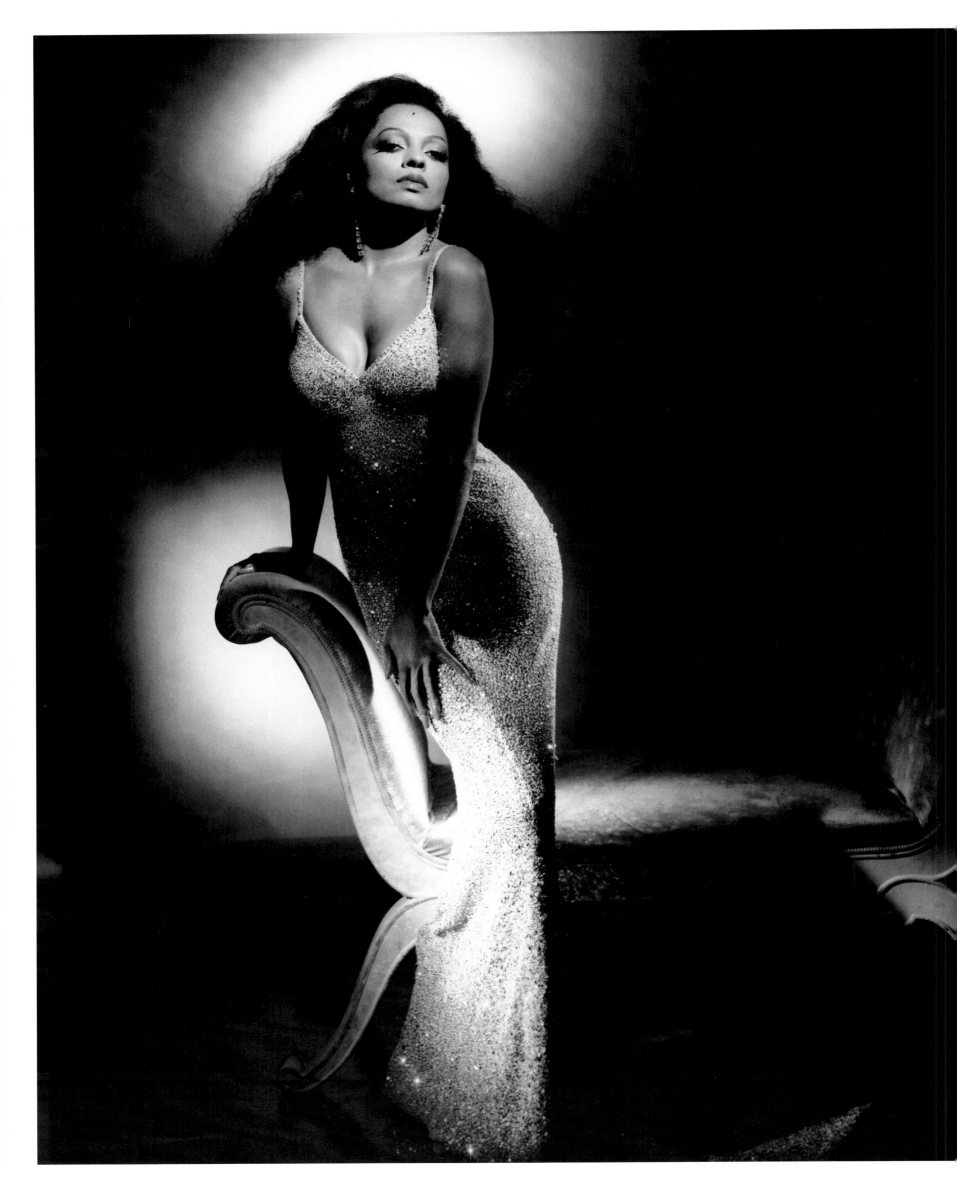

110 DIANA ROSS

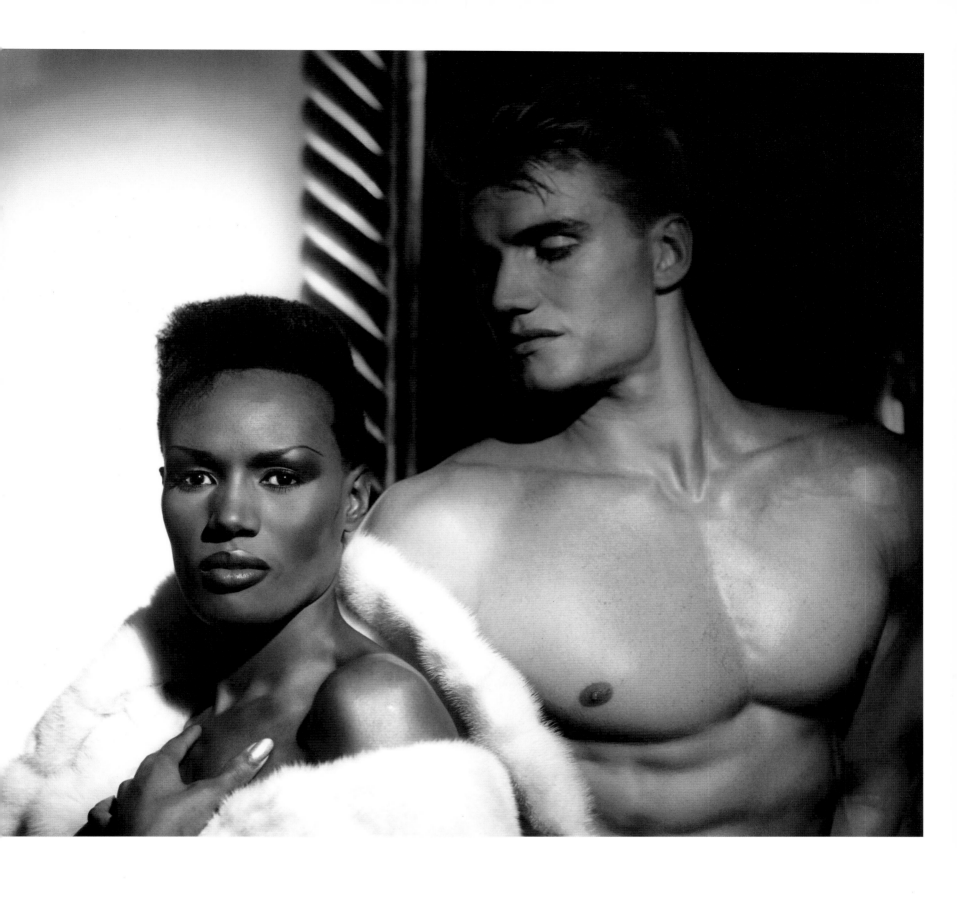

111 GRACE JONES, DOLPH LUNDGREN

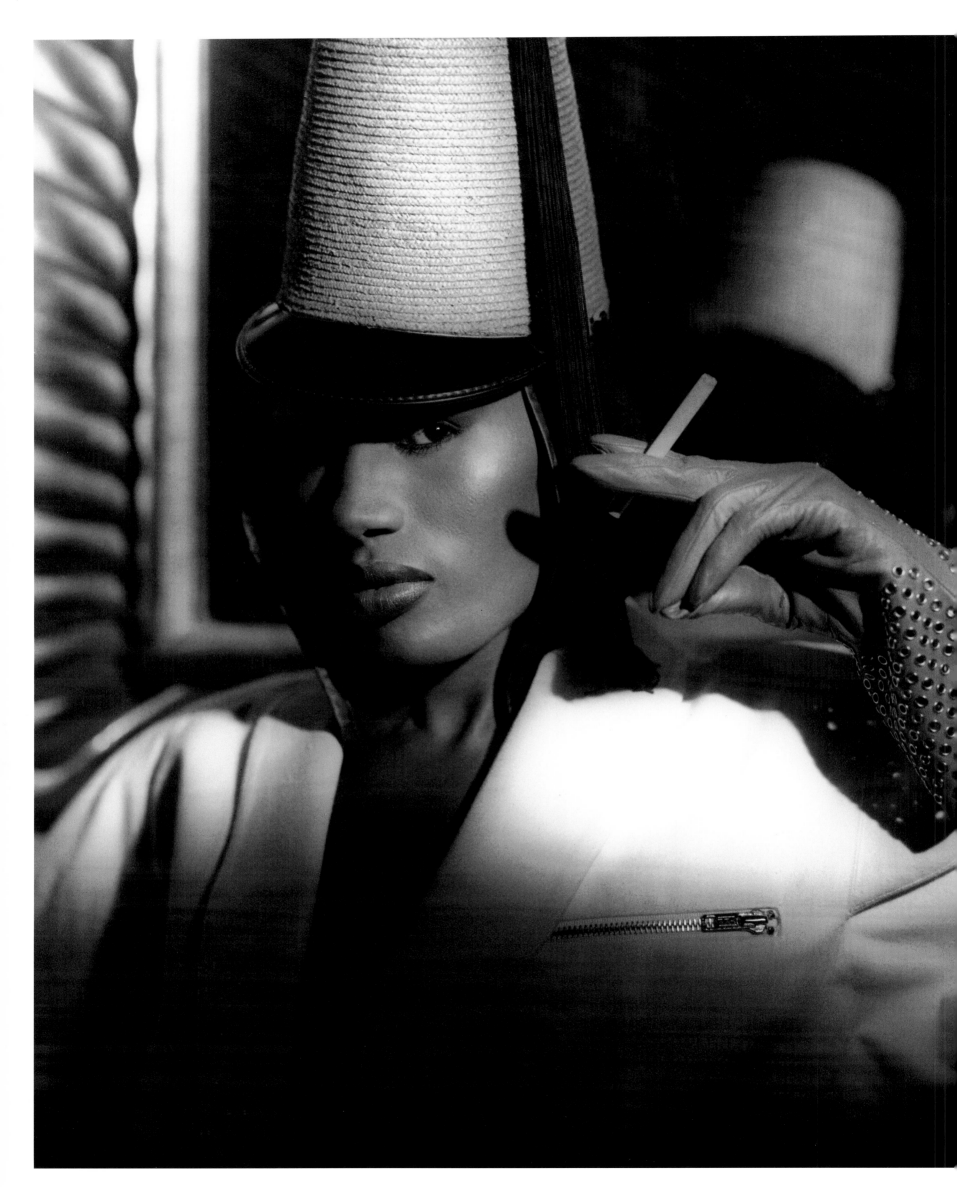

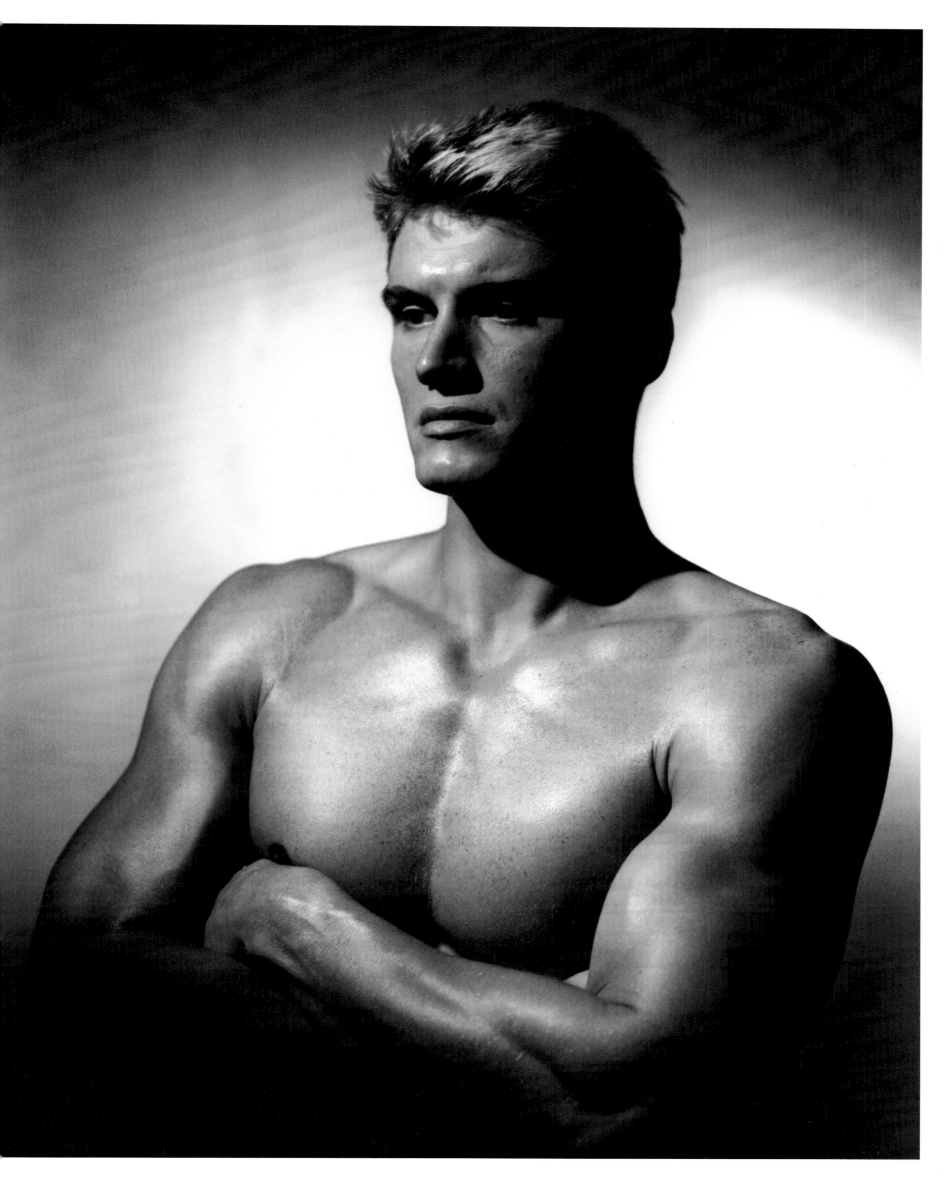

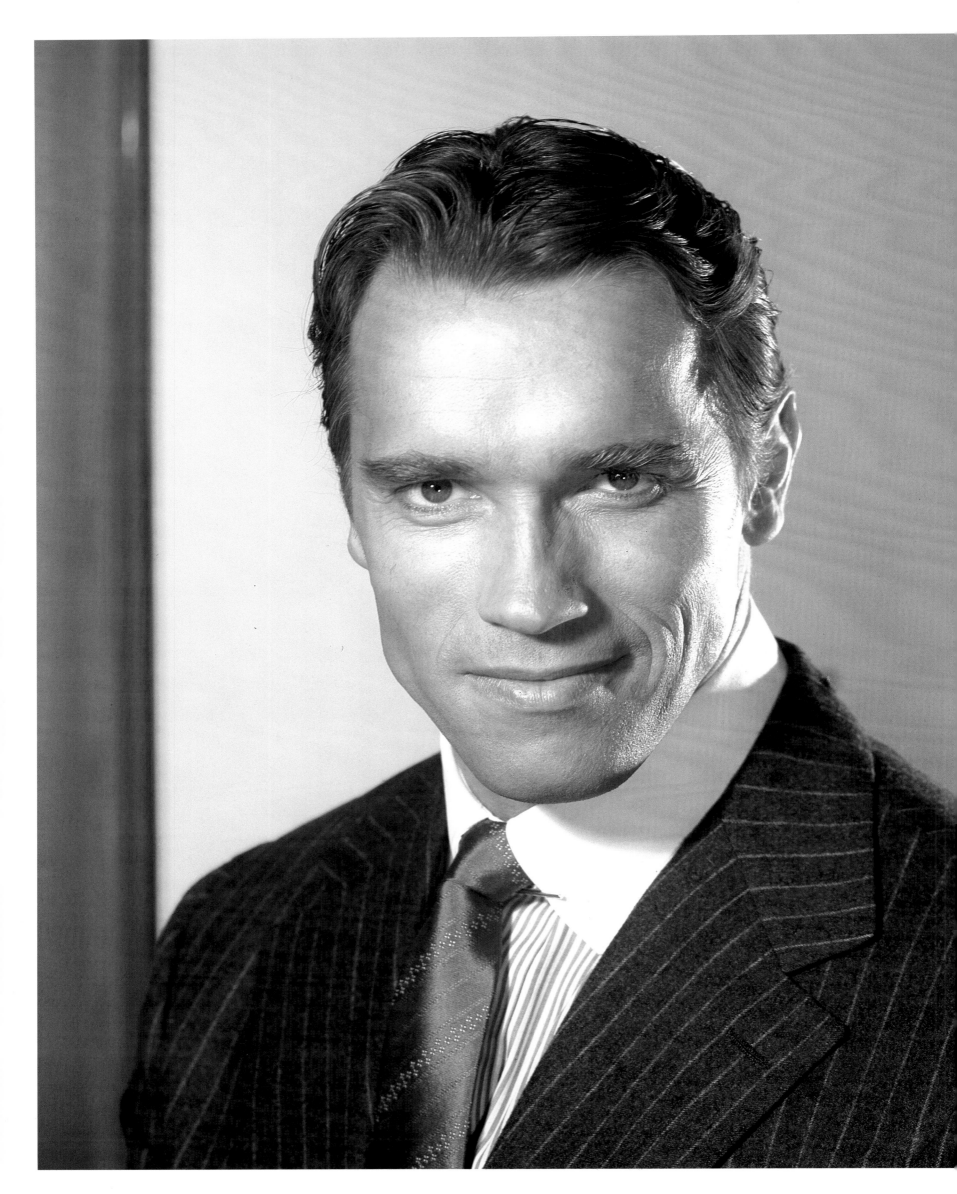

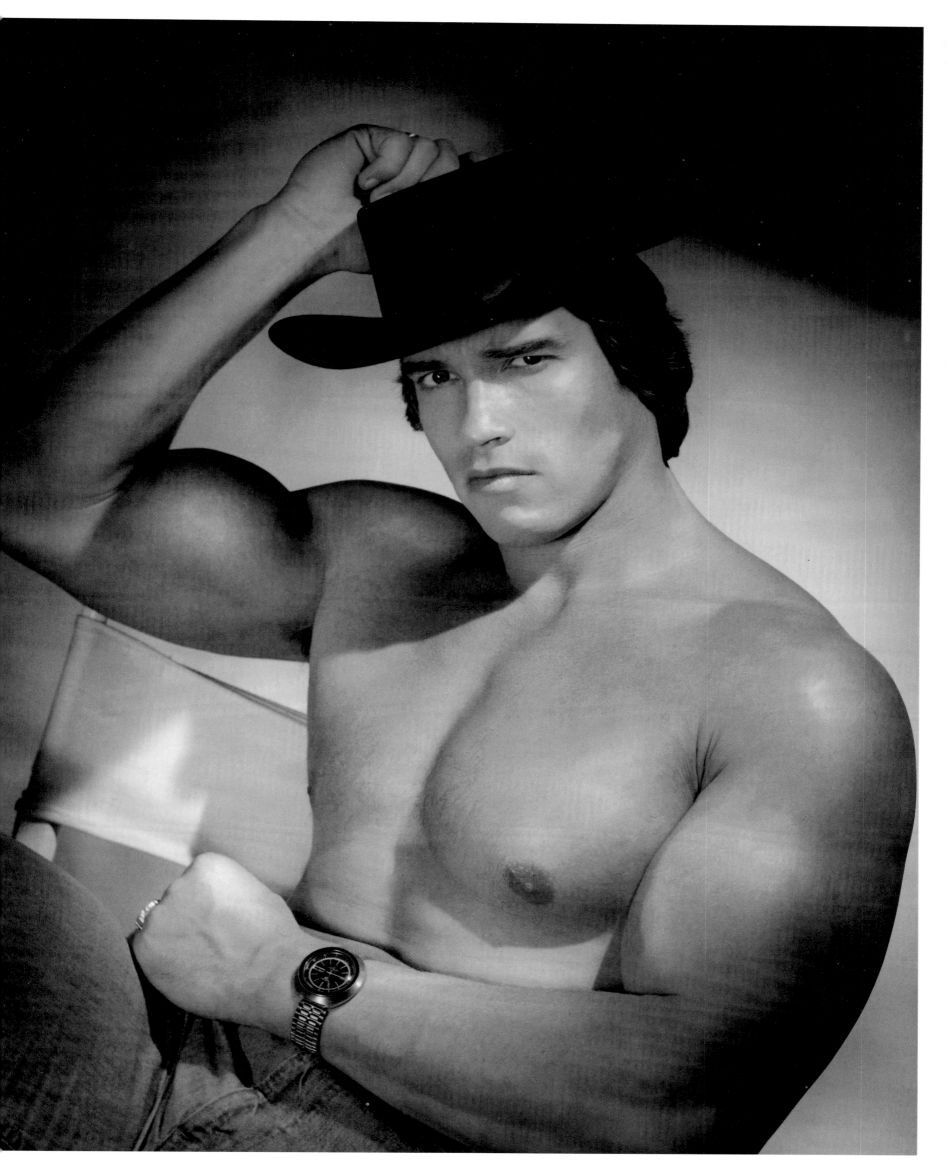

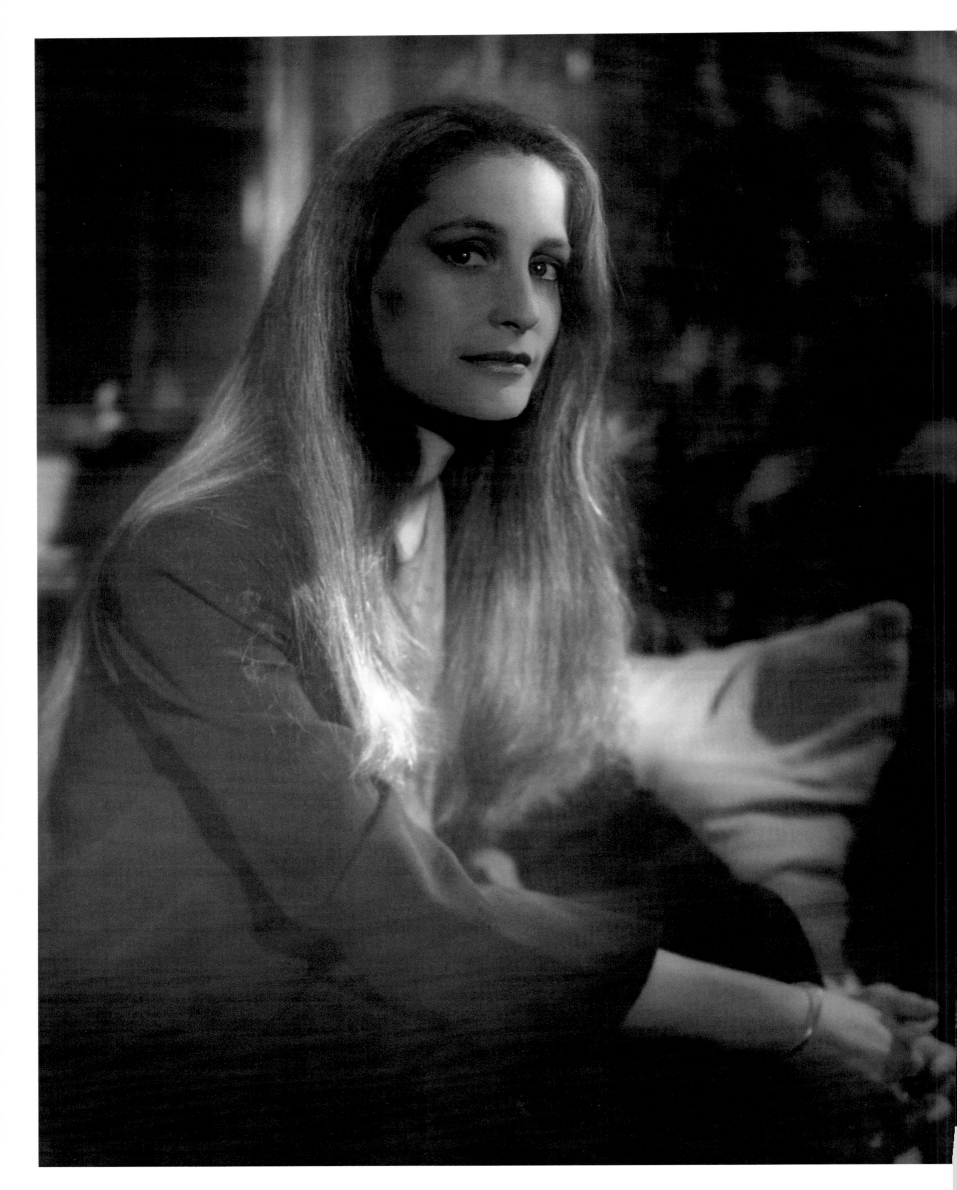

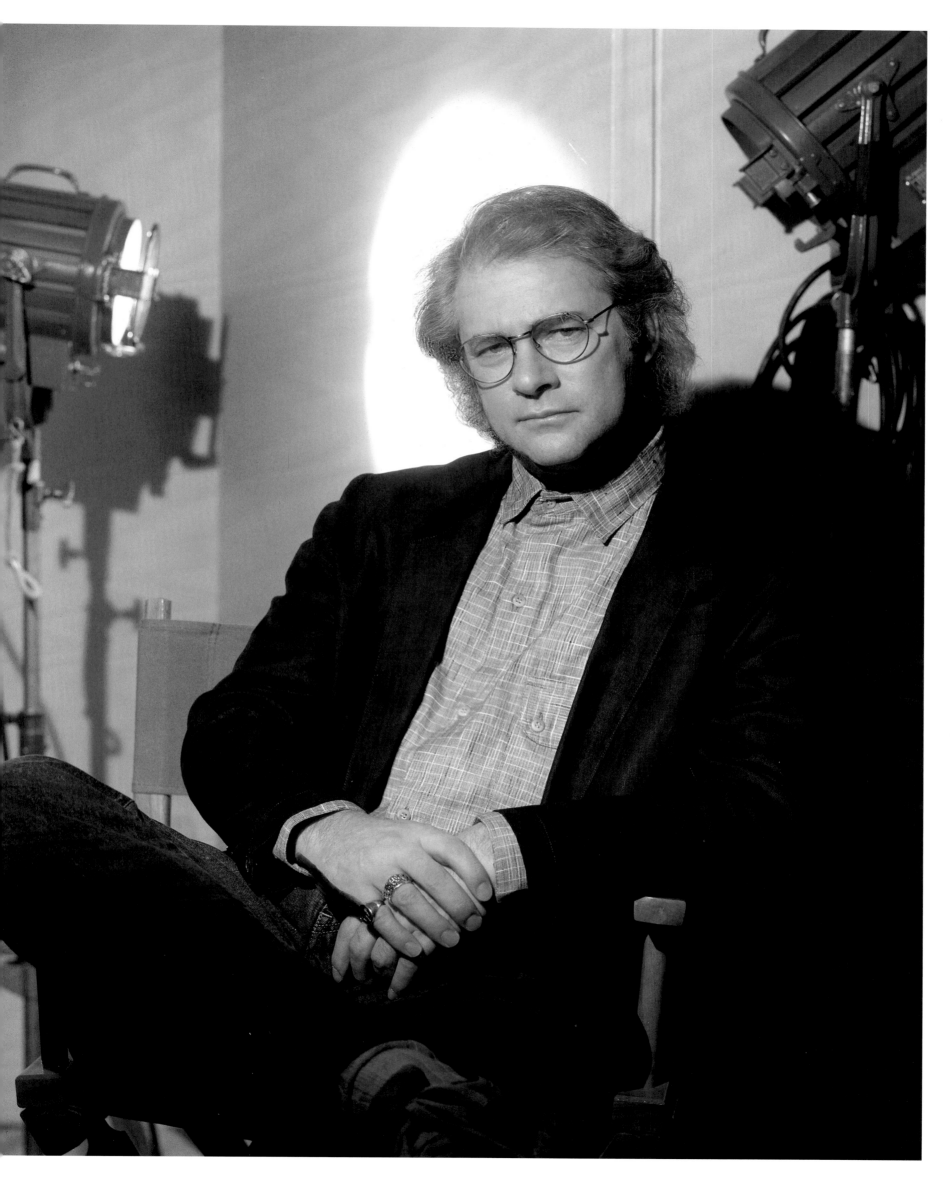

117 BARRY LEVINSON

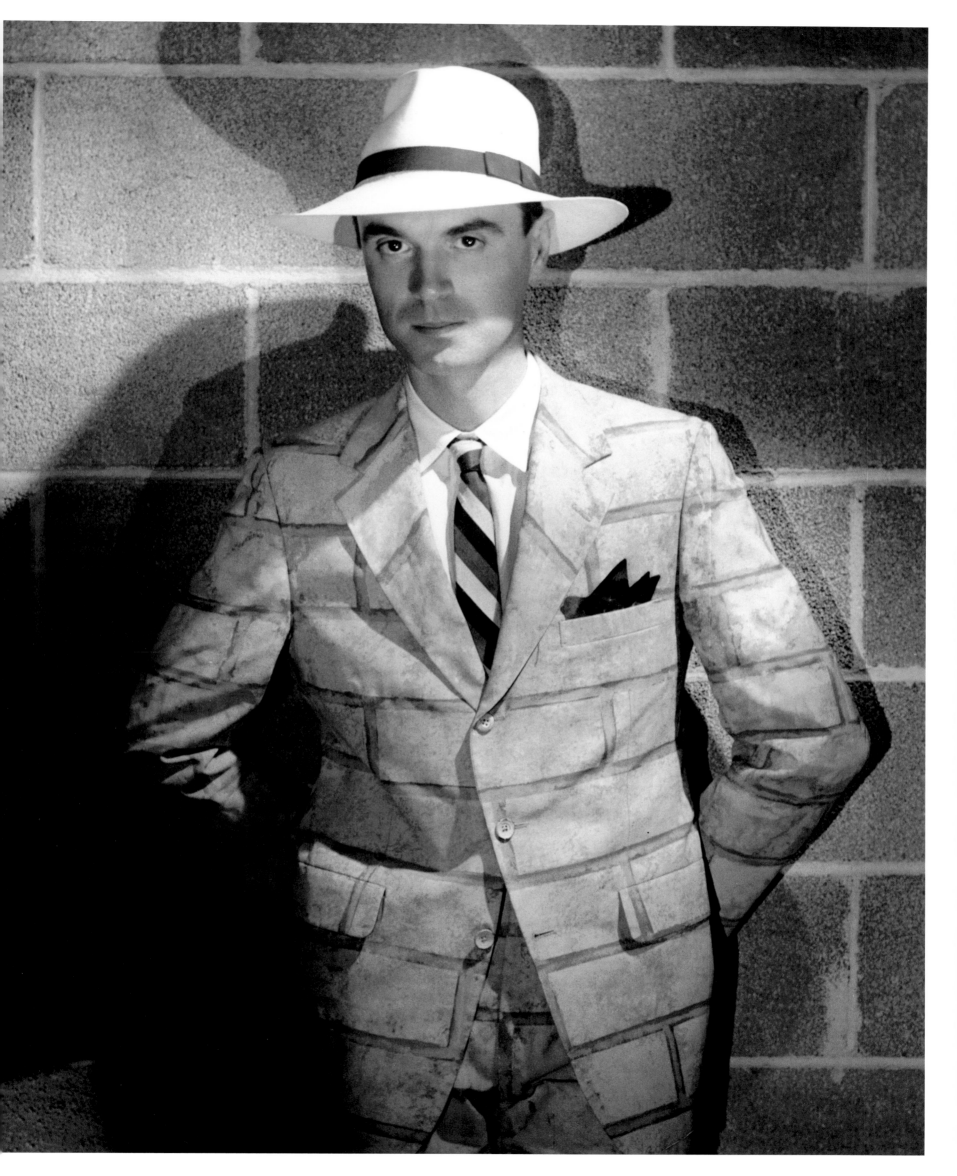

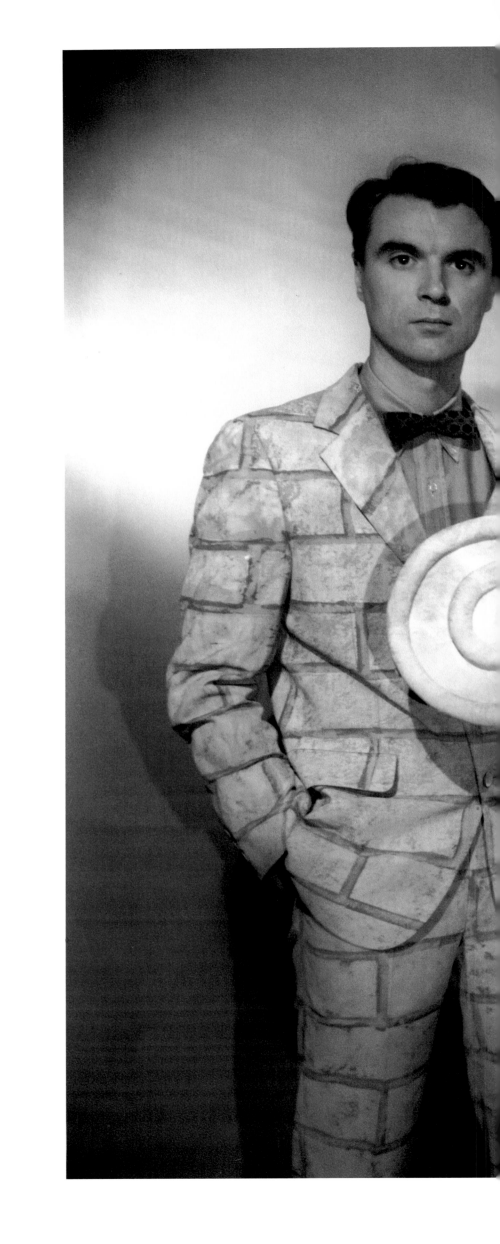

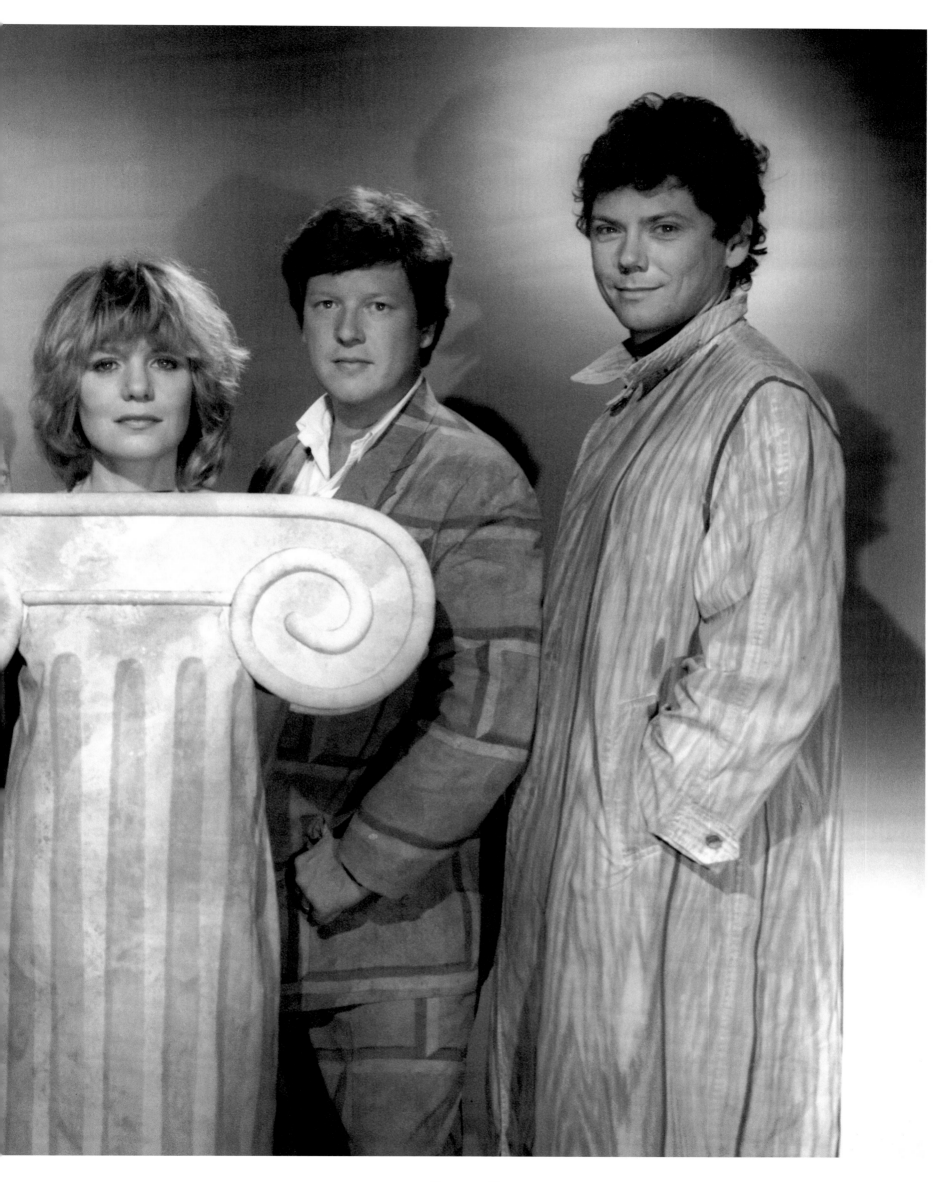

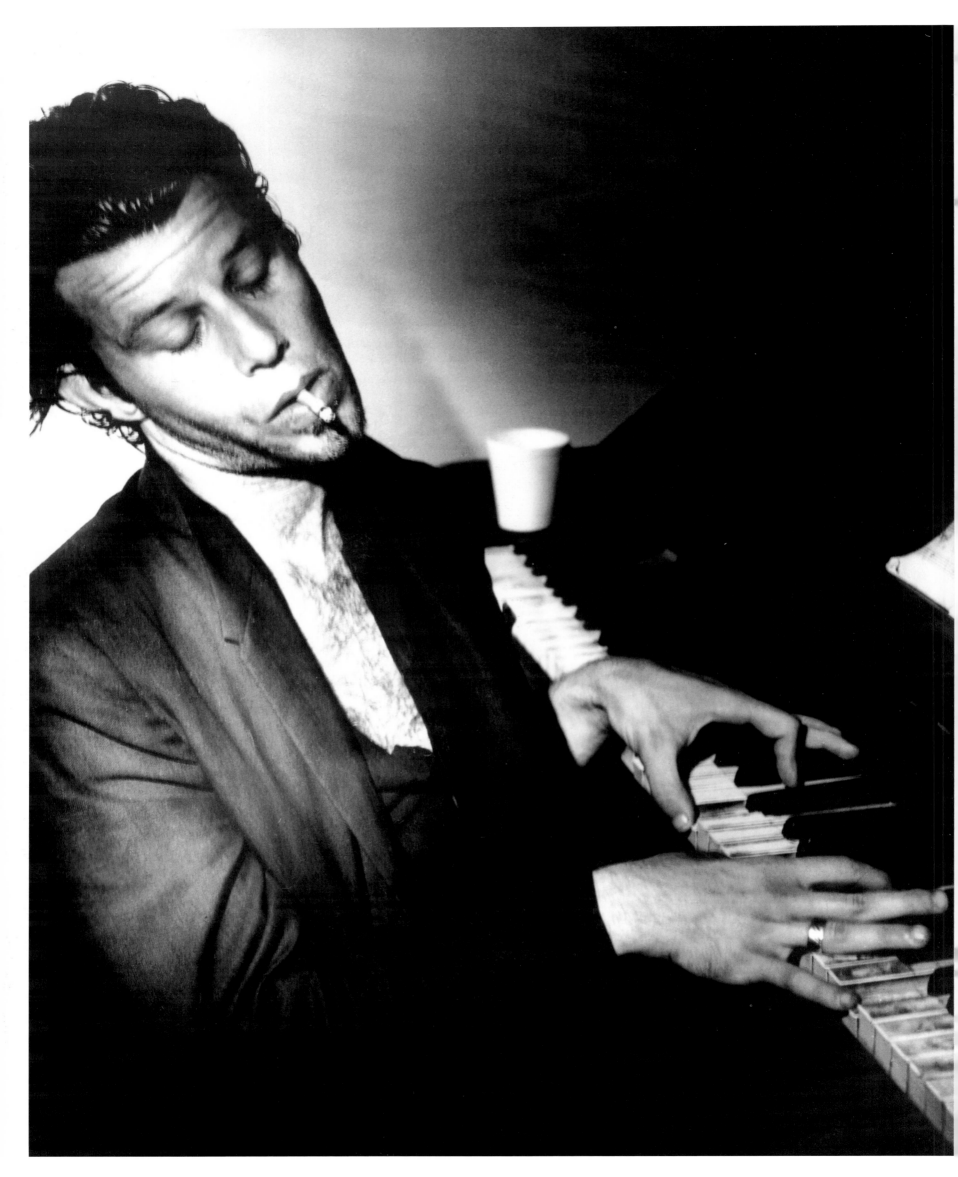

120 TOM WAITS, *Insert Album*

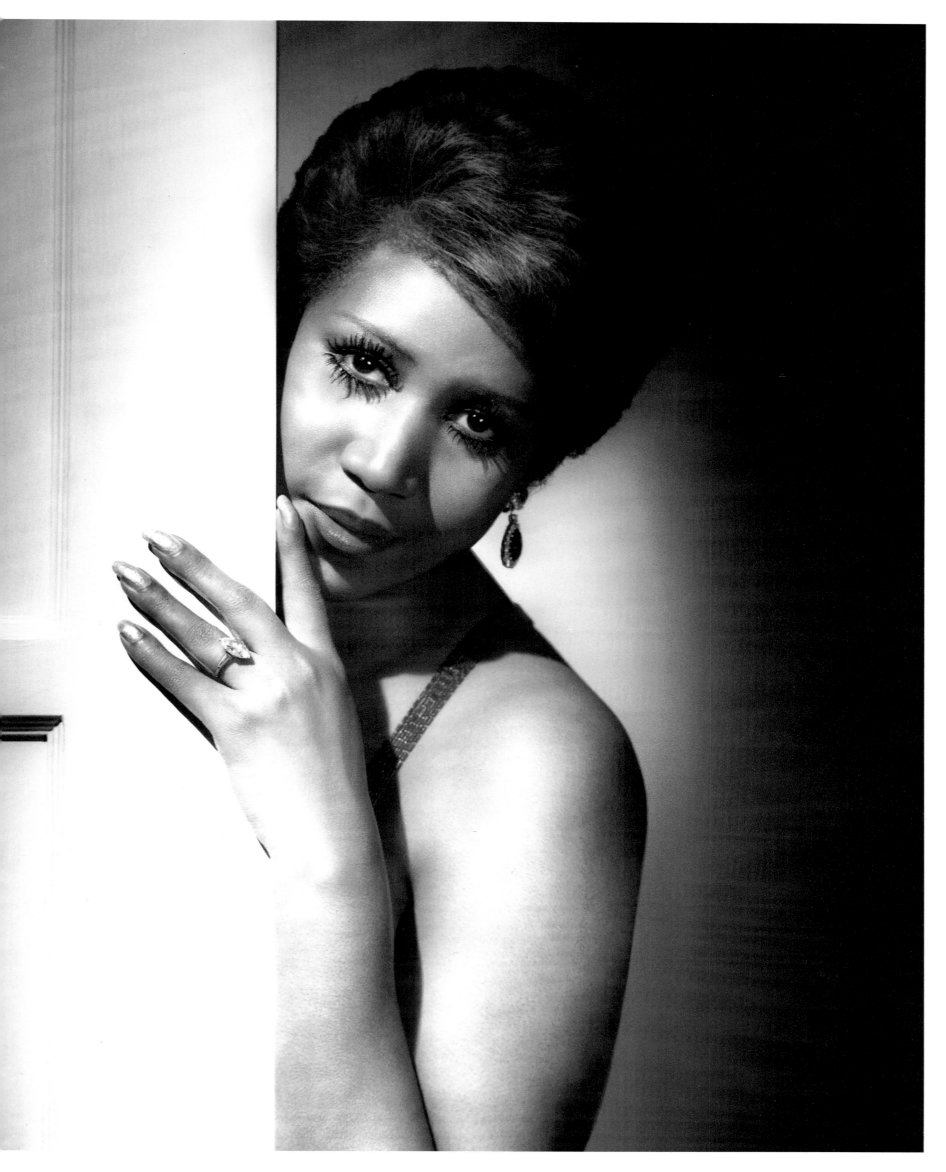

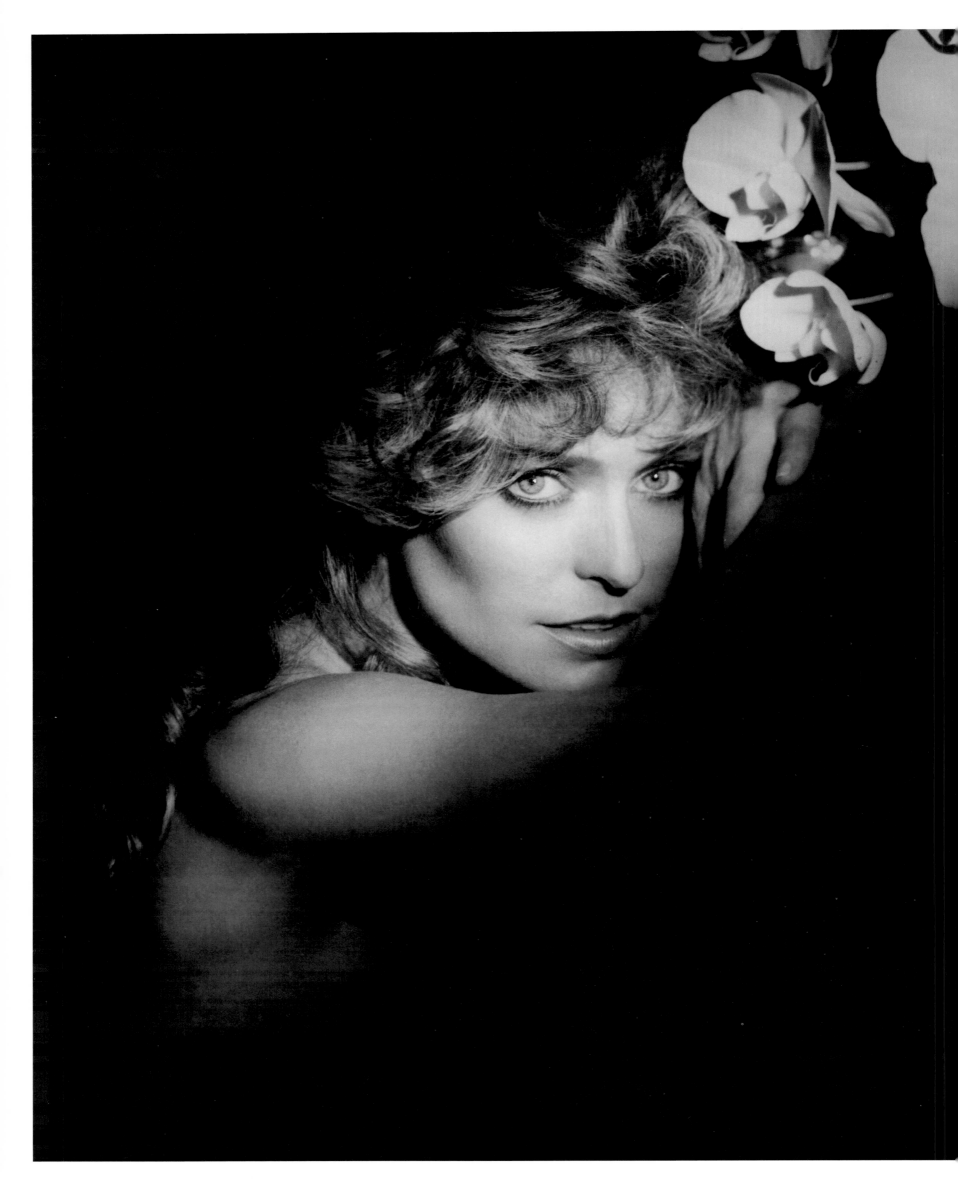

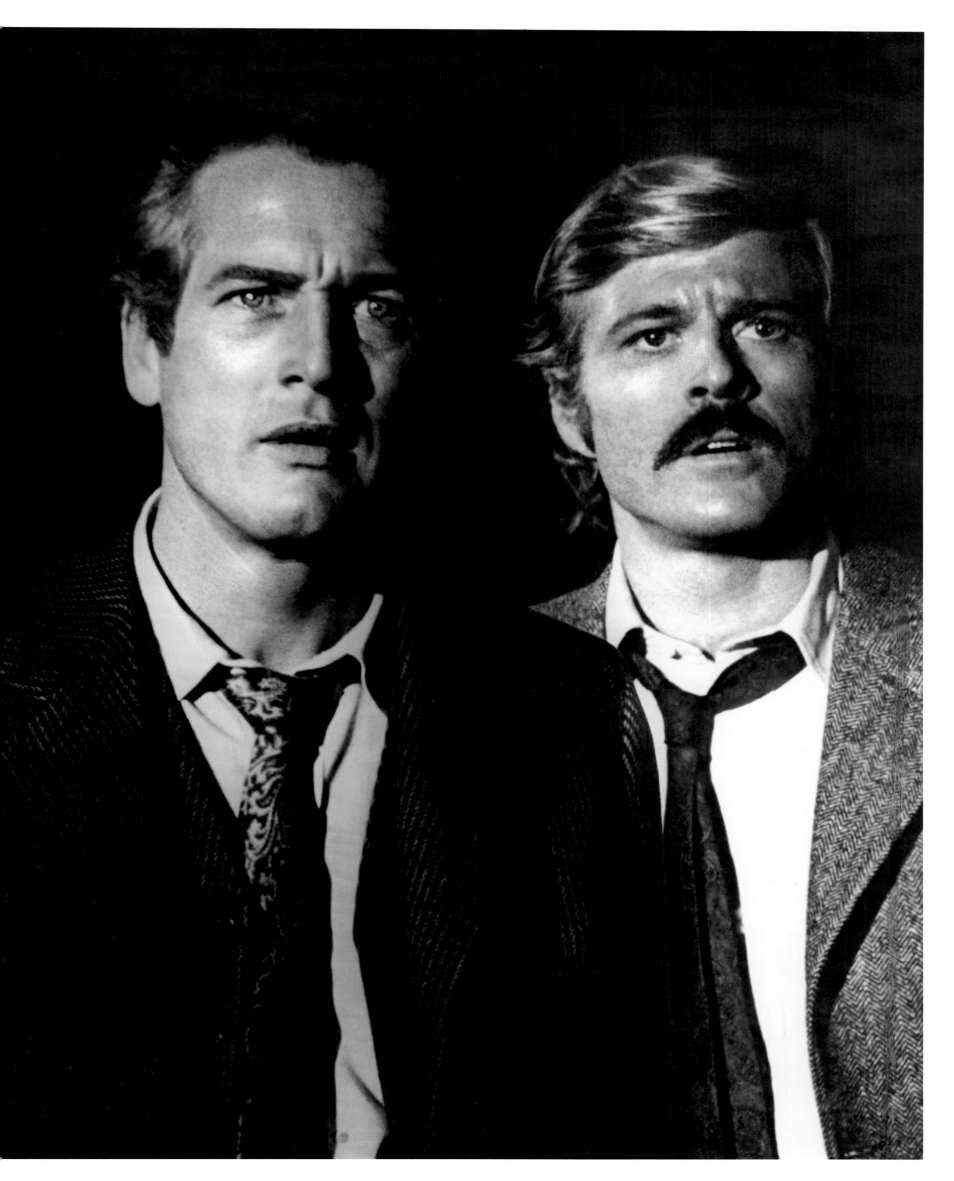

123 PAUL NEWMAN, ROBERT REDFORD, 1969

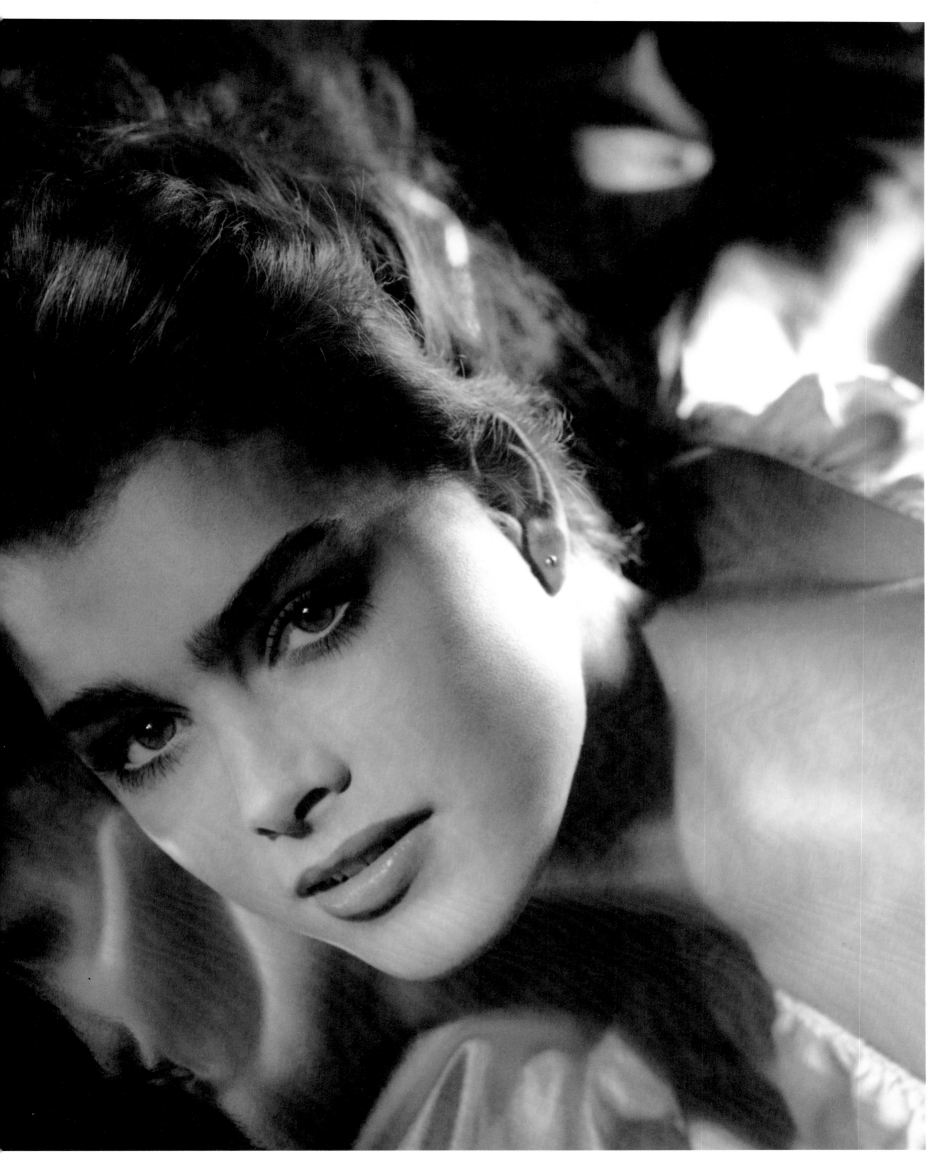

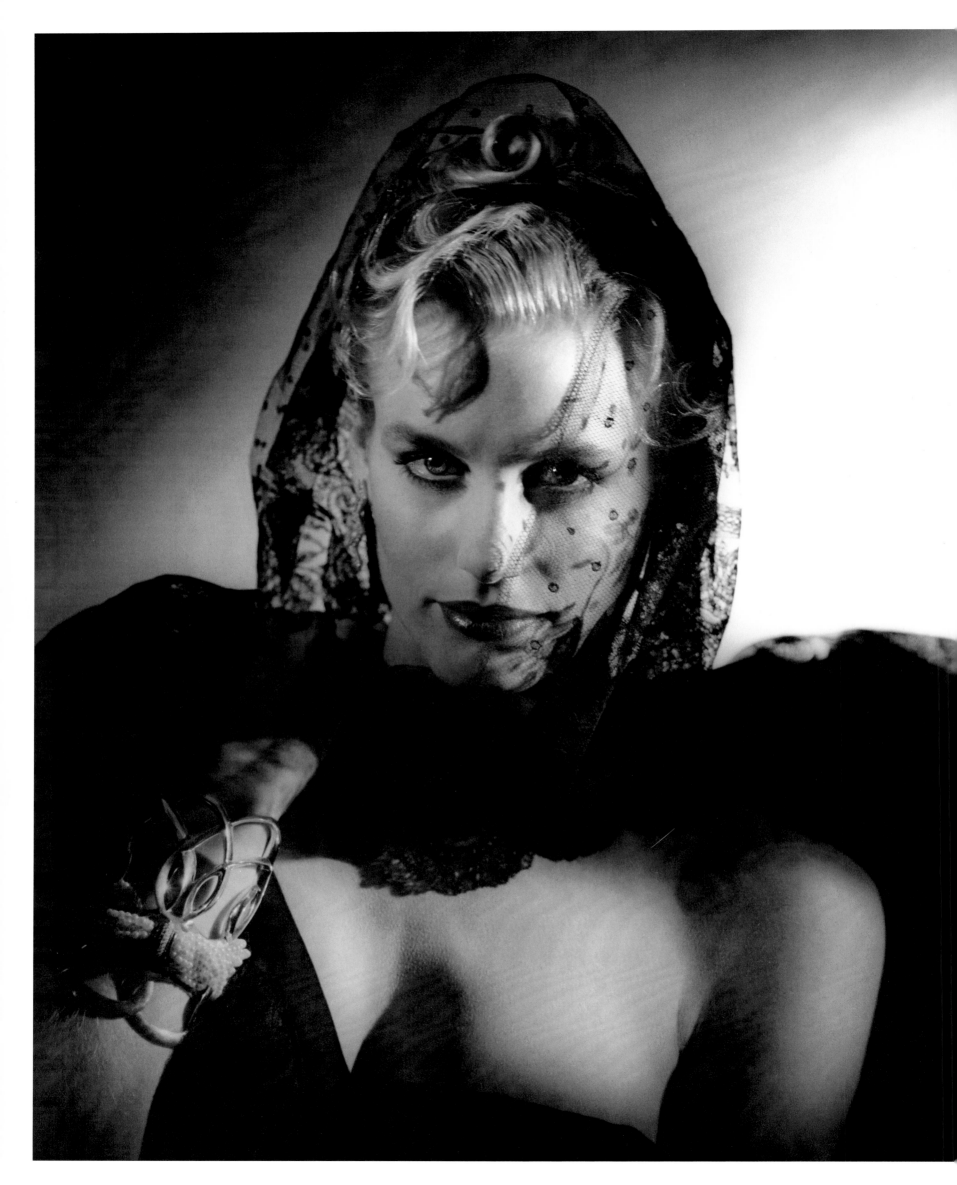

125 DARYL HANNAH

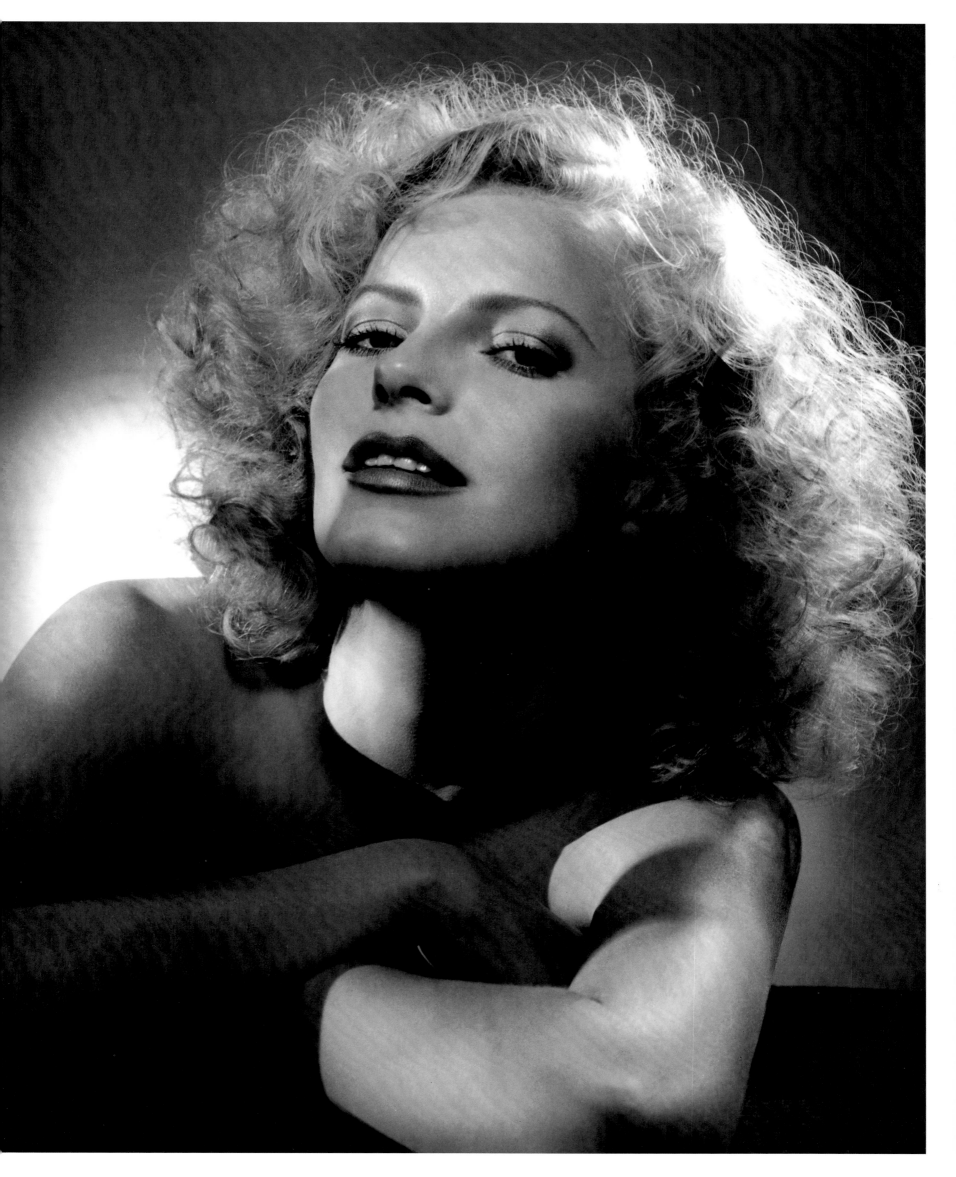

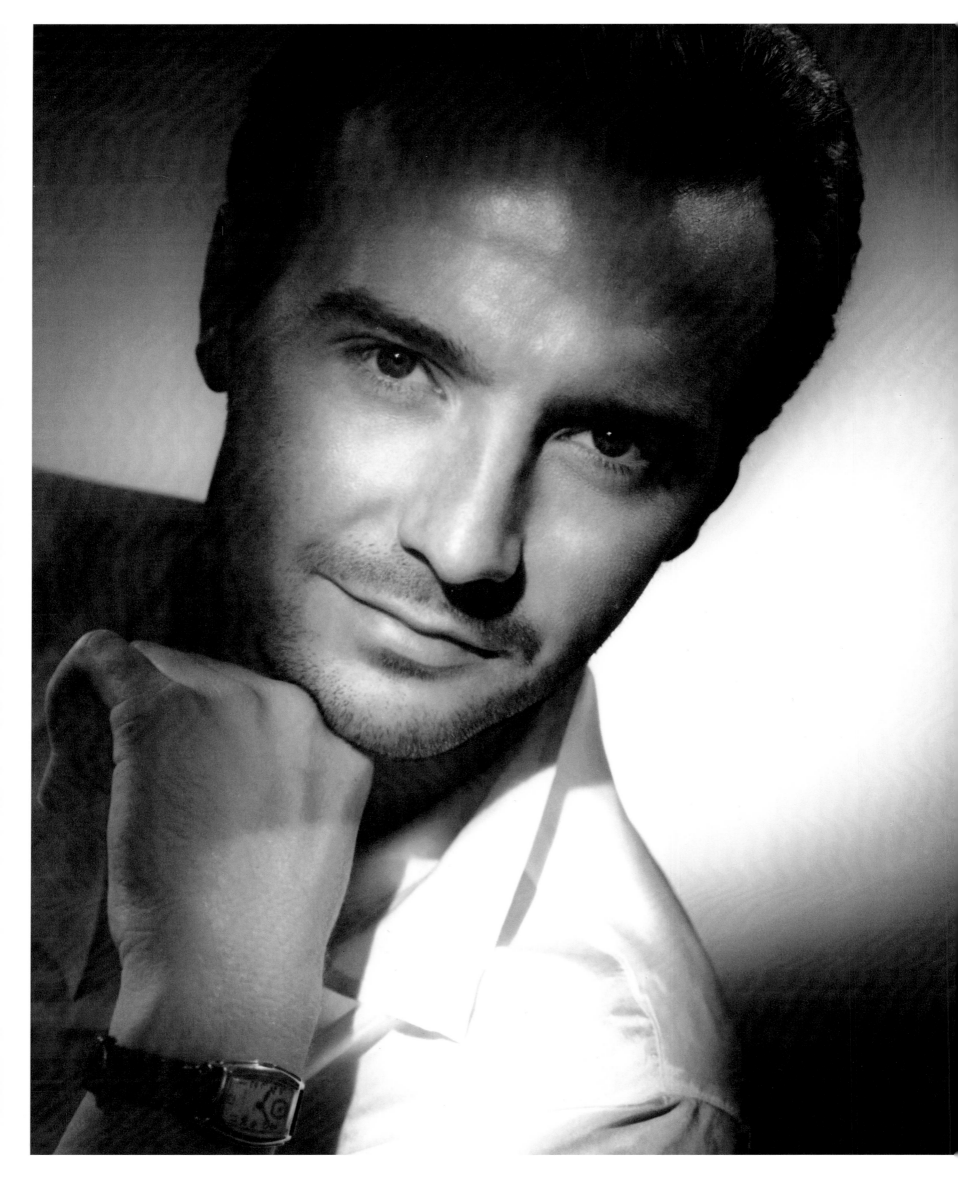

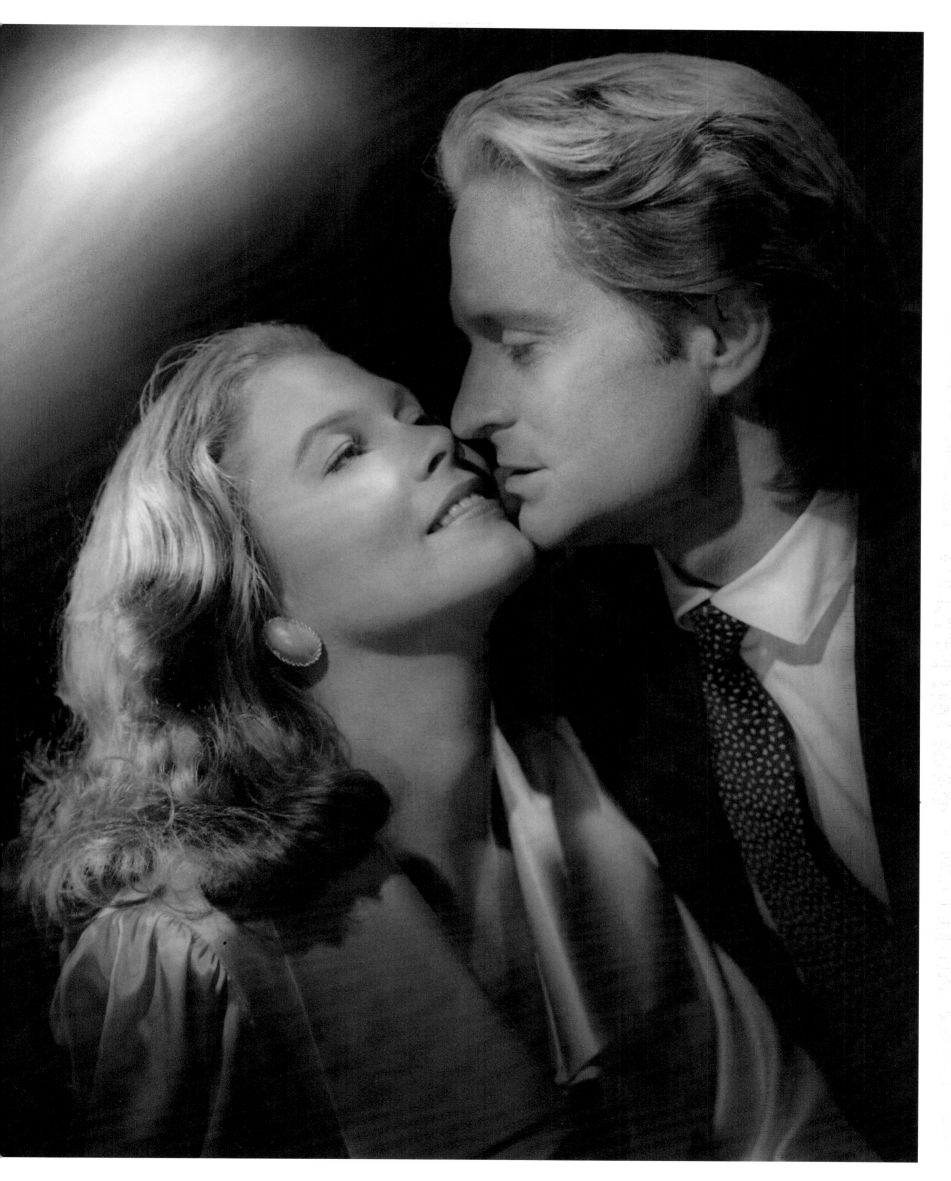

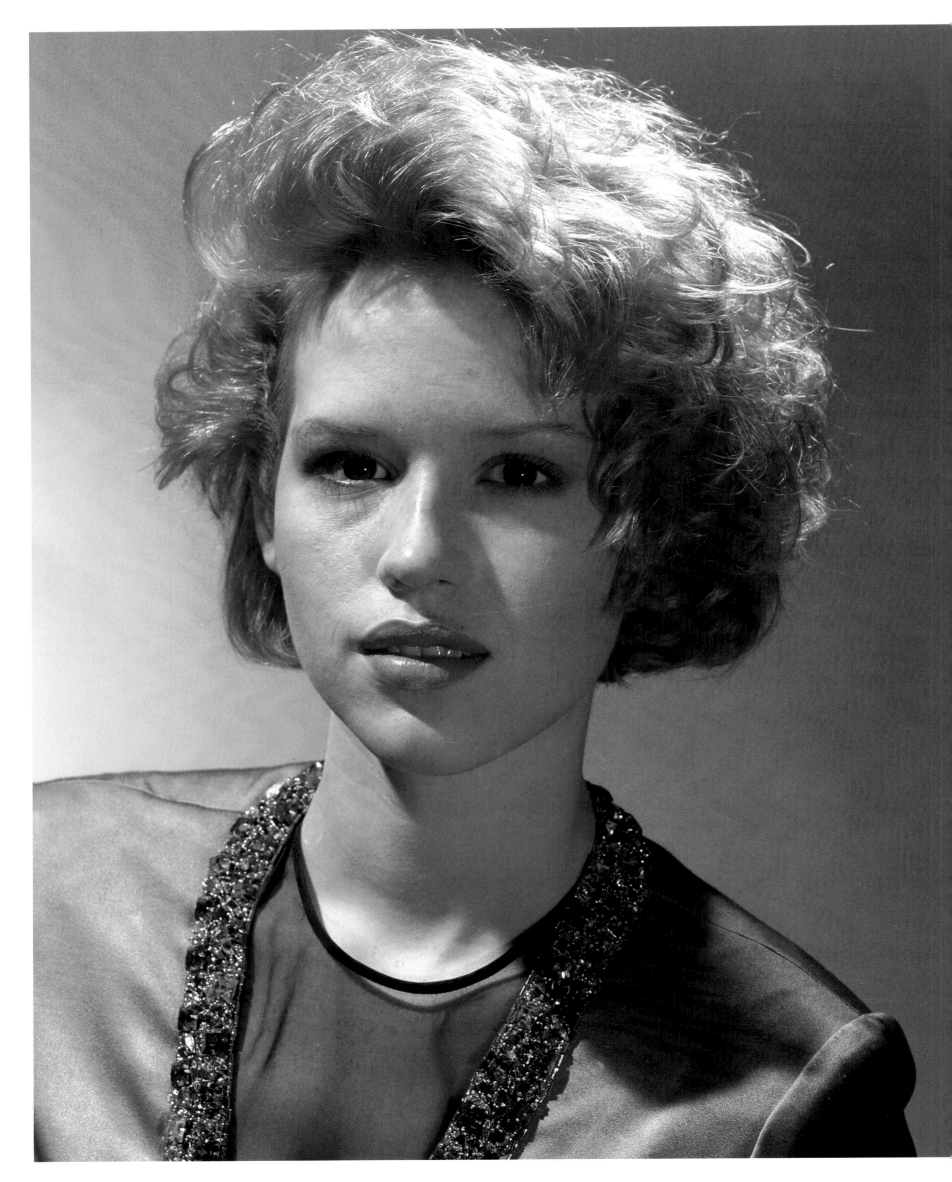

129 MOLLY RINGWALD

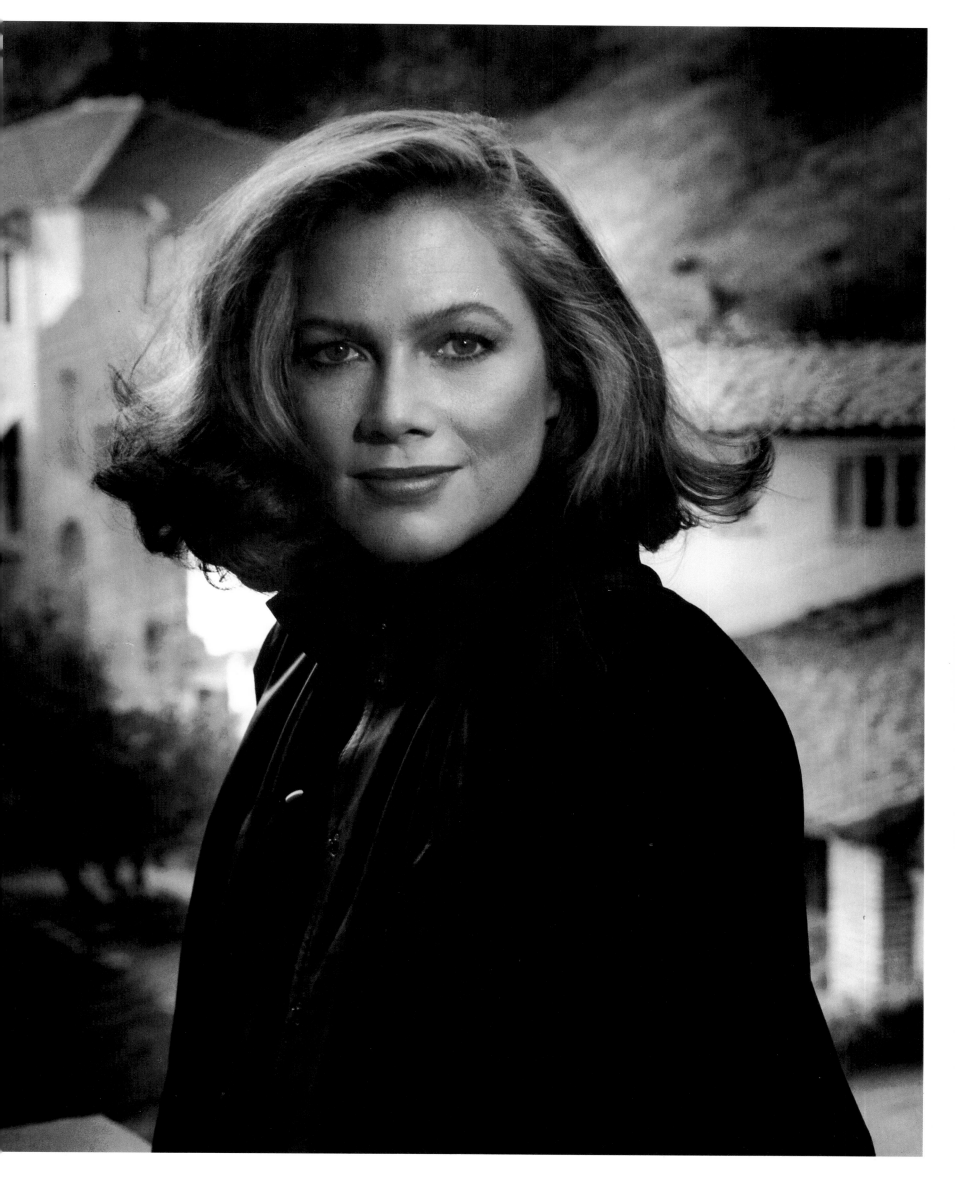

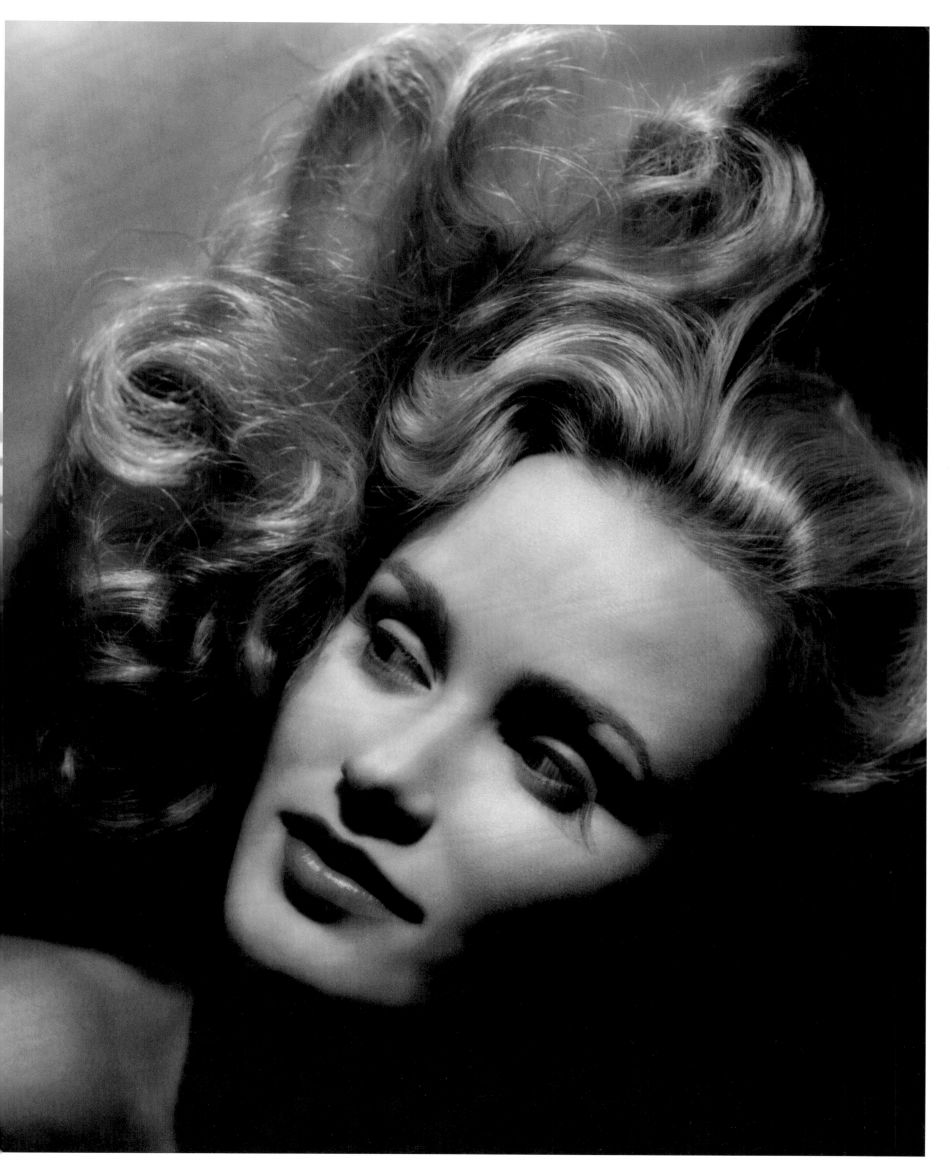

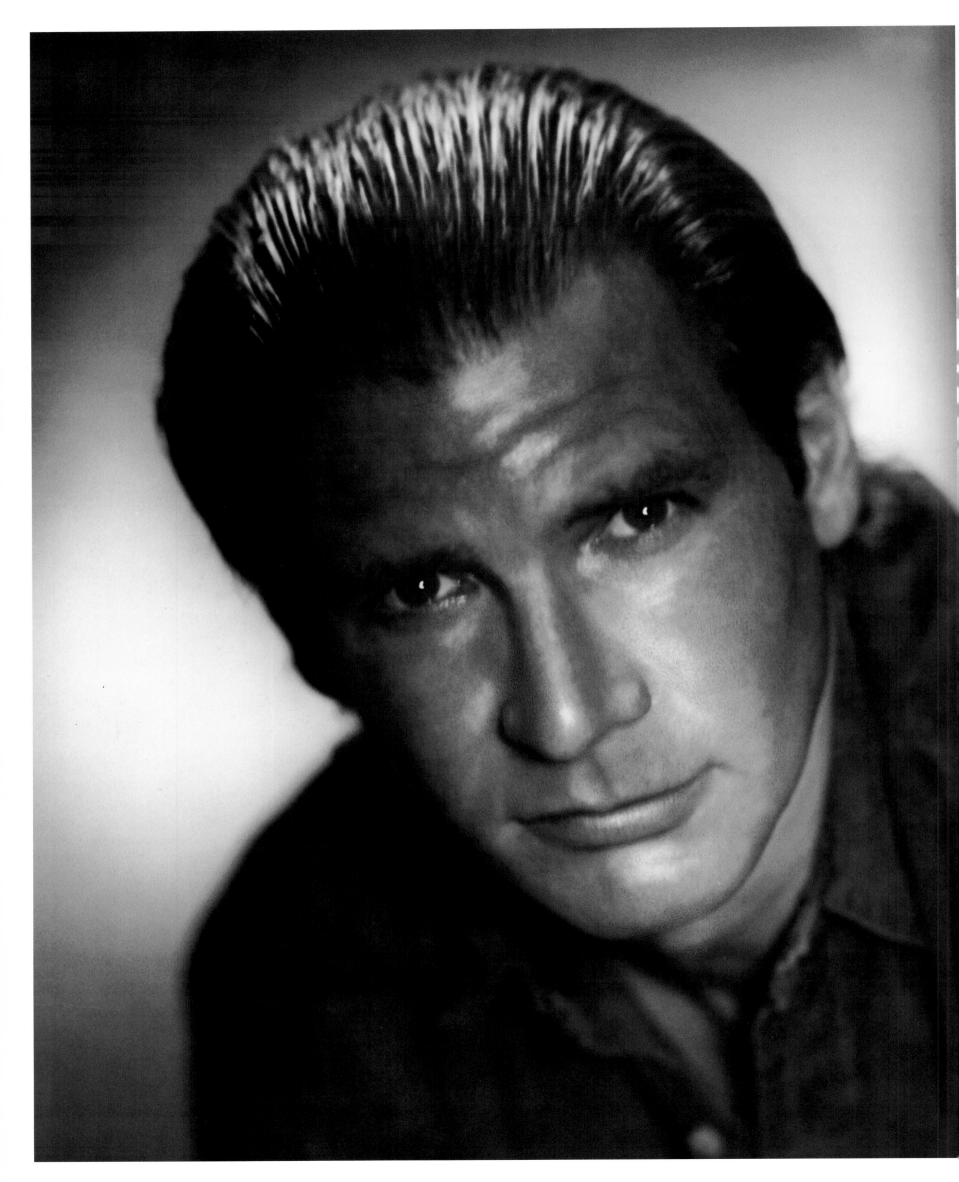

132 HARRISON FORD

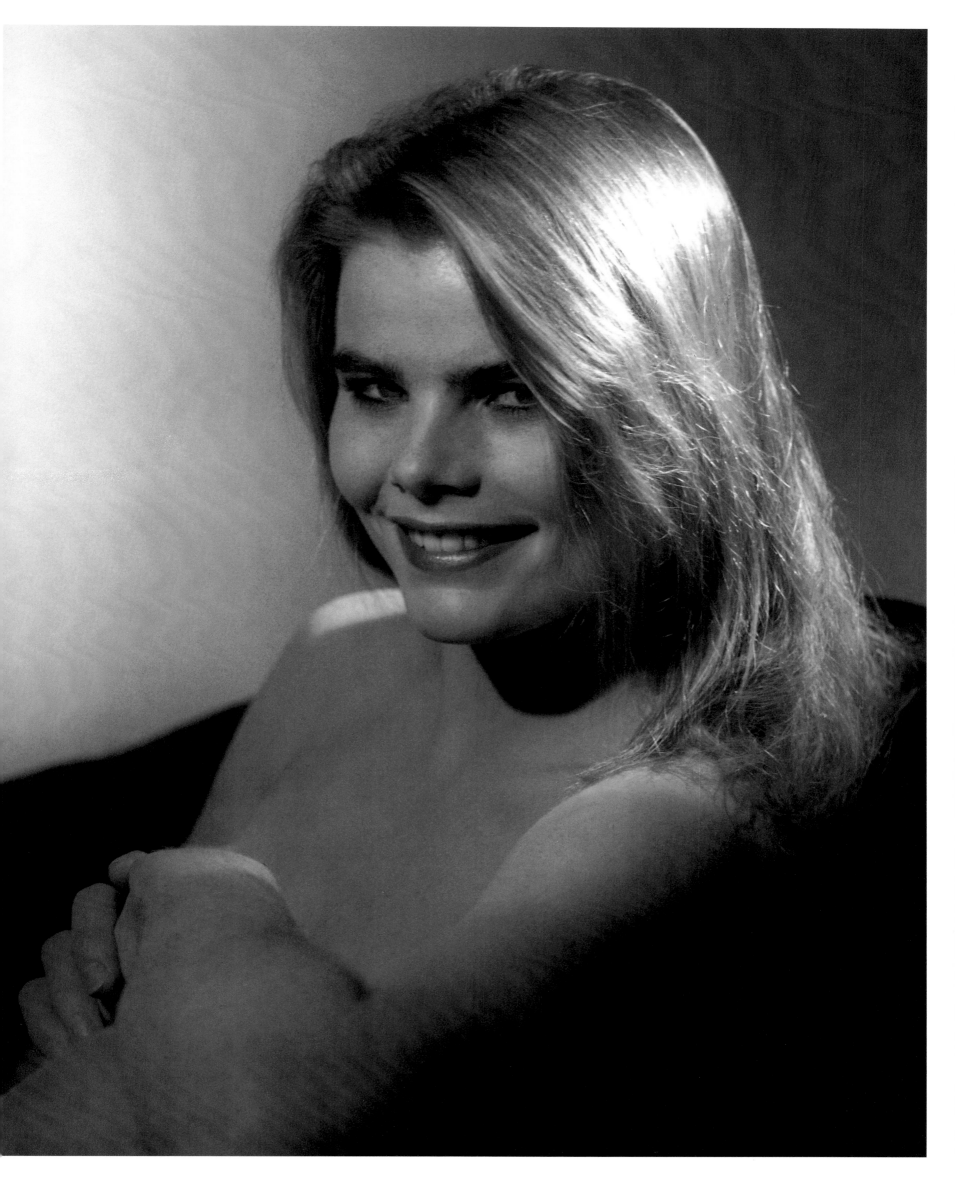

133 MARGAUX HEMINGWAY, 1976

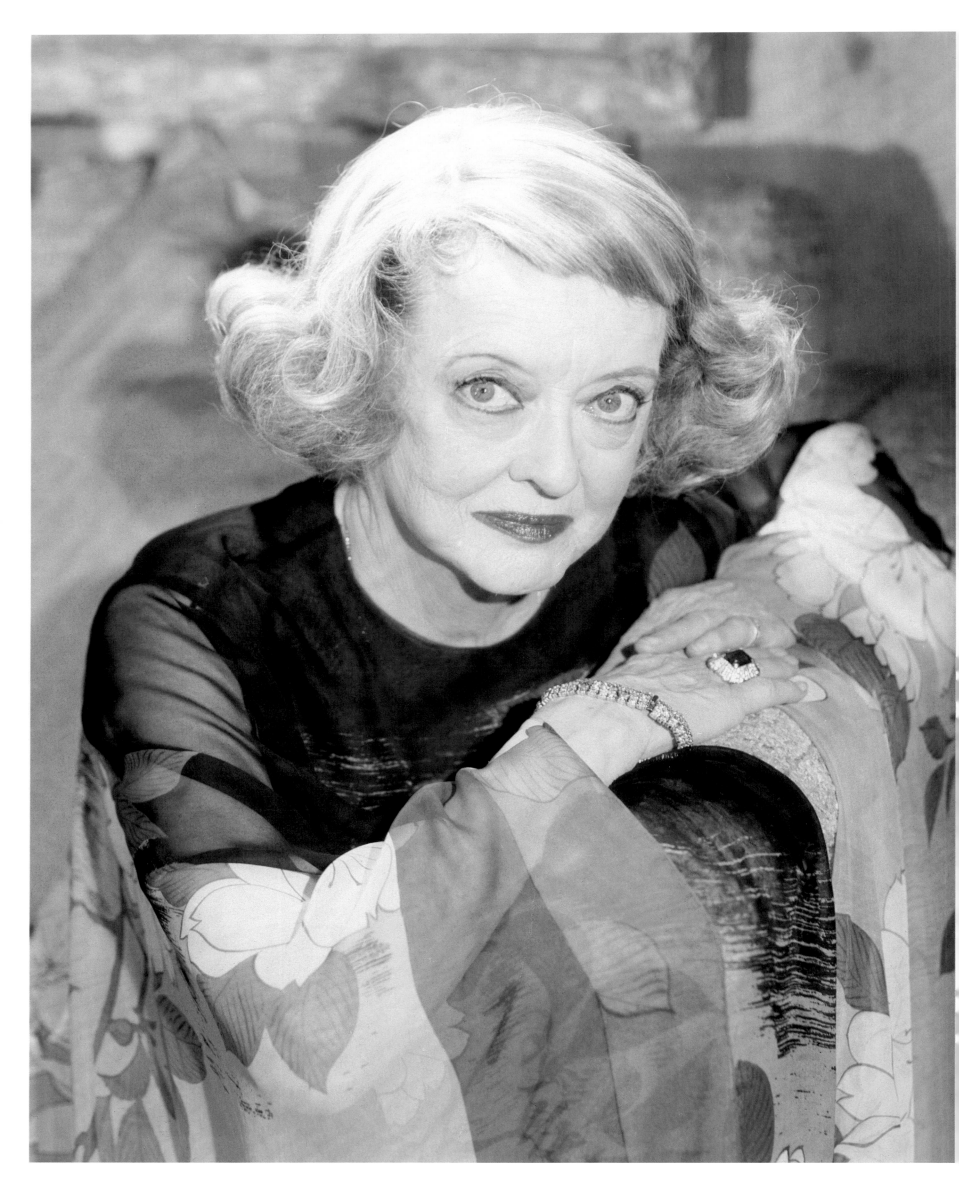

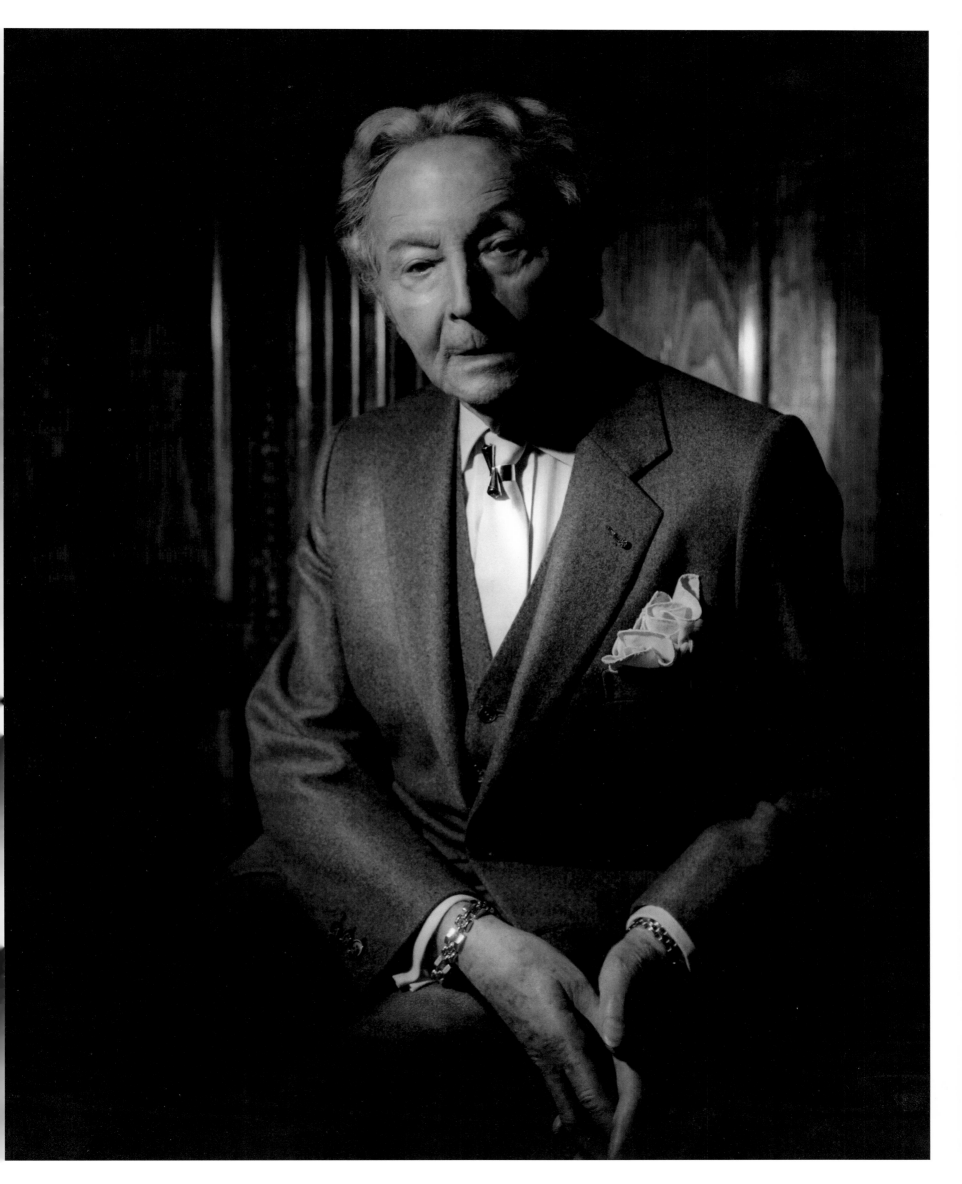

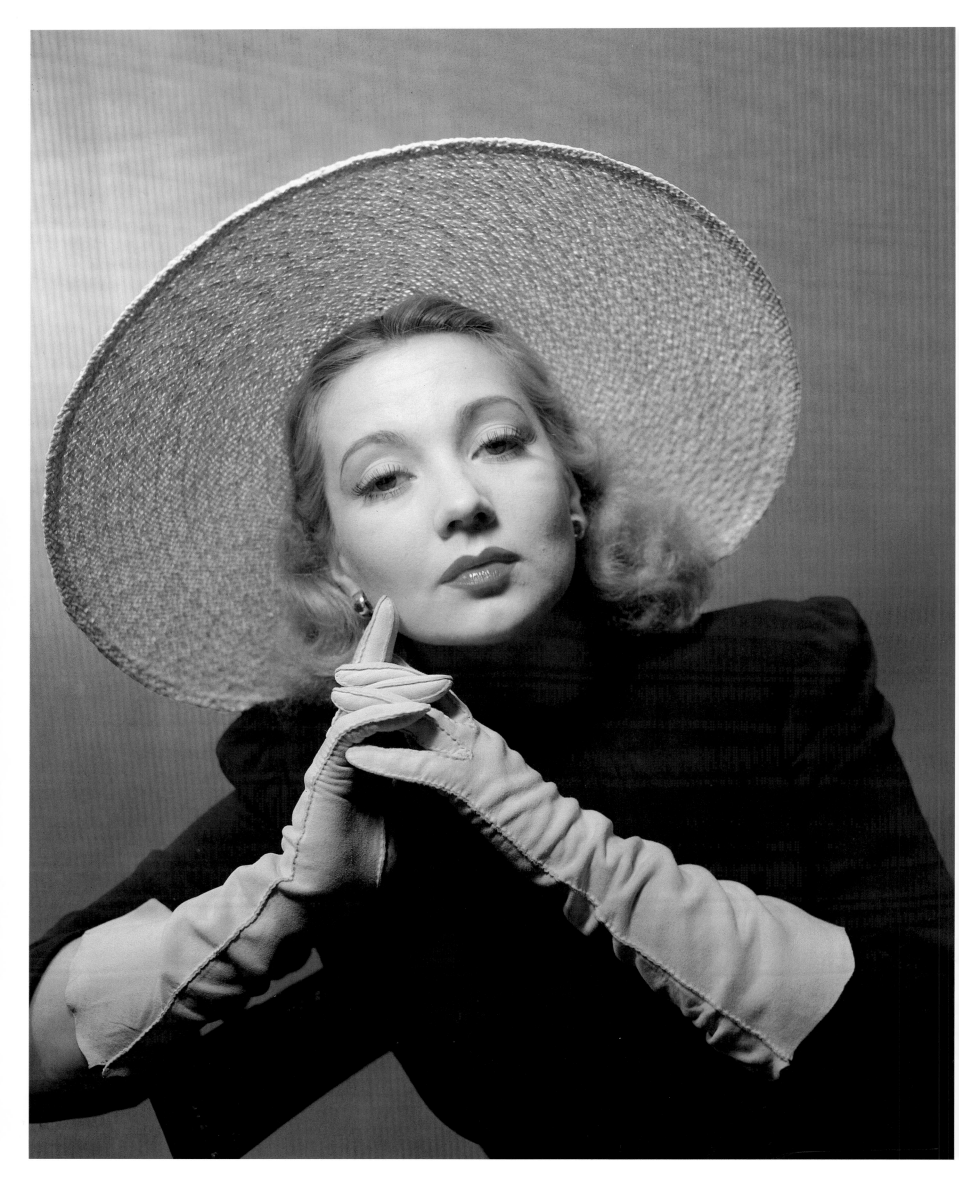

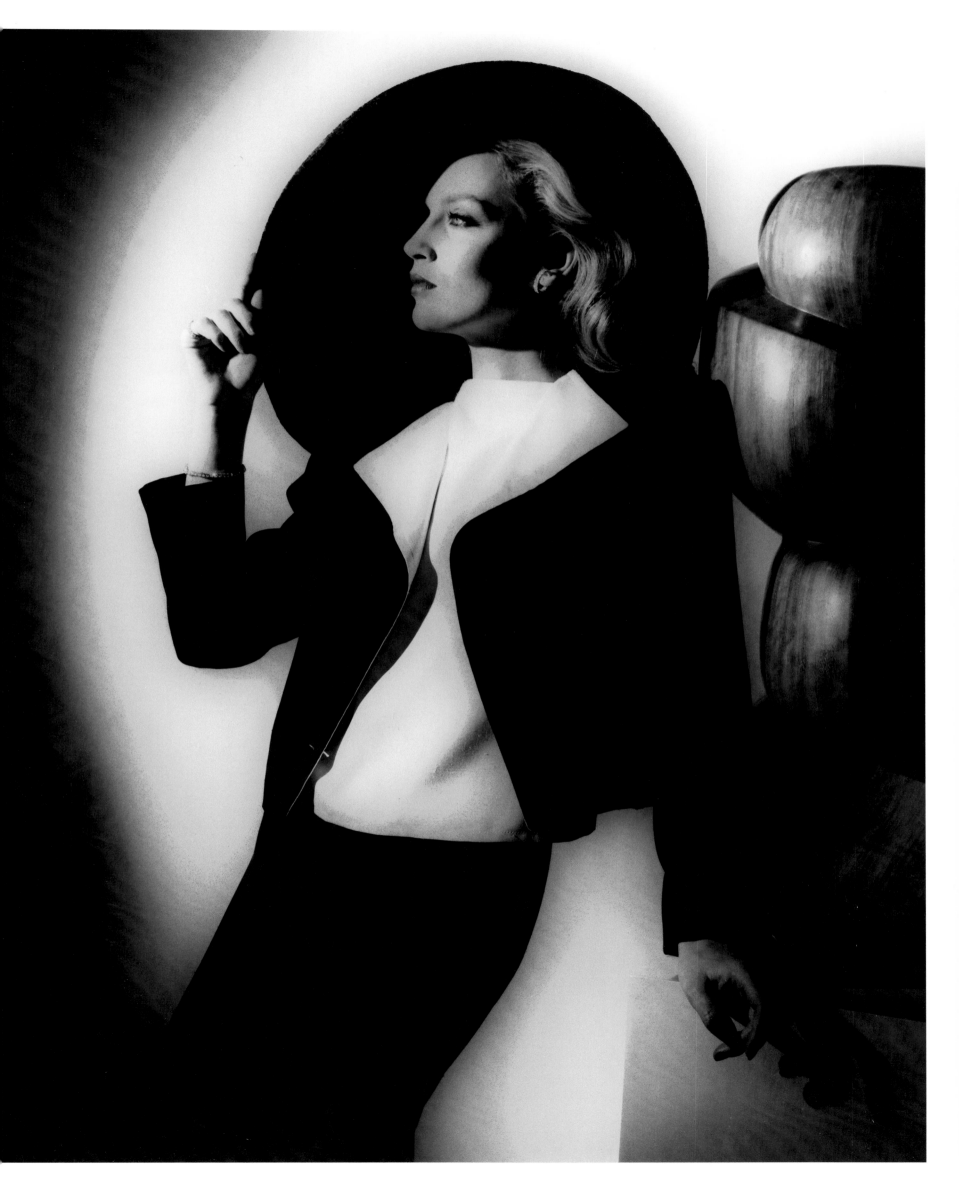

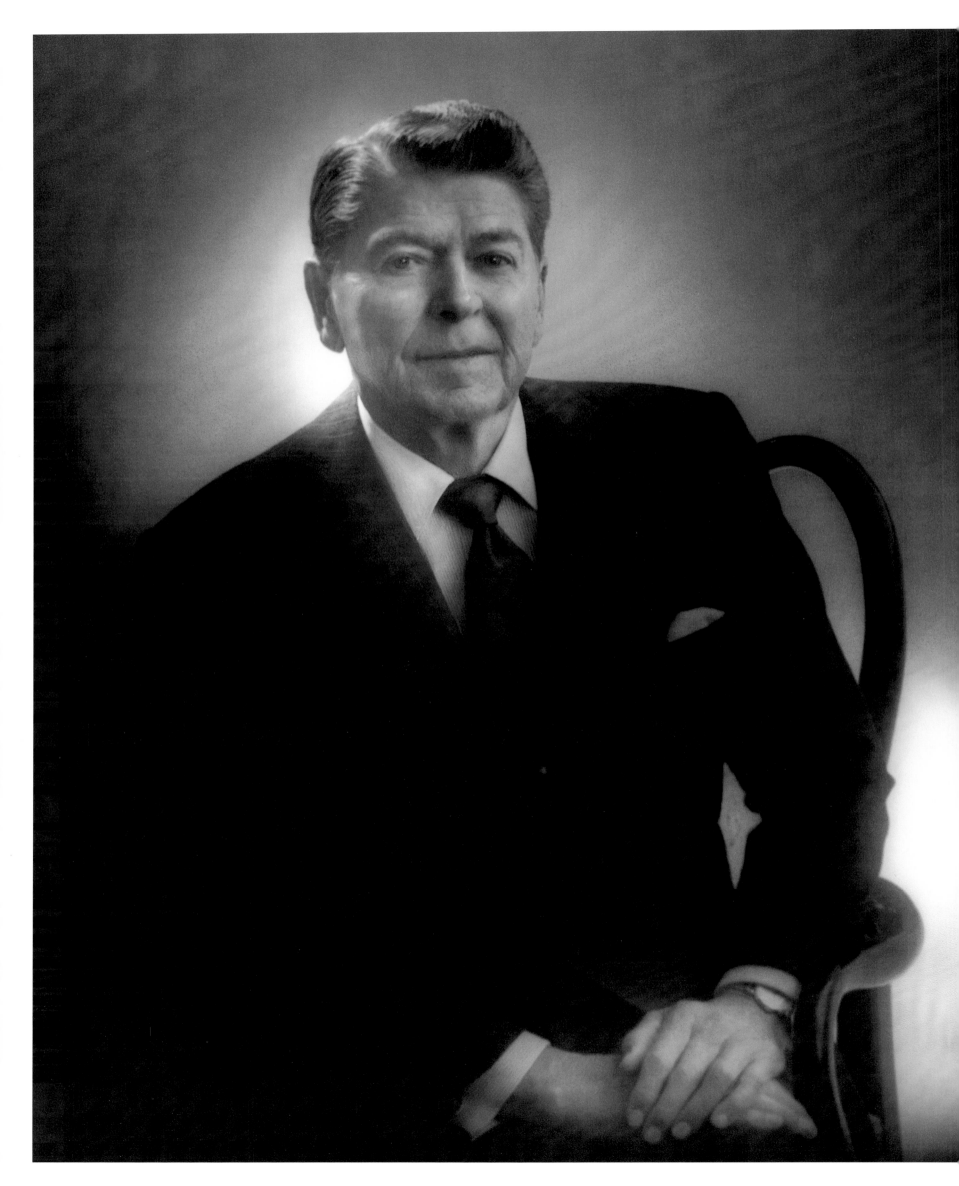

138 RONALD REAGAN, 1990

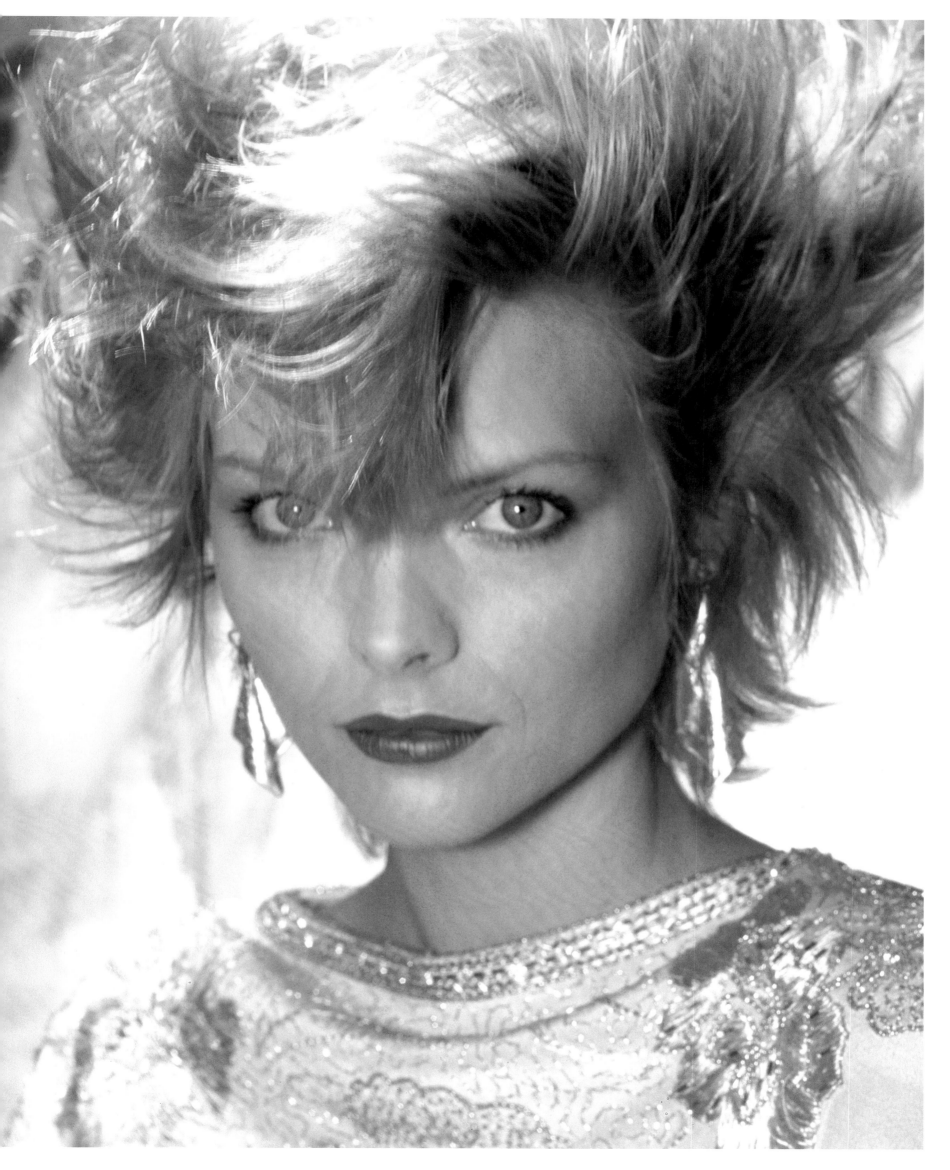

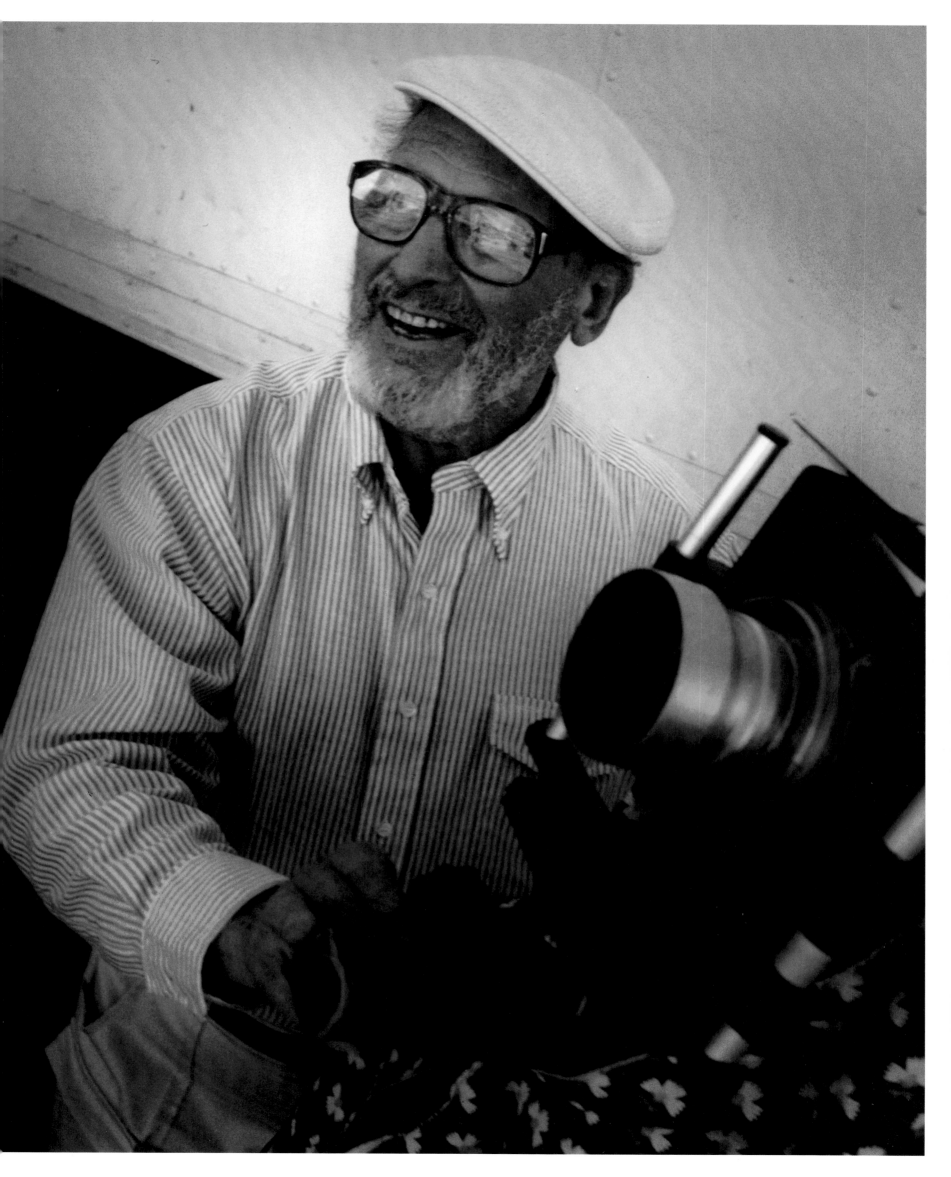

140 GEORGE HURRELL, 1985

BIOGRAPHY

1904 George Hurrell is born in Cincinnati, Ohio. His father, Edward Eugene Hurrell is a shoe manufacturer. George's grandfather was from London, his grandmother from Dublin. His own mother was born to Catholic parents in Baden-Baden. During his school days George becomes strongly interested in art, especially in drawing.

1920 George commences his studies of painting and graphics at the Art Institute of Chicago and Academy of Fine Arts.

1925 George Hurrell becomes assistant to Eugene Hutchinson, a famous Chicago portrait photographer.

1927 In May, Edgar Payne, founder of the Laguna Beach Museum of Art, persuades Georges Hurrell to move to the artists' colony at Laguna Beach, California. Here, George does landscape painting and photographic experiments with sunlight. He opens a portrait studio. Hurrell's photography—primarily reproductions of paintings by other artists—soon earns him more money than his oil paintings. A friendship begins with the wealthy socialite, racing driver and pilot, Florence 'Poncho' Barnes, who has made headlines with her airplane 'Mystery Ship'.

In autumn George Hurrell sets up a small studio at 672 Lafayette Park Place, Los Angeles. His friend, the painter Leon Gordon, arranges a meeting with Edward Steichen, America's leading photographer. Steichen is very impressed with Hurrell's work, lets Hurrell do his film developing in Los Angeles and influences his work. Steichen also gives him important advice that he follows throughout his career. Hurrell is also very impressed with Steichen's fees as a commercial portrait and advertising photographer.

1928 'Poncho' Barnes introduces him to Ramon Novarro. The famous actor is so impressed with the portraits Hurrell made of him in San Marino that he shows him the MGM publicity department and introduces him to his colleague, Norma Shearer.

1929 Norma Shearer contacts Hurrell. She wants to convince her husband, Irving G. Thalberg, who is producing the film *The Divorcée*, that she has the sex appeal for the role of a seductive siren. The portraits in a see-through negligé convince Thalberg. She gets the role and later the Oscar for best actress. Hurrell closes his studio and becomes head portrait photographer at MGM, where he takes publicity stills of all MGM stars.

1930 The first star that Hurrell photographs at MGM is Lon
−33 Chaney, famous for his portrayals of gruesome characters. Unforgetable photographs of Greta Garbo, John Gilbert, Clark Gable and the Barrymore acting family follow. At the same time Hurrell develops his superb talent for entertaining and relaxing the stars with music, acrobatics and other activities during their day-long photo sessesions.

George Hurrell leaves MGM and opens his own studio on 1933 Sunset Boulevard, where in the following years he photographs the stars from RKO Pictures, Paramount, 20th Century Fox, Warner Brothers, etc.: Shirley Temple, Tyrone Power, Loretta Young, Marlene Dietrich, Mae West, Charles Boyer, Gary Cooper, Carole Lombard. His reminiscence on working with Marlene Dietrich: "I shot her many times. All of the sessions were very long with many costume changes and several different hairdos. She felt that she knew exactly what was right for her. She would assume a pose, check herself in the mirror and say 'All right George, shoot!' She was the total perfectionist. It was no use trying to catch her off guard. There was no such thing with Marlene. Everything was studied."

Parallel to his work in Los Angeles he rents a studio in New 1935 York City.

Regular photographic contributions for *Esquire* magazine. Hur- 1936 rell works as independent photographer for film companies such as Paramount, Samuel Goldwyn, 20th Century Fox and Selznick International. *Esquire* praises him: "A Hurrell portrait is to the ordinary publicity still what a Rolls Royce is to a roller skate."

On contract with Warner Brothers, Hurrell photographs Bette 1938 Davis, Ann Sothern, Edward G. Robinson, Humphrey Bogart, James Cagney and many others. Bette Davis commented: "A sitting with this master photographer is an absolute joy. His studies of me were an immense contribution to my career."

George Hurrell opens a studio in Beverly Hills, California. 1941

George Hurrell serves as troop photographer in the First Mo- 1942 tion Picture Unit of the U.S. Army Air Force in Culver City, California.

After World War II, Hurrell returns to Hollywood. For 1945 Columbia Pictures he photographs Rita Hayworth, Claudette Colbert, Mae West and other stars.

Moves to New York. Hurrell works for various advertising 1946 agencies. −56

Walt Disney forms Hurrell Productions for filming TV com- 1960 mercials for Kelloggs, Sunkist, Hunts, Johnson & Johnson and other clients. In the following years George Hurrell works for a number of film and TV productions such as *Gunsmoke*, *Star Trek*, *M.A.S.H.*, *Marcus Welby*, *The Bing Crosby Show*, *The Bob Hope Show* and *The Dany Thomas Show*.

The Museum of Modern Art selects George Hurrell as one 1965 of fourteen photographers—along with Adolph Braun, Cecil Beaton, Edward Steichen, Man Ray, Irving Penn and Richard Avedon—for the exhibition *Glamour Poses*.

Hurrell works on the films *Butch Cassidy and the Sundance* 1970 *Kid, Poseidon Adventure, Towering Inferno, All the Presi-* −75

dent's Men. He photographs Paul Newman, Robert Redford, Charlton Heston, Liza Minnelli, Raquel Welch and others.

1976 George Hurrell's portrait of Joan Crawford is selected for the poster for *Dreams for Sale*, an exhibition at the Municipal Art Museum of Los Angeles featuring famous Hollywood photographers. Hurrell's reminiscence of Joan Crawford: "She was a great gal. She was a very bombastic, energetic, vital personality."

The Hurrell Style, a book written by the Hollywood author Whitney Stein, is published and meets with wide critical acclaim. 1977

The borough of Manhattan, New York, declares December 5th as 'George Hurrell Day'. 1980

After a brief illness, George Hurrell dies of cancer in California. 1992

INDEX

Front cover: Marlene Dietrich
Back cover: Ramon Novarro, 1928

Design: Thomas Elsner

Library of Congress Cataloging-in-Publication Data
Hurrell, George.
Hurrell Hollywood / George Hurrell.
p. cm.
ISBN 0-312-08220-7 : $69,95
1. Motion picture actors and actresses—Portraits. 2. Glamour
photography. I. Title.
PN1998.2.H87 1992 92-23880
 CIP

First Edition
10 9 8 7 6 5 4 3 2 1

First published in Europe by Schirmer / Mosel Verlag.
First U. S. Edition: November 1992

Reproductions: O.R.T. Kirchner & Graser, Berlin
Typesetting: Typ-O-Graph Vera Sponner, Munich
Printing: Appl, Wemding
Binding: Fikentscher, Darmstadt
ISBN 0-312-08220-7
A Schirmer/Mosel Production